A CONCISE HISTORY OF

AMERICAN PAINTING

AND SCULPTURE

D0974770

A CONCISE HISTORY OF
AMERICAN PAINTING
AND SCULPTURE

Revised Edition

MATTHEW BAIGELL

IconEditions
An Imprint of HarperCollins*Publishers*

A previous edition of this book was published in 1984 by Icon Editions, an imprint of Harper & Row, Publishers.

A CONCISE HISTORY OF AMERICAN PAINTING AND SCULPTURE (REVISED EDITION). Copyright © 1984, 1996 by Matthew Baigell. All rights reserved. Printed in the United States of America. No part of this book may be used or reproduced in any manner whatsoever without written permission except in the case of brief quotations embodied in critical articles and reviews. For information address HarperCollins Publishers, Inc., 10 East 53rd Street, New York, NY 10022.

HarperCollins books may be purchased for educational, business, or sales promotional use. For information please write: Special Markets Department. HarperCollins Publishers, Inc., 10 East 53rd Street, New York, NY 10022.

FIRST EDITION
Designed by Abigail Sturges

ISBN 0–06–430986–X

98 99 00 BB 10 9 8 7 6 5

For Margot and Athan,
and
for Kenneth

CONTENTS

LIST OF ILLUSTRATIONS*

*The numbers in italic at the end of each entry are page references.

INTRODUCTION

In this survey I have concentrated on that part of American art which developed from northern and western European traditions in order to sustain the narrative flow and to keep the text from becoming an unwieldy collection of chapters on quite different art traditions and styles. Within these guidelines, the first chapter begins with a discussion of seventeenth-century art along the eastern seaboard, and the last chapter includes sections on current realistic, process, and technological art. I would have liked to discuss many more interesting and provocative artists, but constraints of space prevented me from considering all but the most historically important and intrinsically significant.

When preparing the *Concise History*, I resisted imposing a scheme on American art, such as finding its motivating impulses in the search for the Idea or the Fact, or discussing whether American art is basically idealistic, realistic, expressionistic, or something else. And the notion of finding a quintessentially American art in a pluralistic society seems too reductive to make much sense, anyway.

The chapters are arranged chronologically, and each generally follows the same organizational sequence. But deviations occur. In some chapters, for instance, sculpture is placed at the end, or left out entirely or integrated with discussions on painting. Short introductory sections in each chapter vary, depending on the ways the material seemed to present itself, and social and cultural observations appear, to a greater or lesser degree, when these seemed relevant. From time to time I suggest continuities of themes, ideas, and images. Occasionally contrasts or comparisons are made between artists of the same or of different centuries to point out continuities or discontinuities. My concern was to write a book that could be read as a continuous history rather than a series of separate chronological essays.

Illustrations have been keyed directly to the text, but in some instances photographs of particular works could not be obtained because of excessive costs, special restrictions, or lack of availability. Some favorites, therefore, could not be reproduced. Furthermore, since certain ideas were better explained through the works of a particular artist, I did not always follow the rule of thumb that an artist's importance is measured by the number of reproductions of his or her

works. And indeed sometimes a lesser-known work by a particular artist might explain or make a point more effectively than a notable work by the same artist.

In organizing and writing a book of this type, I had to rely on the research of dozens of scholars. To them I owe an extraordinary debt of gratitude for keeping me as up-to-date as possible and for making the task of synthesis easier than it might have been. Specialists will quickly recognize my sources. Some are quoted directly, others are paraphrased. Because of the incredible number of books, articles, and exhibition catalogues that appear almost daily, I have, no doubt, overlooked some important items. For these oversights, I plead human limitations and fallibilities. I do want to say, however, that the ideas and formulations of Renee Baigell appear on more pages than those of probably anybody else, and to her I acknowledge the warmest possible affection and respect. Of course I assume complete responsibility for my interpretations and for factual accuracy.

I want to thank Cass Canfield, Jr., of Harper & Row for his always generous and continued support. He is everything an author could hope for in an editor. I also want to express my appreciation to Bitite Vinklers for copy-editing the text, and to Leah Baigell, Naomi Baigell, and Jennifer Toher for help in many administrative details.

<div align="center">✳✳✳</div>

For this new edition I have made corrections, revisions, and additions to the text and bibliography and added 13 new illustrations.

<div align="right">M. B.
March 1996</div>

1

COLONIAL ART

NORTHWESTERN EUROPEANS established permanent colonies on the eastern shores of what is now the United States throughout the seventeenth century. English groups settled in tidewater Virginia at Jamestown in 1607; along the New England coast on Cape Cod in 1620 (the Pilgrims); at Salem, Massachusetts, in 1628 (the Puritans); and in the Chesapeake Bay area in 1634. Beginning in 1624, the Dutch began to colonize the Hudson River area, but succumbed to English rule in 1664. In the 1660s, the first settlements were started in the Carolinas and, by 1680, in the Delaware Bay region. At the end of the century, the English controlled the entire seaboard from Portland, Maine, to Port Royal, below Charleston, in South Carolina. In the 1640s, about 50,000 Europeans and Africans lived in the colonies; by 1700, the number had jumped to about 200,000; and, in 1720, to almost half a million.

Because of the patterns of settlement—dispersed plantations in the South and populated towns in the North—the most noteworthy and extensive groups of paintings surviving the first century of immigration come from the areas around Boston and New York City. At least one painter, Augustine Clemens (c. 1600–74), arrived in Massachusetts as early as 1635, but the earliest surviving works date only from 1664. By that time, the rigors of pioneer life and, more important, the rigors of Puritan faith had begun to wane. The Sumptuary Law of 1651, passed by the Massachusetts General Court, ruled against people of "mean condition" dressing above their station, as ladies and gentlemen, thus acknowledging that many people no longer showed their inner sanctity by their outer appearance or honored the class-leveling implications of Puritan religious fellowship. Although conservative elders continued to thunder against the growing interest in worldly goods and pleasures, the rising merchant class and the burgeoning transient population, especially in larger towns, could no longer be controlled. The earlier ideal of self-control and proper religious behavior had so deteriorated by 1675 that the General Court, realizing that many heads of families no longer performed their duties properly, appointed tithing men to see that the Sabbath was observed and that drinking was controlled. (Boston had at least fourteen inns or taverns by 1662.) In addition, the very success of the colonies

altered the once central role of ministers, who had earlier participated in and guided the practical affairs of their communities, but whose place was increasingly narrowed to that of professionals catering only to the spiritual needs of their congregations.

Quite possibly, a painting such as *Mrs. Freake and Baby Mary*, 1674 [1], could not have been painted a generation earlier—and not only because Mrs. Freake allowed the artist to dwell so carefully on her fine clothing, of which she must have been very proud. The Puritans often gave their children to other families to be raised because they feared spoiling their youngsters with too much affection. Parental indulgence might, the Puritans thought, prevent a child from learning to control his or her feelings. Although Mrs. Freake does not show great warmth toward her daughter—the exploration of human emotions was not important in Puritan culture—she displays an obvious pleasure that probably would have caused the earliest settlers to wonder about the future of their Bible commonwealth.

Mrs. Freake and Baby Mary is one of several paintings similar in style. These are characterized by minimal modeling of the face and arms, emphasized linear contours, clearly depicted patterns, and bright colors that hide body volumes. The figures are usually in a frontal position, and, with background elements barely indicated, depth is severely limited. Although it has been suggested that Samuel Clemens (d. 1768), Augustine's son, painted Mrs. Freake and her daughter, the work was probably done by a more recent arrival from England. Compared to similarly styled works, this one, unless significantly altered by cleanings and repaintings, is the most thorough, complete, and consistent in all its parts and details, indicating that its author had received more than rudimentary training

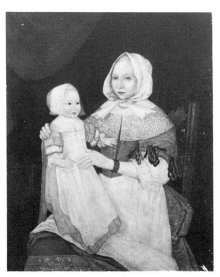

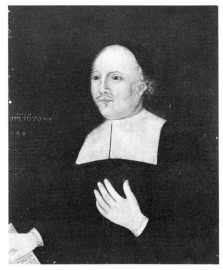

1. Anonymous, *Mrs. Elizabeth Freake and Baby Mary,* c. 1674. Worcester Art Museum.

2. John Foster (?), *Reverend John Davenport,* late seventeenth century. Yale University Art Gallery.

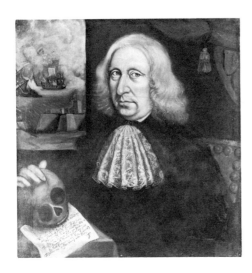

3. Thomas Smith, *Self-Portrait,* late seventeenth century. Worcester Art Museum.

and had, at least in his mind's eye, excellent models on which to base his painting. If the artist was a Puritan, his presence at this time in New England might be explained by the brutal repression of Puritans after Charles II's accession to the throne in 1660. In any event, sources for the artist's work and style lie in provincial English paintings of a generation or two earlier from East Anglia, the area northeast of London from which many settlers emigrated.

In addition to the linear style, which developed from old English modes, East Anglian artists were also influenced by realistic Dutch works because of commercial trade between the two areas. Versions of this style also appeared in New England by 1670, and at least one figure, John Foster (1648–81), can even be identified with it. His woodcut of John Mather, c. 1670, probably the first print made in the English colonies, resembles several portraits of New England ministers. Perhaps it was Foster who painted the portrait of the Reverend John Davenport [2], one of the most conservative of the old-fashioned ministers, shortly before Davenport's death in 1670. (Davenport, a founder of New Haven and a minister there, took over the pulpit of Boston's First Church in 1668.)

In contrast to the linear-styled works, the realistic style is characterized by a greater degree of modeling and psychological insight, despite the stereotyped poses. Like the painter of Mrs. Freake, the artist or artists of the more realistic style could not create atmospheric envelopes around their figures. The accented faces and hands, therefore, do not assume a vibrancy and living presence typical of European works, but have a stiffness of form in which parts of bodies seem frozen, anchored in a sea of darker colors. On the other hand, loss of depth denies these figures a physical and sensuous palpability, a quality the conservative Puritans would have abhorred anyway. Here, religious belief and lack of training seem to coincide.

A third group of colonial works, associated mainly with a mariner, Captain Thomas Smith, reflect contemporary English courtly styles [3]. In these works, Dutch realism is modified by familiarity with the pomp, splendor, and grace of

Flemish baroque art, introduced into England by Sir Anthony Van Dyck in 1620. Van Dyck visited England that year, and he lived there from 1632 to 1641, setting the course of aristocratic portraiture for the next two hundred years. His successors—who were important because their paintings, copied in mezzotints, served as models for American painters throughout the colonial period—were Sir Peter Lely (1618–80), who settled in England in 1641, and Sir Godfrey Kneller (1646–1723), who arrived there in 1674. Both were trained in Holland.

Captain Smith, obviously familiar with London fashions, visited the colonies as early as 1650. Able to model features convincingly, Smith also included distant vistas in his work, a characteristic device of the Van Dyck school. But one may argue that, even though this group of colonial paintings was the most stylistically advanced, it tells us the least about Puritan culture. Rather, it describes the aspirations that ultimately dominated New England culture; the descendants of those who wanted to purify the Church of England turned themselves into provincial imitators of their cosmopolitan English cousins.

The emphasis on portraits throughout the colonial period reflects English taste and religious practice, which proscribed religious scenes. But the first settlers did not consider a face painter more valuable than any other craftsperson. The tradition of the great artist, imported from the Continent, had not yet reached England and, besides, Puritans judged a person by signs of inner grace, of the presence of the living God in one's soul, rather than by a facility with a paintbrush—thus, the anonymity of most portrait painters.

Religious imagery was especially disliked by the Puritans, whose chief mode of communication was verbal rather than visual, and who preferred the sermon to the sensuous effects of an elaborate worship service and elevated the pulpit above the altar. Yet, they developed a mortuary art in the seventeenth century that lasted in rural areas until the nineteenth. The dead, evidently, could not easily be buried without a commemorative gravestone. Students of the period have not yet explained the popularity of gravestones in a religious culture that preferred discourse and rational explanation to imagery and emotion. Probably the fact of death itself was too monstrous to face without symbolically sending off the recently deceased to the other side. Images carved on tombstones might well have had the salutary effect of providing a more direct, personal access to the mysterious workings of the Deity than what was heard in dry, emotionless sermons. The desire and need for a more immediate rapport with God lay just beneath the surface of Puritan thought. This is reflected in Anne Hutchinson's trial and banishment in 1637 for believing that God had revealed Himself directly to her and by the Great Awakening of the 1740s, in which people felt the divine infusion of grace without necessarily having to prepare for it or having to act responsibly because of it. (Nineteenth-century Transcendentalism might be considered a later version of the same longing for direct communion with the godhead.)

For the Puritans, death was viewed as a lesson for the living. That is, people were taught to trust in God and to contain their emotions in the face of death. Accordingly, the carvings on the tombstones showed a variety of images that

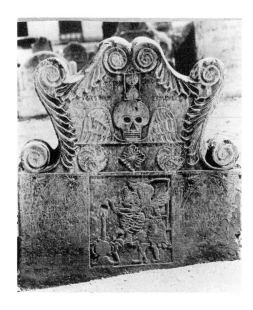

4. Anonymous, *Joseph Tapping Stone,* 1678.

confronted the viewer both with the stern reality of death and with the hoped-for afterlife. In place of the narrative imagery common to Catholic art, there were symbols of death and rebirth, including death's heads and glorified souls, as well as skeletons and living vines. Styles ranged from shallow-planed rural reliefs to deeply cut carvings in urban cemeteries. As in contemporary paintings, European influences appeared to a greater or lesser degree, intermingled with forms apparently of local invention.

By the middle of the eighteenth century, several schools and individual carvers had become well known. The Joseph Tapping Stone, 1678 [4], roughly contemporary with the earliest surviving Puritan paintings, is among the more elaborate of its time. Done in the workshop of an artisan now known as the Charlestown Carver, it has architectural motifs of gothic arches and columns, suggesting the journey to Heaven through these portals. The centrally placed death's head commonly appeared on Boston gravestones of the period. The allegory of time and death, based on sources in English emblem books, was perhaps the first such image to appear in New England.

Painting in the New York City area is much less problematic in respect to content than in New England, but infinitely more complicated in regard to chronology and identification of artists. Manhattan Island, first settled in 1624, primarily as a trading center, had only 1500 people when the British captured it in 1664. It had a rowdy town, open to virtually all religions and nationalities, but it could boast of several artists, including the Frenchman Henri Couturier, who worked there through the 1660s and in the early 1670s. Couturier, or another painter, was responsible for the portrait of Peter Stuyvesant, c. 1660 [5], a remarkable example of the Dutch realistic style in the colonies. This tradition was continued by the Duyckinck family dynasty, whose founder, Evert I (1621–1702),

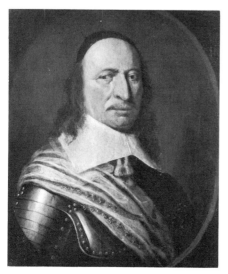

5. Anonymous, *Portrait of Governor Peter Stuyvesant,* c. 1660. The New-York Historical Society.

6. Gerrett Duyckinck, *Self-Portrait,* c. 1700–10. The New-York Historical Society.

emigrated in 1638 from Holland and worked as a painter and glazier, as well as practicing other trades. A son, Gerret (1660–1710), and his son, Gerardus (1695–1746), and also Gerret's nephew, Evert III (1677–1727), continued the family tradition. In effect, they established a measure of artistic continuity in a place where there was minimal artistic instruction, no artistic tradition, and few or no worthwhile prototypes that could be seen or studied. Gerret's work, seen in his self-portrait of about 1700, reveals his knowledge of Dutch realism at second hand [6]. Like virtually all colonial artists, Gerret never developed the ability to paint forms set behind the picture plane in a credible atmospheric space. Instead, faces, bodies, and hands cling to the picture surface, their edges emphasized by taut outlines.

Several portraits have been associated with, but not firmly ascribed to, Gerret's son, Gerardus, as well as a religious painting, *The Naming of John the Baptist,* 1713 [7], perhaps the earliest signed and dated religious painting in the colonies. It is especially intriguing because of its possible connection to religious works from the Albany area. (Gerardus' mother came from Albany.) That community, really an outpost in the wilderness, was about to commence an art boom. Within a few years and until about 1750, an estimated eighteen artists turned out dozens of paintings for a population numbering about 10,000. Unfortunately, many works cannot be firmly attributed to any artist, nor have scholars even agreed on basic stylistic patterns among the artists. For example, the portrait of Johannes de Peyster III, 1718 [8], has been assigned to an English immigrant artist because of de Peyster's aristocratic swagger, as well as to a more Dutch-inspired painter because of the portrait's stylistic resemblance to several works by the Aetatis Sue Limner, now identified as Nehemiah Partridge (1683–c. 1730).

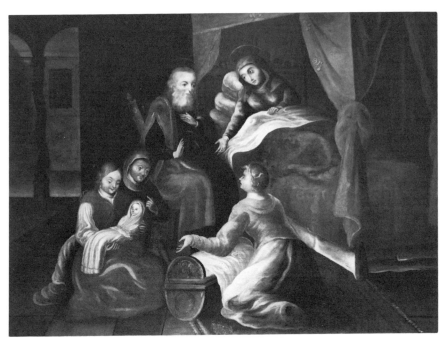

7. Gerardus Duyckinck, *The Naming of John the Baptist,* 1713. Biblical Arts Center, Dallas.

8. Anonymous, *Johannes de Peyster III,* 1718. The New-York Historical Society.

9. Nehemiah Partridge, *Col. Pieter Schuyler,* c. 1715. Collection of the City of Albany.

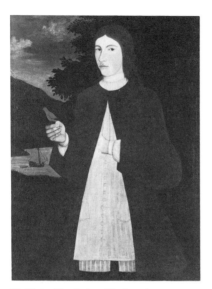

10. Pieter Vanderlyn (?), *Pau de Wandelaer,* c. 1730. Albany Institute of History and Art.

11. Gerardus Duyckinck (?), *Portrait of a Young Man—De Peyster Family,* c. 1730–50. The New-York Historical Society.

This painter may be responsible for as few as twenty-three or as many as eighty portraits! He flourished in the Albany area between 1715 and 1725 and inscribed the words "Aetatis Sue," with the sitter's age, on each painting. One of his strongest works, and probably his first, is the full-length study of Colonel Pieter Schuyler, c. 1715 [9]. This painting, as most by Partridge, is invigorated with a sense of life because of the artist's ability to give character to the face. (Schuyler was a major figure in Albany, serving as its first mayor from 1686 to 1694. De Peyster was mayor on three occasions, between 1729 and 1742.)

Another figure to whom different sets of paintings have been variously assigned is Pieter Vanderlyn (c. 1687–1778), who emigrated to the Hudson Valley area in 1722 and was active there from 1730 to 1745. He has been most closely identified with the painter called the Gansevoort Limner. (Several artists are named for the families they painted.) Vanderlyn painted less aggressively than Nehemiah Partridge. His sitters appear to be more retiring and contemplative, perhaps because they come from a slightly lower social class [10]. His figures are typically two-dimensional, their clothing composed of broad, simplified, and clearly defined patterns of virtually unmodeled color.

Vanderlyn's paintings are contemporary with several done in New York City, indicating the continuation and growth of art activity there. Among the most accomplished are those of children, particularly from the de Peyster and Van Cortlandt families [11]. When they are seen all together, obvious stylistic differences are evident; even specific characteristics emerge, such as Partridge's habit of placing a crumpled glove in a sitter's left hand and Vanderlyn's habit of painting enlarged hands. Yet, there also seem to be family resemblances, due in

part to the sources each artist used. Virtually all of their works, as well as those of most colonial painters, were based on mezzotint copies of English paintings. Often a mezzotint of a particular Lely or Kneller original lies behind works by several painters up to and including John Singleton Copley, allowing us to see how different artists interpreted the same pose. From painting to painting, not only are poses, postures, and proportions similar, but transforming a black-and-white print into a painting with color created problems all colonial artists shared. Their solutions varied, but a "colonial look" emerged that linked the Hudson Valley limners with artists from Boston to South Carolina.

Because the paintings were derived from black-and-white prints, intricate color relationships are lacking. In their place, several artists developed a subtle color sense by juxtaposing closely related hues and relating pigments different in color but equal in lightness or darkness of tone. The artists, whether colonials or émigré Europeans, simplified complex and convoluted outlines into broad arcs defining limbs, facial features, and clothing. Glittering highlights were either smoothed out into sequences of broadly rolling lights and darks or became thickened, jagged splotches of pigment resembling coarse flashes of lightning. Flesh, often lacking an armature of bone and muscle to which to cling, usually ballooned out from cuffs, wigs, and collars. Backgrounds duplicated the landscapes in the mezzotints, not the American forest so near at hand.

Evidently, the colonists wanted to be seen and remembered as persons of elegance and wealth. Many, in fact, were comparatively rich, particularly several from the Hudson River valley, whose patrician status grew from their estates, or patroonships, first established in 1629. But, as the eighteenth century progressed, also merchants, whose newly found wealth could fluctuate wildly if a ship were lost at sea, wanted to be remembered as persons of aristocratic pretension. In the fluid colonial society, the ability to commission a portrait, especially one from a recently arrived European artist, provided an important means of self-definition. It indicated one's power and wealth. Commissioning portraits also identified the sitter with the cultural habits and the artistic styles of the mother country. Furthermore, the portrait of a community hero was expected to look heroic, and the portrait of a traveling man—a mariner, for example, who faced many hardships—was equally grand. Other reasons for commissioning portraits also suggest that a sitter wanted to be remembered with respect. These portraits included paintings of homeowners, of women expecting a first child (who might not survive, considering the hardships and the medical practices of the day), and of the aged or already dead—including children carried off in an epidemic.

As the population and wealth grew, demand for portraits and, to a much lesser extent, for landscapes and religious paintings increased. Artists of greater sophistication began to settle in the larger communities. But since the five largest ones—Boston, Newport, New York City, Philadelphia, and Charleston—in 1775 had only 90,000 residents of the 2.5 million people living in the English colonies, few artists could support themselves exclusively by their art. Several traveled from town to town, altering local tastes as they passed through. Colonial artists who aspired to become portrait painters responded to the works of now one and

12. Jeremiah Theus, *Mrs. Thomas Lynch,*
1755. Reynolda House, Winston-Salem.

13. Justus Englehardt Kuhn, *Eleanor Darnall,*
c. 1710. Maryland Historical Society.

now the other visiting European. In fact, some of the most fascinating stories of the art of this period lie in observing how American-born artists imitated the different European styles and how they wrestled with the seemingly insurmountable task of suggesting three-dimensional volumes on an intractable two-dimensional surface. Some, such as Robert Feke and Copley, worked out plausible compromises, creating splendid paintings in the process. Others, because of either their own preference or lack of training and ability, retained an artisan's respect for the flat surface, providing posterity with sturdy, mythic images, icons really, of the first generations of Americans.

Fewer artists migrated to the southern colonies, because of the development of a plantation economy; there were fewer towns than in the North, and they were more distant from each other. Henrietta Johnston (d. 1728/9) was one of the first to arrive. Settling in Charleston in 1705 with her minister husband, she specialized in pastel portraits. Perhaps as early as six or seven years after her death, Jeremiah Theüs (c. 1719–74) arrived there and for the next several decades was the major artist in the area, possibly in the entire South. Like Johnston, he was not adept at characterization, but he did provide his sitters with a sense of dignity and grace. His ability to indicate detail clearly, whether of lace or flowers, as well as to catch the sheen of satin and silk, recommended him highly to the leaders of South Carolinean society [12].

Justus Englehardt Kühn (active c. 1708 until his death in 1717), the first professional artist to settle in the Middle Colonies, had established himself in Annapolis by 1708. One of many Germans from the Palatinate to emigrate because of religious disturbances, he painted many portraits, but is best known for his full-length works of children [13]. Based on seventeenth-century Palatinate models, the doll-like figures are posed on terraces in front of fantastical architec-

tural and landscape scenes. The desire to include these elaborate features was undoubtedly similar to that felt by the artist, or artists, and by the parents, of the de Peyster and Van Cortlandt children in New York City. No known contemporary portraits of adults contain such complicated backgrounds. Two factors may be significant here. First, the colonies had a relatively large number of children. If figures for New England are in any way applicable to the Middle Colonies, then it is useful to point out that seventeenth-century New England families averaged 7.1 children per family and, in the latter part of the century, children constituted 54 percent of the population of Bristol, Rhode Island. Second, since the success of colonial settlement was beyond question by the early decades of the eighteenth century, parents might have wanted to suggest in the portraits of their children both the kinds of material pleasures the children might expect and the conversion of the wilderness into a European garden. The latter notion, however, should not be considered part of the historical question of God's special relationship to the American people, since the paintings probably suggest human expectation rather than divine destiny. The idea of America as the promised land, an important concept in nineteenth-century American culture, especially for people of northwestern European ancestry, had not been formulated to any significant extent by the eighteenth century, except in New England, and there only minimally. Cotton Mather (1663–1728), the Puritan religious leader, did write in his *Magnalia Christi Americana* (1702), "if this New World were not found out first by the English, yet in those regards that are all of the greatest, it seems to be found out more for them than any other," but his words did not inform the thinking of English patrons and their English, Dutch, or German artists in New York or Annapolis.

A few years after Kühn's death, a notably sophisticated artist visited Maryland, where he remained until about 1726. This was Gustavus Hesselius (1682–1755), the Swedish-born artist who had been trained in England under Michael Dahl before emigrating to the colonies and settling in Philadelphia. During his years in Maryland, he painted a Last Supper for St. Barnabas' Church in Prince George County. He might also have ventured into Virginia, although no documents exist indicating that he did. His style during the 1720s was in the Lely-Kneller tradition of elegance and restrained paint application. Either just before or just after his prolonged visit to the South, he completed two mythological works, *Bacchus and Ariadne* and *Bacchanalian Revel,* among the first paintings of their type in the colonies. But portraits remained his principal means of support and the works for which he is best known. His paintings of the Indian chiefs Tishcohan and Lapowinsa in 1735, commissioned by the Penn family, show the development of a penetrating realism in Hesselius' art, also evident from descriptions of his work written earlier in the decade [14]. His realistic self-portrait and the portrait of his wife, with their comparatively richly textured facial features, were painted about 1740. In the next decade, however, he once again painted women as fashion plates, but in a soft, painterly mode not seen in his earlier works. Such changes were rare among émigré artists, whose styles tended to become more wooden and flat as their memories of European examples faded. It is to his credit that Hesselius undoubtedly responded appreciatively to the paint-

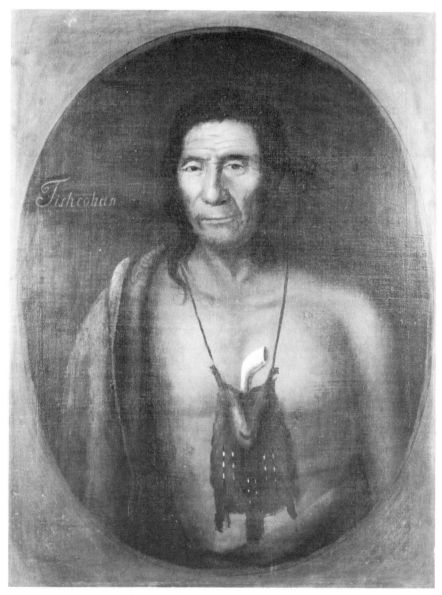

14. Gustavus Hesselius, *Tishcohan,* 1735. Historical Society of Pennsylvania.

ings of younger and more recently trained arrivals from the cosmopolitan centers abroad.

The only painter with a thorough knowledge and command of the Lely-Kneller tradition to work exclusively in the South was Charles Bridges (1670–1747). He arrived in Virginia in 1735, at the age of sixty-five, and remained for

15. Charles Bridges, *Mann Page II,* c. 1743. Oil on canvas, 46½" × 36½". College of William and Mary.

several years before returning to England. Why he came at such an advanced age and precisely how much he painted when in Virginia are as yet unanswered questions, but recent scholarship has assigned thirty-two portraits to his hand, mostly of families of plantation owners. In these, Bridges clearly demonstrated his mastery of standardized poses and the superficial elegance that passed for gracious sophistication [15]. With John Smibert, who had settled in Boston in 1729, Bridges was the best-trained English artist to visit the colonies before the Revolutionary War.

In the years before Smibert brought the Lely-Kneller style to New England, Boston was slowly developing a cosmopolitan culture, led by its increasingly worldly merchants and businessmen, to whom Puritan dogma meant less and less. Symbolic of the changes taking place was the establishment of the Brattle Street Church in 1699, whose members remained Puritan in spirit if not in performance. Like the leaders of colonial society elsewhere, they created a climate of social and intellectual opinion that welcomed stronger cultural ties to England, even as they remained dismayed by the vice and the low moral standards there.

Although Peter Pelham (c. 1695–1751) was the first artist knowledgeable in the Lely-Kneller tradition to reach Boston, arriving there in 1727, he was soon eclipsed by the arrival of John Smibert (1688–1751). It was Smibert who set the stage and tone for the evolution of colonial painting in New England, culminating in the works of Copley, and whose influence was felt by several significant American artists until the early years of the nineteenth century. He might never have left Europe had he not met George Berkeley in Italy, where Smibert lived from 1717 to 1720 and, after renewing their acquaintance in London in 1726, let Berkeley persuade him to go to America as professor of art and architecture in

16. John Smibert, *The Bermuda
Group: Dean George Berkeley
and His Family,* 1729, 1739.
Yale University Art Gallery.

17. John Smibert, *Samuel
Browne, Jr.,* 1734. The Rhode
Island Historical Society.

a college Berkeley intended to establish in Bermuda for converting Indians to Christianity. In any event, Smibert's arrival hastened the spread of aristocratic styles throughout the colonies after 1725, and he may be considered a major symbol of colonial artistic desires to emulate English habits, even as the colonies were developing their own political traditions and economic prerogatives.

Smibert, from Edinburgh, Scotland, entered Kneller's academy in 1711. In the years after his return from Italy, he developed an active practice, completing about 175 portraits, but remained an artist of the second rank. In Boston, he was clearly of the first rank and filled an almost desperate need for a competent portraitist. In 1729, he completed 26 portraits, 106 by 1735, and, his career tapering off during the 1740s, 241 by 1746. Although primarily a face painter, he also created history and conversation pieces, as well as landscapes. His own paintings, as well as his copies and prints of European works, formed the largest repository of art objects in New England and provided artists such as John Greenwood, Copley, John Trumbull, and Washington Allston with key lessons in composition and coloration, as well as the inspiration to persevere in a cool artistic climate. One might even argue that the continued availability of Smibert's collections, which he exhibited in 1729, rivals the importance of the Armory Show in 1913 as a forum for introducing to Americans significant art from abroad.

Smibert demonstrated his mastery of the aristocratic mode early in his American career with *The Bermuda Group,* 1729, 1739, a group portrait of Bishop Berkeley and his family [16]. An easy sequence of movements, by gesture and by glance, links the figures to each other. Light-reflective and light-absorptive textures are clearly differentiated. The colonnade and park to the rear, which are quite subordinate to the group around the table, indicate Smibert's mastery of atmospheric perspective. This work served as a model for later artists attempting group portraits, a difficult task at best and one almost insurmountable for colonials unsure of compositional relationships, color harmonies, and anatomical accuracies. Its echoes reverberate through Robert Feke's *Isaac Royall and Family,* 1741 [19]; John Greenwood's *Lee Family,* c. 1750; and possibly Joseph Blackburn's *Winslow Family,* 1765, although Blackburn, an English artist, probably had access to other models.

Although native-born colonials could learn some tricks from Smibert's portraits, others were beyond their grasp. For example, Smibert's handling of the natural fall and rise of creases in clothing eluded them. The gentle rolls of the vest and coat of Samuel Browne, Jr., in Smibert's portrait of him [17], stiffened into taut ridges in versions by others [20]. And the jagged highlights Smibert brushed into shoulders and arms congealed on the surfaces of paintings by other artists in the colonies instead of becoming integral parts of the garments. The knack of making paint appear to be something else, of hiding the process in the finished product, was often beyond the abilities of most Americans.

Smibert's marriage in 1730 to the daughter of a physician and schoolmaster gave him an elevated social status, which earlier colonial artists had not had. Perhaps it also provided access to the calm, contained, and rational universe of

the eighteenth-century Enlightenment, which is revealed in Smibert's serene and refined portraits of leading colonial officials, merchants, and clergymen. Whatever its cultural and stylistic sources, the humanistic world inhabited by Mrs. Francis Brinley and her son is light-years removed from the religious, Puritan one of Mrs. Freake and her child [18 and 1]. (It is interesting to note that the passion and emotion of the widespread religious revival known as the Great Awakening, which developed in the 1740s in western Massachusetts, did not influence the ideal of balance and control of the Enlightenment, espoused by Boston's cultural leaders. But the entire question of the importance of religious revivals for American art requires much further study.)

Although Smibert brought a new level of professionalism to New York City and Philadelphia during trips in 1740, his style had begun to coarsen a few years before. Crudeness of finish and of textural differentiation, even of recording facial features, replaced the earlier subtle effects. Flattened planes supplanted rounded body volumes. Modeling grew abrupt, and layering of tones, which helps suggest the third dimension, disappeared. Illness and eye problems exacerbated Smibert's difficulties, and by the early 1740s his days of artistic leadership were over. A new, American-born generation, led by Robert Feke, came to prominence, adjusting Smibert's European style not to a particular American vision but to American artistic capabilities and training.

Feke (c. 1707–1751/52), with John Greenwood (1727–92) and Joseph Badger (1708–65), translated Smibert's volumes into an art of taut contours, surface patterns, and generally flattened shapes. Smibert's occasionally realistic faces disappeared, especially in Feke's work, behind the amiable masks of a rising colonial gentry. Rough edges—stylistic and, as it were, cultural—were polished and made smooth. The style spread throughout the colonies, in part because Feke

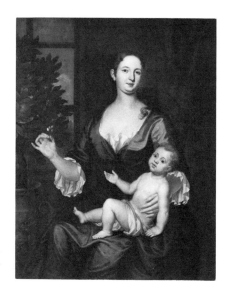

18. John Smibert, *Mrs. Francis Brinley and Son Henry,* c. 1731–32. The Metropolitan Museum of Art.

19. Robert Feke, *Isaac Royall and Family,* 1741. Harvard University.

brought it to Philadelphia in 1746, to Newport and Boston in 1747–48, and once again to Philadelphia in 1749–50. Despite its variations in the hands of other native painters, whether or not influenced by newly arriving European artists, we can recognize a mid-century colonial portrait style.

In his multifigured *Isaac Royall and Family,* 1741 [19], a colonial version of Smibert's *The Bermuda Group* [16], Feke shows how a clever, talented painter can turn weaknesses into strengths. He links figures less by physical and psychological gestures than by repetitive patterns, such as the V-shaped torsos of the women, and by the continuity of forms, in which the movement started by the arm of one person is continued along the shoulder of another. Feke avoided the problem of depth representation and concentrated instead on brightly colored surface patterns. By 1749, however, he had learned to suggest distances through landscape elements, first attempted in his Philadelphia paintings of 1746, and to suggest a greater degree of volume in his figures through a better grasp of modeling techniques [20 and 21]. Obvious shortcuts remained in the inverted triangular torsos of the women and in the inverted conical shapes of the men, the flairs of their coats serving as the broad bases for the cones. But these devices serve only to indicate how dexterously the largely untrained Feke could emulate cosmopolitan styles.

By contrast, Greenwood could not resolve so neatly the conflicting aims of providing a reasonable facsimile of a person's face and suggesting aristocratic bearing. The realism of the former jars against the grace of the latter. But one

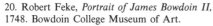

20. Robert Feke, *Portrait of James Bowdoin II*, 1748. Bowdoin College Museum of Art.

21. Robert Feke, *Portrait of Margaret McCall*, 1749. The Dietrich Brothers Americana Corporation, Philadelphia.

might choose to find a poetic justice in Greenwood's amateurism, since his portraits probably describe more accurately both the daily striving of his sitters in a mobile and still only moderately wealthy society and their ambitions to splendor. His *Mrs. Welshman,* 1749, shows his adaption, in the late 1740s, of Feke's style to an underlying realistic mode [22]. Greenwood was, apparently, too restless to remain in the colonies and develop this style further. He left for Surinam in 1752, where he remained for six years before departing for Holland to study engraving methods; he finally settled in London in 1762 as an art dealer.

With Greenwood's departure in 1752, and with Feke's disappearance and Smibert's death, both in the previous year, the inferior Joseph Badger became the leading Boston painter in the early 1750s, before the arrival of Joseph Blackburn from England and the maturing of Copley. Before examining the paintings of the latter two, we should turn to developments in the other main colonial centers.

In addition to Blackburn, the two most interesting and important painters to come to the colonies about 1750 were William Williams (active 1747–91) and John Wollaston (active 1749–60, 1767). Williams settled in Philadelphia, and Wollaston lived in New York City. They introduced a lighter, more informal rococo style to the colonies, which replaced the baroque-influenced Knellerisms of Smibert and Feke. Like earlier artists, they, too, gave their sitters qualities of self-assurance, gentleness, and success, but with less psychological penetration. The military and economic dislocations of the French and Indian War (1754–63) and the rising tensions between colonists and the home country, which must have affected the social class of the artists' sitters, is in no way indicated in their work. Responding at some remove to the tenets of the Enlightenment, they, too, pro-

vided portraits for a society that sought perfection and reasonableness.

The most fascinating of the Europeans was William Williams. Barely a dozen paintings have been assigned to his hand, and he is still a problematic figure who has not been fully disentangled from several other artists with the same name. Nevertheless, our Williams painted landscapes, portraits, and conversation pictures (portrait groups, small in scale, in domestic settings). He was also a stage designer, a musician, and the teacher of Benjamin West. He undoubtedly found in Philadelphia, the most scientifically and culturally adventurous city in the colonies, the kind of diversity that characterized his art [23].

Wollaston, by contrast, concentrated on portraits. Among the most influential of the Europeans, he brought the rococo style to Annapolis, Virginia, and Philadelphia during the 1750s and to Charleston in 1760 and again in 1767. (He sandwiched a trip to India between his visits to Charleston.) Thought to be trained as a painter of drapery and clothing rather than faces, he worked as a portraitist in England before arriving in the colonies. His figures tend to be slender, narrow-shouldered, and almond-eyed [24]. Draperies, with their zigzag highlights, sometimes overwhelm his sitters, who are often buoyed up by Wollaston's emphatically triangular compositions.

Blackburn, who worked in Boston and other New England communities from about 1754 until his return to England in 1763, preferred more informal poses, reflecting the styles of the English rococo painters Thomas Hudson and Joseph Highmore. Blackburn, too, excelled at drapery painting, capturing the

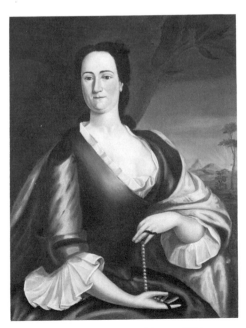

22. John Greenwood, *Mrs. Welshman,* 1749. National Gallery of Art.

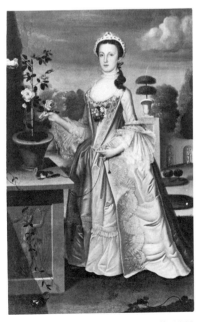

23. William Williams, *Deborah Hall,* 1766. The Brooklyn Museum.

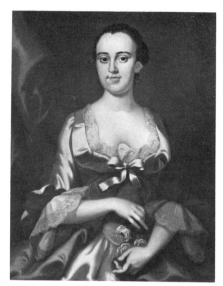 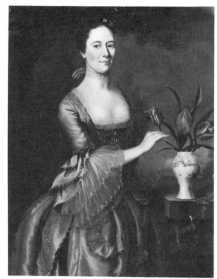

24. John Wollaston, *Mrs. William Allen,*
c. 1760. The Brooklyn Museum.

25. Joseph Blackburn, *Portrait of a Woman,*
c. 1760. The Brooklyn Museum.

glitter and iridescence of shiny fabrics [25]. Reasonably adept at composing multifigured works, then growing in popularity in England, he completed at least two in the colonies—*The Winslow Family* in 1755 and *The Four Children of Governor Gurdon Saltonstall* in 1763.

Among native artists, the Philadelphian John Hesselius (1728–78) is the most interesting, with the exception of Copley, to have been influenced by the rococo style. Hesselius' work points to a dilemma that has affected American artists since the eighteenth century—namely, the discovery of one's own artistic personality only after absorbing and discarding the influences of European masters. At first, however, Hesselius was influenced by Feke, who had been in Philadelphia in the late 1740s. At the end of the following decade, Hesselius responded to Wollaston's style. He learned to model forms better and to infuse more character into a portrait, but he also appropriated some of Wollaston's simpering mannerisms, including the almond eyes. The mature Hesselius emerged only sporadically after he settled in Annapolis in 1759, bringing to such simple and straightforward portraits as that of Mrs. Richard Galloway, Jr., 1764 [26], a psychological realism surpassed before the Revolutionary War only by Copley and Charles Willson Peale.

During the decade in which Mrs. Galloway sat for her portrait, American cultural life quickened—in literature, music, the theater, and art. Prints of biblical subjects, Roman antiquities, and landscapes were purchased by increasing numbers of people. As early as 1763, a Michael de Bruls planned to engrave genre views of New York City. But if that enterprise never got under way, William Hogarth's prints, entitled *The Idle and Industrious Prentice,* proved to be very

popular. The painter John Durand advertised in 1768 in the New York City newspapers his willingness to undertake history paintings, and James Smither opened a drawing school in Philadelphia in 1769.

A new generation of American artists came of age at this time, led by Benjamin West (1738–1820), John Singleton Copley (1738–1815), and Charles Willson Peale (1741–1827), the first two becoming the first Americans to have an impact on European art. It was also in the decade of the 1760s that Americans began to go abroad for study and artistic seasoning, again led by West, who departed in 1760, never to return. Matthew Pratt (1734–1805) was in England from 1764 to 1768, Abraham Delanoy (1742–95) in the middle 1760s, Peale from 1766 to 1768, Henry Benbridge (1743–1812) in Italy and England from 1764 to 1769, and Copley, after 1774, when he left the colonies permanently.

Benjamin West's abbreviated American career lasted from about 1748, when he met William Williams, until his departure for study in Italy and permanent residence in England in 1760. Like John Hesselius, he was influenced by Feke and Wollaston during the 1750s, but his American career holds particular interest because of his desire to become more than a face painter. He read Jonathan Richardson's *An Essay on the Theory of Painting* (1725) and Charles A. du Fresnoy's *De Arte Graphica: The Art of Painting* in John Dryden's translation (London, 1695). Influenced by their theories of the relevance of art to high culture, he even attempted in 1756 to paint a copy of a print, the *Death of Socrates,* a rare excursion before the Revolutionary War into imaginative history painting depicting man's nobility of spirit.

The most important part of Charles Willson Peale's career belongs to the war and postwar period; indeed, after Copley left for England in 1774, Peale was the leading American painter until Stuart's return in 1793. Peale's desire to become

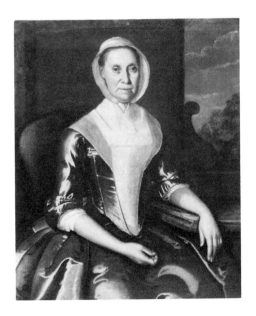

26. John Hesselius, *Mrs. Richard Galloway, Jr., of Cedar Park, Maryland,* 1764. The Metropolitan Museum of Art.

an artist and his inability to find proper training in his native Maryland were typical of a number of artists. In 1763 Peale was finally able to trade a saddle for some lessons from John Hesselius. Two years later, Peale visited Copley in Boston and saw Smibert's old painting room. After studying in London from 1766 to 1768 with West, the mentor of three generations of American artist-students in London, Peale painted several informal portraits, realizing that neither he nor his fellow colonists were ready for more imaginative works. (Interestingly, West's pupils of the 1760s—Peale, Pratt, Delanoy, and Benbridge—painted informal portraits, but the pupils of the 1770s and 1780s—Gilbert Stuart and John Trumbull—preferred formal, more aristocratic ones.)

Of the three major painters of the generation of the 1760s—West, Peale, and Copley—only Copley had a significant career before the war in the colonies. In fact, he is unequaled as a portraitist in American art, except by Thomas Eakins. What makes Copley's career so fascinating to observe is his persistent attempts to master the uncooperative tools and materials, such as brushes, pigments, and chalks, in order to penetrate psychologically the exterior surfaces of his sitters' faces and to penetrate visually the unyielding, flat surface of the canvas. Obviously an extraordinarily gifted person, whose sense of organization was apparent almost from the start, he took advantage of his artistic environment in a way that the artist sons of John Smibert and Gustavus Hesselius, Nathaniel and John, respectively, were unable to do. Copley's mother married Peter Pelham, the English engraver, in 1748, when Copley was ten years old. Pelham died three years later, but Copley had access to Pelham's studio as well as to Smibert's. In addition to studying their works, Copley knew and learned from the paintings of Feke, Greenwood, Badger, and Blackburn. The stylistic influences of each are discernible through the 1750s until about 1758, when, in a series of husband-and-wife portraits, his own style emerged.

Compositionally, this meant developing an increasing mastery over three-dimensional effects, the curving folds of women's gowns, and the integration of background forms into overall harmonious compositions. In respect to the last quality, Copley was a master. Arcs defining clouds in the distance were often continued down the surface of a painting through similar curving forms in a shoulder or elbow. A tree might trace its vertical accent from a starched cuff. Light and dark patterns defining a torso might be repeated in a foreshortened lap below or a cloudy sky above. Even though many portraits were derived from mezzotints, Copley would often subtly alter their light and dark tones, as well as the directional movements of their forms, in order to tie elements more closely together. In effect, he designed the entire pictorial surface rather than merely setting a figure randomly against some landscape forms. Had he lived in the twentieth century, he would have been instinctively sympathetic to the skilled interweavings of figures with their backgrounds in the paintings of the realists Edward Hopper and Richard Diebenkorn [254 and 332].

Copley, like all colonial painters, tried to understand color relationships without ever seeing the great masterpieces of European art. He turned to pastels in 1758 as one way to explore the mysteries of color, ultimately becoming remark-

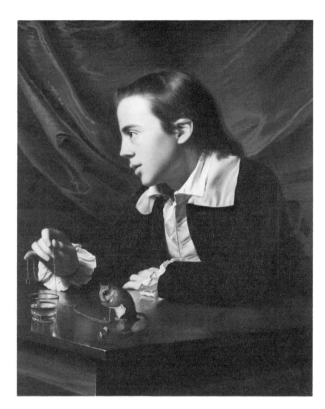

27. John Singleton Copley,
*Boy with a Squirrel (Henry
Pelham)*, c. 1765. Museum
of Fine Arts, Boston.

ably subtle in selecting hues. But he never quite learned how to place figures *in* space, his emphasis on outline and abundant detail forcing his forms back to the picture's surface. When he sent his *Boy with a Squirrel*, painted in 1765 [27], which was a study of his half-brother Henry Pelham, and a portrait of Mary Warner, 1767, to London, both Benjamin West and Sir Joshua Reynolds, president of the Royal Academy, criticized the paintings for hardness of the drawing, for lacking volume in the figures, for coldness in the shadows, and for minuteness of detail. To more modern eyes, the squirrel's fur and the reflections on the table appear beautifully visualized, but these were the qualities Copley was only too happy to sacrifice to learn how to paint in the European manner.

A painter with uncommon skills of psychological observation, Copley looked beyond the geography of his sitters' faces. He painted both aristocratic and realistic portraits, probing the differences of each, and creating, in Edgar P. Richardson's words, portraits of elegance and portraits of character. In the early 1760s Copley tended toward elegance, later in the decade toward realism. In the 1770s, unquestionably reflecting the mounting tensions between the colonies and England, he painted his most profoundly meditated works, which combine both types; they are dark in tonality and stark in background, from which deeply troubled faces emerge, eyes averted, rarely meeting the gaze of the viewer.

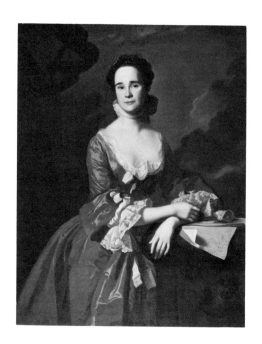

28. John Singleton Copley, *Mary Greene Hubbard,* 1764. The Art Institute of Chicago.

In *Mary Greene Hubbard,* c. 1764, Copley brilliantly illuminates the personality and physical presence of an elegantly dressed and supremely sensitive person [28]. Although her pose is derived from a mezzotint—one of three Copley based on a copy of Thomas Hudson's *Mary, Viscountess Andover*—one is tempted to say that in this particular version Hubbard's untroubled look coincides with the optimism of the few moments of peace after the French and Indian War and before the serious problems caused by the Stamp Act of 1765. The same cheerfulness clearly has no place in Copley's *Samuel Adams,* 1770–72, probably the most psychologically gripping portrait painted in the colonies [29]. In it, Copley depicts Adams confronting Governor Thomas Hutchinson after the Boston Massacre, which occurred on March 5, 1770, and pointing to a document guaranteeing the colonists' rights.

Copley tried to remain neutral during the prewar period, even though his father-in-law was the principal agent for the East India Company, owner of the ship from which the tea was dumped during the Boston Tea Party. With war imminent, Copley decided to leave for further study abroad. He had often expressed his desire to go—both to learn from and to test himself against European artists. He knew that he would never be anything but a portraitist in the colonies. As a youth, he had painted copies of mythological works, but he realized that he would never have the opportunity to develop his artistic imagination in Boston. The press of events, together with his personal desires, finally forced a decision. He sailed on June 10, 1774, never to return. His departure symbolized the end of the colonial era in American art.

During the previous 110 years, despite the facts that European works were

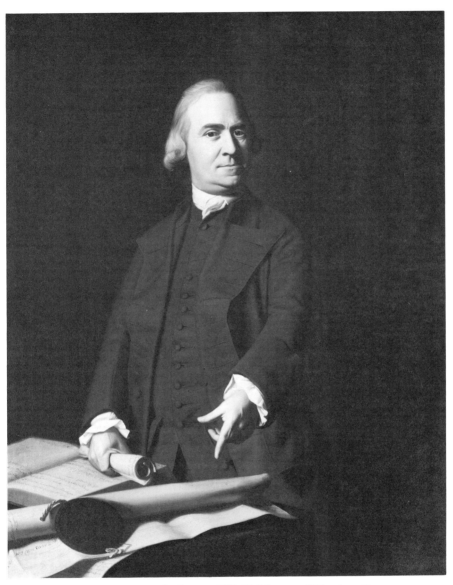

29. John Singleton Copley, *Samuel Adams,* c. 1770–72. Museum of Fine Arts, Boston.

known only at second hand, that no important European painter visited the colonies, that no centers of training were established and therefore that no sustained stylistic continuity characterized the period, American artists did learn about European art, did develop alternative responses, and did continually increase the quality of their work. On the brink of the Revolutionary War, Copley, in his tautly outlined, smoothly brushed, metallic, semi-airless, exquisitely detailed, and probing portraits, provided the era with its definitive statement.

2

THE NEW NATION

THE YEARS covered in this chapter—the mid 1770s to the 1820s—encompass the birth of the United States of America, in 1781; the change in type of government after the acceptance of the Constitution in 1789; the development of those myths, customs, traditions, and even the language by which the inhabitants began to define themselves as Americans; and, not least, the experiment in republican self-rule.

Artists, like probably everybody else, were participating in the initiation and growth of a new nation, and were constantly observing history in the making. People were self-conscious. How were artists to respond to these extraordinary times? What were their responsibilities and obligations? And, given the state of artistic training, support, and general understanding, what were their possibilities? As if these questions, each with endless ramifications, were not difficult enough, also other factors added complications. These included the development in human sensibility called Romanticism and the development of industrial society. In short, despite the explosive increase of the number of artists in America, it was not easy to be an American artist during these years.

Some two hundred years later, it is not easy to make quick or abiding assessments. For example, several artists whom we consider major figures of the time—John Trumbull, Gilbert Stuart, John Vanderlyn, and Washington Allston —spent some of their most productive years abroad. Their training as well as the content of their art was, in great measure, foreign in inspiration. Conversely, several European-born and European-trained artists came to this country during this period and painted aspects of American life that appear closer to the ongoing concerns of the time than those depicted by the other group. And there were also Benjamin West and Copley, who settled in England permanently. In the years after the Revolutionary War, West and Copley were considered to be great American artists who proved to the world that the relatively uncultured provinces could produce artists equal to those of cosmopolitan centers. Yet, during a period of rising artistic nationalism in the 1830s, some of Copley's English works— *Watson and the Shark* (1778) **[33]** and *Death of the Earl of Chatham* (1781)— were attacked for their pro-British biases (in William Dunlap's *History of the Rise and Progress of the Art of Design in the United States,* 1834). Both Gilbert Stuart

and Ralph Earl were Tory sympathizers. Stuart accepted and adopted fashionable English portrait conventions, and Earl kept alive the linear colonial style through the 1790s. Clearly, in the period after the Revolutionary War, there are contradictions.

The two most interesting artists of the first postwar generation were John Trumbull (1756–1843) and Charles Willson Peale (1741–1827). A comparison of two of their paintings of George Washington will help us focus on some of the issues of the time [30 and 31]. Peale's portrait, one of seven painted from life, was done during the seedtime of the republic; Trumbull's was completed after several years' study abroad. Both paintings obviously descend from the European tradition of aristocratic portraits, but both also have very specific American contexts. They are portraits of the person considered, then as now, the most important leader of the period. But more than that, Washington was the chief symbol of American virtue, restraint, courage, and strength—in short, of American republicanism. Although a leader, he had to be portrayed free of aristocratic trappings —as a farmer, albeit a rich one, called to lead his nation's soldiers in times of stress. Peale and Trumbull had to suggest his importance because of his actions, his personal merit, and the purity of his character, rather than because of accidents of birth or inherited position.

Both works succeed in showing Washington as a leader, but the differences

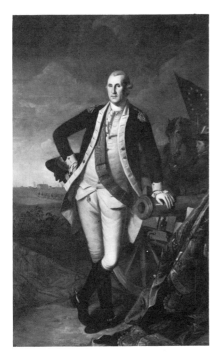

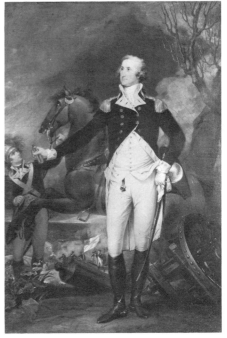

30. Charles Willson Peale, *George Washington at Princeton*, 1779. Pennsylvania Academy of the Fine Arts.

31. John Trumbull, *General George Washington Before the Battle of Trenton*, c. 1792. The Metropolitan Museum of Art.

between them reflect the diverse ways the two artists interpreted the meaning of America. Peale painted Washington as an informal, almost casual, leader, a true democrat who avoided all imperial embellishments. Peale, after all, had been allied with the more radical and leveling factions of republicanism during and after the war. Trumbull, a federalist in politics, believed in a leadership class drawn from the ranks of the wealthy and the well-educated. For him, less democracy was the better alternative. Consequently, his Washington strikes a more heroic stance, in which the concept of nobility of spirit carries slightly aristocratic overtones.

Both artists, however, shared the desire to see virtue become part of the American character. But the yearning to see it develop did not necessarily coincide with the ability to make it develop. The public had to be constantly reminded of its duties—and it was, in countless political and religious tracts, and in paintings and sculpture as well. Trumbull, more sceptical than Peale, feared the worst. In 1784, for instance, he wrote to his family from England that Americans were imitating "every species of Luxury and refinement and does not all this tend to the inevitable destruction of republican Virtue and national Character?—I fear so." He hoped that Americans would live simply and responsibly, and according to the laws of nature. He felt acquisitive tendencies should be held in control, and that even if a leadership class did emerge, persons of merit could enter it.

Public spokesmen bent modes of thought toward strengthening the public's moral behavior. Religion became a useful instrument for secular uplift and therefore a weapon in the arsenal of patriotism. The nineteenth-century historian George Bancroft (1800–91) summed up a long-held attitude when he said that he could find nobody who believed beauty was "something independent of moral effect." Art could obviously play a role in helping society improve by representing ethical perfection and human dignity. Peale and Trumbull no doubt agreed on the elevating purpose of art. Otherwise, art would be considered as a symptom of aristocratic luxury and corruption, an instrument of forces ever ready to destroy the moral fabric of the republic.

Although we cannot read the political and social philosophy of republicanism readily into every work of the period, it is essential to keep it in mind. Republicanism pervaded virtually everybody's way of thinking (see the discussion of Krimmel's genre paintings, pages 56–57). The ultimate failure of artists who did not live up to their individual promise—Allston, Vanderlyn, Morse—has as much to do with the incompatibility of their art with republicanism as with the more easily blamed backwardness of the young country.

All of these artists obtained their first notions of the higher purposes of art, republican or otherwise, from books. They pored over the texts of du Fresnoy, de Piles, and Richardson, mentioned earlier, as well as newer works by writers and aestheticians such as J.J. Winckelmann, whose *Reflections on the Painting and Sculpture of the Greeks* was translated from German into English in 1765. The advice these authors gave was simple and direct. Artists were expected to refine and to improve nature by studying and acknowledging the authority of

ancient Greek and Roman sculpture, as well as the works of such Renaissance and Baroque masters as Raphael, Michelangelo, and Poussin. Themes were supposed to emphasize the nobler aspects of human character. For young artists in the United States without access to art galleries and private collections, travel abroad was essential to see how past masters had turned noble thoughts into fine paintings. Through the 1780s and 1790s, virtually all American artists went to London because England was, in the end, the mother country and also because Benjamin West lived there. His generosity as mentor and teacher lasted for several decades and enabled the visiting Americans to commence their careers as European-trained artists.

West had visited Italy in 1760, where he became acquainted with Winckelmann's circle and its concern for a moral art. Winckelmann preferred to find stylistic sources and themes in ancient statuary, but Anton Mengs, a leading painter of the group, whose own book, *Considerations on Beauty and Taste in Painting,* appeared in 1762, was more eclectic in his preferences. In general, the group felt most comfortable with art that avoided the sensuous caprices of color. West arrived in England in 1763 and, applying the precepts he had learned in Italy, found few rivals in painting multifigured biblical, mythological, and historical works. In 1772, gaining the favor of George III, he was appointed Historical Painter to the King, and in 1792 he replaced Sir Joshua Reynolds as president of the Royal Academy. (Reynolds, as first president, delivered fifteen lectures on art, known as The Discourses on Art, between 1768 and 1790, which upheld the academic tradition.) In a letter West wrote late in his life, in 1809, to Peale, he summed up quite precisely his attitude toward art. "The art of painting has powers," he said, "to dignify man by transmitting to posterity his noble actions, and his mental powers, to be viewed in those invaluable lessons of religion, love of country, and morality; such subjects are worthy of the pencil, they are worthy of being placed in view as the most instructive records to a rising generation."

West, certainly aware of academic theories but not beholden to narrow interpretations, explored a variety of themes and styles throughout his career. His early *Agrippina Landing at Brindisium with the Ashes of Germanicus* (1768, Yale University), a precocious exploration of the neoclassical style, shows the bereaved widow carrying the ashes of her husband, who had died for his country. (West, a patriot despite his self-imposed exile, might have been alluding to the death of American liberties because of the Townshend Acts of 1767, which taxed glass, paper, tea, painters' colors, and other goods.) The central group in the painting is derived from the Ara Pacis, the Roman monument dating about 15 B.C., and the architecture in the background convincingly simulates Roman buildings.

A few years later, in 1770, West painted *The Death of General Wolfe* [32], a work described as causing a revolution in history painting. In it, West commemorated an event that occurred in 1759 in Canada. Much to Reynolds's dismay, West clothed Wolfe and his lieutenants in contemporary dress rather than ancient costume. Reynolds argued that modern clothing detracted from the universal moral significance of sacrifice by particularizing the moment of death. West persisted with his own conception, but he did add several academic details

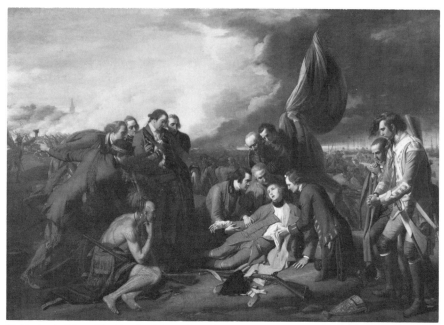

32. Benjamin West, *The Death of General Wolfe*, 1770. The National Gallery of Canada.

that prevented the work from becoming mere reportage. Wolfe is shown dying in a Christ-like pose of a Pieta. The faces of several figures are derived from Charles Le Brun's *Expression des Passions de l'Ame* (1649), which had been recently published in England (Le Brun, the artistic dictator of France under Louis XIV, had indicated the proper features for specific emotions). West also added an emotionally suggestive, painterly sky, which echoes the tragedy taking place on the battlefield. The Indian, representing the New World, sits and contemplates mortality.

Toward the end of the decade, in 1777, West completed a totally different kind of painting, *Saul and the Witch of Endor* (Wadsworth Atheneum, Hartford), an early exploration of the terrors of the sublime. Throughout the 1770s, West also received several commissions from churches for religious scenes. From 1780 to about 1804, he worked on the paintings of *The History of Revealed Religion* for the king's private chapel at Windsor Castle. Between 1795 and 1810, he started a series of paintings based on the Book of Revelations for William Beckford, and after 1810 he publicly exhibited still other religious works. For the artists arriving from America, West was a one-man survey of the latest in art. He painted secular and religious works with neoclassical, baroque, and contemporary motifs. His subjects exemplified notions of public morality as well as melodramatic excitement, staid homilies, and mystical encounters. His influence was so important that Trumbull, who had first met him in 1780, was still following his lead, especially in religious subjects, a generation later.

Copley, less adroit and adept than West, but probably the better painter, concentrated on history paintings as well as portraits. Soon after his arrival in England, he had transformed his colonial style into the softer, brushier English manner and had learned to suggest atmospheric space much more convincingly. His gift for organizing forms also developed, in works such as *Watson and the Shark* [33], *Death of the Earl of Chatham* (1781, the Tate Gallery), and *The Siege of Gibraltar* (1791, Guildhall Art Gallery, London). Copley changed part of *The Siege* after studying Trumbull's *Sortie of the British Garrison at Gibraltar* [1789, Museum of Fine Arts, Boston]. Each of these works is usually considered an extension of the concept of reportage—more sensational in *Watson,* more stately in *Chatham*—as outlined by West in *The Death of Wolfe.* Copley, in fact, wrote a letter in 1783 in which he stated that "modern subjects are the properest for the exercise of the pencil and far more interesting to the present age than those taken from ancient history." Yet, there might be hidden meanings in these works. For example, in *Watson and the Shark,* a pictorial interpretation of an event that occurred in Havana harbor in 1749, when Watson was fourteen years old, Copley might have actually painted a religious sermon about resurrection and salvation. The nude Watson, a symbol of purity, seems to find the rope tossed to him useless as he implores God directly to save him from the shark, a symbol of evil.

Trumbull, who was among West's students during the 1780s, painted both religious and historical works, but the latter are more important by far. Even before going abroad for the first time, in 1780, he attempted examples of both types, based on print sources. Like West and Copley, the Connecticut-born Trumbull had read the major art theorists and aspired to paint a higher form of art than portraits. After taking part briefly in the Revolutionary War from 1775 to 1777 and then living in Smibert's house in 1778 and 1779, he left for Europe, where he lived for twenty-four of the next thirty-five years. He was in America only from 1782 to 1784, 1789 to 1794, 1804 to 1808, and from 1815 until his death in 1843. In the late 1780s, he traveled in France, where he met Jacques-Louis David, the major Neoclassical painter of the period.

Soon after arriving in England in 1780, Trumbull's linear colonial technique gave way before his innate sense of color. He learned from West how to use glazes to tone up and to tone down passages of pigment, and he must also have been deeply impressed by the coloristic style of Peter Paul Rubens, whose works could be seen in London. Trumbull's sensitivity to color and the subtlety with which he used it was evidently held in check throughout his career by his own sense of personal reserve as well as by his continued acquaintance with West. Even in the early 1800s, Trumbull still imitated his master's more metallic textures and opaque color schemes in his portraits (as well as West's figural arrangements in his biblical scenes).

But if West hindered the full blossoming of Trumbull's talents, he encouraged his pupil's thematic explorations, most notably in a series of studies of Revolutionary War scenes begun in 1786 after West decided not to pursue the idea himself. Trumbull, realizing that "the late war opens a new and noble field

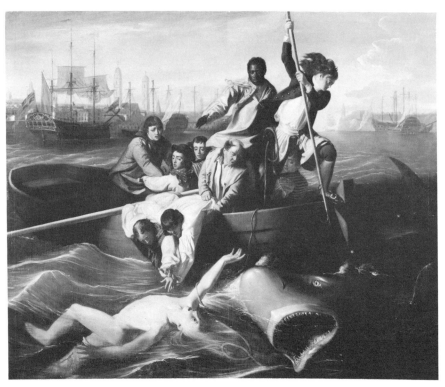

33. John Singleton Copley, *Watson and the Shark,* 1778. Museum of Fine Arts, Boston.

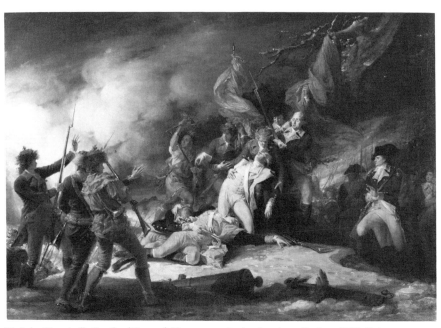

34. John Trumbull, *Death of General Montgomery in the Attack on Quebec,* 1786. Yale University Art Gallery.

for historical painting," as he wrote to his brother in 1784, went on to say, on another occasion, that "no period of the history of man is more interesting than that in which we have lived. The memory of scenes in which were laid the foundations of that free government, which secures our national and individual happiness, must remain ever dear to us and to our posterity." The events, Trumbull believed, constituted "the noblest series of actions which have ever presented themselves in the history of man." He intended to paint thirteen battle and ceremonial scenes, of which six were completed by 1787, for distribution through engravings. As a group, these works were the first and most important pictorial icons of the new nation, key documents in the creation of a visual pantheon of heroes to bind together the fractious colonies, each with its own history, into a united country. In these studies, Trumbull sketched the Founding Fathers engaged in the exalted task of shepherding into existence the Declaration of Independence, citizen-soldiers dying for their country [34], and generals gallantly accepting the surrender of their defeated foes.

In all of them, Trumbull alluded to the highest forms of human behavior. For example, although the American General Warren was probably decapitated at Bunker Hill, Trumbull shows Warren's attacker's bayonet deflected in *The Death of General Warren at the Battle of Bunker's Hill* (1786, Yale University Art Gallery), since gentlemen were not supposed to act in a brutal fashion. General Montgomery, an Irish-born former British soldier and a gentleman farmer, sacrificed his life (on New Year's Eve, 1775) for his adopted country [34]. In *The Surrender of Lord Cornwallis at Yorktown* (1787, Yale University Art Gallery), the English officers are not shown in humiliating poses of defeat or surrender. Trumbull organized the action scenes with great diagonal sweeps and the ceremonial ones with semi-circular movements. His colorism, unprecedented in the works of an American artist, lent excitement to the battle pictures. Trumbull also knew how to wring an extra bit of emotion from a scene. In the *Montgomery*, he thought that the winter's desolation and bare trees "heightened the melancholy character of the scene."

These early studies, the efforts of a young artist heady with patriotism, Neoclassical theories of the ideal, and the encouragement of one of the world's most famous artists, were part of the initial wave of American artistic nationalism. Poets and writers such as Hugh Brackenridge (1748–1816); John Trumbull (1750–1831), the artist's cousin; Philip Freneau (1752–1832); Timothy Dwight (1752–1817); and Joel Barlow (1754–1812) predicted America's forthcoming grandeur. They all agreed that the center of the arts and the center of civilization would inevitably move westward to the United States, a thought with which even the crusty, luxury-hating, and art-fearing John Adams could agree.

But what form would the new civilization take? Would the new country become a materialistic colossus, a new Rome, or an example of virtue, a new Eden, living under divine guidance? Many hoped fervently for the latter. The belief in America's special role in the world grew so strong in the 1790s that people believed the millennium was imminent, that the nation, guided by Christian principles, would bring about a utopian society and help change the course of the world.

35. John Trumbull, *The Vernet Family,* 1806. Yale University Art Gallery.

Unfortunately, despite the rising secular and religious nationalism, neither the American government nor the American public supported the kind of art Trumbull had envisioned in his Revolutionary War series. When engravings were finally ready in the late 1790s, they sold poorly. Excitement over the war had considerably abated and, lacking allusions to divine guidance, perhaps the engravings were too secular. The subsequent history of the series was even more appalling to Trumbull, as much for professional as for patriotic reasons. For years he petitioned Congress to obtain funds in order to paint large versions of his studies, finally succeeding in 1817, when Congress, awash in a sea of nationalism after the War of 1812, commissioned him to paint four works for the Rotunda of the recently completed Capitol in Washington, D.C. These were *The Declaration of Independence* (1819), *The Surrender of Lord Cornwallis at Yorktown* (1820), *The Surrender of General Burgoyne at Saratoga* (1822), and *General Washington Resigning His Commission* (1824). By any measure of comparison, however, the small studies made thirty to thirty-five years earlier were in every way superior to the Rotunda panels.

In the late years of the eighteenth century, Americans did not find paintings based on classical themes particularly interesting either, even though several ancient authors were well known to the educated and had special application to

America. After 1750, Cicero, Tacitus, and Plutarch were especially studied for their thoughts on the decline and fall of the Roman Empire and for their idealized notions about ancient republics. John Adams's suggestion in 1776 that the Great Seal of the United States should include The Choice of Hercules—the choice between virtue and pleasure—found few supporters, and the pioneer neoclassicist, Denis A. Volozon, had little success in Philadelphia about the turn of the century. Instead, Americans preferred portraits to all other types of painting, and, in the end, artists such as Trumbull, tied to the public for support, became portraitists to survive. Whatever his true desires were, he became a leading portraitist during his years in America. Like others, he could turn out hack jobs or sympathetic studies, but all were stamped by the formality of his own character [35].

Among the many portraitists at the end of the century, Matthew Pratt (1734–1805) and James Claypoole, Jr. (c. 1743–1800) worked in Philadelphia, and Henry Benbridge (1743–1812) lived in Charleston. Folk artists, such as Winthrop Chandler (1747–90) and Richard Jennys (active 1760–1800), found clients in New England. Several Europeans arrived, many to stay, including the Dane Christian Gullager (1759–1826) in 1786 and the English pastelist James Sharples (1751–1811), who came in 1793. (In addition, several engravers, sculptors, and landscape painters also visited or emigrated to America late in the century.) The best of the European-trained portraitists to arrive was not a European at all, but an American from North Kingston, Rhode Island—Gilbert Stuart (1755–1828). He might never have left Europe for America if high living and debts had not driven him from Ireland in 1793.

Although Stuart was in Scotland in 1772–73, his European training really began when he settled in England in 1775. He remained there until 1787, when he left for Ireland. A pupil of West, who had great respect for his talent, Stuart absorbed the coloristic, softly brushed aristocratic styles of English portraitists such as Thomas Gainsborough, George Romney, and Sir Henry Raeburn. Upon returning to America, he immediately became its most popular painter. His portraits flattered political, business, and society leaders, first in Philadelphia until 1803, then in Washington, D.C., for the next two years, and after 1805 in Boston, where he lived the remainder of his life. Like Robert Feke's sitters before the war, many of Stuart's also aspired to patrician status, their republican rhetoric to the contrary.

Stuart's style became immensely popular, in part through the works of several younger artists who were, in effect, students of his for brief periods of time. These included John Vanderlyn in 1793–94, Rembrandt Peale soon after, Thomas Sully in 1807, Matthew Jouett in 1816, and John Neagle in 1825. It was Stuart, therefore, more than any other painter, who helped change the style of American portraiture in the decades after the Revolutionary War.

Fortunately, Stuart's advice to his students has survived in notes taken by Matthew Jouett in 1816, in which Stuart's engaging personality and English painting techniques are happily revealed. He concentrated on faces, rarely painting below the torso and barely indicating the background. In a manner distinctly

new to American art, he began a portrait with his paintbrushes rather than with a pencil or crayon. Unlike Charles Willson Peale, for example, who preferred to delineate features precisely, Stuart advised his students to "look [first] at the subject, and not at the features." His method was to suggest initially the general before describing the specific. To capture the quality of palpitating flesh, he did not mix colors on his palette but applied them directly to the canvas. He then added overlapping and transparent layers so that the skin would seem to breathe. His sitters, often appearing as if responding to a call from across the room, always seem capable of movement. The force of personality, as Stuart captured it, carried the picture [36 and 37].

Stuart is best remembered for his portraits of Washington: the "Vaughan" portrait of 1795 [38], the unfinished "Athenaeum" version of 1796, and the "Lansdowne" portrait, also of 1796. The Lansdowne version, based on an engraving by Hyacinthe Rigaud, *Bishop Jacobus Beningnus Bossuet* (1723), is the least successful of the three. First, it is a full-length portrait, a type with which Stuart was not comfortable, and second, the trappings of office with which Stuart cluttered the painting do not ring true. Altogether, Stuart's interpretations are closer to Trumbull's conception of Washington than to Peale's—they are more patrician and remote, more a projection of the artist's imagination than a real person. Stuart, of course, worked in the English aristocratic mode, but his interpretations have particular relevance to the political climate of the 1790s. Like Trumbull, he was a Federalist and might have mistrusted the rising popularity of Jefferson (whom he did paint) and his more democratic followers. It would seem, then, that Stuart's images reflected the mood of the Federalist hierarchy,

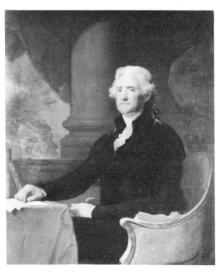

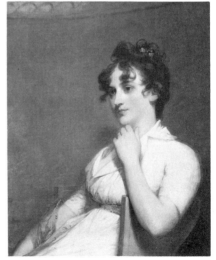

36. Gilbert Stuart, *Thomas Jefferson*, 1805–07. Bowdoin College Museum of Art.

37. Gilbert Stuart, *Mrs. Lawrence Lewis*, 1804–05. National Gallery of Art.

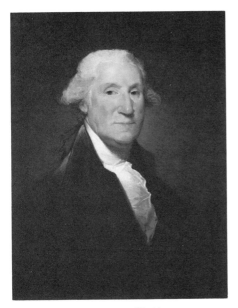

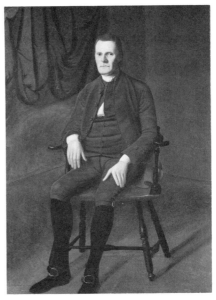

38. Gilbert Stuart, *George Washington* *(Vaughan Portrait),* 1795. National Gallery of Art.

39. Ralph Earl, *Roger Sherman,* c. 1775. Yale University Art Gallery.

fearful of runaway populism as well as of the conversion of responsible republicanism into acquisitive materialism and anxious to fix a national image in the minds of Americans to counter endemic localism.

But Stuart's paintings of Washington were only a small part of what seemed to be a national obsession to obtain portraits of the nation's leader. Painters and engravers of presumably all political persuasions made and remade portraits of Washington, who, rising above time and political party, became the central and uniting symbol of the country during the 1790s.

Artists of Stuart's generation were only too happy to learn and to maintain European styles of painting—with one major exception. Ralph Earl (1751–1801) appears deliberately to have eliminated all traces after returning from England in 1785. A still enigmatic figure, he is a link between provincials such as Winthrop Chandler at one extreme and cosmopolitans such as Stuart at the other. Earl's early portraits [39] approach the compositional sophistication as well as the psychological insights of Copley and surpass the pre-European works of Trumbull and Stuart. While he was in London from 1778 to 1785, his newly learned flamboyant brush techniques softened his colonial linearism. He grew adept at emphasizing faces and hands instead of entire bodies—of focusing on essentials —but exploration of character was blunted by a patina of "taste." After settling in Connecticut on his return, Earl worked out a compromise that lacked the bite of his early style and the social grace of his English period [40]. During his best years, before 1794, he still applied color somewhat thickly, but he had an artisan-

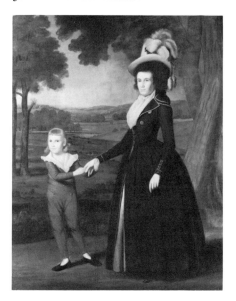

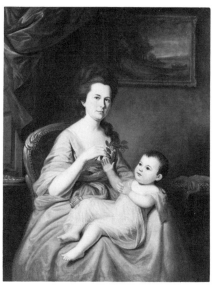

40. Ralph Earl, *Mrs. William Moseley and Her Son Charles,* 1791. Yale University Art Gallery.

41. Charles Willson Peale, *Mrs. David Forman and Child,* c. 1784. The Brooklyn Museum.

like concern for detail and all-over emphasis. A sitter in his or her living room was no more carefully studied than the books on the bookshelf. If a view through a window were included, the family's lands were surveyed. One senses in Earl's paintings a desire to verify rather than to perfect reality. In opposition to academic theory, he seemed to suggest that a painting gained credibility the more minutely it defined objects. He wanted to fix his images—especially his sitters' faces—for eternity rather than catch them, like Stuart, in an instant. Earl's sharply focused observations of people led him to study landscape with equal clarity. Among the few Americans to show an interest in landscape before the end of the century, he made sketches of the battles of Lexington and Concord, engraved by Ezra Doolittle in 1775, and, about 1796, he made a topographical painting of Sharon, Connecticut (Litchfield Historical Society). (See the discussion of landscape painting, pp. 59–60.)

One imagines that Charles Willson Peale might have understood Earl's intentions, but Peale, having the larger imagination, painted with greater flexibility. He was especially clever at integrating reality and theory. Influenced by William Hogarth's belief in the beauty of long, curving lines, described in Hogarth's *The Analysis of Beauty* (London, 1753), Peale added Hogarth's serpentine "line of beauty" to several portraits [41], but, at the same time, wanted to produce perfect illusions of his sitters. That is, he wanted his subjects to possess grace and also to look natural. Despite his interest in Hogarth, Peale, like Earl, deliberately resisted the siren call of "high" art, knowing that he had little opportunity to study ancient art or modern theories. He also had little patience with the concept of the artist as a superior person endowed with inborn talent, believing, instead,

that training and application would better serve the purposes of making art than the interventions of genius. He certainly stressed these precepts within his own family. Whether for this reason, or because of the innate talent of his brother and of their families, he founded the greatest family dynasty of artists in the history of the country. It included his brother James (1749–1831), a miniaturist and still-life painter, and his own children, Raphaelle (1774–1825), Rembrandt (1778–1860), Rubens (1784–1864), and Titian Ramsay (1799–1885). James's children included Anna Claypoole (1791–1878), Margaretta Angelica (1795–1882), and Sarah Miriam (1800–1885).

Altogether, the family might be considered the ideal early American family —hardworking, diligent, involved in the family enterprise, responsible to and for each other, and open to new suggestions and developments. *Peale Family Group*, begun probably in 1771, soon after Peale's return from London in 1769, and retouched in 1808, embodies these sentiments quite graphically [42]. It is, if nothing else, an emblem of family concord and family enterprise, the equivalent in the domestic sphere of the several portraits of Washington in the public realm. Peale is shown instructing his brother, St. George, who sits next to James. The happy witnesses, sharing the bounty at an early moment in the family's history, are Charles Willson's sisters, his wife and child, and his mother. The family servant stands slightly behind. The painting on the easel and the busts on the mantel are by Peale, demonstrations of his efforts in his chosen profession. As the leading painter in the colonies when the Revolutionary War started, and as the artist most sympathetic with its aims, he deservedly received the first commission given jointly by the thirteen colonies to a native painter. In the spring of 1776,

42. Charles Willson Peale, *Peale Family Group*, c. 1770–73, 1808. The New-York Historical Society.

the Second Continental Congress asked Peale to paint a portrait of George Washington (his second from life, now in The Brooklyn Museum) to commemorate the forced evacuation that year of the British from Boston.

Following the war, Peale remained in Philadelphia, the nation's capital until 1800. As the most exciting and lively community in the new country, it attracted several artistic and cultural figures from other cities as well as from abroad. During the 1790s, refugees from the French Revolution as well as their English sympathizers flocked to Philadelphia. These included the deist Constantin de Volney, who in his well-known book, *Ruins* (1791), blamed the decline of civilization on the corruption of kings and priests, and prophesied the perfectibility of mankind following the demise of monarchy and the Church. Others who settled in the area were Moreau de St. Méry, the former governor of Paris; Matthew Cary, the publisher and economist; Alexander Wilson, the botanist; and Joseph Priestley, the discoverer of oxygen. Among the several artists were James Sharples and Christian Gullager, Pierre Eugène du Simitière (c. 1736–1848), Charles Balthazar Julien Fevret de Saint-Memin (1770–1852), and J.J. Boudier, who brought the physiognotrace to Philadelphia in 1796, a mechanical device that allowed its operator to reproduce rapidly the profile of a sitter. (It was invented in France by Gilles Louis Chrétiên in 1786.) The sculptors Giuseppe Ceracchi (1751–1802) and John Eckstein (c. 1736–1817) also spent some time there, as well as Gilbert Stuart, who lived in the city from 1794 to 1803. Probably not until the arrival of European artists and writers in New York City in the middle 1910s, because of the outbreak of the First World War, did the artistic life of an American city again assume such a cosmopolitan and international flavor.

Peale helped advance the cause of art through his own work as well as through his varied enterprises. In 1782, he opened a portrait gallery, which included likenesses of the major figures of the republic, and added a museum of natural history in 1786. (Rubens took over the museum in 1810 and ran it until 1822, when he replaced his brother Rembrandt as director of the other family museum, in Baltimore, which had been established in 1814.) Peale, ever restless, presented to the public in 1785 an exhibition of moving pictures, a two-hour performance of gradually changing scenes of a sunrise, a sea battle, and nature. Based on Philippe de Loutherbourg's *Eidophusikon,* an early form of motion-picture entertainment first presented in London in 1781, Peale's version failed. But a decade later, another type of popular entertainment, the panorama, which became very successful, was introduced into the country by William Winstanley, a landscape painter who emigrated in 1791 or 1792. Winstanley presented the first performances in New York City and then others in Philadelphia in 1795. These performances followed the format initiated by Robert Barker, the inventor of the panorama, who in Edinburgh in 1787 exhibited a circular painting that was viewed from a central point.

Peale was also instrumental in founding in 1794 the Columbianum, intended to be an art school and exhibition gallery based on England's Royal Academy. Because of friction between American and European artists in Philadelphia, the

organization failed after its first and only exhibition in 1795, but the idea of a combined school and gallery was revived with the founding of the Pennsylvania Academy of the Fine Arts in 1805. By that date, however, a similar organization had already been in existence for three years in New York City, the New York Academy of the Fine Arts (subsequently the American Academy of the Fine Arts), which lasted until 1841. Both academies lent evidence to the growing interest in art by their businessmen supporters, who accepted at least minimal public responsibility for refinement of taste through displays of art and sculpture. Such organizations, whatever their "society page" benefits, really did serve educational purposes—for artists as well as for the public. In this respect, they were, in addition, part of the broad movement in the late eighteenth century that sought to explore knowledge—in this instance, the arts—which led to the founding of such organizations as the American Academy of Arts and Sciences in Boston in 1780, the American Philosophical Society in Philadelphia in 1794, the Literary and Philosophical Society of New York in 1814, and their countless progeny in many fields of applied and pure knowledge throughout the nineteenth century.

In addition to overseeing his various enterprises, Peale always painted and explored various kinds of subject matter as well as mediums, notably engraving and etching. His *Accident in Lombard Street* of 1787, probably the first American etching, was also the first American print of a genre scene. His *Staircase Group* was an early genre scene as well as a *trompe l'oeil* painting [43]. Its sharpness of focus, compared to Peale's earlier, softer manner, might have been prompted by the presence of European sculptors in Philadelphia. Arriving European landscapists might also have alerted Peale to the beauties of the countryside so that in 1801, on his way to the site where a mastodon skeleton was uncovered in New York State, he sketched several topographical landscape views. The discovery of the mastodon, which created considerable debate in both scientific and religious circles—how could God allow one of His creatures to become extinct?—led to Peale's *The Exhuming of the Mastodon* (1806, The Peale Museum, Baltimore), a historical genre painting in which the working scientist-entrepreneur is the hero.

Ever willing to learn and to experiment, Peale, who had been painting portraits since the 1760s, altered his portrait style late in life, about 1810. He developed a version of Rembrandt's taut neoclassical style, which the younger Peale had learned in Paris in 1808 and 1809. Actually, it was Charles Willson's third portrait style—the first influenced by the mid-century colonial style, the second derived from the English manner, and the third based on the early-nineteenth-century French mode. In whichever mode, many of Peale's portraits follow traditional compositional formats, in which blandness of personality seems to be the highest aim of character, while others reveal his affable nature and his ability to give old arrangements new life (compare figures 41 and 35). Still others, more original in composition, such as the *Lamplight Portrait* (1822, Detroit Institute of Art), a study of his brother James, or more personal in mood, such as the brooding study of Edwin Dickinson (1770, Historical Society of Pennsylvania), which reveals an anxiety similar to that Copley discovered in New York

43. Charles Willson Peale,
Staircase Group, c. 1795.
Philadelphia Museum of
Art.

City at this time, make clear that of all his contemporaries Peale was the most open-minded and responsive, the most able to grow in his art, and the most attuned to the several strains coalescing to form the new American character.

No artist of the succeeding generation duplicated Peale's achievement. Some, such as Washington Allston, John Vanderlyn, and Samuel F.B. Morse, persisted against all odds in their attempt to bring the grand manner of European art to America. Portraitists such as Thomas Sully and John Wesley Jarvis developed signature styles and rarely departed from them. Others were content to paint still lifes and landscapes, only infrequently straying beyond their specialties. Granted, patronage on the grand scale did not exist. Fortunes of European magnitude, let alone the tradition of aristocratic support, were inconceivable in the new country and incompatible with its republican sentiments. State and federal governments, increasingly run by people of popular taste, were of little help. Cultural habits and patterns of formal education were just being shaped, and these did not necessarily follow European precedents. Those artists who chose to emulate the great traditions of European art could expect only minimal support from a small group of businessmen, unsure in their knowledge or support, and from an equally small group of artists still unorganized into a community of their own. Portraitists, landscapists, and others were bound to the tastes of their clients in the open marketplace. Becoming an artist was chancy at best, and all sooner or later knew that their degree of success or failure depended upon some sort of discourse with their fellow countrymen.

Washington Allston (1779–1843) was one of the lucky few who, although basically ignoring the presence of America in his work, was reasonably well supported and highly regarded. In his lifetime, he was considered the nation's greatest artist. Like Trumbull, he too spent many productive years abroad, from 1801 to 1808 and from 1811 to 1818, and he even considered himself part of the British School. Had he remained in London in 1818, he might have become president of the Royal Academy. Allston's work marks an abrupt break with all previous American painting. With the exception of some of West's English work, it was the first and really the only significant body of work we can call Romantic, the first to which we can apply descriptive phrases such as "mysterious," "filled with reverie," and "reflective of the artist's moods." Allston was the first American artist to represent a turning inward, whose inspiration grew from his imagination rather than from empirical data or from a sense of public responsibility. In addition, he was the first artist who did not depend on portraiture to support himself.

Born in South Carolina, Allston studied at Harvard University from 1796 to 1800, where, unlike the youthful Trumbull, who painted religious and historical works while at Yale University, he explored imaginative landscape themes and genre subjects that included bandits. When he became West's pupil in London in 1801, it is not surprising that the older artist's *Death on a Pale Horse,* based in part on sources in Revelations, excited him more than any other painting he saw in that city. This work, in which the figure of Death strikes down a family,

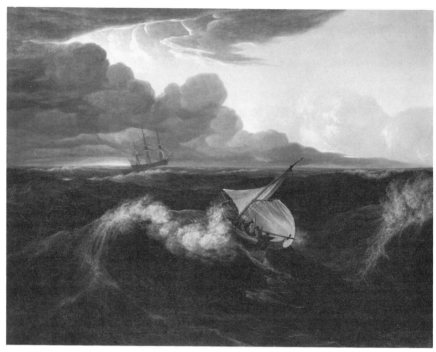

44. Washington Allston, *Rising of a Thunderstorm at Sea*, 1804. Museum of Fine Arts, Boston.

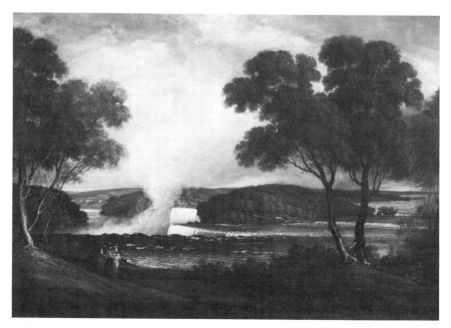

45. John Trumbull, *Niagara Falls from an Upper Bank on the British Side*, 1807. Wadsworth Atheneum.

illustrates well the concept of the sublime as described by Edmund Burke in his *A Philosophical Inquiry into the Origin of Our Ideas of the Sublime and Beautiful* (London, 1756), a major text of the Romantic movement. Burke defined the sublime in the following way: "Whatever is fitted in any sort to excite the ideas of pain, and danger, that is to say, whatever is in any sort terrible, or is conversant about terrible objects, or operates in a manner analogous to terror, is a source of the *Sublime;* that is, it is productive of the strongest emotion which the mind is capable of feeling."

This understanding of the sublime undoubtedly influenced Allston's conception of his *Rising of a Thunderstorm at Sea,* a work painted in Paris in 1804 [44]. An easy way to understand his radical approach is to compare this work to Trumbull's *Niagara Falls from an Upper Bank on the British Side,* painted three years later [45]. Trumbull's *Niagara Falls,* reflecting eighteenth-century European attitudes, is a rationally organized, topographical landscape in which the falls, seen in the distance, have lost their fury and menace. Trees flank and frame them in a compositional scheme derived from the paintings of the seventeenth-century French artists Claude Lorrain and Nicolas Poussin. The landscape is domesticated by the presence of people strolling in elegant clothes. Trumbull's clear design symbolizes belief in a logical design of the universe. The painting appeals to one's sense of reason. Allston's does not. Rather, the sea appears as an arena of challenge. One searches for identity and control in nature, and the individual no longer can count on ordered certainties of thought. He is adrift and probably lost in the sea of life. Emotion and imagination replace reason.

Although Allston usually honored traditional modes of composition and did paint landscapes according to classical French formulation, the simplifications of design in his *Rising of a Thunderstorm at Sea* reflect his more modern point of view. In his *Lectures on Art,* written in the years after 1830, he probably alluded to the necessary changes in organization in that painting when he said that a sublime scene should have as few compositional divisions as possible so that one discerns only a few vast and overpowering elements. The effect should be sudden, simple, "and scarce seen till felt; coming like a blast, bending and levelling everything before it."

Color, too, contributed to the overall result, for Allston realized that color projects distinct meanings. He was influenced by colorists such as Joseph M.W. Turner in England, and overwhelmed by the works of the Venetian painters he saw in Paris. He was lucky enough to be there when many Italian masterpieces, which had been looted and brought to Paris by Napoleon, could readily be seen. Of works such as Veronese's *Marriage at Cana* (the Louvre), Allston said that he "thought of nothing but of their gorgeous concert of colors, or rather of the indefinite forms (I cannot call them sensations) of pleasure with which they filled the imagination," and that "they [the Venetians] addressed themselves, not to the senses merely, as some have supposed, but rather through them to that region (if I may so speak) of the imagination which is supposed to be under the exclusive domination of music." To achieve the luminous effects of the Venetians, Allston began to apply color in thin glazes and, like Gilbert Stuart, to add them one to

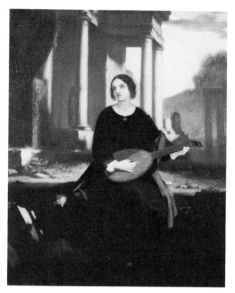

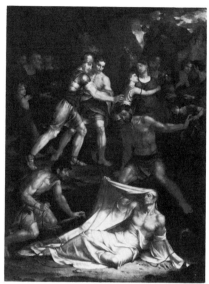

46. Washington Allston, *Evening Hymn,* 1835. Montclair Art Museum.

47. Washington Allston, *The Dead Man Restored to Life by Touching the Bones of the Prophet Elisha,* 1811–13. Pennsylvania Academy of the Fine Arts.

the other in a pure rather than mixed state (red and blue, rather than purple).

Allston also came under the influence of the idea of the German Romantic poets and philosophers that feelings were not based directly on the senses. He probably learned this concept, at least initially, through his friendship with Samuel Taylor Coleridge, the English poet, whom he met in Rome in 1805. (Their friendship was renewed when Allston returned to England in 1811.) Allston believed that after the senses conveyed to the mind either sounds or images, their function ceased. Feeling then arose, as he wrote in his *Lectures,* "from ourselves, which is reflected back by the object—something with which, as it were, we imbue the object, making it correspond to a reality within us." That is, in trying to understand how and why we respond, Allston was willing to give greater responsibility to the organizing and feeling powers of the mind than to the stimulation of the mind by objects and forces. He believed that feelings emerge from within ourselves and do not necessarily need external stimuli to activate them.

Allston, like most Romantics, also believed that the artist should develop his intellect and his moral being to arrive at higher spiritual truths. Art, for him, was part "of that mighty plan which the Infinite Wisdom has ordained for the evolution of the human spirit." Art, therefore, had a role in human betterment. Unlike West, Copley, and Trumbull, who were concerned with public morality, Allston emphasized inner spiritual growth. The earlier generation assumed that objective methods existed to establish values to guide us. Allston believed that the individual's imagination gave value to experience. The earlier generation sought an

abstract ideal, while Allston was after a continuous, never-ending cultivation of the soul. The poet or painter, he thought, was never satisfied in his quest for beauty. "One of the happiest elements of our nature," he wrote, "is that which continually impels it towards the indefinite and unattainable."

Since Allston was so concerned with the imagination, he generally avoided topical subject matter that limited interpretation to a single place or individual moment. He wanted his images to reverberate in the viewer's mind. To allow the viewer to dream a little before his paintings, he softened the edges of forms and allowed them to appear as if seen through transparent veils of color. So subtle were his glazes and harmonies that he was called the American Titian. As the contemporary artist and historian William Dunlap wrote, Allston tried "to awaken images *congenial* to the compositions, but not *in* them expressed." A painting, then, could be a point of departure for a private soliloquy in a way that one by West or Trumbull could never be.

Allston's theories are embodied in the paintings he began in Rome. His figural pieces, derived from literature, and his classical and wild landscape scenes were meant to provoke the imagination. During the three years he spent in Boston, from 1808 to 1811, he turned to portrait painting, still the staple of American artists, but he added a Romantic warmth and mystery, a revelation of inner spirit rather than of public posture, which differed from the standard work of Gilbert Stuart, then still at the peak of his career. Allston also began to paint, for the first time in America, portraits of reverie. These were not necessarily studies of particular individuals, but might be drawn from literature or, as in *Evening Hymn,* might reflect a general mood, a state of mind, that Allston wanted to visualize [46]. These works, more numerous in Allston's later years, reveal his great talent for painting calm and soothing scenes.

During his second period abroad, however, he sought sublime subjects to paint, religious and historical in content, in part prompted by Benjamin West's work of the time. (West's religious works also influenced Trumbull, William Dunlap, and Rembrandt Peale, who were abroad during these years.) Allston's most ambitious and successful painting of this period was *The Dead Man Restored to Life by Touching the Bones of the Prophet Elisha,* a work describing a miracle and the resurrection of life [47]. Despite Allston's concern for the imaginative and, presumably, for the creative spark of individuality in each person, *The Dead Man* is one of his most studied works, an eclectic synthesis based on earlier sculpture and paintings. These include the Ilissos figure from the pediment of the Parthenon, one of Raphael's tapestry cartoons, *The Death of Ananias* (c. 1517), and Sebastiano del Piombo's *The Raising of Lazarus* (1517–19). In addition, a generalized Michelangelesque emotionality pervades the painting. Such quotations and paraphrases, which can be found in virtually all of Allston's more ambitious works and which invite criticism for being too derivative, were perfectly acceptable in his day. They revealed Allston's knowledge, flattered the knowledge of his viewers, and, because of associations with the glories of past art, were thought to contribute to the improvement of society. But the expertise

48. Washington Allston, *Moonlit Landscape*, 1819. Museum of Fine Arts, Boston.

necessary to enjoy this painting as fully as possible was almost entirely lacking in Allston's American contemporaries. His supporters recognized his talents, but could not sustain the tradition in which this art might flourish. Unquestionably, the want of a grand tradition in America caused Allston to give up painting religious works soon after his return in 1818, in preference for idyllic and elegiac themes, evoking memories of Italy or faroff lands of the artist's imagination [48].

These late works show diffuse continuities between objects of reality and emanations of the spirit, which seem to vibrate in sympathy. Sounding very much like an exponent of Transcendentalism, the New England-based philosophical and literary movement that flourished through the middle years of the century, Allston wrote in his *Lectures* that "a ray of light is not more continuously linked in its luminous particles than our moral being with the whole moral universe." This linkage, he proclaimed, provided an intimation "of the many real, though unknown relations, which everywhere surround and bear upon us." Allston's late paintings, mostly landscapes, give off mysterious resonances, not in a frightening, sublime way, but through ambiguity and enigma. In them, one feels the presence of the artist's feelings, as Allston desired, and the challenge to the viewer to allow free play of his.

Poetic responses are much less evident in the art of John Vanderlyn (1775–1852), with whom Allston traveled on the Continent in 1803 and 1804. The two did share, however, a commitment to European art in the grand manner and the desire to see it brought to America. They both also enjoyed living abroad. Vander-

lyn, after study in 1792 at the Columbian Academy of Painting in New York City, conducted by Archibald and Alexander Robertson, and a brief stint as Gilbert Stuart's assistant in 1795–96, left for further training in France, the first American to do so. He remained there until 1801 and, after a two-year stay in America, lived in England and on the Continent until 1815.

Vanderlyn, like others, especially Samuel F.B. Morse, flailed away at Americans for their refusal to support the arts in a more adequate fashion. In a letter Vanderlyn wrote in 1806, illuminating his preferences for life in Europe, he said "the state of the fine arts in America is miserable," and "the spirit of republicanism is directed solely against them whilst luxuries of mere ostentation . . . are alone sought for and cherished in America." Although we can sympathize with the sensitive individual lacking a community of his own to provide support and surrounded by an ignoring—rather than hostile—public, it is also evident that Vanderlyn's expectations were unreasonable. The art style in which he was trained—the hard-edged, glossy-surfaced Neoclassical style of turn-of-the-century France—and the subject matter he preferred, mythological scenes, were simply too remote from American sensibilities to warrant support. Trumbull, at least, tried to appeal to patriotic fervor. Vanderlyn expected an aesthetic response from a middle-class culture that was full of pious talk about republican restraint but at the same time was hellbent on material acquisition. He really needed an aristocratic class to sustain him.

His three most noted paintings, uncommonly high in quality for an American at this time—*The Death of Jane McCrea* **[49]**, *Marius Amid the Ruins of Carthage* (1807, De Young Memorial Museum, San Francisco), and *Ariadne*

49. John Vanderlyn, *The Death of Jane McCrea,* 1804. Wadsworth Atheneum.

Asleep on the Isle of Naxos (1812, Pennsylvania Academy of Fine Arts)—were painted in Paris, Rome, and Paris, respectively. Although the *Jane McCrea* was based on an American subject—the Tory sympathizer McCrea was scalped by Indians on July 27, 1777, on her way to Fort Edwards, New York, to visit her English sweetheart, who was serving in General Burgoyne's army—the style and treatment of the works are entirely French, and the content of the latter two paintings is European. The *Marius,* to which Napoleon awarded a gold medal, was based on Plutarch's *Life of Caius Marius.* It is a pictorial essay on revenge and the mutability of fortune, its lack of activity requiring Romantic empathy on the part of the viewer. Marius, who had fled to Carthage after defeat by Sulla, was ordered to leave Carthage; he asked the messenger to tell the governor that he, the messenger, had seen Marius sitting amid the ruins of Carthage. The third painting, depicting Ariadne abandoned on Naxos by Theseus, is an exercise in painting the female nude in a landscape setting. It obviously harks back to Giorgione and Titian and, more specifically, to Anthony Van Dyck's *Jupiter and Antigone.*

It is to his credit that Vanderlyn did attempt to come to terms with the facts of artistic life in America. During the few years he was in America between stays abroad, he was one of the first artists to visit Niagara Falls, to prepare studies for engravings. These were completed abroad in 1804, but did not prove financially successful. After returning to America in 1815, Vanderlyn had a rotunda erected in New York City—the first building of its kind in the country—in which to show panoramas. His preferred subjects were views of major European cities and sites. *The Palace and Gardens of Versailles,* exhibited in 1819, is the only one that has survived (The Metropolitan Museum of Art, New York City.). Neither Vanderlyn's panoramas nor their promotion were successful, and he abandoned the project after eight years. (Ironically, Trumbull could not turn the popularity of panoramas to profit, either. His intention to enlarge in England small panoramic studies of Niagara Falls, made in 1807, did not receive adequate backing.) Vanderlyn, embittered, retired to his native Kingston, New York. His last major effort, *The Landing of Columbus* (1837), a painting made for the Rotunda of the Capitol in Washington, D.C., is as inferior in comparison to his early work as Trumbull's Rotunda paintings are to his.

The career of Samuel F.B. Morse (1791–1872) reads almost like a parody of Vanderlyn's, for he, too, was an artist of immense talent (but less imagination) whose conception of art had little correlation with American reality. He accompanied Allston to England in 1811 to study with Benjamin West. By the following year, he had won a gold medal from the Society of Arts for his terra-cotta statuette of Hercules, a model for his painting *The Dying Hercules* (1812, Yale University Art Gallery), which also received high praise [50]. Determined to become a history painter and be the rival of Raphael, Michelangelo, and Titian, Morse detested the idea of having to paint portraits. Yet, he was forced to do so after his return to America in 1815. For several years he lived as a semi-itinerant, traveling from New England to South Carolina. In 1821, he decided to try his hand at a large, imaginative painting, *The Old House of Representatives* [51]. He

50. Samuel F.B. Morse, *The Dying Hercules,* 1812. Yale University Art Gallery.

51. Samuel F.B. Morse, *The Old House of Representatives,* 1822. The Corcoran Gallery of Art.

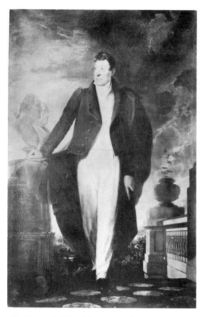

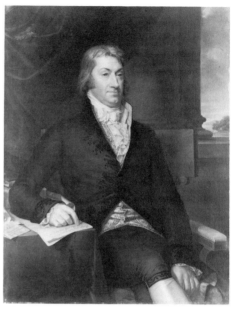

52. Samuel F.B. Morse, *Lafayette,* 1826. 53. John Vanderlyn, *Portrait of Robert R.*
Art Commission of the City of New York. *Livingston,* 1804. The New-York Historical Society.

was probably affected by the rising tide of nationalism after the War of 1812, which led to Trumbull's commissions in 1817 to paint four works for the Rotunda in the Capitol. The following year, the state of North Carolina commissioned Thomas Sully's *Passage of the Delaware* (1819, Museum of Fine Arts, Boston), an interpretation of Washington and his army crossing the Delaware River. No less important, because it affected the number of portrait commissions Morse and other artists received, was the severe depression of 1819. The loss of business probably prompted Rembrandt Peale to paint his *The Court of Death* (1820, The Detroit Institute of Art), which turned a decent profit wherever it was exhibited —32,000 people saw it within thirteen months. Morse's receipts, alas, were meager. *The Old House* was, in fact, an inventory of a large and beautiful room in which people milled about to no special purpose, and it was not a popular success.

Morse settled in New York City in 1823, intending to inherit the mantle of artistic leadership from the aging Trumbull. This might actually have happened. The City of New York commissioned Morse, rather than any other New York portraitist, to paint a full-length portrait of Lafayette in honor of his triumphal return visit in 1824. Morse, rising to the occasion, created the finest flamboyant Romantic portrait of the period [52]. He then led a disgruntled group of artists out of the businessmen-dominated American Academy of the Fine Arts in 1825 to found the organization that became the National Academy of Design. But his career came to a halt in the 1830s and, after inventing the telegraph in 1837, he devoted his time to other interests, including the introduction of the daguerreotype to America in 1839.

It is unfortunate that Vanderlyn and Morse found portrait painting so unsatisfactory. Each could have added considerable luster to its history in the first half of the nineteenth century. Vanderlyn's study of Robert Livingston [53] indicates that he could have offered a strong Parisian-derived alternative to Gilbert Stuart's English style. Together with Rembrandt Peale, who painted several fine neoclassical portraits after his return in 1811 from a two-year stay in Paris, Vanderlyn might have created a significant trend. Vanderlyn, however, faded into near oblivion, and Peale turned his portraits of George Washington into a small industry, reproducing twelve times his study from life of 1795 and making 79 replicas of his famous Porthole Portrait of 1823 [54].

A bit of neoclassical salt might have toned down the sometimes cloying sweetness of Thomas Sully's portraits. Sully (1783–1872), a very popular painter who spent most of his life in Philadelphia, continued the English manner well past the middle of the century. After studying briefly—about three weeks—with Stuart in 1807, he went to London in 1809–10, where he never quite recovered from the influence of Sir Thomas Lawrence [55]. But few, if any, American artists of the time could equal his ability to create creamy surfaces or to give a portrait an aura of an occasion rather than merely do another competent job—certainly not the Philadelphia artist John Neagle (1796–1865) or the New York portraitists John Wesley Jarvis (1780–1840) and Samuel Lovett Waldo (1783–1861). Jarvis, like Sully, was a native Englishman who was brought to America as a child; he became New York City's leading portraitist after he settled there in 1802. Jarvis's years of greatest achievement lasted roughly from 1810 to 1820, but he was never able to create a "New York style" in the same way that Stuart had created a style

54. Rembrandt Peale, *George Washington,*
c. 1823. The Metropolitan Museum of Art.

55. Thomas Sully, *Mary Siddons Whelen,*
1812. Philadelphia Museum of Art.

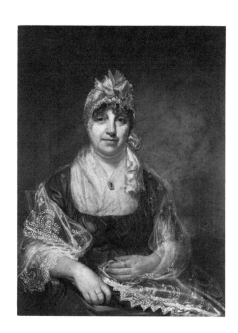

56. John Wesley Jarvis, *Mrs. Solomon Etting,*
1810–12. Maryland Historical Society.

in Boston and Sully in Philadelphia. In 1816, Jarvis received five of the eight
commissions given by the City of New York to paint portraits of the heroes of
the War of 1812. Although all are good, workmanlike studies, his finest portrait
was completed a few years before—a vivid, realistic likeness in which careful
attention was lavished on details **[56]**.

Jarvis had no interest in affectation, evidently, or in inventing a public
personality for his sitters. In this sense, his portraits can be read as political
statements, whatever their artistic merits, and they provide perhaps more inter-
esting insights into the early-nineteenth-century American mind than the studies
by Sully. Each artist's approach to character, bearing, and dress raises the issue
of how an American was supposed to act. Sully might have been encouraged by
his sitters to be generous in suggesting qualities of leadership, class, and accom-
plishment. Jarvis, closer to Peale's point of view, emphasized virtue, self-restraint,
and a certain quality of unimaginative perseverance.

Jarvis's sitters would probably have agreed in principle with a certain Emma
Willard, who petitioned the New York State Legislature in 1819 to establish
female seminaries. Believing that wealth threatened the existence of the republic,
she thought that these seminaries would preserve among women "that purity of
manners which is . . . so necessary to the existence of a republican government."
She found that "the depravation of morals and manners can be traced to the
introduction of wealth as its cause." To many, then, appearances were important
in that personal virtue reflected public morality. Conceivably, a large number of
sitters might have preferred Jarvis to Sully for patriotic, rather than aesthetic,
reasons, Ms. Willard among them. How else to explain the steady stream of
portraits that issued from Jarvis's studio?

Americans were caught in a dilemma. Encouraged to be thrifty and industrious, many began to grow rich. How could one maintain self-restraint when financial rewards were so seductive? How could one keep the concept of virtue properly enshrined, but also enjoy the pleasures of one's labor? How could growing class distinctions and divisions be kept from destroying the ideal of social unity? These were questions never resolved, until they became irrelevant in the 1870s, when fortunes of incredible size were being amassed. But a bare handful of paintings of factory scenes early in the century suggests that the concept of republican simplicity had already become so firmly embedded in the nation's developing character that it began to assume mythic proportions.

In *Interior of a Smithy,* Bass Otis (1784–1861) painted the interior of a factory in which the workmen go about their tasks without obvious supervision or distinction in rank [57]. Although manufacturing was obviously a major path to wealth, Otis painted the scene as if it were an exercise in both self-reliance and social integration. The ideal of cooperation and public responsibility underlines this work rather than the more truthful one of aggressive individualism. In *Pat Lyon at the Forge,* Pat Lyon wanted John Neagle to paint him as a working man as a protest to the authorities, who jailed him for an unproved bank robbery [58]. But the painting also makes clear that Lyon is a responsible citizen, toiling hard and honestly for his reward, no different from his workmen. Lyon seems to deny that his growing wealth has created social distinctions and that it might interfere with the cohesiveness of society. In the years that mark the beginning of industrialization, this portrait pays homage to an already simpler time and to the concept of "just plain folks" that is still with us today.

57. Bass Otis, *Interior of a Smithy,* c. 1815. Pennsylvania Academy of the Fine Arts.

58. John Neagle, *Pat Lyon at the Forge,* 1826.
Museum of Fine Arts, Boston.

The idea of republicanism and all that it implied was probably inescapable in the first decades of the country's existence. The literature of the period suggests strongly that artists and writers had to subordinate personal interests and idiosyncracies to public morality. For example, a critic commenting on John Lewis Krimmel's copy of *The Blind Fiddler* by the English genre painter David Wilkie in an 1813 issue of *The Port Folio* said that Wilkie's work was "fitted to our republican manners and habits, and more likely than any other [type] to be appreciated at present." In other words, genre paintings might contain humorous elements or interesting anecdotes, but they should always convey a simple moral about making one's way in the world or of societal responsibility, or, at the least, they should be easy to understand. Krimmel (1786–1821), a native of Germany, accepted these guidelines with little difficulty. After settling in Philadelphia, he began to paint two types of genre scenes, all easily understandable. In one type, derived from Wilkie's paintings, characters were placed in shallow, boxlike interiors. Meaning was conveyed through easily grasped gestures. The second type consisted of outdoor scenes describing particular events in Philadelphia—Independence Day celebrations, election-day scenes—and were filled with crowds of small figures. If meaning was intended for this second group, it lies in the celebration of community, since several social classes are seen enjoying the same events together [59].

Krimmel probably developed this second type after studying the twenty-eight engravings published in Philadelphia in 1800 from the designs of William Birch (1755–1834), an English printmaker who settled there in 1794. Called *The City of Philadelphia in the State of Pennsylvania,* this was an early collection of

urban views based on the English topographic tradition, in which detail and precision were substituted for character analysis. Descriptive genre scenes of this type also began to grow in popularity as people became increasingly interested in seeing what they looked like, how they behaved, and how American cities began to take shape. Although Krimmel was the first true genre painter to emigrate to America, Francis Guy (c. 1760–1820), who came from England in 1795, catered to similar tastes in his two elaborate genre scenes, *The Tontine Coffee House* [60] and *Winter Scene in Brooklyn* (c. 1817–20, Brooklyn Museum). Both are full of visual incident as well as humor, and both record the bustle of city life.

The genre scenes of Krimmel, Birch, and Guy fed the growing self-awareness of Americans and were, in turn, encouraged by it. Unlike, say, Trumbull and Vanderlyn, these genre artists catered to the tastes of a broader public, anxious to see itself recorded for posterity. Perhaps like immigrant colonial artists, they inspired native-born painters to attempt similar scenes, less through direct stylistic influence than by their presence and the dissemination of their work through prints. In any event, Massachusetts-born Alvan Fisher (1792–1863) began to paint anecdotal rural genre scenes as early as 1811 and, after 1815, added landscape and barnyard scenes to his repertory of subjects. He was, therefore, one of the first American artists to turn his attention to themes that would occupy the next several generations of American artists.

Fisher's works of this period do not seem to convey meanings other than what is evident in the anecdote presented [61]. Nor do we know with what feelings

59. John Lewis Krimmel, *Election Day in Philadelphia*, 1815. Winterthur Museum.

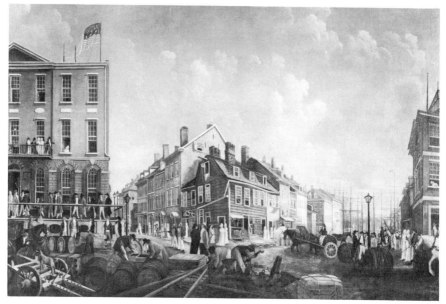

60. Francis Guy, *The Tontine Coffee House,* c. 1797. The New-York Historical Society.

61. Alvan Fisher, *Winter in Milton, Massachusetts,* 1815. Montclair Art Museum.

he viewed the American landscape—whether he considered it an object to be described topographically, whether he sought in it charming or sublime views derived from the English interest in picturesque taste, or whether he found in it the nationalistic-religious elements that so concerned later artists. In any case, when Fisher painted his first views, interest in the American landscape was already widespread.

In the colonial era, landscape painting found few enthusiasts. Owning a landscape painting did not carry with it social distinction, and love of nature for its own sake was uncommon. Nevertheless, artists such as John Smibert painted landscapes, and a number of homes were decorated with scenes of the countryside. Several prints of city views were published, with the cities often seen across bodies of water—the Delaware River in front of Philadelphia, New York harbor in front of New York City. By the late 1780s, interest in the landscape began to grow appreciably. The first formal description of American scenery appears to have been published in 1788, when Thomas Jefferson described the meeting of the Potomac and Shenandoah Rivers in his *Notes on the State of Virginia.* Landscape views also began to appear in magazines about this time; the first scenes date from 1787. They were usually of an individual's estate or of a particular place—an illustration of Niagara Falls appeared in 1790 in *Massachusetts Magazine.* Only occasionally was a rural or farm scene illustrated. Charles Willson Peale's engraved view of farm lands in 1787 is an early and rare example.

These illustrations antedated by a few years the arrival of landscape painters, primarily from England, who were really responsible for initiating American landscape painting. Beginning about 1790, some came to settle permanently, others only to visit—intending to engrave and sell views of city and countryside. All these artists, including Archibald and Alexander Robertson, William Winstanley, William Groombridge, George Parkyns, and William Birch and his son Thomas, were topographical artists. They recorded detail accurately, with only a rare concern for mood or reverie.

By the late 1790s, however, a specific national flavor began to influence perceptions of the landscape. Slowly, Americans recognized the uniqueness of their landscape. It was wild and largely untouched by civilization. By contrast, Europeans tended to enjoy landscapes that had human or historical associations. *American Universal Magazine* announced in 1797, for example, that it would publish views illustrating "the national beauties of our own country, convinced that no quarter of the world, however celebrated, affords more novel and sublime scenes than are to be met with among the romantic wilds of America." Like the new, hoped-for American character, the American landscape was innocent and uncorrupted. It was an easy next step to assign to it religious qualities; it was to be viewed as an example of God's handiwork on earth, left undisturbed for development by the God-supported new nation. In response to Romantic impulses from Europe, individuals increasingly felt that, when in nature, they were in the presence of God, that their souls could join in direct communion with Him, without benefit of Bible or religious instruction. (The Puritan elders would have

been horrified, but Anne Hutchinson would have understood.) Unfortunately, artists had not kept pace with public sentiment. Even though Trumbull, Vander-lyn, Morse, the Peales (Charles Willson and Rembrandt), and a host of English artists had painted and sketched the American landscape since the late 1780s, no paintings were produced that adequately conveyed these complex religious mean-ings until the work of Thomas Cole in the late 1820s.

Another important attitude about the landscape appeared by 1815—the concern about the destruction of the wilderness by the growth of both population and industry. As early as 1812, complaints were heard concerning the loss of natural scenery as a result of the construction of mills. But preservation was not yet a critical issue in the first years of the nineteenth century. If anything, the nationalistic implications of industrial growth were much more important. One of the continuing arguments between political factions in America concerned the development of manufacturing in order to break England's grip on the largely agrarian American economy. Technological growth was seen as a way to preserve and extend the nation's independence. Technology and republicanism, therefore, progressed together. A mill was not necessarily seen as a desecration of the countryside; it also showed the assertion of national strength and national will. A painting of a mill near a waterfall, its source of power, might be construed, in this light, as a painting in praise of American resourcefulness.

Thomas Birch (1779–1851), whose active career began about 1800, is proba-bly the best landscapist of this generation. Brought to America in 1794, he helped his father, William, both with views of Philadelphia, published in 1800, and with the production of *The Country Seats of the United States* in 1808. One of the engravings in this set was of a pure wilderness scene—perhaps the first such engraving in America. In 1811, Birch exhibited a landscape and a seascape at the Pennsylvania Academy of Fine Arts, and continued to paint both topographical and dramatic landscapes and seascapes throughout his career [62 and 63]. In his earlier years, he developed a tight, linear style influenced by both English and Dutch examples. The use of low horizons and clear readings of detail served him exceptionally well, particularly in the several paintings he made of American naval victories in the War of 1812.

Birch probably admired the meticulous technique of his fellow Philadelphian artists, the still-life painters. Virtually all were members of the Peale family. The best and most precocious was Raphaelle Peale (1774–1825). At the Columbianum exhibition in 1795, he showed five still lifes and three "deceptions." Although none of his works from this year survive, the deceptions were probably similar to his later "rack" painting of 1802, in which bits of paper placed under ribbons were painted realistically enough to fool the eye. His still lifes are of arrangements of fruits and vegetables in a single bowl or plate sitting on a table. They are austere in their simplicity and geometry of shapes, and their forms seem immobilized and ageless [64]. In another time and another country, with fellow artists to stimulate him, such as the seventeenth-century Spaniard Juan Cotán, whose works were shown in Philadelphia in 1818, Raphaelle might have turned each of his paintings

62. Thomas Birch, *Point Breeze on the Delaware,* 1818. Private collection.

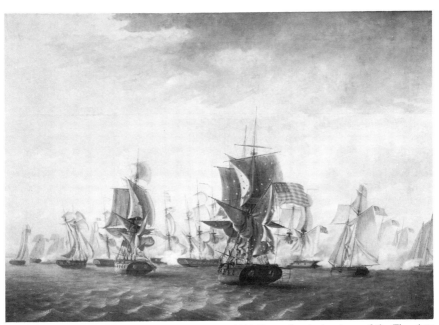

63. Thomas Birch, *Perry's Victory on Lake Erie,* c.1814. Pennsylvania Academy of the Fine Arts.

64. Raphaelle Peale, *Still Life with Celery and Wine,* 1816. Munson-Williams-Proctor Institute.

into an act of metaphysical contemplation. His most famous work, a humorous deception called *After the Bath* (1823, Nelson Gallery–Atkins Museum, Kansas City), shows a bath towel behind which we see the foot, arm, and hair of a woman. Like his tabletop still lifes, *After the Bath,* based on James Barry's *Venus Rising from the Sea* (1772), reveals an extraordinary sensitivity, probably the most subtle in this generation, to abstract shapes and the inherent qualities of objects.

SCULPTURE

In the years after the Revolutionary War, the quality and quantity of American sculpture expanded slowly. Unlike painting, in which artisan and cosmopolitan styles existed side by side, sculpture was largely contained within the former tradition. Wood was the common material, not stone. Subjects were ships' figure-heads, not mythological or religious themes. Portraits were beyond the abilities of most, if not all, carvers. When monumental works were wanted, European sculptors were commissioned. When architectural decoration was desired, Euro-peans were hired. Except for a few notable exceptions—Patience Wright, Joseph Wright, and William Rush—American sculptors did not enter the trans-Atlantic community of artists until the 1820s.

The most important European works imported before the Revolutionary War were statues of George III and William Pitt, by the English sculptor George

Wilton. These were set up in New York City in 1770, and a copy of the Pitt was erected in Charleston soon after. Because of the war, no school of sculptors developed from these works, nor were there any European sculptors in the country to keep a minimally flickering tradition alive.

The most important work of the period is Jean Antoine Houdon's statue of Washington, commissioned in 1785 [65]. Houdon, given a portrait of Washington by Peale and finding it unsatisfactory, traveled to Mount Vernon to make his own studies. (Not incidentally, Houdon also made the trip to interest the government in an equestrian monument of Washington, but nothing came of it.) The statue, after a long delay, was installed in the Virginia State Capitol in 1796. It shows Washington in contemporary dress as a modern Cincinnatus, the Roman general who returned to farming after achieving military victory; Houdon's conception dates from the period after the war, before Washington became president. The subject holds a walking stick, and behind him is a plow. The fasces, a symbol of Roman political office, contains thirteen rods, symbolizing the original states, from which hangs Washington's sword.

General knowledge of the commission undoubtedly sparked interest in other commissions for monumental sculptures as well as for portrait busts. As with painting, the center of activity was in Philadelphia, where good examples of European works could be seen as early as 1779. At that time, Benjamin Franklin sent to friends perhaps as many as three plaster casts of a bust made by Jean Jacques Caffieri in Paris in 1776. A few years later, in 1786, several busts by Houdon could also be seen in Philadelphia, at the studio of Robert Edge Pine, an English artist then living in the city, who had brought his own collection of casts of ancient statues. In fact, plaster casts were the only way to provide information about the size and shape of ancient and Renaissance statuary. Very early in its history, in 1803, New York's American Academy of the Fine Arts acquired a set of casts; and a set, exhibited in Peale's museum in 1804, became the nucleus of the collection of the Pennsylvania Academy of the Fine Arts. It was shown at the first exhibition, in 1807.

Francesco Lazzarini's full-length statue of Benjamin Franklin, placed on the exterior of the Library Company of Philadelphia, was the first monumental piece in that city. Commissioned in Italy in 1790 and installed in 1792, it was the first large statue to arrive in America after the war. In the intervening year, Giuseppe Ceracchi (1751–1802), a friend of Lazzarini, arrived in Philadelphia with the idea of erecting an enormous multistatued monument to Washington. Like Houdon, he could not convince Congress to support his scheme, but in the year that he stayed, he completed about thirty portrait busts.

By 1806, activity had spread elsewhere. Giuseppe Franzoni carved an eagle for the Hall of Representatives in Washington, D.C. Two years later, he worked at St. Mary's Chapel in Baltimore, the early Gothic Revival building. Franzoni also carved the famous corn-cob capitals in the Capitol in 1809. (Francesco Iardella carved the tobacco-leaf capitals in the Senate Rotunda about 1816.) And Luigi Persico, who arrived in the Philadelphia area in 1818, began to work at the

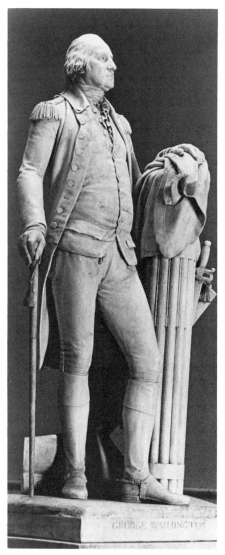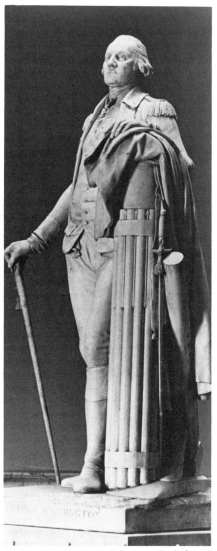

65. Jean Antoine Houdon, *George Washington,* 1788 (installed 1796). Virginia State Capitol.

Capitol in 1826. These sculptors certainly influenced the next generation of Americans to choose Italy as the country in which to learn the art and craft of sculpture.

The only American who could compete with the wave of Europeans was William Rush (1756–1833). Among the most skilled carvers of figureheads, he learned his trade under the London-born Edward Cutbush, from 1771 to 1775. Over the next twenty years, Rush had few competitors in imbuing a figure with

66. William Rush, *Justice*, 1824. Fairmount
Park Art Association.

a sense of life. By the 1790s, his fame had spread to Boston, where, despite the
active workshops of the Skillin and Fowle families, Rush's designs were in de-
mand. One of his designs, for example, was used by the Skillin family for a carving
for the ship *Constitution*, in 1796.

Rush, who might have met Houdon in 1785, began to make free-standing
figures after 1800, and in the next few years he made the transition from an artisan
working in the vernacular tradition to a sculptor aware of international styles. A
prolific worker, he carved at least nine statues for public buildings or monuments;
this was a feat unprecedented at the time. His *Justice*, made for the triumphal
arch honoring Lafayette's visit to America in 1824, shows Rush's attempts to
master the Neoclassical style of European sculptors [66]. His style, with all its
intricacy of pattern, never lost its artisan stiffness, however, in part because his
sources were usually linear designs reproduced in design and pattern books, the
most notable of which was Charles Taylor's four-volume *Artist's Repository, or
Encyclopedia of the Fine Arts* (London, 1803). In comparison to his earlier work,
the drapery of the figure of Justice flows more smoothly and with fewer distract-
ing folds, but it would take another generation of sculptors, working in clay and
marble, to learn how to soften flinty edges as well as sharp creases, and how to
unify an entire composition.

3

SELF-DISCOVERY

AMERICAN ART developed explosively between 1820 and 1860. Even though many artists still relied on portrait painting to earn a living, landscape and genre scenes grew increasingly popular. Perhaps not until the 1930s was the country scrutinized again so closely, its inhabitants and its diverse landscape examined so intently. But even as artists found growing numbers of patrons and better teaching facilities, they still wanted to travel abroad—but with at least one major difference. Several, notably Thomas Cole and Asher B. Durand, refused to prostrate themselves before European artists and styles. True, they delighted in the works of young and old masters, as well as in the scenery and the splendors of the ancient and medieval epochs, but they traveled as nationalistic Americans and retained a critical spirit. Some artists did remain abroad for the better part of their careers or permanently, but virtually all who returned felt themselves allied with or connected to their fellow citizens and a part of the cultural growth of the country. Their art in some way reflected national purpose—in its examination of the populace, in its concern for moral improvement and patriotism, and in its exploration of the landscape.

Exhibitions were held in ever-increasing numbers of communities, and organizations that were formed in regional centers helped with the task of bringing art to the populace. The most spectacularly successful organization to promote American art was the American Art Union in New York City. Formed in 1838 as the Apollo Gallery, it lasted until 1851. For an annual fee, subscribers received an engraving, the publication of the Union, and a chance to win works of art in an annual lottery. The success of this organization spawned a host of imitators in Boston, Newark, Philadelphia, Cincinnati, and Sandusky, Ohio, in the late 1840s and 1850s. Although these groups quickened interest in art in several sections of the country, by the 1840s New York City had assumed the central role in the development of American art. Its American Art Union, National Academy of Design, and New York Art Gallery, open from 1844 to 1854, became the main clearing houses for new styles, ideas, and attitudes throughout the country.

Artists born about the turn of the century lived through a wildly expansionist phase of American history. Between 1820 and 1860, the population increased from 9.5 million to 31 million, and the number of states from 22 to 33. Although

several cotton and textile mills were in operation in the 1810s and 1820s, the decade of the 1830s was the "take-off" decade for industry. Cotton cloth production increased 500 percent, and pig iron production rose from 20,000 tons annually to 192,000 tons. About 2000 miles of railroad track were laid, and roughly 2000 miles of canals were dug. Between 1830 and 1860, almost five million people emigrated to the United States. By 1840, 36 percent of the population was engaged in commerce, industry, or administration.

Although many people became wealthy, the rich grew richer faster than the poor, which led to economic stratification and the rise of a permanent white underclass. It has been estimated that by 1860 5 percent of the nation's families owned over half its wealth and 10 percent controlled almost three fourths. One percent of the inhabitants of Philadelphia owned 50 percent of that city's wealth. Keepers of the nation's conscience, realizing that the ideal of economic equality had been lost, translated that notion into the competitive ideal of equality of opportunity. Individual achievement rather than public responsibility characterized social aims as older elite groups lost political control to less educated and less civic-minded citizens. The freedom to pursue one's own aims and desires replaced the previous ideas of virtue and self-control. Exploitation of the land and of the people grew increasingly common. Laborers, increasingly degraded and aware of their plight, worked twelve-hour days often for less than a dollar a week. Brutal working conditions led to organizations of mechanics and other labor groups. Over 160 strikes were recorded between 1833 and 1837 alone.

The antagonism between employers and employees spilled over into newly developing enmities between native-born and immigrant groups, particularly in Massachusetts, where large numbers of Catholics settled. Fears that the Catholics might take over the government led to repressive measures against them. Expansion to the western parts of the continent also provoked fractiousness, especially in regard to the increase in the number of slave states and the desire by many both in and out of the federal government to wrest land from Mexico by whatever means possible.

Regardless of which side people supported in these devisive issues, hardly anyone protested—least of all the nation's presidents—the callous destruction of native American cultures and the wanton murder of the Indians who blocked the westward rush of settlers. In 1845 the term "Manifest Destiny" was coined to justify the establishment of an American empire spanning the continent, although the concept had been formulated as early as the 1820s. A tricky idea to understand easily, Manifest Destiny included at least three distinct elements. The first was millennialism, in which God's kingdom on earth was immanent in Anglo-Saxon America. The second was a holy mission, in which Anglo-Saxon America was destined to revitalize the world spiritually and lead it to freedom. (Even Ralph Waldo Emerson, the Transcendentalist, could write in his journal for August 29, 1849, that "only the English race can be trusted with freedom.") And the third was expansion and exploitation, in which the continent was available for development by an aggressive and presumably superior people.

Obviously, many people cynically exploited belief in Manifest Destiny for personal gain, just as others considered it a noble cause and associated its religious

aspects with spiritual uplift and public morality. In fact, religion was thought to serve both religious and secular purposes in nineteenth-century America. Religious faith along with public education were considered the chief bulwarks of republican America, the most important props of democracy, because of their ability to wield moral influence and instill self-control on the populace without the use of force. Religion, it was thought, would help develop a national conscience and, in the difficult battle against rapacious economic individualism, religion would remind the public of its moral obligations. Religion, in effect, became part of a secular crusade to develop and maintain civility in the country and to call attention to the evils of luxury and wealth. Where the Founding Fathers might have invoked political theory and enlightened rationalism to provide cement for the union, nineteenth-century figures relied heavily on religion to prevent atomization of society and to control greed.

It is important to realize that artists played a key role in this essentially conservative effort. Whether or not they knew it, they were enlisted in the effort to quiet the turbulence of American life and to act as guardians of social order. In virtually every piece of writing on art in these decades, the salutary effect of art on the emotions, on the human spirit, and on the national character was emphasized. As the Reverend H. W. Bellows commented at the annual meeting of the American Art Union in 1844, "no nation needs its [art's] exalting, purifying, calming influence more than ours," and Thomas Cole, the landscape painter, summed up the feelings of many when he wrote in his essay, "Lectures on Art," "through art ideal beauty takes possession of the mind, hallows and elevates it above the sordid and vulgar and though it may not sanctify the heart, it renders it susceptible to religious impressions."

Artists responded to their task by portraying an ideal image of the country, not its realities. Landscape paintings became exercises in religious contemplation, and genre scenes often pointed out familiar homilies. Artists perpetuated the developing myths of the redemptive and holy qualities of the landscape, of the essentially well-intentioned character of the populace, and of the virtual lack of conflict on any level of thought, activity, or intention in white America. Hardly any pointed out the environmental or human costs of industrialization and empire-building, of genocide and slavery. A few broke through the crust of self-deception—Thomas Cole, George Caleb Bingham, and David Blythe. Cole, whose notions of virtue and self-restraint resembled those of the Founding Fathers, clearly recognized the contradiction between assigning religious meaning to the landscape and using it as a commodity for exploitation. Bingham provided an honest account of western democracy at work in his election scenes, and Blythe observed the American character in ways that bordered perhaps on the pathological. The anxieties reflected in the works of these artists suggest that the sense of optimism often attributed to the art of this period might have been more superficial than we have thought, a mask used to hide the complexities of a nation trying to complete itself according to an impossibly high set of standards, but which functioned daily in accordance with another, meaner one.

LANDSCAPE PAINTING

In their search for self-knowledge and self-identification in the early decades of the nineteenth century, Americans increasingly turned to the landscape. Its features and contents, let alone its extent, were not fully known. The endless wilderness, the most distinctive feature, was shared by all the states. Just as scientists found in it a great natural laboratory, artists (and authors) used its unlimited resources for creating national images and myths. It was raw data to be manipulated at will.

Through the late teens and early twenties of the century, artists approached the wilderness, as well as the rural countryside, in a topographical manner, as a vast subject to document. Ironically, English artists led the way, as they had a generation before. John Hill (1770–1850) and Joshua Shaw (1776–1860) settled in Philadelphia in 1816 and 1817, respectively. William Guy Wall (1792–after 1864) and William Bennet (1787–1844) reached New York City in 1818 and 1826, and Robert Salmon (1775–c. 1843), the marine painter, arrived in Boston in 1828. The works of these artists were disseminated largely through engravings and aquatints; the most notable were the collaborative efforts of Shaw and Hill in *Picturesque Views of American Scenery* (1820–21) and of Wall and Hill in *Hudson River Portfolio* (1821–25) **[67]**.

Like earlier landscapists, Shaw, Hill, and the rest acknowledged the uniqueness as well as the grandeur of American scenery, and provided the public with

67. William G. Wall, *Landscape—Bakers Falls, New York*, 1820. The New-York Historical Society.

views of popular tourist sites—such as waterfalls and the Palisades of the Hudson River—which became identified as typically American scenes. The illustrations catered to the growing American pride in possessing such spectacular scenes and natural wonders. Moreover, the works provided an instance in which a current mode of psychological thought, association psychology, enhanced the rising nationalist bias. According to the tenets of association psychology, one's imagination was affected by means of associations. Sir Joshua Reynolds acknowledged the interaction between objects and mind in his *Discourses,* but Archibald Alison, in his *Essays on the Nature and Principles of Taste* (London, 1808), had the greater impact on American thought. Alison held that, whatever purely visual pleasures one derived from looking at the wilderness or rural scenes, such views were "exalted by the record of the events [these] have witnessed and that in every country, the scenes which have the deepest effect upon the admiration of the people, are those which have become sacred by the memory of ancient virtue or ancient glory." That is, one's strongest associations grew from one's own country, history, and geography. Although this kind of reasoning could provide American scenery with both aesthetic validity and nationalistic resonance, it was not always possible to find high-minded associations with the trackless wastes of the wilderness. But natural wonders and, say, Revolutionary War battlegrounds identified the landscape as an American landscape. Such scenes became the American

68. Thomas Doughty, *In Nature's Wonderland,* 1835. The Detroit Institute of Arts.

equivalent of Chartres Cathedral or the Parthenon. They stood for America's antiquity or as mementos of America's beauty and strength.

Alison's theories also helped associate religion with the landscape. He believed that being in nature awakened one's moral sense. "Nature," he said, "in all its aspects around us, ought to be felt as signs of his providence, and as conducting us, by the universal language of these signs, to the throne of DEITY." Most American landscape painters of the period would have agreed with Alison, but others might have arrived at the "throne" by at least two other routes; the more religiously conservative would have believed that the message of Revelations came through the Bible rather than through nature, and the more radical would have identified God directly with nature in a pantheistic attitude.

Alison's thoughts might have been incomprehensible to artists of Feke's generation, perhaps even West's, since they are predicated on the revelation of the artist's most private being and upon allowing his feelings to expand toward a merging with the Infinite. Landscape painters often suggested this Romantic interaction of man and nature by the simple expedient of placing a small, solitary figure in an immense landscape [68]. The viewer, invited to gaze over the figure's shoulder, could also contemplate both the beauties and the cosmic design of nature. For Americans, this also meant that nature was not an adversary or a locale for adventure, but a place in which to seek knowledge and moral instruction in solitude, an especially reassuring notion because it meant that uncivilized wilderness was not destructive of one's moral sense. In addition, the continued use of the calming, stable Claudian stylistic formulas—trees flanking a view that might include a placid body of water—added to the artistic taming of the countryside.

Thomas Doughty (1793–1853) was among the first native painters to suggest these various associational qualities in his landscapes, replacing the topographical approach with a more personal response to nature. He began to paint landscapes about 1816, initially in the topographical manner, but he soon broadened his style by studying Dutch and English works in his native Philadelphia and in the collection of one of the rising art patrons, Robert Gilmor, Jr., of Baltimore. During the 1820s, Doughty painted forms with clarity and handled pigment crisply. By the late 1830s and especially after a trip to England in 1837–38, he increasingly softened landscape features, blurred outlines, and added silvery tones that suggested moods of bland revery, not unlike those in the late works of Washington Allston. Although Doughty was acknowledged as a founder of the American school of landscape painting and considered a leading exponent, his later, more artificial and mannered, works were criticized by an increasingly nationalistic audience, which demanded more realistic evocations of the American wilderness. These attacks were significant because they indicated that American artists, always closely tied to their sources of patronage and support, were no longer encouraged to imitate European models so carefully and that a measure of artistic strength could be achieved by painting realistic landscape scenes at home.

The difference of opinion between artists wanting to create imaginative

landscape paintings, or even elevate this category to the level of history painting, and patrons who preferred realistic views of nature is a leitmotif that runs through the career of Thomas Cole (1801–48). Not content, as he said, to be "a mere leaf painter," he took seriously the ever-present injunction to use art for moral purposes. Although atypical because of his overriding interest in using landscape as a backdrop for dramatic content, Cole is really the central figure in landscape painting of this period. He is considered the founder of the Hudson River School, which consisted of the landscape artists who, beginning in the 1820s and continuing for another generation, painted views of the Hudson River valley; the mountainous regions of the Northeast—the Catskills, the Adirondacks, and the White and the Green Mountains; and the New England coastline. The year 1825 may serve, symbolically, as the year of the school's inception, since Cole's work was discovered at that time by Trumbull, Asher B. Durand, and William Dunlap.

Despite the fact that Cole often used the compositional formulas of Claude Lorrain as well as the more dramatic ones of Salvator Rosa, he was probably the first artist in America to suggest the actual physical, emotional, and visual experiences of being in the wilderness. In addition, he was probably the first artist to articulate in essays and poems the many levels of meaning the landscape held for Americans as well as the first artist of quality whose works were visual analogues to the writings of nature poets such as William Cullen Bryant and authors such as Washington Irving and James Fenimore Cooper. And since many of these figures lived in or around New York City, they formed a broad artistic fraternity in which the landscape served as a major focus of concern; this was probably the first time in the history of the country that artists and writers interacted in such an amiable, symbiotic fashion.

A native of England, Cole came to the United States in his teens. Evidently possessing great talent, he hardly studied art—neither in Steubenville, Ohio, where his family settled, nor in Philadelphia, where he lived from 1823 to 1825 —before moving to New York City. The paintings that so electrified the artistic community in 1825 were scenes of the Catskills [69]. Within two years, however, Cole began to use the landscape as a dramatic foil in works such as the paired *Garden of Eden* (now lost) and *Expulsion from the Garden of Eden* (Museum of Fine Arts, Boston). Together, these and his other painting cycles completed after 1835 announced his preoccupations as an artist—that man cannot live without God and that man, as well as the United States, should try to live in a state of harmony with nature by not succumbing to worldly lust, greed, and avarice. His overwhelming desire to paint moralizing works was thus predicated on an intricate web of profound religious and political considerations. Anything less—he painted landscape views throughout his career to satisfy his patrons—was, to him, mere leaf painting.

Unfortunately, he never completed an individual work or a cycle of paintings on the theme that obsessed so many political and religious thinkers of his day— the necessity of the Protestant faith for the preservation of the republic. Instead, his two greatest cycles dealt with separate parts of this theme: the *Course of*

69. Thomas Cole, *The Clove, Catskills,* 1827. The New Britain Museum of American Art.

70. Thomas Cole, *The Course of Empire: "The Consummation of Empire,"* 1836. The New-York Historical Society.

71. Thomas Cole, *Schroon Mountain, Adirondacks*, 1838. The Cleveland Museum of Art.

Empire (1833–36), an imaginary secular description of the rise and fall of an empire, from its simple pastoral beginnings, through its luxury-loving pinnacle, to its final overthrow and disappearance [70], and the *Voyage of Life* (1840, Munson-Williams-Proctor Institute, Utica), a symbolic life history of a human being who accepts God as the means to personal salvation.

Cole's interest in painting cycles quickened while he was abroad from 1829 to 1832. Probably the panoramas he saw in England reenforced the idea of painting in series, and his ruminations in Italy on the passage of civilizations— the sharp distinction between the finite structures of man and the eternal essence of the Deity—clarified his handling of these themes. Even though he still painted landscapes, didactic subjects began to engage his thought more profoundly and might even have contributed to the broadening of his painting style in the 1830s. In place of his earlier claustrophobic attention to detail, vistas grew appreciably, but his brushwork remained vigorous and he often resorted to Rosaesque dramatic compositions [71]. Although Cole, like other landscapists, took great pleasure in hiking in the woods and studying nature directly, he began to paint less as one experiencing the outdoors at first hand and more as one who enjoys it in retrospect. In a manner parallel to that of the English poet William Wordsworth, who in his preface to the second edition of the *Lyrical Ballads* (1802) said that "poetry is the spontaneous overflow of powerful feelings: it takes its origins from emotion recollected in tranquility," Cole wrote to Asher B. Durand in 1838, "I never succeed in painting scenes however beautiful, immediately on returning from them. I must wait for time to draw a veil over the common details, the unessential parts, which shall leave the great features, whether the beautiful or the sublime, dominant in the mind." The search for the essentials of nature rather than its seductive surface charms allowed Cole to probe deeper for meaning, for understanding, and for some way to come to terms with the fragility of life. He became a devout Episcopalian in 1842, finding greater succor in the Bible than in nature. As a result, his late landscapes lack the intensity of his earlier ones, and religious themes, which he had painted right through the 1830s, gained importance in the next decade. At his death, he was working on a cycle based on John Bunyan's *Pilgrim's Progress,* one of the most popular books in nineteenth-century America.

No other painter of the time reflected so clearly the paradoxes of American society—the sense of gratitude for being blessed with geographical and economic abundance, a unique landscape, and a sense of destiny, but at the same time a fear of forfeiting everything by abusing the land and, in a nonstop orgy of self-indulgence, losing sight of the larger issues and responsibilities of nationhood. Cole also challenged the myth, or dream, of the New World as a source of endless wealth and perpetual renewal. Only Fitz Hugh Lane and Martin Johnson Heade, among the major landscapists, suggested this vision in some of their Luminist paintings of the 1860s [81]. For example, in Lane's *Brace's Rock, Eastern Point, Gloucester,* one senses less the longing for harmony with the Deity than the indifference of nature to man; that is, one feels in the contrast between the

disabled boat and the utterly quiet atmosphere the random and impersonal inter-
jection of a moral or physical disaster into an otherwise benevolent universe, akin
to the kind Herman Melville described in *Moby Dick* (1851).

In contrast to Cole, most landscapists of the period celebrated the American
countryside less complexly, trying to rivet in the national memory the wilderness
and rural splendor, "to rescue," as a writer for *The Literary World* stated in the
issue of May 8, 1847, "from its [Yankee enterprise's] grasp the little that is left,
before it is forever too late." Asher B. Durand (1796–1886) was the key figure
in the development of this mode of painting. His career is also important because,
like that of William Rush, it hints at the difficulties as well as the possibilities of
a person determined to become an artist. Apprenticed as an engraver to Peter
Maverick of Newark, New Jersey, from 1812 to 1817, Durand moved to New
York City in 1817 to pursue a career as an artisan, engraving bank notes, book
illustrations, and copies of paintings. Acknowledged as the best engraver in the
country, he nevertheless turned increasingly to painting during the 1830s and by
mid-decade had abandoned engraving entirely. At first, he painted genre and
literary themes, but by 1840 began to concentrate on landscapes. He became so
popular that, although a landscapist rather than a painter of narrative and reli-
gious works, he was elected president of the National Academy of Design in 1845,
a post he held until 1861.

During his presidency, he wrote "Letters on Landscape Painting," the clos-
est equivalent to Sir Joshua Reynolds's *Discourses* that was completed by an
Academy president. The nine letters, published in *The Crayon* in 1855, are
important because they sum up the general attitudes of the Hudson River School
painters. Taken altogether, these attitudes are a blend of romanticism, realism,
patriotism, religiosity, sentiment, and, least of all, neoclassicism.

For Durand, the ideal in art was based neither on past art nor on a set of
theories, but on the perfection of the real. He believed that artists should primar-
ily study nature and do little more than select and arrange its typical and least
blemished forms. Exaggeration was permitted, but only to heighten a mood or
to emphasize a physical feature, rather than to allow an artist to impose his will
or personality on a scene. If anything, the artist had to hide his presence by not
calling attention to brush strokes, textures, and odd compositional schemes—all
the devices that might detract from contemplating the landscape. Durand espe-
cially felt that an artist should not compete with fellow artists to create special
effects, but should act humbly before nature instead.

In this regard, Durand viewed the artist as a tool of nature. Before communi-
cation between artist and viewer could take place, the artist himself had to be
"imbued with the true spirit [of nature] to appreciate and enjoy the contemplation
of her loveliness." Loveliness, of course, meant more than mere surface beauty.
Durand aimed at "the understandings and feelings." He wanted to tap the "in-
most susceptibility of the mind and heart," by searching the "deep meaning of
the real creation around and within us." Like Alison, who had earlier written in
his *Essays on the Nature and Principles of Taste* that contemplating a landscape

72. Asher B. Durand, *Haying*, 1838. Vose Galleries of Boston.

scene led to thoughts of the Deity, Durand believed that a painting "will be great in proportion as it declares the glory of God, by the representation of his works, and not of the works of man." And, like several writers, including Irving, Cooper, Emerson, and Hawthorne, Durand believed that significant subject matter, even a style, could be found at home rather than abroad, along a roadside or in the wilderness—anywhere.

Durand also described the style of the typical Hudson River School painting in his "Letters" **[72]**. A painting should resemble or represent, but not imitate, nature. Careful attention to detail was important, more in the foreground than in the middle ground and far distance, but an overly zealous insistence on detail could lead to a feeling of airlessness. The suggestion of atmospheric space permeating a picture was essential to its success. Sunlight especially enhanced a view both spiritually and stylistically, because it suggested the presence of the Deity, it warmed up the cool green colors of the landscape, and, because of the play of shadows, added to the variation of surfaces and colors. Durand believed colors should not be allowed to run riot, since the greatness of nature—and presumably an artist's ability to suggest it—lay primarily in forms and details, not in surface hues. To be sure, Durand's training as an engraver probably caused him to "see" light and dark tones more easily than degrees of color, but it is also true that virtually all the Hudson River School painters were tonalists rather than colorists. Henry T. Tuckerman, the art critic, summed up well this way of perceiving nature when he wrote in *Artist-Life* in 1847 that "nature so blends her tints as to produce a genial but not dazzling impression, which gratifies without disturbing vision."

73. Asher B. Durand, *The First Harvest*, 1855. The Brooklyn Museum.

Although Durand and other landscapists were intimate with nature's climatic and geographical variations, they emphasized its more pleasing aspects. Storms rarely occur in their paintings. Wilderness scenes are often panoramic views that suggest sublime feelings derived from the vastness of the spaces shown rather than feelings of terror. Hardly ever is one made to feel lonely and isolated in nature. A pleasant waterfall or a sun-filled opening often prevented the forest from closing in around the viewer. Nor is there the need to look back over one's shoulder. Rugged terrain in the style of Salvator Rosa is less common than we might expect (although some artists, such as William Sonntag [1822–1910], favored this style). Depending upon how we choose to read a typical landscape, it can reflect faith in the harmony of nature; a wish, whether calm or desperate, to believe in the harmony of nature; or, on a mythic level, a desire to return to society's beginnings, to evoke through the American landscape the earthly paradise that never really existed.

Durand painted genre scenes, some American history scenes, such as *The Capture of Major Andre* (1834, Worcester Art Museum), and many portraits before turning to landscape painting about 1835. Although most of his landscapes are realistic rural and wilderness scenes, he also painted imaginary ones, with added literary or religious elements. In emulation of Cole, he completed a two-part cycle, *Morning of Life* and *Evening of Life* (both 1840, National Academy of Design). Most of the imaginary works were painted, however, after Durand's trip abroad in 1840–41 with the younger artists John W. Casilear (1811–93), Thomas P. Rossiter (1818–71), and John F. Kensett. These generally optimistic works lack the cutting, neurotic edge of Cole's post-European cycles concerned

with the life and death of individuals or the rise and fall of empires. Durand's *The First Harvest*, with its wilderness elements combined with planted fields bathed in sunlight, might be considered a nostalgic painting for its time (1855), or it might be taken to allude to God's providential plan for America [73].

Durand's style was little affected by his European trip, but it did begin to change in the late 1840s. Earlier, his landscapes were calm and contained [72]. Horizons were often low, trees tended to flank open spaces in the middle distance, and the light was diffused. Although foreground elements were carefully studied, foliage tended to be generalized. In these works, Durand evoked pleasant feelings rather than concentrating on the description of individual places. In the mid-1840s, he began to make precise outdoor studies instead of mere sketches (the reverse of Cole's procedures), and, as a result, detail grew more particularized and textures more realistic [74]. Outlines became sharper and the surfaces of objects more scratchy. Larger masses yielded to individual forms. Although Durand continued to portray rural scenes with ample spaces, he painted several wilderness scenes with cut-off views that cramped the easy flow of depth from foreground to the horizon line. In these later works, as Durand suggested in his "Letters," nature spoke through the artist (and almost overturned the artist's desire for rational compositional order). These works were among the most selfless in a generation of landscapists for whom selflessness was an ideal—not only in the sense of suppressing brush strokes and insisting on smooth surfaces, but in permitting the look, touch, and feel of nature to take possession of a painting.

74. Asher B. Durand, *Study of Wood Interior*, c. 1850. Addison Gallery of American Art.

Because of his position as president of the National Academy of Design, Durand must have been aware of new currents and attitudes affecting American art. His change of style in the mid-1840s, as well as changes and developments in the styles of other artists, owes something to the writings of John Ruskin, the popularity of the Düsseldorf School, the introduction of daguerreotypes into America in 1839, and possibly the Transcendentalism of Emerson and others.

The first volume of Ruskin's *Modern Painters,* published in England in 1843 and in America in 1847, was especially important because it reenforced certain tendencies in American art. Ruskin argued for great truth to nature rather than for using artificial compositional formulas. He condemned Claude Lorrain, for instance, for calling attention to art rather than to nature and for painting general rather than particular truths about a given locale. Ruskin wanted reliance on the sensibility of each individual rather than on formulas, and he wanted a landscape painting to state something about the past and future of a scene, what it had been and would become, in a single season or over a period of years. Ruskin also associated art with religion and moral uplift, stating: that "art is greatest which conveys to the mind of the spectator, by any means whatsoever, the greatest number of the greatest ideas." Neither Ruskin nor American painters seemed bothered by the paradox of painting great ideas while observing a strict fidelity to nature's forms. Perhaps Durand tried to fuse these contradictory notions in his paintings of the 1850s, such as *The First Harvest,* and certainly Frederic Church triumphantly suggested great ideas, even though he painted with extreme precision (see below).

During the 1840s and 1850s, several American artists—Emanuel Leutze, Robert Woodville, Eastman Johnson, and Albert Bierstadt—studied in Düsseldorf, at the Academy and with artists who lived there. In addition, the art of that city grew especially popular in America when John G. Boker opened the Düsseldorf Gallery in New York City in 1849. The gallery collection was sold in 1857, but until its final dispersal in 1862, it served as a continuing exhibition of Düsseldorf art, available to the public and artists alike. Although a surprising variety of styles can be associated with Düsseldorf, the basic "Düsseldorf style" was characterized by a concern for virtuoso detail, accurate drawing, elaborate finish, and easily understood subject matter. In its day, the Düsseldorf style offered American artists a European pictorial model without eliminating a democratic content.

The connections between the Hudson River School and Transcendentalism are not entirely known, and are probably minimal at best. Most historians associate the Luminists with Emerson and his circle, but even that relationship is one of parallel developments rather than of direct influence. But we might say that Transcendentalism, which commenced as a literary and philosophical movement in New England in the late 1830s, held (or hoped) that the individual could transcend material reality and identify himself directly with a universal spirit, that a close correlation existed between what the eye saw and the soul felt. The Transcendentalists wanted to reunite man with nature, to feel the forces of nature

within man's being, and to experience the presence of the Deity both in nature and in man. Since Durand painted nature more directly after 1850, he and others might have sought to understand it in a manner similar to that of the Transcendentalists, but with this difference. Durand was probably less involved with experiencing the Deity *in* nature than in finding nature an example of God's handiwork.

Photography certainly contributed to the growing attention to detail in painting during the 1840s and 1850s. Some artists, such as Robert S. Duncanson and Worthington Whittredge, worked for a time as daguerreotypists and were undoubtedly affected by the precise rendering of forms and tones of photographs. As many as three million daguerreotypes were produced each year during the mid-1850s and, by the end of the decade, other processes of film duplication brought photography to virtually everybody's attention. As a result, its properties reenforced the ideas and styles artists found in Ruskin and in the Düsseldorf School.

Despite the many influences on American landscapists, a surprisingly homogeneous style developed through the 1830s, 1840s, and 1850s. Equally surprising was the number of paintings of high quality that were produced, despite the varying backgrounds and experience of the artists. Most followed Durand's manner rather than Cole's, but we can find in their work several additional factors that broaden our understanding of the Hudson River School. Of the many artists who might be included here, perhaps three are most useful to consider—Jasper Cropsey (1823–1900), Robert S. Duncanson (1821–72), and Worthington Whittredge (1820–1910).

Cropsey is particularly interesting because he was among the very few to combine successfully the tumultuous elements of Cole's style with the more

75. Jasper Cropsey, *Autumn on the Hudson River*, 1860. National Gallery of Art.

76. Jasper Cropsey, *Starrucca Viaduct, Pennsylvania,* 1865. The Toledo Museum of Art.

lyrical aspects of Durand's. In addition, like Cole he used landscape as a vehicle for presenting literary and religious subjects. During the 1850s, for example, he painted allegorical works (*Spirit of Peace* and *Spirit of War,* both 1851), and in 1855 he intended to paint a five-part series based on John Bunyan's *Pilgrim's Progress.* Works of this type link Cropsey, as well as Cole and others, with a host of figure painters such as Daniel Huntington (see below), who painted scenes of similar moral and allegorical intent, but without such vast landscape settings.

Fidelity to nature underlay Cropsey's works, a point emphasized in the artist's essay "Natural Art," written for the American Art Union in 1845, and in his article "Up Among the Clouds," published in *The Crayon* in 1855. Whether in intimate scenes or in the panoramic-scaled works he favored in the 1860s, he made special efforts to emphasize topographical features and to delineate clearly trees and other plants. He especially liked the autumn season and channeled his evident love of color into high-keyed studies of mountains, valleys, and river banks awash with reds, yellows, and oranges [75].

In *Starrucca Viaduct,* Cropsey brought together images of wilderness and technology, of innocence and despoilment [76]. Unlike Cole, he seemed undisturbed by the presence of the railroad in nature. He placed the graceful viaduct in the middle distance and incorporated its forms into the swelling and rounded contours of the countryside, evidently agreeing with several public figures, including Thomas Jefferson and Ralph Waldo Emerson, that it was possible to have it both ways, to have, in the phrase used by Leo Marx as the title of a book on the subject, "the machine in the garden."

A painting such as *Blue Hole, Flood Water, Little Miami River* by Robert Duncanson is significant for other reasons [77]. Duncanson, a black artist, lived

in Ohio at the time he painted this work and had been supported by the Cincinnati patron Nicholas Longworth. The significance of Duncanson's career lies as much in the artist's race as in the fact that by the 1830s midwestern centers had begun to support artists competent in the latest styles. Landscape paintings such as *Blue Hole,* despite the flood waters, also demonstrated to both eastern and midwestern audiences that the trans-Appalachian states had become as safe, settled, and domesticated as eastern ones, and that the midwestern wilderness could also be considered a visitor's paradise. A work like this really celebrates the results of Manifest Destiny.

Most midwestern artists left the area for long stretches of time and some abandoned it altogether. Duncanson traveled through the northeastern states in the late 1840s and visited Europe in 1853–54, but returned to Ohio. Worthington Whittredge, on the other hand, left Cincinnati in 1849, studied in Düsseldorf until 1855, returned to America in 1859, and settled in New York City. Like artists of the previous generation, he had some problems readjusting to America, but his were primarily ones of altering his style rather than his basic outlook. He spent several months, as he wrote in his autobiography, reacquainting himself with the primitive and cluttered American wilderness, which was so unlike the more populated and "clean" European forests. After a false start, he succeeded in suggesting the qualities of the American landscape in *The Old Hunting Grounds* [78]. In the mid-1860s he added Luminist elements, probably through his friendship with Sanford Gifford, a major Luminist painter, and in the 1870s a brushy Barbizon-inspired manner characterized several works. As with other contempo-

77. Robert Duncanson, *Blue Hole, Flood Water, Little Miami River,* 1851. Cincinnati Art Museum.

78. Worthington Whittredge, *The Old Hunting Grounds,* 1864. Reynolda House, Winston-Salem.

rary artists who spent several years abroad and who were neither overly nationalist nor internationalist, we can observe the fluctuations between European and locally developed styles and the differing ways Worthington responded to American subjects, whether eastern scenes or those of the West, to which he traveled in 1870 and again in 1877.

Frederick E. Church (1826–1900), perhaps the most famous American painter of the 1850s and 1860s, was one of the very few to develop a personal style and point of view beyond those of Cole and Durand. One of Cole's two pupils, he combined his master's intense and broad outlook with Durand's celebration of nature. But Church's vision extended beyond America to celebrate the entire earth and, to the nineteenth-century mind, the immanence of God everywhere. In pursuit of his aims, he traveled twice to South America, in 1853 and 1857, to Newfoundland and Labrador in 1859, to Europe and the Middle East from 1867 to 1869, and to Mexico several times after 1883.

In Church's *Andes of Ecuador* (1855, Reynolda House, Winston-Salem), his first mature painting, his peculiar ability to combine intricate detail with the palpable quality of light is already evident; it gives his paintings a unique vibrancy, as if space actively eats into and surrounds each form with an aureole of air [79]. Church accomplished this technical feat in part by using newly available cadmium colors, by subtly softening the edges of forms so that the painted surface of the canvas appears more like a continuous skin than as a sequence of outlined objects, and by adjusting atmospheric perspective with brilliant sensitivity so that objects in the middle distance do not interrupt the steady concave roll of space along the ground cover to the far horizon line and back along the colors of the sky to the top of the picture.

Twilight in the Wilderness, which Church painted after fifteen years of

experiments with dawn and dusk scenes, is among his best works, not only for its incisive glimpse of the American wilderness, but for its implicit religiosity [80]. Never before and probably never since has the American wilderness been so successfully depicted in all its various levels of meaning—topographical, nationalistic, religious. Yet, this work was for its time already a wishful demonstration of faith in America rather than an accurate symbol of the American present. It comes as a shock to realize that *Twilight in the Wilderness* was painted during an increasingly turbulent age. The divisions between northern and southern interests over slavery, the possibility of disunion through secession, the northern reaction to the fugitive slave laws (about which Emerson raged in his journals), the Kansas-Nebraska Act of 1854, which helped bring about the conditions that created "bleeding Kansas," raised desperately serious questions about the purposes, aims, and ideals of the nation. Politicians and clergymen in speech after speech and sermon after sermon reaffirmed their belief in America's goals and aspirations at this time. Church added his voice of reassurance by painting this and other comforting images—the radiance of the New England landscape; the energy and force of Niagara Falls. symbol of the nation's strength and hopefully still pristine character; and the South American scenes bursting with natural and religious life-sustaining imagery.

Contemporary religious figures undoubtedly contributed to Church's positive outlook (so unlike Cole's), but at least two secular thinkers fired his imagination to paint the grandiose visions no other American artist was able to realize so completely. The first was the German scientist Alexander von Humboldt, whose encyclopedic *Kosmos* was published in the late 1840s. Von Humboldt tried to synthesize and coordinate scientific knowledge of the period, but, more important for our purposes, he indicated that art would flourish brilliantly when paint-

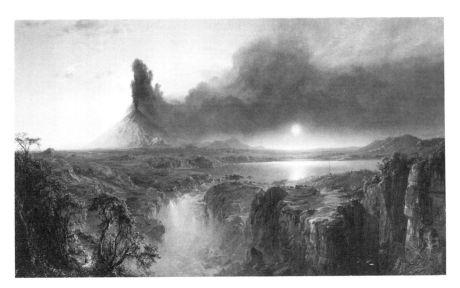

79. Frederick Church, *Cotopaxi, Ecuador,* 1863. The Reading Public Museum and Art Gallery.

80. Frederick Church, *Twilight in the Wilderness*, 1860. The Cleveland Museum of Art.

81. Fitz Hugh Lane, *Brace's Rock, Eastern Point, Gloucester,* c. 1864. Private collection.

82. Fitz Hugh Lane, *Owl's Head, Penobscot Bay, Maine,* c. 1862. Museum of Fine Arts, Boston.

83. Fitz Hugh Lane, *Ships in the Ice off Ten Pound Island, Gloucester,* c. 1850–60. Museum of Fine Arts, Boston.

ers found the most varied and luxurious forms of nature. These, according to von Humboldt, were in the Andes and the Amazon regions of South America. He also suggested that a good physical environment was important to the development of a culture. Although this theory was known in America at least since the late eighteenth century, it especially appealed to mid-nineteenth-century Americans,

84. John Frederick Kensett, *View from Cozzens Hotel, near West Point,* 1863. The New-York Historical Society.

85. Martin Johnson Heade, *Thunderstorm over Narragansett Bay,* 1868. Amon Carter Museum.

either as an affirmation of their country's glittering future or as reassurance in face of rising sectional and economic strife. The second figure was John Ruskin, whose *Modern Painters* Church probably read between 1853 and 1857 (between his two trips to South America). Also Church's style of painting probably owes something to Ruskin, since it was probably in the pages of *Modern Painters* that Church read about Joseph A.M. Turner, whose diaphanous veils of color he adapted to his own purposes.

During the 1850s, several other painters began to study the properties of light, but in a less personally charged manner than Church. Called Luminists, they have been grouped together by modern art historians, most notably John I.H. Baur and Barbara Novak. The principal figures—Fitz Hugh Lane (1804–65), John Frederick Kensett (1816–72), Martin Johnson Heade (1819–1904), and Sanford Robinson Gifford (1823–80)—either knew each other personally or were probably familiar with each other's work, but they did not knowingly form a group or adopt a collective point of view. Rather, their art shared certain stylistic features and, presumably, a related aesthetic content [81–87].

Lane, the oldest of the four, was also the first to make a Luminist painting —*Twilight on the Kennebec* (1849, private collection). From Gloucester, Massachusetts, he was trained as a commercial lithographer before he turned to oil painting about 1842. Kensett, who came from Connecticut, was an engraver before he turned to painting in the late 1830s. He accompanied Durand to Europe in 1840 and remained there until 1847. His painting style resembled Durand's until roughly 1856, when he began to paint Luminist works such as *Beacon Rock, Newport Harbor* (1857, National Gallery of Art, Washington, D.C.). Heade, from Lumberville, Pennsylvania, was the most complex artist of the group. He painted

86. Martin Johnson Heade, *Haystacks on the Newburyport Marshes,* 1861. Walters Art Gallery.

both landscapes and still lifes, perhaps the only important mid-nineteenth-century painter to do so. He was a peripatetic traveler and made several trips to South America. His earliest Luminist paintings date from the late 1850s. His most popular works, the seacoast marsh scenes, first appeared in 1861 [86]. Friendly with Church in New York City, where they both lived for periods of time, Heade might also have met Lane, about 1860. At least, Heade and Lane painted similar themes at that time—stormy seaside views and beached boats. Gifford, from Greenfield, New York, traveled in Europe from 1855 to 1857 and again in 1868–69. His Luminist works, which date from the 1860s, are different from those of the other artists because of his more emotional handling of atmospheric color and more vigorous manipulation of textures [87]. We might place him on a

87. Sanford Robinson Gifford, *Mount Mansfield, Vermont,* 1859. National Academy of Design.

stylistic scale between Church on the one hand and Lane-Kensett-Heade on the other.

Luminism draws, of course, on the attitudes and styles of the Hudson River School, but narrows its focus to quiet, contemplative waterside views in place of elaborate mountain and valley scenes. Its great concern for detail links it to topographical modes both in America and abroad, particularly to those of the Dutch masters of the seventeenth century and their English followers. In regard to Lane, the influence of the English topographical seascapist Robert Salmon (1775–c. 1848/51), who lived in Boston between 1828 and 1842, is especially important. And perhaps Church's art, so different in other respects, contributed to Luminism the concern for open-ended compositions (no framing trees), an interest in sunset scenes, and the use of visible atmospheric colors—golden yellow and blue—to suggest the palpability of light.

A typical Luminist work shows an eastern coastal scene long since domesticated and settled [82, 86]. The foreground leads easily to an expanse of water and then to a relatively low horizon line. Although internal framing devices are generally absent, precise atmospheric effects and horizontal banding indicate measured recessions into space. However, middle distances are usually stronger in intensity and the far distances weaker than they should be, thus pulling one's eyes quickly into deep space. Instead of having a continuous weakening of color and tone intensity from foreground to middle ground to far distance on a scale of 1, 2, 3, a Luminist painting recedes on a scale of 1, 1 ½, 4. There is minimal overlapping or superimposition of forms. Directional movements within a painting do not often link the various parts and shapes into a tight compositional entity. As a result, forms might appear isolated from each other structurally, but are tied coloristically because of the golden glow or blue tonality that might play over them. Brush strokes and the marks of an artist's individual temperament are hidden and repressed to an extent even greater than that suggested or envisioned by Durand in his "Letters."

Luminist subject matter is of the type that Cole would have enjoyed—people seemingly living in accord with the laws of nature, attending to their business in a rural atmosphere, respecting the environment and not taking from nature more than they are able to return to it. When humans appear, they are small in scale. If they labor, their activities are not emphasized, nor do they interfere with the pervading calm. Even port scenes show an ideal of commerce—individual workers or small groups of people laboring without frenetic intensity or activity. No sense of physicality and noise is imparted to the viewer. The occasional impending storms and beached boats of Lane and Heade, sometimes considered symptomatic of the agonies of the Civil War, might indicate little more than the insertion of an impersonal reality into an otherwise idyllic world. But even these scenes, painted in a century committed to action and progress, are remarkably static, perhaps in desperate reaffirmation of the American myth of escaping the cycles of civilizations. Nor should we overlook more sinister interpretations. Individuals rarely relate to each other in any meaningful way in Luminist works. Perhaps they unwittingly reflect Alexis de Tocqueville's interesting observation in his

Democracy in America (1835) that democracy is capable of breaking links among people, causing them to be thrown back upon themselves, alone and in isolation. Although direct connections between Luminism and Transcendentalism have not been clarified yet, the two movements have been associated with each other. Transcendentalist writers often stated that the spirit of the Divine seemed present in physical matter, and Luminist painters seemed to suggest a similar feeling because of the clarity of focus and sense of light that pervaded their paintings. In addition, one senses both in the literature and in the paintings a yearning to lose one's self in the Divine or to submerge one's personality in the Divine. Orestes A. Brownson succinctly wrote in 1836 in his *New Views of Christianity, Society, and the Church,* "we are to reconcile spirit and matter." In the paintings, we see the hand and personality of the artist virtually disappear as we concentrate on the landscape, hopefully sensing the presence of the Divinity in the crystal-clear atmosphere.

However, linking Luminism with Transcendentalism and especially with the writings of Ralph Waldo Emerson raises several unresolved problems. First, one can contemplate the Divine in nature passively or actively, let the Divine sweep over you or purposefully seek it out. The paintings suggest a passive acquiescence, but Emerson sought the Divine very actively. Second, Emerson wrote about the constant motion of the universe, but Luminist paintings appear to be quite static. In any event, even if we do not yet fully understand the parallels between the two movements, connections do exist.

GENRE AND NARRATIVE PAINTING

A similar ambiguous relationship exists between Emerson and contemporary genre painters. Art historians have equated Emerson's call for celebrations of the common, the familiar, and the typical in his Phi Beta Kappa address of 1837 and again in his essay, "The Poet," of 1844, with an interest in realism, when in fact Emerson was less concerned with the American scene in its own right than with its poetical and spiritual correspondences, its universal signs, and its intimations of and connections to the Universal Spirit. American genre painting, by contrast, was resolutely of this world, and its messages, if any, were moral and civil rather than mystical and esoteric. The audience was neither philosophically inclined nor overly intellectual. Genre painters sought instead the idealization of the real, as Durand described in his "Letters."

During the 1830s, when both literary and anecdotal genre painting was growing in popularity, virtue was the hidden message of many paintings, and agrarian life was equated with innocence. Some artists, such as William Sidney Mount, gently sermonized in paint. Most preferred to record typical situations rather than explore individual character. Hardly any artist considered exploring the underside of the American character. An artist such as the politically radical Gustave Courbet is unthinkable in nineteenth-century America, since virtually all genre painters, like the landscapists, wanted to feel a part of the fabric of society.

Annual illustrated gift books, filled with stories and poems, provided one

important outlet for genre painters. The first one appeared in England in 1823. The idea caught on in America and within a few years gift books were being printed in the larger eastern cities: *The Atlantic Souvenir* in Philadelphia from 1826 to 1832, which then merged with *The Token* of Boston, lasting until 1842; *The Talisman* in New York City from 1828 to 1830; and *The Gift* from 1836 to 1846, an especially good outlet for genre illustrations, also in New York. By 1857, however, the vogue for gift books was over.

The American Art Union, with its membership cutting across social and economic lines in all states, supported genre painting to an even greater extent. The distribution of an engraving of Mount's *Farmers Nooning* (1836) to its members in 1843 encouraged artists to create typically American images understandable to both sophisticated and unsophisticated tastes [89]. But at the same time, the Union wanted to refine the nation's artistic interests. As the decade progressed, the Union increasingly recommended to artists that anecdotal painting would benefit by the inclusion of historical and literary themes and that painters would profit from European study, especially in Düsseldorf. In effect, the Union supported a democratic art, but at the same time encouraged an increasingly refined vision of American scene painting. As a result, we might say that rustic scenes, the kind considered typical of American genre painting, flourished most energetically during the 1840s and that in the following decade a greater degree of artifice became apparent.

Genre painting derived from literary themes could be found in the 1820s, however. As part of the rising nationalism of the period, several artists turned to the new American literature for thematic material. Beginning at least as early as 1822, several artists, such as Charles Bird King (1785–1862), John Quidor (1801–81), Henry Inman (1803–46), and later Charles Loring Elliott (1812–68), George Loring Brown (1814–89), and Albertus De Orient Browere (1814–87), found subject matter in the writings of Washington Irving and James Fenimore Cooper, the two most popular authors among the painters. (The artists also found themes from European writers, such as Cervantes and Sir Walter Scott.) Irving's imaginary folk tales of the Hudson River area proved especially adaptable, particularly the adventures of Rip Van Winkle and Ichabod Crane. Inman, a landscapist and a portraitist, was the first to illustrate both authors—a set of illustrations from Cooper's work in 1822 for *The Port Folio,* a Philadelphia magazine, and a painting of Rip Van Winkle in 1823.

Of all these paintings and illustrations, Quidor's work is the most interesting in both interpretation and style. Quidor, who came from Tappan in the Hudson River valley, was apprenticed to John Wesley Jarvis from about 1814 to 1822. He painted portraits before turning to subjects from Irving's tales in 1827. Of his approximately thirty known paintings, about twenty are based on Irving and date from 1827 to 1839 and from about 1855 to 1868. Quidor's stylistic sources included English caricaturists and the works of the Dutch Little Masters, but his exaggerated and baroque-like figures are distinctive and easily recognizable. Whether he worked with thickened pigment, in his early years, or used thin glazes, after 1835, his style lent itself well to his preferences for those passages

88. John Quidor, *The Return of Rip Van Winkle*, 1829. National Gallery of Art.

that emphasize terror, shock, or conflict. His *The Return of Rip Van Winkle* [88] illustrates that moment in the story when Rip, seeing his younger alter ego leaning against a tree, grows confused by his twenty-year absence. In showing Rip's discomfort, Quidor also insinuates into the postures and attitudes of his questioners Irving's pointed criticism of the new American society and its "busy, bustling, disputatious tone."

William Sidney Mount (1807–68), the major anecdotal genre painter of the period, had a gentler touch. After a false start as an artist in the grand manner, he turned to genre with his *Rustic Dance After a Sleigh Ride* (1830, Museum of Fine Arts, Boston), based on Krimmel's *Dance in a Country Tavern* (known only by lithographic copy). For the next two decades, he and the artists he influenced, including James G. Clonney and Francis W. Edmonds, made rustic genre one of the most popular categories within the larger field of genre painting. Unlike his followers, however, Mount often added a moral lesson to his paintings, concerning the virtues of hard work or of temperance or of restraint from gambling. But he rarely, if ever, became as sentimental as such younger mid-century figures as Tompkins H. Matteson (1813–84) and Lilly Martin Spencer (1822–1902).

Mount's *Farmers Nooning,* in which the youth at the left sharpens his scythe during a rest period while the scythe of time hangs over his head, is a not-so-subtle allegory on the benefits of hard work and making one's way in the world before

89. William Sidney Mount, *Farmers Nooning*, 1836. The Museums at Stony Brook.

it is too late [89]. This work also contains the figure of a black man, an image Mount painted perhaps more often than other white painters before Civil War. Although he wrote in his journals of his sympathy for the indolence and carefree life that the black man seems to represent, he also questioned the abolition of slavery. In this painting, the young boy who wears a Tam o' Shanter, a symbol of the abolitionist cause, tickles the black man's ear which, in the slang of the day, meant filling the man's ear with irresponsible talk about freedom. In another painting based on an episode in Mount's personal life, *Eel Spearing at Setauket* (1845, New York State Historical Associations, Cooperstown), he could not escape the pervading racist climate in that he replaced the black man from whom he learned eel spearing with the much less challenging figure of a black woman.

Although Mount wrote of his delight in painting from nature and of his desire to be free of European styles, he studied the old masters through engravings, instruction books, and plaster casts. After 1837, his style changed subtly in the direction of slicker surfaces and tidier compositions, indicating his concern for greater refinement of style, his protestations to the contrary. Regardless of what he wrote, he was always interested in capturing precise effects of color and atmospheric space. His interest in proper spatial placement of figures was also always evident, especially in his numerous paintings in which figures stand or sit on either side of open barn doors [90].

90. William Sidney Mount, *Dance of the Haymakers,* or *Music Is Contagious,* 1845. The Museums at Stony Brook.

Among the other New York-based painters of rustic genre scenes, Francis William Edmonds (1806–63) was also greatly concerned with the delineation of architectural interiors, perhaps more for the possibilities of design they offered than for the spatial problems involved [91]. Several of his works, like those of Edward Hopper in the twentieth century, might almost be read as abstract paintings into which people have been inserted. A banker as well as an artist, Edmonds studied at the National Academy of Design as early as 1826, but developed his mature style—tighter and drier than Mount's—during the following decade.

English-born James Goodwyn Clonney (1812–67) borrowed motifs from Mount as well as from Mount's sources—Krimmel and the English genre painter Sir David Wilkie. Clonney turned to genre painting about 1840, after a ten-year career as a lithographer and miniaturist. Many of his works, in contrast to Edmonds's, show figures placed in outdoor settings [92]. The persons rarely labor, and if they show emotion it is usually one of pleasure. Whether by preference or because of lack of extensive training, Clonney left his paintings remarkably uncluttered. Detail is minimal, and usually just one or two figures are placed parallel to the picture's surface. Although few of Clonney's later works are

known, these suggest that his style and handling of themes grew more sophisticated, in keeping with the wishes of the American Art Union.

The paintings of Richard Caton Woodville (1825–55) especially reflect the shift to more refined styles and themes in the 1850s, although he largely refrained from using literary sources. He spent the last ten years of his short life abroad —in Düsseldorf from 1845 to 1851 and in France and England for the next four years. His explorations of specific American traits are less penetrating than Mount's, but Woodville's technique is more competent in the handling of detail and manipulation of light and shadow. His figures are more obviously posed, their characters more varied, and, in comparison to those of the rustic genrists, better dressed [93]. Compared to Clonney's contemporary newspaper readers, as well as to those by Mount (*California News,* 1850, Suffolk Museum and Carriage House, Stony Brook, New York), or to those of Arthur Fitzwilliam Tait (*Arguing the Point, Settling the Presidency,* 1854, Norton Art Gallery, Shreveport, Louisiana), Woodville's figures come from a higher social class.

But whether fashionably dressed or in work clothes, whether urban or rural, whether at work or at rest, virtually all of these figures indicate that the American dream was flourishing. With gentle reminders and with touches of humor, the artists made problems vanish or, rather, never appear. From the record of these paintings, it would seem that everybody in America enjoyed his place in society, that nobody labored under hardship, and that nothing equaled the rural life for inner peace or communal contentment. Logic and the facts show that this was not a truthful picture of American life, that even then Americans wanted to believe that things had been simpler at an earlier time and that a rural childhood

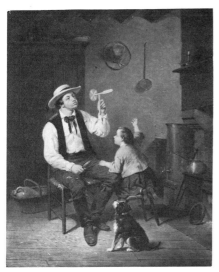

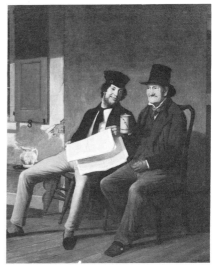

91. Francis William Edmonds, *The Windmill,* c. 1858. The New-York Historical Society.

92. James Goodwyn Clonney, *Mexican News,* 1847. Munson-Williams-Proctor Institute.

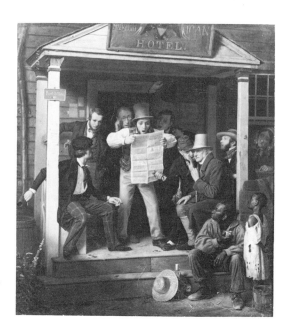

93. Richard Caton Woodville,
*Reading the News (War News
from Mexico)*, 1848. National
Academy of Design.

was the best childhood one could have. At least one artist cut through this visual pap by exploring the underside of urban existence and by showing that the American dream did not work for everybody. This was David Gilmor Blythe (1815–65), whose images of degradation and deprivation were not seen again until the turn-of-the-century photographs by Jacob Riis.

Born in Ohio, Blythe spent his young adult years as a portraitist and a failed panoramist. About 1852, he turned to genre painting and by the time he settled in Pittsburgh in 1856 his thematic interests had turned to a sardonic examination of the world about him. Pittsburgh, then probably the filthiest city in the country because of its heavy industry, was afflicted with severe labor problems, unemployment, a growing immigrant population, and totally inadequate social, health, and educational services. It was a prototype of the modern city, with few of the conveniences or amenities of such a city. Blythe recorded its effects on children, on working-class adults, and on those who were presumably responsible for maintaining some degree of civility and respect for the law.

In developing his fluent and complex style of portraying overly fleshy, boneless children and seemingly deranged adults, he looked to the works of artists such as David Teniers, the Dutch seventeenth-century artist, Sir David Wilkie, Durand, and Edmonds. Blythe's paintings of street urchins, which date mostly between 1854 and 1860 [94], obviously show a grittier side to life than that preferred by other urban-scene painters, such as the currently popular Thomas Le Clear (1818–82) [95]. Blythe also pilloried lawyers for subverting the law and the court system for corrupting justice [96]. His version of a trial scene, populated by card players, loutish people, and a defendant in leg irons, contrasts radically

with the obvious celebration of justice seen in Tompkins H. Matteson's *Justice's Court in the Backwoods* **[97]**.

Life was not necessarily easier in the Far West, but it offered respite from the world Blythe portrayed, for either newly arriving settlers or armchair travelers. Domestication of the trans-Mississippi region occurred rapidly. The Louisiana Purchase took place in 1803. All important trails to the Far West were opened by 1832. The first important emigrant party reached California by 1841 and, between 1850 and 1900, the area's Euro-American population jumped from 2 million to 20.6 million. The West became a national obsession through the middle decades of the century. Dozens of books were published about it, and almost every issue of the major magazines carried factual articles or imaginary tales about the characteristics of the landscape, the new settlements, the frontier, or the Indians. Especially during the 1850s and 1860s, when reports were published about the government-sponsored expeditions seeking the best transcontinental railroad routes, the West played a considerable role in the national imagination.

Several kinds of artists explored the West. Beginning in 1819, some, such as Titian Ramsay Peale (1799–1885), accompanied official expeditions and recorded plant, animal, and Indian life in scientific fashion. Others, both American and European, such as George Catlin and Karl Bodmer (1809–93), concentrated on painting Indian scenes. Still others, such as George Caleb Bingham, lived in the West and described life in frontier and established communities. Many, such as William Ranney, visited the West on occasion, but painted scenes in their eastern

94. David Gilmour Blythe, *Street Urchins,* 1856–58. The Butler Institute of American Art.

95. Thomas Le Clear, *Buffalo Newsboy,* 1853. Oil on canvas, 24″ × 20″. Albright-Knox Art Gallery.

96. David Gilmour Blythe, *Trial Scene*, 1860–63. Memorial Art Gallery of the University of Rochester.

97. Tompkins H. Matteson, *Justice's Court in the Backwoods*, 1852. New York State Historical Association.

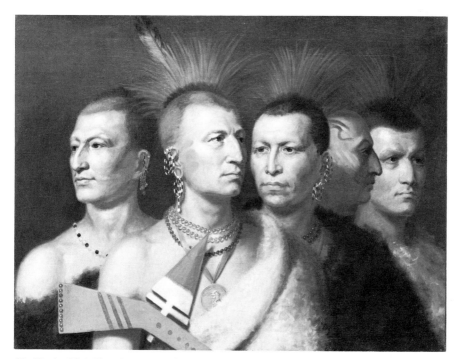

98. Charles Bird King, *Young Omahan, War Eagle, Little Missouri, and Pawnees,* 1821. National Museum of American Art.

studios. Taken altogether, the works of these artists range from accurate documentation to exploitation of eastern fantasies about the West.

The native American had been painted by artists from the period of the earliest European explorations. Colonial artists, such as Gustavus Hesselius, included Indians in their portraits. The number of artists who depicted Indians increased about the turn of the century and included Charles Willson Peale, Charles Févret de Saint-Mémin, and Alvan Fisher. Charles Bird King (1785–1862) painted about 143 portraits of Indian visitors to the nation's capital between 1822 and 1842 **[98]**. Unfortunately, many of his Indian paintings, as well as those of John Mix Stanley, housed in a specially designed Gallery of Art in the Smithsonian Institution, were burned in a disastrous fire early in 1865. But most of King's portraits had been copied by Henry Inman for lithographic reproduction in *The Indian Tribes of North America* by Thomas L. McKenney and James Hall (1837–44), so this valuable record has not been entirely lost to us.

Beginning in 1819, artists began traveling to the West as part of official and private exploratory groups or as individuals working alone. Subject matter initially tended to be documentary—what the Indians and their settlements looked like, how they lived, how they hunted. Melodramatic confrontations between Indians and whites began to be painted more commonly in the middle of the century, and then very frequently later on, when the Indians were caught in the juggernaut vise between settlers and mining interests. (About 940 of the recorded 1240 Army-Indian battles occurred after the Civil War.)

99. George Catlin, *The Last Race, Part of Okipa Ceremony,* 1832. Museum of American Art.

100. Alfred J. Miller, *Trapping Beaver,* 1858–60. Walters Art Gallery.

George Catlin (1796–1872) was the most important of the early painters of Indians. From Pennsylvania, he had become both a lawyer and an artist by 1821. After seeing Indians visiting the Peale Museum in Philadelphia in 1824, he decided to devote his life to recording their customs and habits. He traveled in the West from 1830 to 1836, toured the United States with his Indian Gallery until 1839, and then went abroad, where he spent most of his life. He painted the natives of South America from 1853 to 1858 but died before his important collection finally entered the Smithsonian Institution in 1879.

In Catlin's day, two main attitudes prevailed about Indians, neither one recognizing them as human beings. They were either considered noble savages living in a state of harmony with nature or, in the more popular attitude, they were considered vermin to be eliminated before the advance of a superior civilization that would cultivate the land and make it bountiful. Catlin, like others, held both views simultaneously. He wanted to rescue from certain oblivion a "truly lofty and noble race," he wrote in his *Letters and Notes on the Manners, Customs and Conditions of the North American Indians* (London, 1841), but he also mentioned at the same time that the soil of the Missouri River valley was "rich and capable of making one of the most beautiful and productive countries of the world." His compromise solution was to herd the Indians into a national park somewhere in the West, where they could live in a state of nature in perpetuity. (In fact, few Indians remained east of the Mississippi River after 1845.)

It is to his credit that Catlin captured several aspects of Indian civilization, including rites and ceremonies, before contact with whites either decimated entire tribes or altered their customs [99]. The Mandans of the upper Missouri River valley, for example, were almost wiped out in a smallpox epidemic in 1837. Catlin's approximately six hundred paintings, many completed under arduous and hazardous conditions, reveal that he documented the most thoroughly and perhaps understood better than any other artist the cultures of the Plains Indians.

Alfred Jacob Miller (1810–74) toured the West in 1837, one year after Catlin left the region. Miller, a native of Baltimore who had traveled in Europe in 1833–34, probably would have remained a portraitist had he not met William Drummond Stewart in New Orleans. Drummond, a Scot, enjoyed touring the farther reaches of the West, and together they visited the territory through which the Oregon Trail passed. There, Miller became one of the very few to sketch the rugged mountain men, the legendary fur trappers who flourished between the 1820s and the 1840s [100]. From his approximately two hundred sketches, he made about six hundred paintings over the next few decades in an exuberant, impressionistic manner emphasizing anecdote rather than documentation.

John Mix Stanley (1814–72), from New York State, toured the upper Mississippi River valley in 1839, a favorite area for visitors at the time. During repeated trips to the West, Stanley joined the Stephen Watts Kearny expedition to California in 1846, as well as one of the governmental railroad survey teams in 1853. His work, most of it destroyed with Charles Bird King's paintings in the Smithsonian Institution fire in 1865, was great in scope and variety, and included

101. John Mix Stanley, *Prairie Indian Encampment,* n. d. The Detroit Institute of Arts.

panoramic views of plains and mountains, as well as intimate studies of Indian settlements [101]. Like other artists, he was also a photographer. Together with his paintings, his photographs form a rare and authentic record of the West before it was acquired by the United States.

Among the artists who traveled to the West, several concentrated on the activities of white men—the trappers, hunters, and sportsmen. These include William Ranney (1813–57), Charles Deas (1818–67), and Arthur Fitzwilliam Tait (1819–57). Unlike the eastern landscapists, who would often place a sedentary thinker before a spectacular view, these artists portrayed the westerner as a person of action and of violence, a person not entirely cultured or civilized. At the same time, their westerner could also be a primitive type of entrepreneur, shooting game or trapping animals for a living [102 and 103]. Their paintings provided factual information, but also catered to eastern fantasies of life in the West.

Ranney served in the army of the Republic of Texas in 1836. Deas, who painted scenes of greatest danger, lived in and around St. Louis from 1841 to 1847. Tait, several of whose works were lithographed by the firm of Currier and Ives, never traveled farther west than the Adirondacks of New York State.

George Caleb Bingham (1811–79) was the most important genre painter of the West during this period. A portraitist early in his career, he turned to genre in 1838 after studying briefly in Philadelphia that year. Perhaps Mount's work prompted him to explore western themes, but Bingham's desire to become, as he indicated, a historian of his time, was strengthened by his own great interest in

102. Charles Deas, *The Voyageurs,* 1846. Museum of Fine Arts, Boston.

103. William T. Ranney. *A Trapper Crossing the Mountains,* c. 1853. Anschutz Collection.

104. George Caleb Bingham, *Raftsmen Playing Cards,* 1847. The St. Louis Art Museum.

the give-and-take of daily life. Rather than retreat into his studio, he became a politician. He ran unsuccessfully for public office in 1846, was elected to the Missouri legislature in 1848, and became State Treasurer in the early 1860s.

More than the other painters of western themes, Bingham preferred to capture characteristic moments, activities, and traits of the settlers and townspeople rather than focus on individual anecdotes and momentary confrontations between whites and Indians, hunters and wild animals, or canoeists and white water streams. For example, from his several paintings of Mississippi River raftsmen, completed between 1846 and 1857, we begin to understand, as Mark Twain intimated in his novel *Huckleberry Finn* (1884), the attractions of working on the river, of the pleasures of river life, suggested by the inward-turning raftsmen who ignore the scenery, and, by contrast, the drudgery of labor elsewhere [104]. And from Bingham's series of paintings of election scenes, we learn about the desire for democratic procedures, but also of the violations of those procedures, from the postures of drunken and perhaps bribed voters [105]. The compositions of these scenes, with their large buildings to one side and their open spaces to the other, seem to be visual metaphors for the controlled chaos of western democratic processes. With his ability to generalize from the specific and to place figures in symbolically appropriate compositions, Bingham suggests archetypal experiences of the western settlement in ways no other genre painter was able to accomplish [106]. No wonder the American Art Union supported him handsomely by purchasing twenty of his paintings between 1845 and 1852. Neverthe-

105. George Caleb Bingham, *The County Election,* 1851–52. The St. Louis Art Museum.

106. George Caleb Bingham, *Daniel Boone Escorting Settlers Through the Cumberland Gap,* 1851–52. Washington University.

107. Daniel Huntington, *Mercy's Dream,*
1841. Pennsylvania Academy of the Fine
Arts.

less, it should not be overlooked that Bingham, perhaps catering to eastern notions of the western agrarian ideal, painted not one of the 230 steamboats then plying the Mississippi River nor in any way suggested that 36,000 people lived in St. Louis in 1845. Yet, Bingham, perhaps acknowledging the explosive growth of western settlement as well as the nationalism engendered by the Mexican War of 1846–48, painted one of the mythic images of Manifest Destiny, *Daniel Boone Escorting Settlers Through the Cumberland Gap* [106]. Presenting the frontiersman as a modern-day Christopher Columbus leading a representative group of travelers as well as an American Holy Family into the Promised Land, he visualized the country's determination to settle the West. In fact, about the mid-century period, several artists explored this theme, some emphasizing the presumed sacred mission of settlement (William S. Smith's *The Promised Land,* 1850, Terra Museum of American Art, Evanston), the bringing of Christianity and civilization to the native Americans (John G. Chapman, *Baptism of Pocahontas at Jamestown, Virginia, 1613, 1840,* Rotunda of the Capitol, Washington, D. C.), or the actual movement of hordes of people (see discussions of Manifest Destiny at the start of this chapter and of Albert Bierstadt in the next).

Bingham lived in Düsseldorf from 1856 to 1859. Unfortunately, he learned there to turn his compositions into sweetened, staged tableaux with posed actors in place of vital, ordinary people. Bingham's somewhat belated turn toward stylistic artifice and refinement in the late 1850s calls attention to the still unclear connections between traditional narrative painting and historic and rustic genre of the period. Although largely forgotten today, several artists continued to paint conventional religious and literary works as well as historical genre scenes derived

from European themes and styles. Some even surpassed in public esteem such artists as Bingham. Their paintings, if based on a literary source, often conveyed a larger historical idea, or, if taken from the life of a famous person, pointed to a moral principle. Reliance on history and literature, including American history and literature, reflected the growing artistic strength of American painters and their increasingly equal relationship with their European counterparts in a way that Bingham's rustic, contemporary "historical" works, however captivating and typically American, could not. In other words, while American artists were encouraged to depict the manners and customs of their new country, there was still the nagging feeling that real quality was to be derived from European models and that one key test of American art was its ability to compete with European art on European terms.

Daniel Huntington (1816–1906) was an artist who met the test. His *Mercy's Dream,* illustrating a passage from John Bunyan's *Pilgrim's Progress,* was among the most popular paintings of the 1840s [107]. It is an ideal (as opposed to realistic) figure painting with religious and moral overtones, and it indicates clearly through its strength of execution the continuing vitality of the tradition of Trumbull and Vanderlyn into the mid-century period. Huntington was so highly respected that he served as president of the National Academy of Design, following Asher B. Durand, from 1862 to 1870 and again from 1877 to 1890.

Robert W. Weir (1803–89), John G. Chapman (1808–89), and Emanuel Leutze (1816–68) also painted narrative works as well as genre scenes. Of all the works by these three artists, the one that most nearly fitted the American ideal of portraying an easily understood scene in an elevated style, and which also had an American subject, was Leutze's wildly popular *Washington Crossing the Dela-*

108. Emanuel Leutze, *Washington Crossing the Delaware,* 1851. The Metropolitan Museum of Art.

ware [108]. This painting marked, as it were, the midpoint between the works of Mount and Bingham at one extreme and those of Huntington at the other. Leutze, who lived in Düsseldorf for most of the years between 1841 and 1859, painted this meticulously detailed work in response to the failed European revolution of 1848 and as part of a cycle of paintings based on the development of liberty in Europe and America. To Europeans, it suggested that America was an island of moral regeneration as well as an ideal for which to strive. For Americans, it triumphantly reasserted the spirit of the Revolutionary War period in a time of growing national crisis. It soon became and still remains the most famous American work ever painted.

STILL-LIFE PAINTING

The public's regard for finely detailed paintings and the artists' desires to provide such works coincided with the revitalized interest in still-life subjects about 1850. American-born artists, such as John F. Francis (1808–86) and George Henry Hall (1825–1913), as well as the Europeans Severin Roesen (active 1848–71) and Paul Lacroix (active 1858–69), turned away from the austerity of the earlier Peale tradition toward opulent botanical arrangements in which the beauty and succulence of each flower or fruit replaced the earlier emphasis on compositional structure [109]. Fruit pieces predominated and, like floral arrangements, the fruits were generally placed on table tops rather than studied in their natural environments. Although glasses and cups might appear half empty, suggesting the presence of humans and the passage of time, each object appears as if in celebration of its ideal form.

In the late 1850s and through the 1860s, the influence of John Ruskin and the more limited interest in the Pre-Raphaelite Brotherhood modified this approach. The Brotherhood, formed in England in 1848, shared with Ruskin a desire to study nature with extraordinary fidelity, a microcosmic intensity of vision, and a willingness to paint humble objects that might otherwise be overlooked by still-life and landscape painters. As a result, increasing numbers of paintings of leaves, birds' nests, and wild flowers appeared in more natural settings than those favored by Francis and Severin. In *Bird's Nest and Flowers* by John William Hill (1812–79) [110], an early Ruskinian still-life painter, the different objects are assembled on the ground rather than on a table top. Although this type of arrangement appeared more spontaneous, it was not until the 1870s that plants were shown growing naturally in their proper environments, and then the influence came more from Charles Darwin than from Ruskin.

William Trost Richards (1833–1905), the most notable landscapist to adopt Pre-Raphaelite techniques, created what might be called still-life landscapes in the late 1850s and 1860s [111]. The author of an article in *The New Path* for November, 1863, an American Pre-Raphaelite journal, might have had Richards in mind when he wrote, "the artist is a telescope—very marvelous in himself, as an instrument. . . . And the best artist is he who has the cleanest lens and so makes you forget every now and then that you are looking through him." This passage

109. Severin Roesen, *Still Life with Fruit*, n. d. Richard York Gallery.

110. John William Hill, *Bird's Nest and (Flowers) Dogroses*, 1867. The New-York Historical Society.

111. William Trost Richards, *In the Woods*, 1860. Bowdoin College Museum of Art.

also reminds us that in whatever form, approach, or aspect, this generation of artists searched for the truth that lay through and beyond reality, and that for many the search included trying to understand the nature of their country as well as the meaning of nature in their country.

SCULPTURE

American sculpture grew into its first maturity in the 1830s, its history repeating several aspects of the history of earlier American painting. That is, young men from remote villages and farms, barely exposed to art of any kind in their youth, turned themselves into sculptors by sheer force of will. A few brashly set up as sculptors with only the most minimal training. Others went abroad, stayed for lengthy periods of time, and followed as well as contributed to ongoing international trends. Still others either remained or returned home, rejecting European developments or at least preferring to explore American themes rather than foreign ones. And, finally, young sculptors, like young painters, found patrons to support and encourage them. (The most important patron was Nicholas Longworth, the Cincinnati businessman who helped Hiram Powers, Henry Kirke Brown, and Shobal Vail Clevenger launch their careers.)

At least two artists, following the example of William Rush, started as

artisans but, in the 1820s, became sculptors. The first was John Frazee (1790–1852), the other, Hezekiah Augur (1791–1858). Frazee, from New Jersey, settled in New York City in 1818, where he carved funerary monuments. By 1824, he had begun to make portraits; his head of John Wells in St. Paul's Chapel (1824), part of a larger funerary piece, was the first marble bust completed by an American. The only sculptor among the founders of the National Academy of Design in 1826, Frazee received several commissions in the 1830s, in part prompted by the success of his bust of John Jay (1831), the first such Congressional commission awarded to an American. With its juxtaposition of European and American elements, Frazee's point of view paralleled those of Feke and Copley. Torsos might be draped by togas and planes made smooth according to fashionable neoclassical formulas, but realistic features dominated and individual characteristics were carefully studied [112].

Augur tried to adopt the neoclassical style more completely than Frazee. A Connecticut merchant turned woodworker and then, after encouragement by Samuel F.B. Morse, a carver in marble, Augur attempted several ideal pieces, including his ambitious two-figured *Jephthah and His Daughter* [113], which was probably the first ideal group in stone completed by an American sculptor. Its angled cuts and sharp ridges reflect Augur's greater sensitivity to wood rather than to stone. Nevertheless, the details of costume as well as of facial features, including the straight line between forehead and nose, reveal Augur's determined study of classical and neoclassical sources.

As Wayne Craven has pointed out in his monumental *Sculpture in America*

112. John Frazee, *Joseph Story*, 1834. Boston Athenaeum.

113. Hezekiah Augur, *Jephthah and His Daughter*, 1828–32. Yale University Art Gallery.

(1968), the careers of Frazee and Augur ended about 1840, when Horatio Green-ough, Hiram Powers, and Thomas Crawford became better known. These men had gone to Italy earlier, and by 1840 their ideal pieces and portraits had begun to educate a new generation of patrons and clients. But even if many still preferred naturalistic works, a slightly younger group of talented sculptors, ignoring the more mannered aspects of neoclassicism, catered to that taste. This group in-cluded Henry Kirke Brown and Erastus Dow Palmer.

Whether they remained abroad or at home, all shared several characteristics. They worked largely in marble, or, rather, they would work up a figure in clay, cast it in plaster, and then, especially if they lived abroad, hire workmen to carve the marble version. In effect, the Americans were modelers rather than carvers, but since the final product was intended for carving, they thought as carvers who would release the image from the stone block rather than as craftsmen working up an image from pieces of clay. Like Trumbull's generation, they enjoyed creat-ing ideal pieces, which they believed to be the true test of their abilities as artists, and also made portraits. Beginning with Greenough, they began to receive major government commissions, which had previously gone to Italian sculptors. Virtu-ally all the Americans, whatever their aesthetic point of view, portrayed Ameri-can themes for these commissions, but instead of developing a range of genre subjects appropriate to the medium, they preferred symbolic figures representing the nation or ennobled images of Indians. (In this generation, only Crawford, in the 1850s, designed a significant number of genre pieces.)

Greenough (1800–52), the first of the group to travel abroad, arrived in Rome in 1825, where he became acquainted with the major Neoclassical sculptor of the period, Albert Bertel Thorwaldsen. After returning to America for two

years, Greenough then settled in Florence in 1828, where he remained for most of his life. Early in his stay, he worked under Lorenzo Bartolini, whose realistic predilections tempered Greenough's growing neoclassical leanings, which, like those of the other Americans, were entirely eclectic. Motifs and poses were taken from fifth-century works as well as from Hellenistic pieces. (Among the three— Greenough, Powers, Crawford—Crawford's style was the most neoclassical.) Like virtually all nineteenth-century artists, thinkers, and literary figures before the German philosopher Friedrich Nietzsche explored the darker side of Greek civilization in his seminal *The Birth of Tragedy* (1872), Greenough and the others found themes in the more congenial and rational aspects of ancient history, legends, and tales. Their works, like those of contemporary American painters, usually carried a moral based on the meaning of the classical subject or the Christian message inferred from the subject.

Greenough's ideal works date from his initial trip to Italy. Capable of modeling meltingly sweet figures, he also completed more aggressive ones, such as *The Angel Abdiel* from Milton's *Paradise Lost* [114]. His rapid progress and growing reputation, along with the support of his friends Washington Allston and James Fenimore Cooper, prompted Congress to commission a statue of George Washington from him in 1832. This award, certainly a major triumph for American sculptors, caused Greenough much anguish when the statue was finally unveiled in Washington, D.C., in 1841. Although he had used Houdon's portrait bust of Washington for the head, Greenough derived the statue from the Zeus of Phidias (fifth century B.C.). The body was draped by a toga and the chest was left bare. To a public that wanted recognizable images of Washington and was too prudish even for an unclothed male chest, Greenough had committed two unpardonable sins, and he was severely criticized for them.

Hiram Powers (1805–73) was able to circumvent the problem of nudity when he exhibited *The Greek Slave* in America in 1847 [115]. The most famous of his nude female figures—a woman in bondage—*The Greek Slave* passed the purity test because she was made to represent Christian chastity and virtue in face of Turkish barbarism. Not all of Powers's works carried such explicit "texts," but most, whatever their contemporary interpretation, were derived from ancient prototypes—the fourth-century Venus of Knidos in the case of *The Greek Slave*. Actually, Powers had sculpted powerful realistic works before settling in Florence in 1837 [116]. Soon after, Powers created some busts in a style that Wayne Craven has called "Byronic naturalism" [117]. Developed by Greenough, works in this manner projected the force of personality then associated with the English poet George Gordon Byron. Subsequently, Powers began to model ideal pieces and became America's best-known neoclassical sculptor. He continued to create works in that style until the 1870s, long after both its and his creative energies had passed their peaks.

Thomas Crawford (1813–57), unfortunately, died at the peak of his career. Settling in Rome rather than Florence in 1835, where he briefly worked under Thorwaldsen, he created the most purely neoclassical works of all the Americans, especially through the 1840s. His style then grew more naturalistic, as he gained

114. Horatio Greenough, *The
Angel Abdiel,* 1839. Yale
University Art Gallery.

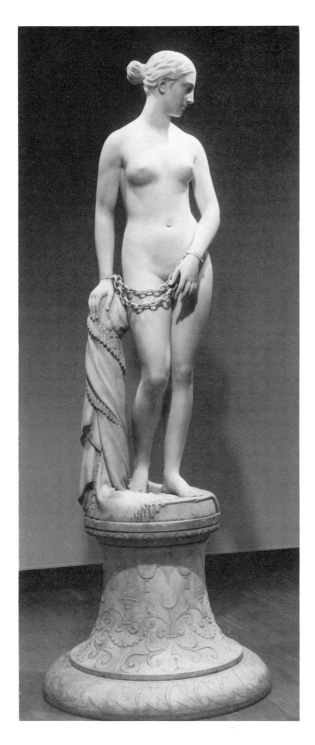

115. Hiram Powers, *The Greek Slave*, 1843. Yale University Art Gallery.

one major American commission after another, including a bronze equestrian statue of Washington for the Washington Monument in Richmond, Virginia (1849–57), the pediment for the Senate wing of the United States Capitol (1853–55), the *Armed Liberty* atop the Capitol dome (1856–63), and the bronze doors in relief for the Senate and House wings (1855–60), completed by William Rinehart after Crawford's death in 1857. Nevertheless, Crawford still made neoclassical works in the 1850s, few lovelier or as lively as *Flora* of 1853 **[118]**.

Of the three expatriates, Greenough and Crawford helped develop an American sculptural iconography because of their works at the United States Capitol. Crawford's bronze doors illustrated scenes from the Revolutionary War and the immediately succeeding years, and his pediment symbolized the triumph of Euro-American civilization over that of the native Americans. The pediment might owe its theme in some measure to Greenough's earlier multifigured group, *The Rescue* (1837–52), formerly located on the east side of the Capitol's main entrance, in which the conflict between the invading whites and the defending Indians is more directly and brutally shown. The best-known individual piece from these works is Crawford's replica of *The Dying Indian Chief* from the pediment, an amalgam of classical forms and realistic observation **[119]**.

Ironically, the two other significant sculptors of this generation, Henry Kirke Brown (1814–86) and Erastus Dow Palmer (1817–1904), never received important governmental commissions, even though they remained in America. Brown initially studied painting, but turned to sculpture when living in Cincinnati in the late 1830s. After gaining some recognition for his naturalistic portrait busts,

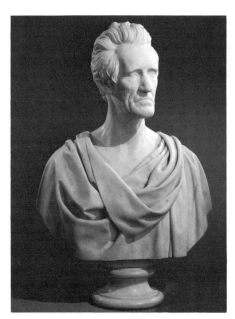

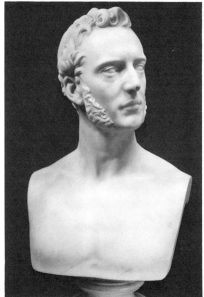

116. Hiram Powers, *General Andrew Jackson,* 1835. The Metropolitan Museum of Art.

117. Hiram Powers, *Bust of Horatio Greenough,* 1838. Museum of Fine Arts, Boston.

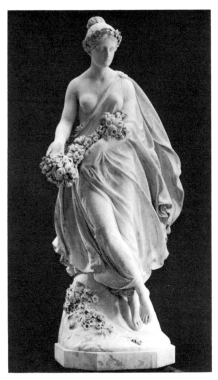

118. Thomas Crawford, *Flora*, 1853. The Newark Museum.

119. Thomas Crawford, *The Dying Indian Chief Contemplating the Progress of Civilization*, 1856. The New-York Historical Society.

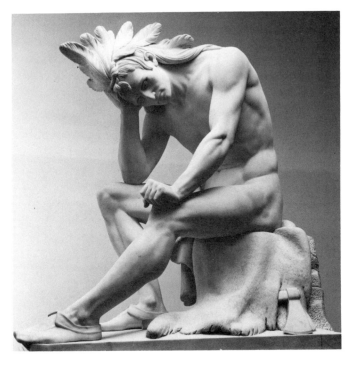

he worked and studied in Italy from 1842 to 1846. Obviously influenced by Neoclassical and Renaissance forms during those years, he turned away from them after returning home. He soon became the leading naturalistic sculptor of the mid-century period. He tried to explore American subjects, particularly Indian themes, but his greatest strength lay in straightforward portraits and unexotic figure studies. Just as his friend, the painter Asher B. Durand, had sought the ideal in the real, so Brown probably pursued the same goal, rarely more effectively than in his bronze *George Washington* in New York City's Union Square [120].

Erastus Dow Palmer must have been similarly motivated. In an article written in 1856, he stated "the mission of the sculptor's art is not to imitate forms alone, but through them to reveal the purest and best of our nature." Since he did not go abroad until 1873, late in his life, his ideal lacked neoclassical proportions and features, conforming instead to actual human norms. His *White Captive* [121], another female in bondage, is fleshier, more robust, and more familiar-looking than Powers's *The Greek Slave* [115]. Palmer also created some of the

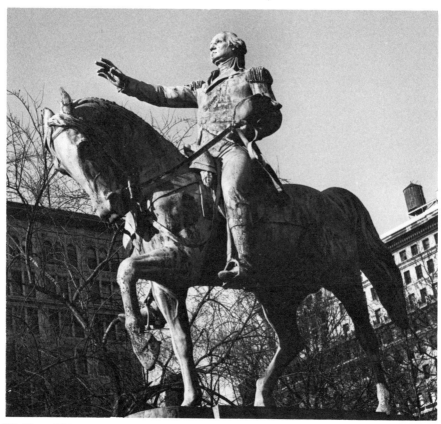

120. Henry Kirke Brown, *George Washington*, 1853–56. Union Square, New York City.

121. Erastus Dow Palmer, *White Captive,* 1859.
The Metropolitan Museum of Art.

122. William Rimmer, *The Dying Centaur,*
c. 1871. The Metropolitan Museum of Art.

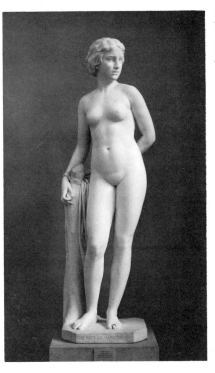

most delicate and softly modeled reliefs of the period, perhaps as a result of his training as a cutter of cameos.

One of the most vital and certainly the strangest figure of this generation was William Rimmer (1816–79), a painter, sculptor, and doctor, whose work was unique in America. His *Despair* (c. 1830, Museum of Fine Arts, Boston), perhaps the first sculpted nude in the country, projects a kind of physical tension and psychological intensity that was beyond the grasp of any of his contemporaries. A student of anatomy, Rimmer ignored the pleasantries of neoclassical modes when completing such significant pieces as *Falling Gladiator* (1861, Museum of Fine Arts, Boston) and *The Dying Centaur* [**122**].

4

AT HOME
AND ABROAD

THE YEARS between 1860 and 1900 are considered classic ones for American art. As the nation began to assert itself beyond its continental limits, artists both reflected and helped define the contours of the developing American character—the concern for religion, for the land, and for the American's place in the world. Until recently, the period was viewed as a kind of battleground between the stay-at-homes, such as Thomas Eakins and Winslow Homer, and the expatriates, such as James Abbott McNeill Whistler and Mary Cassatt. American qualities, both real and imagined, were seen in the former group of artists, while imitative European qualities were assigned to the latter. Historians and critics read the period in terms of adversarial relationships. Artists either advanced their American artistic heritage or they abandoned it.

Because we no longer tend to channel thoughts into "either-or" confrontations and because of the tremendous amount of new information available, we now realize that the post-Civil War decades are not reducible to simplistic formulas. On the contrary, these years have been among the richest and most complex in the entire history of American art. At any given moment, especially during the 1880s and 1890s, several different strands can be seen developing both independently and in interaction with each other. Artists who might have explored one aspect of art at one period can be seen immersed in another a few years later. While this raises serious questions about the restlessness of American art and perhaps the inability of artists to find their artistic matrix, it also reflects the increasing energies of American art.

Because of the complexity of the period, it seems appropriate at this point to indicate briefly the changes and developments before looking at the works of individual artists.

A key factor in understanding the period is to acknowledge the pervasive foreign influence—even in the works of Eakins and Homer. European styles and themes, of course, have always been present in American art, but, in comparison to the prewar period, they were much more evident and obvious. All of the major artists and literally hundreds of minor ones traveled abroad during their formative years, studying with acknowledged masters and absorbing as much as possi-

ble the traditions and craft of European art. They felt ready to learn from and to challenge the best that Europe had to offer. They realized that foreign instruction was superior and, having matured beyond the limiting nationalism of the Jacksonian decades, they knew that a viable American art must develop from the still-dominant European culture. By the 1870s, with the passing of Rome and Düsseldorf as popular centers of study, artists flocked to Munich—as many as 270 at that time—but Paris ultimately became the most important center, a position it held until the start of the Second World War in the late 1930s.

Despite, or because of, the influence of European art, activity blossomed as never before in American art. Several museums and art schools were opened, including the Metropolitan Museum of Art in New York City (1870), the Massachusetts School of Art in Boston (1873), the California School of Fine Arts (1874), the St. Louis School and Museum of Fine Arts (1875), and the Rhode Island School of Design in Providence (1877). By 1882, thirty-nine art schools were flourishing. The Society of American Artists was founded in New York City in 1877, in reaction to the conservative policies of the National Academy of Design. Because of the explosive interest in different mediums, several specialized groups were also formed, including the American Society of Painters in Water Color (1866), which became the American Water Color Society in 1877; the Society of American Etchers (1880); the Society of American Painters in Pastel (1882); the National Sculpture Society (1893); and the National Society of Mural Painters (1895). Small private clubs, such as New York City's Century Club, open to both businessmen and artists, helped bridge relations between the two communities as well as influence the essentially conservative development of American art. Galleries, such as the Vose Galleries in Providence and Boston, and Durand-Ruel in New York City, grew more common and provided important outlets for artists. And by 1880, there were approximately 150 significant private collections in the country. Not all were concerned with American art, of course, but major collectors did emerge, including Thomas J. Clarke and Charles Freer, whose collection formed the basis of the Freer Collection in Washington, D.C.

One of the most important European teachers of American artists was Thomas Couture, with whom artists such as William Morris Hunt [148], William Babcock, and Robert Loftin Newman [165] studied. Couture emphasized the value of the sketch and of one's initial impressions, rather than the traditional methods of drawing and studying from antique casts, which were favored by other French teachers. Couture also provided the Americans with an alternative set of techniques to those preferred by the Düsseldorf School, the painters of the Hudson River School, and the Ruskin-influenced artists. Couture's methods allowed the Americans to appreciate more easily the works of the artists whom Babcock and Hunt met in and around the town of Barbizon in the late 1840s, such as Jean François Millet, Charles-François Daubigny, and Théodore Rousseau. The brushy, moody, and intimate style of the Barbizon artists, which Hunt brought back to New England in 1856, soon became the first important alternative to the detailed and, by comparison, more impersonal styles of the Hudson River School and Luminism. Naturally, Hunt was not alone in this endeavor.

George Inness also discovered the Barbizon painters in the middle 1850s, and although he was criticized for his vague, introspective landscapes, he was finally acknowledged as one of the century's finest artists [151]. Dwight Tryon [154] and Alexander Wyant [152], among others, followed Inness's lead. Over the next few decades, their contemplative landscapes, often characterized by subtle tonal differences rather than by bright coloristic effects, attracted many artists. Modern scholars have grouped their work under the rubric of Tonalism, but it was a diffuse movement rather than a specific style, reaching its apogee in the 1890s [155 and 162].

During the 1860s, when Hunt and Inness were domesticating the Barbizon style in America, a few artists, Winslow Homer [133] and John La Farge [171] being the most prominent, began to explore more acutely the properties of light. Their paintings indicate that, like the young French Impressionists, they too were willing to consider the scientific properties of light and the ways light affected color relationships as well as compositional organization. Both Homer and La Farge were aware of such seminal texts as Michel Eugène Chevreul's *Le loi du contraste simultané des couleurs* (1839; English translation, 1859), but neither pursued such studies in the 1870s.

Instead, the major new development during that decade originated in Munich, where artists such as Frank Duveneck had gone to study [156]. He and others brought back a vigorous, dashing, almost sketchlike style of painting that initially provoked great hostility. In fact, several Munich students were instrumental in forming the Society of American Artists in 1877 to guarantee exhibition space to painters using newer styles. The Munich style crested in the 1880s, and with the Barbizon manner provided a broad spectrum of styles for American painters.

During the 1860s and 1870s, several other artists preferred to study in Paris, where the range of instruction extended from the linear precisionism of Jean Léon Gérôme, with whom Thomas Eakins studied from 1866 to 1869, to the more painterly approach of Thomas Couture. Several teachers represented a point between these two, but others, such as Carolus-Durand, the teacher of John Singer Sargent, and Léon Bonnat, with whom Eakins also studied, tended toward the painterly. Since most instruction in France centered on figure studies, the Americans became increasingly adept at figure painting. Landscape studies played a secondary role in the art schools or were relegated to leisure-time activities. During these years young sculptors, such as Augustus Saint-Gaudens, were also absorbing the new naturalistic modes emanating from Paris.

Through the 1870s, palettes began to grow lighter and more colorful, preparing Americans for the full impact of Impressionism in the 1880s. Most Americans were initially wary of the movement—with the notable exception of Mary Cassatt [143]—and did not fully comprehend its pictorial implications. They were never as artistically radical as, say, Claude Monet. Perhaps we may attribute their reserve to an underlying American regard for the inviolability of the object, but it is just as reasonable to assume that most of the American Impressionists, who had arduously learned to paint the figure in Parisian art schools, had no intention

of abandoning their painstakingly acquired skills. In any event, the movement became immensely popular in the 1890s, especially after the World's Columbian Exposition in Chicago in 1893, where it was greatly acclaimed.

Actually, we should be very cautious in using the term "Impressionism" with American artists. For most, it was a decorative mode rather than a technique to explore color relationships. Several artists, such as John Singer Sargent and William Merritt Chase [145 and 158], passed in and out of Impressionist phases. In addition, the group closely associated with Impressionism, the Ten American Artists, formed in 1898, included artists closer to Tonalism, such as Thomas Dewing [155] and John Twachtman, who might better be considered an American Post-Impressionist [162].

During the 1880s, yet another movement emerged—the American Renaissance. Its roots lay in the kind of academic art favored by Sir Joshua Reynolds and sustained through the mid-century period by Daniel Huntington [107]. The American Renaissance, which trailed off in the 1920s, reached its high point at the World's Columbian Exposition at the same time that American Impressionism also established itself as a major American style. In historical terms, the Renaissance marked the final acknowledgment of the fact that America was going to be the gaudy new Rome rather than the innocent new Eden.

Throughout the late nineteenth century, artists also grew increasingly introspective. Mood, subjective feelings, and private thoughts came to characterize much of the art of the period. Insistence on personal sensibility replaced notions of public responsibility. The kind of democratic community in which a Bingham or a Durand might thrive was subverted by many artists into, as Thomas Dewing wrote to the collector Charles Lang Freer in 1901, a "poetic and imaginative world where a few choice spirits live." But this is only to say that, like their European counterparts, American artists felt increasingly less constrained by social norms, patriotic gestures, or allegiances to governments and their varying ideologies. Several, such as Elihu Vedder, George Fuller, Robert Loftin Newman, and Albert Pinkham Ryder, whatever their individual spiritual quests, replaced the God-drenched mid-century American landscape with interior worlds to explore [163–170]. But even in pursuing their own thoughts, these artists were not always oblivious to current affairs or the moods that affected society in general. For example, the mood of pessimism that Vedder communicates in his imaginative works is matched by an equivalent feeling in Eakins's late portraits [140 and 169]. And Ryder, whose religious work often suggests the benevolence of God, might have been responding to the confusion caused by Darwin's theories of determinism and natural selection [164].

Americans followed at a distance those European artists who explored concepts of abstract composition. There were no homegrown Cézannes, yet several artists began to organize compositions in which all parts of the surface were equally important rather than continuing the traditional way of composing, with dominant forms and subordinate backgrounds [162]. Depth, even among realistic artists, was increasingly controlled and arbitrarily manipulated. Horizon lines were tilted upward or made to disappear entirely. Shapes did not always coincide

with recognizable objects but were related to each other as elements in an overall scheme of design. Color could be used for harmonious arrangements of hues as well as for the description of realistic appearances. The most stylistically radical artists were Whistler, Cassatt, Dewing, Twachtman, and Ryder (as well as Maurice Prendergast, who will be considered in the next chapter).

Japanese art, especially Japanese prints, was a major source for these departures from tradition. Characteristics, which can be found as early as the 1860s in works by Homer, La Farge, and Whistler, include bright and arbitrary colors, stylized patterns and contours, simplified detail, and loss of depth. These are, of course, stylistic motifs. Later in the century, more profound understanding of East Asian cultures influenced the more contemplative art of Dewing, Wyant, and Arthur Wesley Dow. But, as if to symbolize the difficulties and perhaps irrelevance of isolating single strands of influence, the introspective mood characteristic of their work is also rooted in Barbizon painting, as well as in contemporary religious, philosophical, and literary developments, including spiritualism, aestheticism, Symbolism, and Swedenborgianism.

The Civil War was the most profoundly disturbing event of the 1860s, but its effect on artists is not easy to determine. Only a few actually served in military uniform—Robert Loftin Newman, Sanford Gifford, and Jervis McEntee. Others, including Eastman Johnson, Albert Bierstadt, David Blythe, Lilly Martin Spencer, Winslow Homer, and Edwin Forbes, painted Civil War scenes. Unlike photographers, such as Mathew Brady, who provided chilling visual documentation of wartime brutalities, the painters concentrated on noncombat scenes. The stirring portrayals of Revolutionary War battles found no echoes in the works of this generation of artists. The need to cover over sectional differences was probably more important than dwelling on themes of bloodshed and confrontation.

Certainly, the Civil War turned artists away from the kind of religious awe with which Durand's generation viewed the American landscape. Just as the start of World War II made a mockery of the provincialisms of the American Scene movement (see Chapter 6), so the Civil War compromised the kind of wonder-eyed innocence typical of the Hudson River School. It seemed ludicrous to continue the pretense of painting the landscape of a pre-industrial civilization when railroad trackage jumped from 60,000 to 165,000 miles between 1870 and 1890, anthracite coal production increased from 11 million to 57 million tons, and petroleum production grew from 500,000 to 63 million barrels between 1860 and 1890. Kansas, so recently a part of the frontier, became a major corn-producing state in the 1880s, and urban populations quintupled, from 5 to 25 million, between 1860 and 1900.

Nevertheless, the need for paintings of pristine wilderness persisted, and these were provided most grandly by Albert Bierstadt (1830–1902) and Thomas Moran (1837–1926), who substituted enormous views of western scenery for the more familiar eastern vistas. On a mythic level, the scenery they depicted reaffirmed belief in the unsurpassed beauty, uniqueness, and power of the American landscape; in more mundane terms, their paintings fed the national passion for information about the West, an area rapidly being settled, but about which

123. Eadweard J. Muybridge, *Loya (The Sentinel), Valley of the Yosemite, No. 14,* 1872. University of California, Los Angeles.

124. Albert Bierstadt, *In the Mountains,* 1867. Wadsworth Atheneum.

reliable information was difficult to obtain. The photographs by Carlton Watkins (1829–1916), Eadweard J. Muybridge (1830–1904), and William Henry Jackson (1843–1942), among others, also provided vital information, which ultimately contributed both to the conservation movement and to the creation of the National Park System [123].

Bierstadt, who had studied in Düsseldorf from 1853 to 1857, traveled west for the first time in 1858. He visited the Yosemite Valley in 1863 and, following that trip, produced the series of Rocky Mountain and Yosemite Valley scenes that made him, with Frederick Church, one of the most popular painters of the 1860s and 1870s [124]. His conservative amalgam of Düsseldorfian itemization and Ruskinian attention to detail turned the frightening and unmeasurable empty spaces of the West into domesticated parklike areas, entertaining and educational in their variety of floral and topographical features, and reassuring with their Garden of Eden atmosphere.

Like Emanuel Leutze, whose *Westward the Course of Empire Takes Its Way* (United States Capitol, 1861–62) is a visual apotheosis of Manifest Destiny, Bierstadt, too, painted at least one major, and more interesting, version of the settlement of the West [125]. The major geological divisions—wet lands, dry lands, mountains—are seen; water sustains the flocks; the future, still hazy and indeterminate ahead, has yet to be penetrated; but the clear skies and solemn pace of the procession suggest God's guiding hand and the settler's ultimate success.

With their gauzy layers of atmospheric haze, Bierstadt's paintings reveal knowledge of Turner's works, which the artist undoubtedly studied during his many trips to England. But Bierstadt's Düsseldorf training usually prevented light from penetrating the edges of trees, bushes, or rocks, and indulgence in the

125. Albert Bierstadt, *The Oregon Trail,* 1869. The Butler Institute of American Art.

126. Thomas Moran, *The Grand Canyon of the Yellowstone,* 1893–1901. National Museum of American Art.

broad, gestural sweep of Turner's painterly style. By contrast, Thomas Moran came under Turner's spell in the 1850s after studying in Philadelphia with James Hamilton (1819–78), who was known as "the American Turner." Unlike Bierstadt, Moran turned the majestic and awe-inspiring valleys and canyons of the Yellowstone and Colorado Rivers into great candy-coated, wispy confections, but his acquaintance with the work of the western photographers probably kept his basically realistic mode of perception from succumbing to Turner's diaphanous manner [126].

Interestingly, both Bierstadt and Moran knew the photographers quite well. Watkins and Muybridge were based in San Francisco, when Bierstadt visited it. He even visited Yosemite with Muybridge, and Moran traveled with Jackson to the Yellowstone area in 1871 as part of Dr. Frederick V. Hayden's exploratory expedition. (Jackson and the painter Sanford Robinson Gifford were members of Hayden's party the previous year.) But unlike such Impressionist painters as Theodore Robinson, who obviously adopted cropping techniques from photography, Bierstadt and Moran used photographs like sketch pads—as reminders of what they saw rather than as tools to develop new compositional schemes. They were quite conservative in this regard.

Basically landscapists, Bierstadt and Moran did not paint Indian themes to the same extent as other artists associated with the West. Many, including Henry Farny (1847–1916), Frederic Remington (1861–1909), and Charles Marion Russell (1864–1926), also provided illustrations for the major literary and popular monthly magazines. Their work continued the examination of native Americans popularized by earlier figures, such as George Catlin—but with certain differences. By the 1890s, when the three began to produce their major paintings, the frontier was largely a memory. Remington traveled to it in a Pullman sleeping

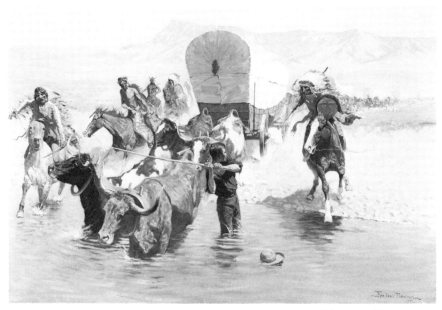

127. Frederic Remington, *The Emigrants,* before 1904. The Museum of Fine Arts, Houston.

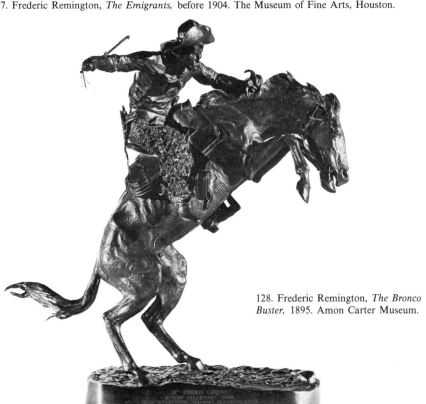

128. Frederic Remington, *The Bronco Buster,* 1895. Amon Carter Museum.

car! Both he and Russell, with the author Owen Wister, helped transform the cowboy from the surly, often dangerous drifter he actually was into the pure, nearly virginal Lone Ranger, defender of wagon trains and responsible citizen auxiliary of the United States Cavalry, and only occasionally a roisterer [128]. Reflecting late-nineteenth-century racist attitudes concerning the superiority of Anglo-Saxons, Remington and Russell portrayed Indians as savages impeding the orderly settlement of the West, rather than as a people heroically defending their ancestral lands from intruders [127]. Their art illustrates the post-Civil War domestication of the West, a few years after the great majority of the Indian battles were fought and at the time when the government conspired with mining and commercial interests, along with the endless streams of immigrants, to destroy the remaining Indian cultures.

Of the three artists, Farny, following the tradition of Catlin and John Mix Stanley, documented the most closely the activities of Indians, in a style that reflected his European studies at Düsseldorf in 1867 and Munich in 1875–76 [129]. The works of Remington and Russell are closer to the adventure paintings of Deas and Tait. Employing more sketchlike techniques than Farny, they focused attention on particular events or objects, such as Indian fights, horse roping, or campfire scenes. Remington, who wanted to be known as a painter rather than as an illustrator, even experimented with Impressionist techniques after 1905. He probably wanted to be associated with the many "eastern" academic artists, such as George de Forest Brush (1855–1941), who depicted Indian and cowboy life in subtler and more discreet ways. (The exhibition of several paintings and statues with Indian themes at the Pan American Exposition in Buffalo in 1901 climaxed this phase of interest in western life.)

Genre scenes were of course not limited to western subjects. Perhaps the

129. Henry F. Farny, *Indian Camp*, 1890. Cincinnati Art Museum.

most important artist to develop further the path taken by William Sidney Mount was Eastman Johnson (1824–1906), also a significant portraitist. His art clearly reveals the increasing sophistication of style and theme supported by the American Art Union through the 1840s and 1850s. Johnson studied in Düsseldorf in 1849, and lived in Holland from 1851 to 1855, where he was affected by Rembrandt and the Dutch Little Masters; he then spent some time in Couture's classes in Paris in 1855, before returning to America. During the remainder of his career, he combined the several stylistic features he had found in the European artistic centers into a very good eclectic manner and applied European motifs to his favorite subjects—rural themes, children, and blacks.

Johnson's *Old Kentucky Home, Life in the South* [130], a success when exhibited at the National Academy of Design in 1859, is a backyard scene derived from similar scenes by Dutch artists. The several anecdotal elements, the attention to detail, and the dry brushwork reflect Johnson's training in Düsseldorf, but the sketchlike finish of the foreground owes more to Couture. No wonder the painting was probably the most accomplished American genre scene of its time.

Its subject, paradoxically, satisfied both pro-slavery and anti-slavery sympathizers. Although Johnson completed other paintings more sympathetic to blacks during the years of the Civil War, he, like others, found the subject difficult to

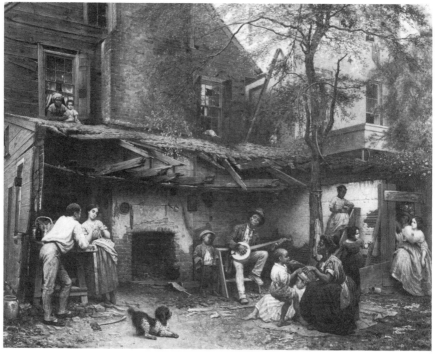

130. Eastman Johnson, *Old Kentucky Home, Life in the South,* 1859. The New-York Historical Society.

131. Eastman Johnson, *Winnowing Grain,* c. 1870. Museum of Fine Arts, Boston.

handle. By the 1870s, surprisingly few white painters included blacks in their works, evidently recoiling from the Constitutional principle of equality and unable to translate into art the changing conditions of blacks as they entered the mainstream society.

From the 1860s through the 1880s, Johnson painted many rural scenes of dignified labor and communal activities. Unlike contemporary works by, say, Jules Breton, Théodore Rousseau, and Jean François Millet, Johnson's paintings have neither heroic peasants nor faceless clods. Nor are his figures the caricatured bumpkins of Mount. Instead, they exist as individuals and perform their chores with dispatch [131], although the maple sugaring scenes of the 1860s and the cranberry harvest scenes of the late 1870s and of the 1880s are wrapped in a nostalgic gloss. Despite the themes of work, some of these are also vacation pictures and suggest simpler life styles than those normally led by their subjects [132]. The paintings appeal to the desire for rural tranquillity characteristic of all generations of Americans and certainly of the post-Civil War generation, sorely in need of binding common experiences and relief from the effects of rapid industrialization and urbanization.

In these works, Johnson explored various effects of light as well as varied brush techniques to suggest both subtle, transparent shadows and the bold, abrupt reflections of sunlight on coarse clothing. But Johnson, a disciplined studio technician rather than an artist seeking outdoor, *plein-air* effects, rarely, if ever, painted consistent lighting conditions over an entire canvas surface or treated all parts equally. Nevertheless, he was among the first to explore such effects and might even have influenced Winslow Homer during the 1860s, when both had

132. Eastman Johnson, *The Cranberry Harvest, Island of Nantucket,* 1880. Timken Art Gallery.

studios in New York City's famous University Building, a home to many artists. Johnson stopped painting genre scenes in the 1880s and concentrated instead on portraits, to which he brought an ability to suggest in the turn of a head or the focus of an eye the character of a sitter.

Several other genre painters, including John Whetten Ehninger (1827–89), Thomas Waterman Wood (1823–1903), and Enoch Wood Perry (1831–1915), painted scenes through the last decades of the century similar to those of Johnson or even closer to the rural subject matter of Mount and James Goodwyn Clonney. Their works might be considered the pictorial equivalents of such "local color" writers as Edward Eggleston and Sarah Orne Jewett. More probing stylistically and thematically, however, were the paintings of Winslow Homer (1836–1910) and Thomas Eakins (1844–1916), who, with James Abbott McNeill Whistler, were the best and most consistently interesting painters of the period. Both Homer and Eakins transformed genre painting and portraiture into strong statements of personal sensibility and, in their late works, discovered an America that Impressionist pleasantries and American Renaissance escapism entirely overlooked.

Homer, from Boston, apprenticed as a lithographer with J.H. Bufford's firm from 1854 to 1857 and worked as a magazine illustrator until 1875. His illustrations, mainly in *Harper's Weekly,* range from children's games to factory scenes, from close-up studies to multifigured compositions, and from sentimental incidents to impersonal descriptions, but the most famous, by far, are his Civil War views. Some of the combat and camp scenes, which include battlefield panoramas as well as intimate studies of sharpshooters sitting in trees, are clearly dependent on photographic techniques in their silhouetted forms, flattened compositions, croppings, and odd-angled close-ups.

Homer's experiences as a Civil War illustrator provided themes for his earliest paintings, the most famous being *Prisoners from the Front* (1866, Metro-

politan Museum of Art, New York City), exhibited at the Universal Exposition in Paris in 1867. The confrontational yet enigmatic poses assumed by the Confederate captives and their Union captor indicate that Homer was not interested in anecdotal genre but in exploring a particular idea. Here, it would seem to be the opposition of forces, a theme to which he returned again and again in his late landscapes and seascapes. Over the several decades of his career, he also painted individuals in a wide variety of contexts—vacationers, farmers, hunters, fishermen, and wives of fishermen. During the 1860s and 1870s, his figures worked or vacationed in amiable environments. About 1880, they began to live in hostile relationship to their surroundings. Nature was no longer benign. The diffuse and generous religious aura given to the landscape by the Hudson River School was blown away by violent winds, shattered by gun shots, or claimed by the fittest for their survival. But regardless of the particular subject, Homer painted as one recording his physical experiences both directly and in a self-consciously artistic manner. That is, the viewer is acutely aware of Homer's immediate responses to a scene as well as his manipulations of composition, color, and tone. And it was the abstract qualities of Homer's compositions that provided his generalized thematic content with a gravity and profundity unique among his contemporaries.

In the period just before his visit to Paris in 1866–67, Homer began a series of delightful vacation pictures especially noted for their daringly flattened shapes and subtle lighting effects [133]. The probable influence of Japanese prints, as well as his interest in the effects of sunlight on objects, indicates the importance of his friendship with John La Farge, who had discovered Japanese art in the late 1850s

133. Winslow Homer, *Croquet Players,* 1865. Albright-Knox Art Gallery.

and who had also become familiar with Chevreul's studies on color. Homer continued his experiments after returning from Paris, where he possibly saw the exhibition of Japanese art at the Universal Exposition, as well as the special showing of Edouard Manet's work. Occasionally, Homer added the scumbled brushwork of the Barbizon painters to his smoothly finished surfaces, but in all of these paintings he refused to treat the foreground and the background as one continuous space, in the manner of the Impressionists. Instead, he allowed light to clarify the contours of objects in the foreground while throwing into hazy relief the landscape forms in the distance. In an interview in 1880, Homer acknowledged the importance of lighting conditions—the light of the sun, and of reflections—but like La Farge and Eastman Johnson, he did not develop, or perhaps was unaware of the possibility of developing, a style of painting with light and color as the principal organizational motifs.

By the middle 1870s, Homer's palette had darkened considerably, and the recreational subject matter, which he shared with the Impressionists, disappeared from his work. His paintings of blacks later in the decade, based on at least one visit to Virginia, in 1875, reflect his new interests. The figures, distant counterparts to the peasants of Millet, dominate the spaces around them and are serious, if not heroic, in their work [134]. They herald the appearance of the monumental female figures Homer painted at Cullercoats in England in 1881–82. These women, among the first to inhabit the sublime spaces of the waterside usually reserved for men, confront the sea, battle daily with the possibility that it may devour their men, and indicate by their defiant bearing that they will endure. Although English artists painted similar scenes, Homer concentrated on the factor of conflict as if this were his true subject and the women only the vehicle to convey it.

This is borne out by Homer's subsequent work, especially after he moved to Prout's Neck in Maine in 1883. Man, no longer the woodland wanderer in search of religious inspiration or self-knowledge, becomes a hunter, and the landscape, no longer benefiting from God's kindly attentions, becomes an arena for the most elemental encounters among land, sea, and sky [135 and 136].

Coincidentally, one of the principal themes of William Graham Summer's magisterial *Sociology,* published in 1881 when Homer was in Cullercoats, was the competition for existence in nature. Other writers, such as John Fiske, Henry Ward Beecher, and Herbert Spencer, also explored aspects of this theme, but, recoiling from the implications of their findings, they tried to show how evolution reflected God's planning. Homer's paintings are the pictorial equivalents of these literary, philosophical, and religious discussions concerning Darwinian natural selection and Biblical revelation, or natural order and moral force, then animating American cultural life. How he came to paint this grand and elemental theme— or even what he believed—still remains unknown. Nevertheless, in his isolated home on the Atlantic shore, he tapped one of the most profound controversies of his age.

To match his elemental subject matter, Homer developed a seemingly sim-

134. Winslow Homer, *The Cotton Pickers*, 1876. Los Angeles County Museum of Art.

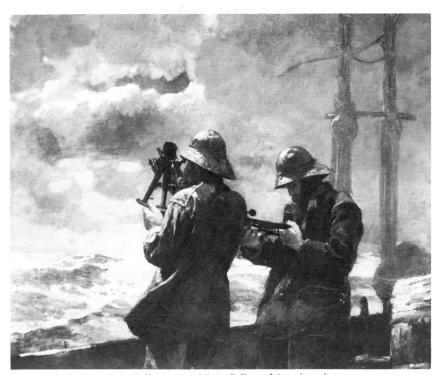

135. Winslow Homer, *Eight Bells*, 1886. Addison Gallery of American Art.

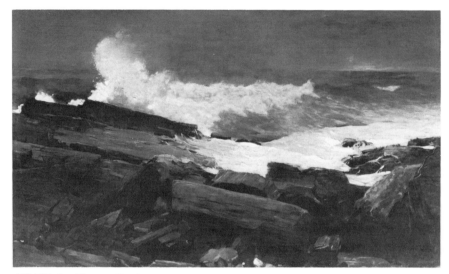

136. Winslow Homer, *Weatherbeaten,* 1894. Portland Museum of Art, Maine.

plified style, in part dependent on watercolor painting, which he took up about 1870. In these early watercolors, close-valued areas of color were often energized by whiplash outlines. Together with a resurgence of Japanese influence in the 1890s, these features found their way into his late oils. A few large shapes defining the shore, the ocean, and the sky were brought close to the picture plane by bold silhouettes, tipped perspectives, and a palette of intense colors for both the foreground and the background planes. But in his paradoxical manner of combining direct experience with artifice, Homer modified the obvious artfulness of his compositions by brilliantly approximating the realistic textures and glinting reflections on the seaside rocks and boulders.

Because of the unsophisticated public, which was more interested in storytelling pictures and flashy brushwork than in understanding the subtle interactions of form and content, Homer's work never achieved the popularity of the painting of artists such as Bierstadt, Johnson, or William Merritt Chase. Thomas Eakins (1844–1916), an artist with at least equal intellectual discernment and with better technical ability, received even less acknowledgment than Homer, and, as with Homer, no major school developed around him. This is quite surprising, since Eakins was probably the best teacher of his generation and taught at the Pennsylvania Academy of the Fine Arts from 1876 to 1886 and at other schools in Philadelphia and New York City until 1895. But he was also one of the most obsessive. A relentless student of human and animal anatomy and a devotee of preliminary perspectival studies, he taught—and painted—with a vision that substituted perspicacity for imagination.

Born in Philadelphia, which remained his permanent home, Eakins studied at the Ecole des Beaux-Arts in Paris from 1866 to 1869 with Jean Léon Gérôme and then, for a brief period, with Léon Bonnat, who was not associated with the

Ecole. From Gérôme, he learned to pay attention to detail and precise renderings of form, to call attention to the subject rather than to his own technique, and to appreciate genre scenes, although not the exotic Oriental kind Gérôme favored. Bonnat, a more painterly artist than Gérôme, tempered the latter's insistence on the drawn line and direct opaque painting with softer forms and multilayered glazes. But it was the styles of José Ribera and especially of Diego Velázquez, which Eakins studied during a visit to Spain in 1869, that helped him form his mature style—essentially a combination of Gérôme's line and detail, very much modified by Velázquez's brushwork and integrated compositions. As Eakins said in an interview in 1879, "there are no lines in nature . . . only form and color. . . . The outline is not the man, the grand construction is."

Eakins returned to the United States in 1870, never to leave again. In the early years of that decade, he painted several outdoor scenes, especially of friends rowing on the Schuylkill River. His other genre paintings, both in oil and water-color, tended toward character studies rather than story-telling incidents. In the early 1880s, he painted outdoor Arcadian scenes, often aided by photographs, which he began to make in 1880. In place of active rowers, the subjects, usually men or boys, either swam or sat in passive poses. By the middle 1880s, Eakins had turned largely to portraiture and, over the next two decades, he painted the most profound and moving portraits, mostly of friends, in all of American art.

In his most famous early painting, *Max Schmitt in a Single Scull* (1871, Metropolitan Museum of Art, New York City), Eakins had not yet reached full maturity. The trees at the left appear to be the result of meticulous outdoor studies, but Max Schmitt was probably painted in the studio. The limpid sky and precisely rendered figures owe more to Gérôme than to Velázquez and probably very little to the often-mentioned American Luminists. Later rowing pictures are more unified and more softly focused, their glazes more palpable on the picture surface [137].

Eakins's use of lush, resonating glazed pigments reached a climax in the middle and late 1870s in works such as *The Gross Clinic* [138]. Dr. Gross's Rembrandtesque head dominates the proceedings in the amphitheater. As a portrait, it is a brilliant revelation of the inner person, suggesting an ideal of intellectual and emotional qualities rather than a concern for outer poise, rank, and grace in Sir Joshua Reynolds's manner or a democratic interest in virtue, directness, and determination in Charles Willson Peale's. Eakins followed this work with others similarly deep in feeling, such as *The Chess Players* (1876, Metropolitan Museum of Art, New York City), and his *William Rush Carving His Allegorical Figure of the Schuylkill River* (1877, Philadelphia Museum of Art), a rare painting of a nude.

Perhaps Eakins's turning to photography in 1880 helped provide an alternative to the brown colors in which he bathed these paintings, by calling attention to lighter tones and sharper focusing. The results, however, were mixed at best, since the Arcadian scenes of the early 1880s—*The Swimming Hole* (1883, Fort Worth Art Center Museum) and the studies of nude youths—are among the artist's most artificial and least insightful compositions. Furthermore, the realisti-

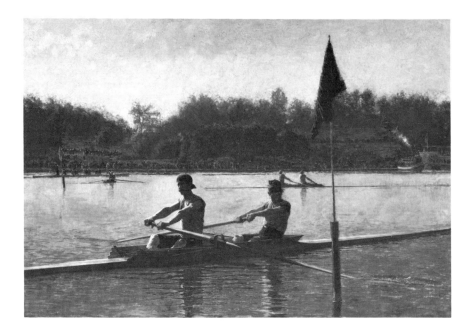

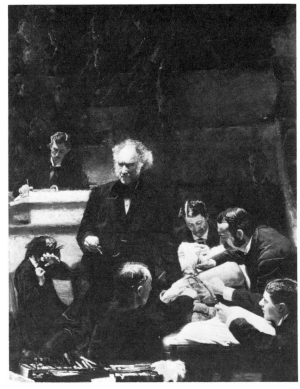

137. Thomas Eakins, *Biglin Brothers Turning the Stake,* 1873. The Cleveland Museum of Art.

138. Thomas Eakins, *The Gross Clinic,* 1875. Jefferson Medical College.

139. Thomas Eakins, *Portrait of a Lady with a Setter Dog (Mrs. Eakins)*, 1885. The Metropolitan Museum of Art.

cally proportioned figures appear to be visitors rather than dwellers in their idyllic, sylvan surroundings, naked rather than nude. Although without clothes, they uncomfortably resemble all of those realistically painted models dressed up in period costumes who inhabit so many dreary genre paintings by Eakins's contemporaries.

Eakins's strength lay rather in his extraordinary ability to extract from his subjects—in full length and in portrait busts—delicate and multilayered nuances of feeling. In place of the self-assured smiles of mid-century sitters and even the otherworldly glances of Washington Allston's young women, Eakins most often captured a sense of alienation and isolation, as if his figures were transfixed by deep psychological pain [139 and 140]. Their body positions, gestures, and gazes indicate their retreat from reality, not into fantasy but into despair and sorrow. Mostly friends of the artist, clearly well educated and intelligent, they perhaps mourn the final passing of the natural aristocracy of wealth, intelligence, and industry envisioned by the Founding Fathers. On the other hand, Elizabeth Johns, in her *Thomas Eakins: The Heroism of Modern Life* (1983), has suggested that these people might also be suffering from real or imagined mental fatigue, since a medical theory of the time held that intellectual effort depleted brain matter.

140. Thomas Eakins, *Portrait of Mrs. Edith Mahon,* 1904. Smith College Museum of Art.

These observations are not meant to explain Eakins's late portraits, but to suggest levels of meaning they might have. No doubt, Eakins, wounded by lack of artistic recognition, also projected his sense of failure onto the dispirited features of his sitters. By contrast, James Abbott McNeill Whistler (1834–1903), one of the few portraitists whose work is at least equal in quality to Eakins's, became well known, but was more often condemned than praised. We do not know if this gave him strength to pursue his artistic goals or whether he would have done so regardless of public approval. In any event, Whistler denied in his

famous *Ten O'Clock Lecture* (1885) any correlation between art and society—the denial itself being a kind of response to his critics.

Had he lived in the United States, Whistler might not have adopted such a radical position. Born in Lowell, Massachusetts, he spent part of his youth in Russia and, after studying at West Point and working as a cartographer for the United States Coast Guard and Geodetic Survey from 1851 to 1855, he settled in Europe. Initially a student of the academic painter Charles-Gabriel Gleyre in Paris, he was attracted to Courbet soon after his arrival. Although Whistler had bitterly rejected realistic painting by the late 1860s, he never lost interest in realistic themes, including genre scenes and portraits of friends. These were especially evident in his four major sets of etchings: "The French Set," completed a year before he moved to London in 1859; "The Thames Set," largely completed in the 1860s; and the first and second Venice sets, based on his visit to that city in 1879–80.

Whistler did not treat these themes in a realistic manner, however. A pioneer of the Aesthetic movement and a proselytizer of art for art's sake, he transformed them into exercises in decorative effects and emanations of mood. His interest in aestheticism, already apparent in his *Symphony in White No. 1: The White Girl* (1862, National Gallery of Art, Washington, D.C.), blossomed after he became acquainted with Japanese art in 1863. With his already deep and abiding respect for Velázquez's compositional motifs and brush techniques, he developed a style of strongly silhouetted forms, of flattened perspectives, and of objects determined more by areas of shimmering color than by well-defined borders. Whistler, believing that color, like music, could suggest moods, began to use musical nomenclature for his paintings in 1866, calling his new works (and renaming his old) nocturnes and symphonies. In these, he exhibited his extraordinary gifts for bringing into harmony subtle tonal modulations of a single family of colors or even of one color [141].

The public, raised on story-telling pictures in which meaning was established by the actions of the characters rather than by colors and compositional arrangements, was mystified and responded quite critically. Ruskin launched the most famous attack when, in 1877, in reference to *Nocturne, Black and Gold: The Falling Rocket* (1875, Detroit Institute of Arts), he accused Whistler of flinging a pot of paint in the public's face. Ruskin, who was a champion of Turner, probably objected less to Whistler's diaphanous forms than to their lack of ethical meaning. But by the mid-1870s, morality and piety had no place in Whistler's artistic universe.

His aesthetic beliefs, outlined most cogently in the *Ten O'Clock Lecture,* revolved around nature, color, and the responsibilities of art only to itself. Nature, he felt, should be used as a point of departure for creating a composition. The artist, he believed, usually had to transform nature entirely, since it was "very rarely right, to such an extent even that it might almost be said that nature is usually wrong." Whistler believed that color should aspire to the state of music. "As music is the poetry of sound, so is painting the poetry of sight, and the subject matter has nothing to do with harmony of sound or of color." Although he

141. James Abbott McNeill Whistler, *The Lagoon, Venice: Nocturne in Blue and Silver,* 1879.
Museum of Fine Arts, Boston.

emphasized formal and coloristic relationships, Whistler did not neglect mood.
He could find, under proper conditions, poetry in factories and warehouses, but
—and this is important—the poetry would arise as much, if not more, from the
harmony of forms and colors than from the objects shown, and certainly not from
extraneous notions of duty or patriotism or virtue. The purpose of art, he wrote,
was to seek the beautiful, not to teach or instruct. "Art *is,*" he stated, and the
artist "stands in no relation to the moment at which he occurs—a monument of
isolation—hinting at sadness—having no part in the progress of his fellow men."
 In the American context, Whistler's ideas were quite the opposite of those
expressed by Asher B. Durand thirty years earlier in his "Letters on Landscape
Painting." They reflect instead the late-nineteenth-century artist's growing desire
for imaginative freedom and independence from commonly held concepts of
society. Key sources that might have influenced Whistler include Edgar Allan
Poe's poetry and his important theoretical essay, "The Poetic Principle," pub-
lished in 1850; Théophile Gautier's concept of *l'art pour l'art;* and the poetry of
Charles Baudelaire.
 Despite the strong European associations Whistler had, he was popular and
influential among American artists. As the most notorious American painter
abroad, he was well known both in Europe and in the United States, where major
exhibitions were held as early as 1883 and 1889. Frank Duveneck and his students

met him in Venice in 1880 and were especially responsive to his etchings. William Merritt Chase, already aware of his art, was introduced to him in England in 1885, and John Singer Sargent was also a friend. For many other American artists, a visit to Whistler's studio assumed the aura of a pilgrimage. Indeed, without Whistler, Tonalism in the 1880s either would have taken a different form or might not have existed at all.

Mary Cassatt (1844–1926), another expatriate, was also an adventurous artist, but, unlike Whistler, she responded more to innovations in color harmonies and compositional arrangements than to self-conscious poetic moods and crepuscular tonal harmonies. Nevertheless, she probably would have agreed with Whistler's assertions in his *Ten O'Clock Lecture.*

Born near Pittsburgh, she lived in Europe from 1851 to 1855, studied at the Pennsylvania Academy of the Fine Arts from 1861 to 1865, and then returned the following year to France, where, with the exception of rare visits to the United States, she lived the rest of her life. Through the early 1870s, she was influenced by Courbet and Monet, but about 1875 she began to respond to Japanese prints and especially to the art of Degas, whom she met and befriended in 1877. Through her acquaintance with Degas as well as the other Impressionists, and also because of the quality of her work, she participated in the third, fourth, fifth, sixth, and eighth Impressionist exhibitions in 1877, 1879, 1880, 1881, and 1886, respectively. Her works, shown at the Society of American Artists as early as 1879, were probably the first Impressionist examples by an American to be shown in the United States.

Her keen sensitivity to the new art became evident in the 1870s. Among Americans, not even Whistler understood so completely the innovative emphasis given to the picture surface itself—the activation of the entire surface through bright color and rich texture, as well as the suppression of the third dimension. Cassatt's *Woman and Child Driving* is a remarkable performance for any artist at that date because of the cropped composition, scale of the images, and the relative equality of importance assigned to specific objects and the spaces between [142]. Cassatt did not pursue this type of structural organization much further, but in succeeding years revealed her admiration for Renoir by concentrating instead on color harmonies and exquisite brushwork. Nevertheless, like Degas, she invariably positioned her figures in careful relation to each other and to the edges of the canvas. In this regard, her work merits studied comparison with that of her contemporary Thomas Dewing, and of the late-twentieth-century artist Philip Pearlstein [**143, 154, and 357**].

Beginning in 1880, Cassatt began seriously to explore the theme of mother and child, with which she is most closely identified [**143**]. She created many quiet, intimate scenes of family life in oil, pastel, drypoint, and aquatint. Although her attraction to this theme has been credited to the fact that she was a woman, male artists, Renoir among them, painted similar subjects with equally monumental figures, indicating that even within the modernist camp there existed a conservative regard for domestic harmony and stability as well as for maintaining the compositional dominance of the human figure.

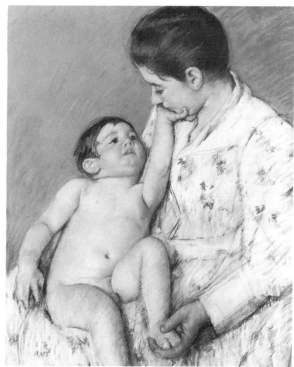

142. Mary Cassatt, *Woman
and Child Driving,* 1881.
Philadelphia Museum of Art.

143. Mary Cassatt, *First
Caress,* 1891. The New Britain
Museum of American Art.

After the exhibition of Japanese art at the Ecole des Beaux-Arts in 1890, Cassatt began once again to emphasize more purely decorative arrangements, now modified by her bright Impressionist palette. The superb *The Boating Party* is the masterpiece of this period in her career [144]. Subsequently, faltering eyesight and her lack of sympathy for progressive art movements prevented her from exploring further Post-Impressionist pictorial form and structure, but her works of the period revealed the keenest understanding and most original interpretation of European modernism until Maurice Prendergast's paintings of the late 1890s (see Chapter 5).

Although he was more popular and more financially successful than either Whistler or Cassatt, John Singer Sargent (1856–1925), a third important expatriate, never fully understood the revolution in composition and pictorial structure that occurred around the turn of the century. This helps explain why his reputation suffered so greatly during the middle decades of the twentieth century. Regardless of the style he pursued at the moment, whether with a Tonalist or Impressionist palette, or with the thick, planelike brush strokes of his teacher, Carolus-Duran, or with the gauzy ones of Velázquez, Sargent viewed the picture surface as a traditional window through which one looked at a three-dimensional scene and as a surface upon which the human figure assumed preference over intricacies of design. There were brief moments in the late 1870s and again in the

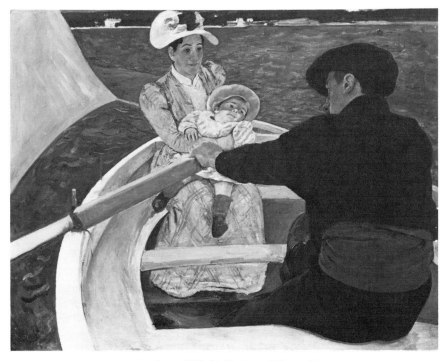

144. Mary Cassatt, *The Boating Party*, 1893–94. National Gallery of Art.

1880s when in a few semi-Impressionist landscapes it seemed as if he would develop a modernist style, but he subsequently pursued more orthodox means of composition. Now, in the late twentieth century, when modernist concern for two-dimensional pictorial organization is considered more a point of view than an article of artistic faith, Sargent's fluid and flowing brush strokes, his ability to evoke character by the posture of a sitter, and his evocation of an era ended by the First World War arouse renewed interest and excitement about his art.

Born in Florence, Italy, Sargent considered himself an artist by the time he entered his teens. In 1874, he began studying in Paris with Carolus-Duran, whose own style of layered, tonal planes and visible brushwork appealed to Sargent. In fact, Sargent's first successes as a portraitist were imitations of his teacher's style. A visit to Holland and Spain in 1879–80, where he studied the art of Hals and Velázquez, brought out further his latent robust painterliness. In Venice in 1880, where he met Whistler, and again in 1882, he painted dark, austere genre scenes, but soon after he returned to his fluent manner of painting. His stunning portrait *Madame X* (of Madame Pierre Gautreau) (1884, Metropolitan Museum of Art, New York City), which created such a scandal when shown at the Paris Salon of 1884 because of the plunging neckline and the lavender skin, prompted him to move to London. There, he developed into one of the most successful portraitists of the age because of his ability to flatter his sitters without polishing all personality out of their faces.

For a change of pace from his busy portrait schedule, Sargent experimented with Impressionist techniques during vacations at Broadway in England in 1885–86 and again at Calcot and Fladbury in 1889. In 1887, he visited Monet at Giverny and maintained a friendship with him for several years. Although Sargent never adopted Monet's palette entirely, nor atomized forms to the same extent, he shared with Monet an interest in boating scenes and outdoor figure studies [145]. The rapid-fire application of pigment and sketchlike finish of Impressionism released in Sargent an even more energetic brush stroke, one that often seemed loaded with creamy pigment. Perhaps the Impressionist necessity of immediate organization also prompted him to unify his compositions more tightly in the 1890s and to add a new vitality to the poses of his sitters. But his tighter and more planar compositions also reflected his interest in the paintings of Sir Joshua Reynolds during this decade. These very different influences came together in the murals he began to design for the Boston Public Library in 1890 (final installation in 1919), which are among the most coherent and best organized compositions of his career.

One of Sargent's finest group portraits of the period is *The Wyndham Sisters* [146]. In a suggestively opulent interior, the three sisters have arranged themselves in distinct poses, each revealing a slightly different state of mind—the reflective one on the left, the hawkish one sitting on the back of the sofa, and the centrally placed youngest one innocently flaunting her youth. Their gowns, exercises in painterly scintillation, barely suggest the presence of bodies underneath. Elegance pervades—in a manner totally foreign to, say, Eakins's portraits and even those of Whistler and Cassatt.

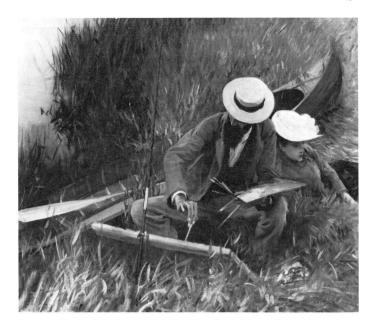

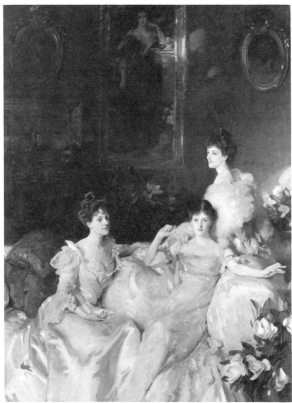

145. John Singer Sargent, *Paul Helleu Sketching with His Wife*, 1889. The Brooklyn Museum.

146. John Singer Sargent, *The Wyndham Sisters*, 1889. The Metropolitan Museum of Art.

Sargent appealed to a cosmopolitan American audience of international travelers, aesthetes, and the recently rich in search of an instant cultural heritage. William Morris Hunt (1824–79), of a slightly earlier generation, was instrumental in first introducing that audience to Continental styles, beginning in the late 1850s. Originally planning to become a sculptor, the Vermont-born Hunt studied in Düsseldorf in 1845–46, before moving to Paris. There, he studied with Thomas Couture until 1852 and then with Millet at Barbizon, returning to America in 1855. Hunt borrowed Couture's interest in generalized character and expression rather than in meticulous detail, his desire to build a painting by tonal variations, to develop the finished work right over the initial sketch, and, finally, to superimpose layers of thin pigment in order to give flesh the qualities of movement, resilience, and depth. To these characteristics, Hunt added the opaque surfaces, softer brushwork, and rounded forms of Millet.

After returning to America, Hunt initially preferred to paint large, single, idealized figures [147]. As his fame spread and as the public accepted his then modern style, he became a popular portraitist. His emotionally generous style served as an alternative to the common hard-edged stern manner well represented by New York City's popular Charles Loring Elliot (1812–68). Hunt also painted many genre scenes through the 1860s, but turned to landscape only in the 1870s, which was surprising for one so familiar with Barbizon painting [148]. (Some of Hunt's broad, horizontal landscapes of the 1870s might have influenced Winslow Homer's turn-of-the-century seascapes.)

Because of Hunt, the city of Boston, where he settled, became a center for Barbizon-trained American artists, such as Thomas H. Robinson (1835–88) and J. Foxcroft Cole (1837–92), the major Boston landscapist after Hunt's death. In addition, several adventurous collectors in Boston purchased works by Millet, Corot, Rousseau, Daubigny, and others before these artists were recognized in their own country. Hunt was also an effective teacher; William and Henry James as well as John La Farge were among his earliest pupils. Hunt's opinions were collected in his *Talks on Art* (1875, 1883), an early summation of the new currents then affecting American art. Hunt believed that the artist should interpret rather than record nature. "If you've forgotten the poetry and the mystery, you can't get it again," he said. To aid the artist, he suggested that he study Japanese art, suppress detail, and emphasize simple masses. Hunt sought the vitality of the initial impression instead of the potentially deadening effects of a carefully worked-over surface.

Among the several landscapists influenced by Barbizon artists, George Inness (1825–94) was clearly the most interesting and influential—with Winslow Homer the most important landscape painter of the last half of the century. Born in Newburgh, New York, Inness had minimal training. Apprenticed briefly as an engraver in the early 1840s, he apparently taught himself to paint by imitating seventeenth-century artists, such as Claude Lorrain and Hans Holbein. As a young artist finding his way, he was criticized for failing to record the American landscape as accurately as a Hudson River School painter, when, paradoxically, European-inspired genre painters, including Emanuel Leutze, were being praised

147. William Morris Hunt, *Margurite,*
1870. Museum of Fine Arts, Boston.

148. William Morris Hunt, *Pine
Woods, Magnolia,* 1877. Museum of
Fine Arts, Boston.

149. George Inness, *Delaware Water Gap,* 1859. Montclair Art Museum.

for the cosmopolitan tone of their work. But Inness never acknowledged the sanctity of the American landscape and, after a visit to France in 1854–55, began to incorporate Barbizon elements into his work. This was completed by the early 1860s and, through that decade, he was the most consistent Barbizonist in the New York City area **[149 and 150]**. A Barbizon movement may be said to have begun in the 1870s, when artists such as Alexander Wyant and Homer Dodge Martin started to paint in that manner.

It is impossible to know how Inness might have handled typical Barbizon elements—intimate, nonpanoramic views, pastoral scenes, forest interiors, single trees, free handling of pigment, blurred forms, and subjective ruminations—if he had not become a Swedenborgian early in the 1860s. The tenets of that religion, based on the mystical writings of Emanuel Swedenborg (1688–1772), clearly pervaded Inness's thought and art, but in ways that are not easily understood, especially since introspection, mysticism, and symbolism had filtered through the works of many artists of the period. For example, Inness's belief that "the purpose of the painter is to simply reproduce in other minds the impression which a scene has made upon him," a notion strange to the Hudson River School painters but common to earlier European Romantics as well as later modernists, such as Wassily Kandinsky, might derive from Swedenborg's writings. And Inness's belief that "the paramount difficulty with the artist is to bring his intellect to submit to the fact that there is such a thing as the indefinite—that which hides itself that we may feel after it" is a good definition of Symbolism as well as a key to Swedenborg's cosmos.

Briefly, Swedenborg believed in the indivisibility of body and soul, that in the phenomenal world there is also a spiritual world linked by correspondences.

Of this he was very certain, and he had worked out precise correlations. "Nothing is to be found in the created universe which has not a correspondence with something in man, not only with his affections and their thoughts, but also with his bodily organs and viscera." Swedenborg considered God to be the Divine Man, the embodiment of infinite love and the manifestation of infinite wisdom. From God emanated a divine sphere, which in the spiritual world was a sun and from which our natural sun proceeded—thus spirit and matter were extensions of each other. Swedenborg also believed that all things in Heaven appear as they do on earth, but as spiritual emanations rather than in equivalent spaces. Things in Heaven, therefore, were not fixed spatially, nor was God in a particular space but was omnipresent.

Inness's paintings of hazy skies and elusive suns might therefore symbolize the hidden nature of the celestial sun and, ultimately, of God. And Inness's suppression of detail and measured perspectives suggest the unfixity of spiritual space [151].

Inness attempted to show the effect an object produced rather than describe the object itself. Humans, when they appear in his paintings, seem to be emanations, as he said, of "that Infinite Mind or Spirit which we call God." In 1879, in a statement filled with religious as well as poetic and artistic implications, he said, "You must suggest to me reality—you can never show me reality." It is no wonder that he rejected overly realistic art, condemning the Pre-Raphaelites because they ignored "the reality of the unseen" and spurning the Impressionists for their literal adherence to surface impressions.

150. George Inness, *Peace and Plenty*, 1865. The Metropolitan Museum of Art.

151. George Inness, *Home of the Heron*, 1893. The Art Institute of Chicago.

In Inness's early masterpiece, *Peace and Plenty,* he used nature's forms to express his thought rather than, as in Church's almost contemporary *In the Wilderness,* to celebrate nature itself **[80 and 150]**. The painting and its title commemorated the still-present hope of an agrarian utopia in America (then recently rekindled by the Homestead Act of 1862), the end of the Civil War, and the replenishment of the American spirit from the native soil. Despite the painting's panoramic elements, it hints at intimacy because of the palpability of the pigments—opaque on objects, transparent in other areas to suggest depth—and the use of a golden tonality to draw the forms together.

Inness often organized his paintings into horizontal planes. The principal subjects, generally placed in the middle plane, were allowed to rise above the horizon line. Even if skies threatened or if the human figure was emphasized, a characteristic of the paintings of the early 1880s, all activity seemed suspended.

Through the 1880s, Inness's style grew increasingly abstract. Horizontal planes became flattened bands. Opulent color increasingly blurred details, and broad masses replaced specific forms. Inness seemed to concern himself more with the process of painting than with the subject, and, as his religious beliefs suggest, with the spiritual correspondences of natural facts **[151]**. His late paintings, like those of Homer, are remarkable for their proto-modern compositions and for their distillation of essences.

Inness's version of Barbizon art appealed to younger artists and, like Whistler's art, entered the broad current of late-nineteenth-century subjectivism. Recently, scholars have used the term "Tonalism" to identify painters influenced by these two artists, but it should be understood that Tonalism points to a general tendency rather than to a specific movement. There are no Tonalists, as there are Hudson River School painters. A near-contemporary of the Tonalists, Charles Caffin suggested in his *Story of American Painting* (1907) that these artists "through communing with nature . . . , acquired so strong a sympathy with their subject that the mood of their own spirit became reflected in nature; their works interpreted their own souls in terms of nature; they were nature poets." Wanda Corn, a modern historian, has called Tonalism "a style of intimacy and expressiveness, interpreting very specific themes in limited color scales and employing delicate effects of light to create vague, suggestive moods."

As the term "Tonalism" implies, artists who at some point in their careers passed into or through Tonalism explored subtle tonal modulations rather than the more strident color differentiations of the Impressionists. They often painted scenes of dusk and dawn, even covered with mist, to emphasize tonal relationships **[154]**. Preferring poetic truth to scientific fact, they enjoyed rural scenes rather than industrial ones, meditation rather than activity, and reverie rather than reality. The daydreams of Tonalism affected photographers as well, and we might include several turn-of-the-century figures, such as Edward Steichen and Gertrude Käsebier, as kindred spirits **[210]**.

None of the Tonalist painters had Inness's sense of inner urgency. Alexander Wyant (1836–92) developed his mature style in the 1870s, after he had worked

152. Alexander Wyant, *Autumn at Arkville*, n. d. National Museum of American Art.

153. Homer Dodge Martin, *Mussel Gatherers*, 1886. The Corcoran Gallery of Art.

in the Hudson River School manner and had studied in Düsseldorf in 1865. He painted both quiet forest interiors and horizontally banded landscapes with thickened, blurry detail and with splotches of often near-monochrome pigment [152]. Homer Dodge Martin (1836–97) also painted initially in the Hudson River School manner, but his meeting Whistler in 1876 confirmed his already apparent interest in moody, more intimate tonal studies. A stay in France from 1881 to 1889 turned him into a thorough-going Barbizon painter. Because he did not paint outdoors until the late 1880s, and then only rarely, the personality of his paintings is carried more by overall effect than by remembered detail [153].

The late landscapes of Dwight Tryon (1849–1925) are closer to Inness's work than to that of Wyant or Martin. Typically, they include rows of diaphanous trees arranged in horizontal bands rising from an earth cover of indistinct areas of grass and low wild flowers [154]. Of all the landscapes of the period, Tryon's seem to be the most fragile and refined, filled with a pervading spirit that is neither intensely personal nor religious in the western sense. Undoubtedly, his friendship after 1889 with Charles Freer, the collector of East Asian art, prompted Tryon to indicate in a more eastern way the presence of a benign spirit in the physical world. In any event, Tryon appears to have been more concerned with contemplating the oneness of spirit and matter than either describing a particular place or interrelating three-dimensional space with two-dimensional design.

The figure painter Thomas Dewing (1851–1938) is also considered a Tonalist, because of his preferences for elegiac moods and tonal use of color. Although

154. Dwight Tryon, *November Evening,* 1924. Smith College Museum of Art.

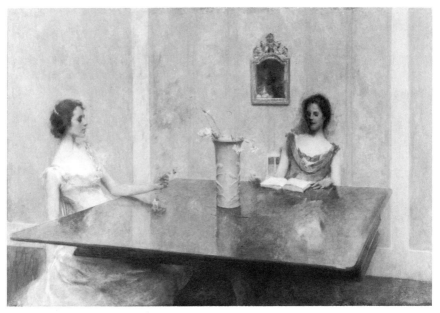

155. Thomas Dewing, *A Reading*, 1897. National Museum of American Art.

his studies with Jules Joseph Lefebvre at the Académie Julian in Paris from 1876 to 1878 encouraged his often austere compositions and the use of blank backgrounds, the influence of the seventeenth-century Dutch artist Jan Vermeer, the Japanese artist Utamaro, and Whistler are probably more important. Dewing's works generally lack narrative elements and might rather be termed meditations on beauty—on objects held by his subjects or on music in those works in which instruments are included [155]. The women he painted are neither the robust types of the American Renaissance painters nor the quietly suffering ones of Eakins; instead, they inhabit a private world not easily penetrated by the viewer.

Whatever the mood he evoked, Dewing was a first-rate arranger of forms. His figures, seemingly able to breathe and move in an ambience of their own, are also integral to the picture's structure in ways that prompt comparison with Mary Cassatt's paintings and look forward to those of Edward Hopper and Philip Pearlstein [143, 254, and 357]. Dewing often used interior reflections from mirrors to "lock in" various forms, a device that also added to the other-worldly quality of many of his paintings. Such pictorial meditations continued into the twentieth century and grew increasingly out of joint with modernist styles. Whatever their date, his works seem eternally frozen in a late-nineteenth-century time warp.

Some artists who exhibited Tonalist elements in their work also luxuriated in rich textures, lively brushwork, and, beginning in the 1880s, Impressionist color. Their subject matter appeared less remote and dreamy, and more physi-

cally responsive to the world about them. Although such artists were influenced by Barbizon painters, they also responded to the works of such artists as Caravaggio, Frans Hals, and Gustave Courbet—if not always directly, then through intermediaries. For Americans in the 1860s and 1870s, Munich, rather than Paris, was the most significant art center for learning the styles of these artists. From teachers such as Karl von Piloty and Wilhelm Diez, they learned to attack a canvas with vigorous brushwork, to model with broad, sketchlike planes rather than with subtle alterations of tones, to paint directly rather than to prepare preliminary sketches, to be as much concerned with the spirit of a picture as with the subject, to emphasize tonal variation rather than coloristic possibilities, and to prefer a dark-toned palette to a light one.

Of the approximately 275 Americans to study in Munich before 1885, when the allure of Paris began to dominate, the most important included Frank Duveneck, William Merritt Chase, and John Twachtman. Duveneck was especially significant, in part because he opened his own school in Munich in 1878, attracting many Americans to it, and because his works, seen in Boston in 1874, were among the first in America representing the Munich style. By 1877, so many excellent works in that style were sent to the exhibitions of the National Academy of Design that its conservative members limited the amount of hanging space allocated to the more progressive artists. Younger and more experimental artists, including the Parisian-trained sculptor Augustus Saint-Gaudens, promptly formed a new exhibiting organization, the Society of American Artists, to promote their own interests. The founding of the Society marked the first significant organized break with conservative artistic taste and provided needed strength and support for the more artistically adventurous Americans no longer willing to churn out versions of Hudson River School landscapes or sculpture in the neoclassical style.

Frank Duveneck (1848–1919) left his Cincinnati home for Munich in 1869 and became adept at the European style soon after his arrival. He visited Cincinnati in 1874, but returned to Munich in 1875. John Twachtman and Henry Farny accompanied him, and together with other Americans they became known as the "Duveneck Boys." They worked together in the small village of Polling and visited Venice and Florence regularly. When in Venice in 1880, they met Whistler, whose etchings proved influential and probably helped modify the excesses of the Munich style in the later works of Duveneck and his friends.

Duveneck's *Whistling Boy* is typical of the kind of painting that initially surprised American audiences in the mid-1870s [156]. It appears to be a collection of a rapid, even improvisatory, flurry of brush strokes. Clothing and flesh, which emerge from a murky "brown soup," are a patchwork of colored planes. The unblended tones of a particular color—brown or lemon-white—are often set off by another color dropped in their midst, such as the reddish plane on the young boy's cheek. But according to Duveneck's wife, the artist Elizabeth Boott, his method was anything but slapdash. He first modeled paint as if it were clay and puddled it when appropriate. Then he scraped down the surface and built up the

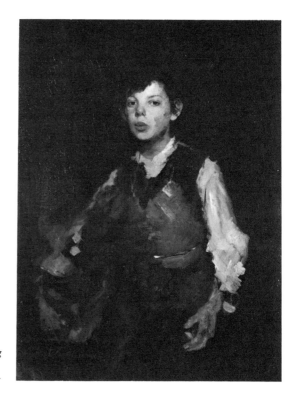

156. Frank Duveneck, *Whistling Boy*, 1872. Cincinnati Art Museum.

finished parts bit by bit, calculatingly brushing in broad lights into dark masses. He then is supposed to have spent a week painting a single eye!

Duveneck's subsequent work appears less raucous. In landscapes, he incorporated Impressionist elements, but these existed in uncomfortable association with his essentially tonal and airless style. In contrast, William Merritt Chase (1849–1916) ranged over the styles available to him, absorbed now more, now less from each, and seemed to be comfortable with all. He was, like Sargent, a thorough eclectic, a type of American artist able to create his version of a style, but unable to turn any into an original statement. (Others, such as John Twachtman, Max Weber, and Arshile Gorky, after an "apprenticeship" period, could find their own styles.) Nevertheless, Chase became extremely popular in his day, in part because he could paint with enough dazzle to attract the artistically curious, but not frighten off the fainthearted, and because he was an excellent and popular teacher. In addition, he played to the hilt the role of the elegant, bohemian artist, inventing a stateside version of Whistler's public personality.

Coming from Indiana, he studied in New York City and lived in St. Louis before attending Munich's Royal Academy from 1872 to 1878. With Duveneck and Twachtman, he visited Venice in 1877. Back in New York City, he helped found the Society of American Artists in 1877 and the Society of Painters in

Pastel in 1884; he taught in New York City, Philadelphia, and Chicago, and from 1891 to 1902 he ran a summer school on Long Island. He traveled abroad often, altering his style to reflect his latest interests. In 1881, he studied Velázquez in Spain and Manet in France and was especially impressed by the modified Impressionism of the Belgian artist Alfred Stevens. He met Whistler in 1885, but had been influenced by him earlier in the decade, and in the late 1880s he began to experiment with Impressionist techniques.

Chase's bravura brushwork formed the essential connecting link through each twist of style. His attitude toward subject matter also remained constant. A realist, he painted, in the novelist William Dean Howell's phrase, "the more smiling aspects of American life." His *Portrait of Miss Dora Wheeler* [157], an amalgam of Whistler's and Stevens's styles, shows a person more content than any of Eakins's sitters and less aristocratic than Sargent's. Subsequent figure studies ranged from Munich-inspired portraits to pure Whistlerian exercises (especially his portrait of Whistler, done in 1885 and now in the Metropolitan Museum of Art, New York City) and on to old-masterish emulations of Hals and Velázquez.

Chase's palette lightened during the 1880s, probably because of his interest in pastels. He painted increasing numbers of landscapes, but also completed several charming interior scenes and still lifes. His Impressionist seaside scenes of the 1890s, among his loveliest and most relaxed works, contain figures neither dissolved in a welter of brush strokes nor completed as if in a studio setting [158]. Flooded with an amiable light and filled with coastal flora, sparkling sand, and

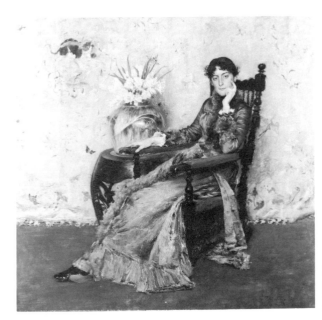

157. William Merritt Chase, *Portrait of Miss Dora Wheeler*, 1883. The Cleveland Museum of Art.

calm waters, these paintings are among the most pleasant vacation pictures ever realized by an American artist.

Chase's use of Impressionist techniques in the late 1880s was adventurous, but not radical. A decade earlier, Mary Cassatt had begun to emulate Degas's style and then Renoir's. Her work was seen in New York City as early as 1879. Paintings by Manet, Monet, Renoir, Sisley, and Degas were shown in Boston in 1883 and in New York City in 1884, and, in 1886, Durand-Ruel exhibited three hundred Barbizon and Impressionist paintings in his New York City gallery. By that time, Americans had started to visit and study with Monet at Giverny, including Willard Metcalf in 1886, Sargent and Theodore Robinson in 1887, and Theodore Butler and Lilla Cabot Perry in 1889. Subsequently, Robinson exhibited works at the Society of American Artists in 1889, and Childe Hassam returned from Europe that year, a convert to Impressionism. J. Alden Weir adopted Impressionist elements in 1891. Through the 1890s, a Boston group,

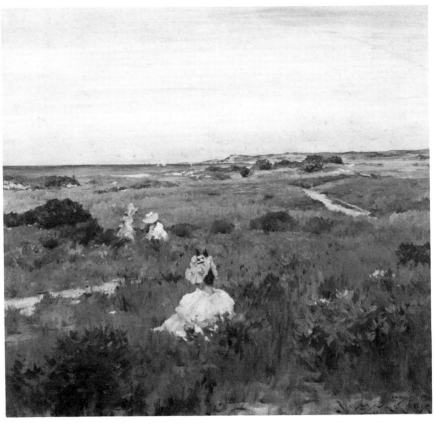

158. William Merritt Chase, *Landscape: Shinnecock, Long Island,* c. 1895. The Art Museum, Princeton University.

including Edmund Tarbell, Frank Benson, and, marginally, Joseph De Camp, employed Impressionist techniques. At the World's Columbian Exposition in Chicago in 1893, the Impressionists were finally recognized as a major force in American art, and, in 1898, a group of Impressionists, Tonalists, and allied figure painters, which became known as The Ten American Painters, formed an exhibition group to further their careers. It included Childe Hassam, Twachtman, Weir, Benson, De Camp, Tarbell, Metcalf, Dewing, Robert Reid, and Edward Simmons. When Twachtman died in 1902, Chase replaced him. The group exhibited until 1919.

Many American Impressionists explored a variety of mediums, including watercolor, etching, and pastel. Their experimentation with various processes was greater than their investigation of Impressionist techniques, however. Several artists who first studied in academic ateliers in Paris evidently refused to give up their arduously learned figure techniques by atomizing objects. Instead of imitating Monet's style or adopting Renoir's rainbow palette, they followed artists such as Bastien-Lepage, who embellished his academic technique with Impressionist window dressing. Many Americans painted the figure—often of women in interiors, adding only bright Impressionist color and noticeable brush strokes to an otherwise conservative technique. To a degree greater than that of French artists, the Americans avoided pure visual description by investing scenes with personal moods, or they provided such scenes with a portrait quality. That is, they painted particular places rather than doing exercises in color-pattern relationships. The Americans also indicated depth to a greater degree than their French counterparts. Subject matter was drawn largely from middle-class life, and several Impressionist painters in the 1890s concentrated on the visual sparkle and spectacle of urban streets and buildings as well as the activities of the wealthy. With the exception of Theodore Robinson and perhaps a few others, no American made repetitive studies of the same scene under different lighting conditions, as Monet did in the *Haystacks,* as if analysis of form by color was foreign to them. As the art historian H. Barbara Weinberg has rightly indicated, "the Americans often appear impressionizers rather than Impressionists."

If we were to extend a line between "impressionizers" and Impressionists, Theodore Robinson (1852–96) would be placed closer to the latter. From Vermont, he studied in Chicago; at the National Academy of Design from 1874 to 1876; with Carolus-Duran and Gérôme in Paris from 1876 to 1879; and then worked briefly as a decorator for John La Farge in New York City. His early paintings, dark in color even after he returned to Europe in 1884, grew lighter and brighter after he became an informal pupil of Monet's in 1887. Compared to his mentor, Robinson never dissolved forms to the same extent; he muted ultra-bright color effects and tended to use a wide tonal range of a given color rather than add yellow highlights and purple shadows. He also indicated recessions in space clearly. Since he painted several peasant figures, he might even be considered a Barbizon-Impressionist.

Compared to mid-century American landscapists, Robinson, and his con-

159. Theodore Robinson, *The Valley of the Seine*, 1892. Addison Gallery of American Art.

160. Childe Hassam, *Celia Thaxter in Her Garden*, 1892. National Museum of American Art.

temporaries, preferred domestic rather than wilderness views, visual sensation rather than religious feeling in landscapes, and neutral genre scenes rather than message-laden anecdotes. Even though his *Valley of the Seine* [159], one of three views he made of this scene, contains a church steeple in the distance, it projects absolutely none of the religious aura of, say, Asher B. Durand's *Early Morning at Cold Spring* (1850, Montclair, New Jersey, Art Museum).

After Robinson's return to America in 1892, his style grew more diffuse. In place of a firm drawing technique and disciplined composition, outlines grew hazy and color was applied with loosened strokes. Perhaps he was growing closer to Monet's style, or he might have begun to grope his way toward an as yet incomplete Post-Impressionist style, but he died before a new mode had crystallized.

Childe Hassam (1859–1935) never developed beyond Impressionism, but John Twachtman (1853–1902) leap-frogged it, as it were, to develop one of the most interesting late-nineteenth-century styles in America—an amalgam of Tonalism and Impressionism, modified by Japanese and Whistlerian influences. Both Hassam and Twachtman developed their mature styles by 1900.

Hassam, from Massachusetts, worked mainly as an illustrator and painted in a detailed manner before going abroad in 1886. Before returning in 1889 to settle in New York City, he learned to express atmospheric effects more colorfully and he developed a more textured kind of brush stroke. Although works by Monet and Pissarro ultimately lay behind Hassam's work, popular artists of the time, such as Giuseppe de Nittis and Jean Béraud, were more immediately influential, particularly for the many city views Hassam painted both abroad and in America. Of all the American Impressionists, he painted some of the most flamboyantly colorful garden scenes, with masses of flowers enlivening large areas with multihued spots of reds, yellows, and purples [160].

Before he began to devote his energies to printmaking in 1919, Hassam completed his most famous series of works, which show Fifth Avenue as "the Avenue of the Allies," to commemorate the end of the First World War. The flutter of the seemingly airborne flags helps charge the street with the electricity of celebration. But Hassam's views, when compared to similar celebration scenes by Europeans, such as Van Gogh and Monet, are more reticent in color, less frenzied in brush strokes, more logical in spatial articulation, and more specific in geographical location.

John Twachtman, on the other hand, was a more probing artist and less popular during his lifetime, probably for that reason. From Cincinnati, he accompanied Frank Duveneck to Munich in 1875, visited Venice in 1877, returned to the United States until 1881, and visited Europe again, where he remained until 1885. During his studies in Paris with Gustave Boulanger and Jules Lefebvre, a lighter-keyed style replaced his dark Munich-influenced manner, probably the result of his knowledge of Japanese prints and Whistler's nocturnes. Twachtman's Tonalist masterpiece, *Arques-la-Bataille,* a moody study in gray-greens accented with selectively detailed waterside plants, clearly reflects his nonacademic interests [161].

Friendly with many American Impressionists and especially responsive to

Theodore Robinson's work after his return to America, Twachtman let his palette grow even lighter and his compositions even more abstract in the late 1880s. Through the 1890s, he painted several intimate, light-colored landscapes, including many of the waterfalls and rapids on his farm in Connecticut [162]. These works, among the most original of the decade, combine Tonalist nuances with the opacity and textures of Impressionist brushwork. And although boulders, small pools of water, and bushes are easily identifiable, their shapes and placement are determined by a keen sense of abstract relationships of form.

Among works by artists living in America, only the paintings of Arthur Wesley Dow (1857–1922) and Albert Pinkham Ryder (1847–1917) were at least as formally incisive or as close to European Post-Impressionist developments. Dow, who lived in Pont-Aven in 1886 and again in 1888–89, when Gauguin lived there, is better remembered as a teacher of Max Weber and Georgia O'Keeffe than as a strong painter. Ryder, however, created a substantial body of work over an almost forty-year period that places him in the forefront of artists of this time.

From New Bedford, Massachusetts, Ryder settled in 1870 in New York City, where he became a founding member of the Society of American Artists. Late in his life, he explained in dramatic language the genesis of his mature style. "The old scene presented itself one day before my eyes framed in an opening between two trees. It stood out like a painted canvas—the deep blue of a midday sky—a solitary tree—a foundation of brown earth. There was no detail to vex the eye. Three solid masses of form and color—sky, foliage and earth—the whole bathed in an atmosphere of golden luminosity. I threw my brushes aside; they were too small for the work in hand. I squeezed out big chunks of pure, moist color and taking my palette knife, I laid on blue, green, white and brown in great sweeping strokes."

Although he described his style accurately (most colors have long since faded to browns and grays), he told only a part of the story, since his content is just as interesting and certainly more enigmatic than his manner of composition. A painter of small landscapes in the 1870s, he added literary, biblical, operatic, and marine themes to his repertory in the 1880s [163]. Perhaps Ryder's biblical subjects were influenced by the religious images of Robert Loftin Newman (see below), who lived in the same building as Ryder in the 1880s. And Ryder might also have been aware of the religious work of John La Farge, a Newman admirer, who had painted *The Resurrection* in St. Thomas's Church in 1877–78. In a way parallel to that of his idol, the composer Richard Wagner, Ryder wanted to present his subjects as pictorial dramas rather than in an anecdotal manner. One theme that runs through several biblical and literary works is the contest of good against evil (*Constance* [1896, Museum of Fine Arts, Boston], from Chaucer's "Man of Law's Tale" in *The Canterbury Tales, The Tempest* [after 1890, Detroit Institute of Arts], from the play by Shakespeare, and *Jonah* [164]). In these paintings, good triumphs—in the *Constance* and the *Jonah* with God's help. It would seem, therefore, that Ryder was asserting his faith against the challenge of Darwinism—that in a malign world God redeems those who display personal fortitude.

161. John Twachtman, *Arques-la-Bataille,* 1885. The Metropolitan Museum of Art.

162. John Twachtman, *Snowbound,* c. 1895. The Art Institute of Chicago.

163. Albert Pinkham Ryder. *Marine Moonlight,* c. 1880s. The Brooklyn Museum.

The entirely personal way in which Ryder composed and painted these works allies him with a variety of artists whose paintings border on the mysterious, if not the mystical. These include Robert Loftin Newman (1827–1912), George Fuller (1822–84), William Rimmer (1816–79), Elihu Vedder (1836–1923), and Ralph Blakelock (1847–1919).

Newman, a recluse like Ryder, studied briefly with Thomas Couture in Paris in 1850, visited Millet in Barbizon in 1854, and returned there briefly in 1884. Known to William Morris Hunt and John La Farge (and supported by artists), he worked for the artist-designer Francis Lathrop in New York City from 1873 to 1879. Newman preferred to paint children, as well as mothers and children, often providing them with religious connotations [165]. His spectral figures emerge from murky, barely indicated landscapes defined as much by arbitrary lights as by their bodily contours. Although he spent only six months with Couture, Newman followed his teacher more closely than other Americans. He massed highlights and shadows like Couture and seemingly accepted as literal truth Couture's statement, which appeared in his *Méthode et entretiens d'atelier*

164. Albert Pinkham Ryder, *Jonah,* c. 1885.
National Museum of American Art.

165. Robert Loftin Newman, *Madonna and Child,* 1897. The Brooklyn Museum.

166. George Fuller, *The Dandelion Girl,* 1877. Museum of Fine Arts, Boston.

(1867; translated in 1879): "Beauty of outline, beauty of masses, as beauty of color require an incessant sacrifice of detail."

George Fuller's figures look both spectral and spooked. Fuller, from Massachusetts, began his painting career in 1841, became a farmer about twenty years later, and was rediscovered in 1875. He resumed his career in Boston, where his rural figures [166] undoubtedly recalled those of Allston and the recently deceased Hunt. Although Fuller toured Europe in 1860 and liked Millet's paintings, his figures are neither robust peasants nor heroic laborers. Rather, they tend to be immobile, hesitantly tied to the scumbled, scraped, and layered surfaces through which they softly glow.

Unlike Newman and Fuller, Ralph Blakelock emphasized the landscape. If figures were present, they added to but did not dominate the prevailing mood. Beginning in the mid-1870s, Blakelock enjoyed painting quiet evening scenes in which moonlight or the setting sun burned through large, fully leafed, and wonderfully textured trees [167]. Although his haunting landscapes are usually considered products of reverie and imagination, they are in fact reasonably accurate images of the forest after dusk. Nevertheless, Blakelock chose the time of day most easily given to moments of brooding and deep thought.

The paintings of Elihu Vedder, especially those of the 1860s, are much more crisply and cleanly painted than those of the other artists, but their meaning is more obscure—and purposely so. Some, like *The Questioner of the Sphinx* [168],

were painted in the United States between 1861, after Vedder returned from a five-year stay in Europe, and 1865, when he settled permanently in Italy. About this painting he wrote in 1884, "my idea in the sphinx was the hopelessness of man before the immutable laws of nature." He subsequently said about the monuments of Egypt, "it is their unwritten meaning, their poetic meaning, far more eloquent than words can express; and it sometimes seemed to me that this impression would be chilled or lessened by a greater unveiling of their mysteries, and that to me Isis unveiled would be Isis dead."

After returning to Europe in 1865, he painted the first of several images of pensive young women. Seen as if in a sensuous dream, they suggest neither a specific time nor connote a particular action. On occasion, Vedder allowed glimpses beneath the surface equanimity of these paintings, as well as of other works, such as his illustrations for the *Rubáiyát* of Omar Khayyám, completed in 1884. One can well imagine several of Eakins's sitters pouring over this poem about the sadness of life and the unfulfilled nature of one's dreams. In Vedder's *The Soul in Bondage* [169], a more terrifying image than, say, Hiram Powers's *The Greek Slave* [115], the entire painting vibrates in sympathy with the constrained soul in a manner not unlike that in Edvard Munch's *The Scream*.

It is altogether too easy—and wrong—to assume that Vedder and other highly imaginative artists communicated only with their private muses. They

167. Ralph Blakelock, *Moonlight*, c. 1885–89. The Brooklyn Museum.

168. Elihu Vedder, *The Questioner of the Sphinx*, 1863. Museum of Fine Arts, Boston.

169. Elihu Vedder, *Soul in Bondage*, 1891. The Brooklyn Museum.

were, after all, nineteenth-century, not twentieth-century, artists. Vedder, for example, also painted monumental figures perfectly suited for public murals. In fact, his *Rome,* or *The Art Idea* **[170]**, installed at Bowdoin College with additional murals by Abbott Thayer (*Florence,* 1894), Kenyon Cox (*Venice,* 1894), and John La Farge (*Athens,* 1898), is a major example of the American Renaissance. Like much public art of the time, Vedder's panel carries allegorical meaning. Of it, he wrote that the right hand of the figure, Nature, "rests on the trunk and roots of the Tree of Life; her left holds a detached branch with its fruit— an art having reached its culmination never lives again; its fruit, however, contains the seeds of another development."

The American Renaissance was a diffuse movement that, like Tonalism, arose after the Centennial Exposition in Philadelphia in 1876 and lasted until the 1920s. The art exhibitions at the Centennial demonstrated that American art had not yet reached the level of sophistication of European art. Young artists, returning from Europe in the immediately succeeding years, wanted to transplant to America the great traditions of the European past as if to fulfill the centuries-long European dream of America's great promise. In actuality, this meant not only reviving the styles of the Renaissance and those of painters such as Sir Joshua Reynolds, whom John Singer Sargent admired, and sustaining the academic principles of the Ecole des Beaux-Arts, but also creating unified environments in which architecture, sculpture, painting, and the decorative arts were integrated. The reassertion of the academic ideal was also supported by the publication of Walter Pater's *Studies in the History of the Renaissance* (1873; American edition, 1877) and Jakob Burkhardt's *The Civilization of the Renaissance in Italy* (1860; American edition, 1879), as well as by individuals as disparate as Darwin and Matthew Arnold, the English literary figure. Proponents of the American Renaissance probably viewed the movement as the survival and continuation of the best

170. Elihu Vedder, *Rome,* 1894. Bowdoin College Museum of Art.

qualities in art, and Arnold's notion, expounded in his popular *Culture and Anarchy* (1869), that an elite remnant must save society from the barbarians certainly comforted those supporting an art of high refinement. The irony, of course, is that many patrons were predatory industrialists, financiers, and businessmen hellbent on acquiring an instant heritage, even if it was not theirs. Their vision of themselves can still be seen in the architectural extravaganzas, some with entire rooms imported from Europe, in Newport, Rhode Island.

The American Renaissance also fulfilled the desire for a cosmopolitan art expressed by the American Art Union in the 1840s and 1850s. Paradoxically, it may also be regarded as a very sophisticated version of early-nineteenth-century republican art, a last hurrah for a communal, shared American art, for the following reasons: artists worked together on group enterprises in churches and private mansions, painted murals in public places, used Renaissance sources that were neither obscure nor difficult to understand, and created works for an easily identifiable clientele, which obviously shared their interests. But it is also just as clear that the Medician nature of the commissions, the stylistic and thematic borrowings from an idealized past, and the expensive materials used meant a nearly total rejection of the attitudes of the Founding Fathers. True, American scenes were sometimes painted, but in storybook fashion. And, finally, just as the American Renaissance summed up the past in a perverse way, it also looked to the future, for it helped prepare the way for avant-garde movements that also ignored the nation's heritage, geographical particularities, and social concerns.

The artists associated with the movement presumably believed in the continuity of great art through the ages. Renaissance and Baroque masters were considered guides and mentors, as well as distant contemporaries. Time, rather than implying a distancing action, came to signify an extended frozen moment. As Kenyon Cox, the artist and writer, explained in his *The Classic Point of View* (1911), "the Classic Spirit is the disinterested search for perfection; it is the love of clearness and reasonableness and self-control; it is, above all, the love of permanence and of continuity . . . It would have each new work connect itself in the mind of him who sees it with all the noble and lovely works of the past. . . . It wishes to add link by link to the chain of tradition, but it does not wish to break the chain."

John La Farge (1835–1910) is the major artist of the American Renaissance, a pioneer muralist as well as an important theorist. Born in New York City, he was raised in a thoroughly cosmopolitan atmosphere. He had met Inness about 1855 before going abroad in 1856, where he studied briefly with Thomas Couture. In 1859, he became a pupil of William Morris Hunt, probably the most advanced American teacher at the time, but La Farge, very sophisticated even then, found Hunt's work old-fashioned because it lacked air, light, and space.

La Farge's precociousness was revealed in a decorative project of 1860, showing Japanese influence, and in his *Flowers on a Window Ledge*, which combined indoor and outdoor lighting effects and subtle atmospheric changes [171]. La Farge also challenged himself with interesting landscape projects, as in

171. John La Farge, *Flowers on a Window Ledge*, 1862. The Corcoran Gallery of Art.

172. John La Farge, *Bishop Berkeley's Rock, Newport*, 1868. The Metropolitan Museum of Art.

Bishop Berkeley's Rock, Newport [172], in which he tried to paint from nature, but also to create a work of art—to combine reality with artifice without emphasizing the latter in typical European fashion. As he said, "in nature, nothing sticks out, the problems are *not visible* in nature. Nature . . . looks as if it had done itself and not been done by an artist."

La Farge's flower pieces of the 1860s and especially those of the 1870s and 1880s are fascinating not only because of the obvious Japanese influences on his style, but also because of the emphasis on natural environments. These are outdoor still lifes, and flowers or plants are brought together as they might actually appear in nature, a novel departure from earlier arbitrarily arranged floral arrangements. (Martin Johnson Heade's hummingbird and orchid studies of the 1860s and 1870s are also painted in their natural environments. Perhaps not coincidentally, Darwin, who was probably known to La Farge and Heade, also wrote about orchids at this time.)

La Farge's interest in the ideal had begun to dominate his interest in the real by 1870. This led to his participation in the building and decoration of the first great monument of the American Renaissance, Trinity Church in Boston. Designed by Henry Hobson Richardson in 1872, the structure was decorated by a team of painters and sculptors led by La Farge. Within the next decade, he completed murals for St. Thomas's Church (1877–78), Church of the Incarnation (1885), and Church of the Ascension (1886–88), all in New York City. He favored an eclectic, coloristic style based on sixteenth-century Venetian sources, as well as the paintings of Eugène Delacroix, with occasional glances at the Roman-

173. John La Farge, *Halt of the Wise Men*, c. 1869. Museum of Fine Arts, Boston.

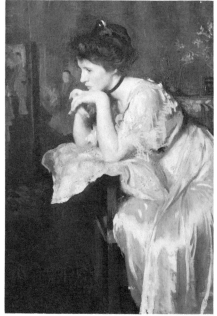

174. Abbott Henderson Thayer, *Virgin Enthroned*, 1891. National Museum of American Art.

175. Edmund C. Tarbell, *Reverie*, 1913. Museum of Fine Arts, Boston.

Florentine High Renaissance. For his secular and religious figures, whether earthbound or airborne, La Farge sought believability, but also elegance, a balance between realism and idealism [173].

His later murals, as well as those completed by other artists in the 1890s and after, grew more academic. Figures, increasingly derived from High Renaissance sources, lost credibility in their transformation to museum-like images. Some artists, such as Abbott H. Thayer (1849–1921) and George de Forest Brush (1855–1941), never managed to paint figures that comfortably inhabited their clothing. Figures always seemed dressed in costumes, playacting their assigned roles, as in Thayer's *Virgin Enthroned* [174]. Nevertheless, the female subjects generally looked happier and more vigorous than the sad, bored women in the paintings by the Boston Impressionists—Joseph De Camp and Edmund Tarbell [175]—who seemed to have nothing better to do than to dress up and sit around.

STILL-LIFE PAINTING

In the early twentieth century, distinctions between types of subject matter grew meaningless, but in the immediately preceding decades still-life painting remained a separate category with its own practitioners. At least two types of still-life painters flourished: those who painted flower pieces in a brushy, sketchlike style, and those who preferred to paint objects—usually common, humble objects—in a precise, realistic manner. La Farge was an important flower painter. Maria Oakey Dewing (1845–1927) was probably the most significant flower specialist. She became a flower painter in 1862, even before she began to study art seriously later in the decade, but her most fully realized works date from the 1880s. At that time, she often painted asymmetrically cropped, close-up views of flowers, isolating fragments for intimate study, attention, and contemplation [176]. Japanese influence is evident, as much in her flattened compositions as in her evocations of an interior world slightly beyond the viewer's grasp. As she indicated in 1915, "the exhaustive expression of the inexhaustible suggestion of nature can never be attained."

In contrast, the ultra-realistic, or *trompe l'oeil*, painters probably thought that truth and understanding lay in precise, external description. Yet, depending on the content and the manner of presentation, a variety of meanings adheres to their works.

William Michael Harnett (1848–92) is the chief figure among the *trompe l'oeil* artists, the one most responsible for popularizing a meticulously realistic art after the Civil War. Trained as an engraver, he studied art in New York City before turning exclusively to painting in 1875. His early works, dark in tone and stark in presentation, included fruit and vegetable pieces as well as writing tables, which might be covered with open books, sheet music, vases, and smoking pipes. At least once, he painted a rack picture, which was a meticulous study of flat pieces of paper held down by crossed ribbons. Harnett went abroad in 1880 and lived in Munich from 1882 to 1886, where he painted four versions of *After the Hunt*. These paintings as well as later works consisted of objects hung from a wall

176. Maria Oakey Dewing, *Garden in May,* 1895. National Museum of American Art.

177. William Harnett, *Still Life—Violin and Music,* 1888. The Metropolitan Museum of Art.

178. John Peto, *Reminiscences of 1865,* 1897. Wadsworth Atheneum.

or a door with eye-fooling emphasis on textures and shadows [177].
John Peto (1854–1907), another important *trompe l'oeil* artist, whose career
began in the middle 1870s, allowed his objects greater "breathing space" than
Harnett in his austere arrangements. Although influenced by Harnett, he played
down the simulation of objects by softening edges of forms and permitting brush
marks to be seen. His range of subjects included common household objects
(newspapers, food) placed on table tops; bookshelves filled with old books; ink
wells, candles, and broken objects; and musical instruments, often hung on doors
or walls and letter racks. Unlike Harnett, Peto preferred to paint old and common
objects rather than more costly ones, often adding a portrait of Lincoln to his
paintings [178]. His "lost and found" sensibility bears a striking relationship to
the works of Robert Rauschenberg and other mid-twentieth-century assembla-
gists (see Chapter 8). The differences between the works of Harnett and Peto
suggest the range of meanings available to artists who used similar subjects and
styles. Harnett, more conscious of abstract arrangements and impersonally
painted surfaces, seems more classical in comparison to Peto's autobiographical
romanticism, in which images often suggested notions of decay, pessimism, and
death. Similar contrasts also occur in the works of, say, the photographers Carle-
ton Watkins and Eadweard Muybridge, and in late-twentieth-century earth art-
ists such as Michael Heizer and Robert Smithson, the former in each contrasting
pair being the more classical and the latter the more romantic.

SCULPTURE

Developments in sculpture through these years were nearly as complex as those
in painting, but we can follow the activities of the sculptors most easily by
concentrating on three significant trends: first, the continuation and expansion of
the kind of naturalism represented by Henry Kirke Brown; second, the continua-
tion and expansion of neoclassicism in a second generation of expatriates in Italy;
and, third, the importation of the naturalistic styles associated with the Ecole des
Beaux-Arts in Paris in the mid-1870s. Altogether, these trends point to a surpris-
ing amount of activity in a field in which expenses for materials were high and
collaboration between sculptors and patrons—federal and state governments in-
cluded—was essential.

Since many public and private commissions had educational as well as
morally uplifting themes, sculpture, rather than painting, became the medium
through which an "official" American art was best projected through these
decades. That is, the kind of high style that artists such as Vanderlyn and Morse
wanted to bring to America early in the century flourished in sculpture later in
the century to a greater extent than in painting, and the public triumphs denied
to the earlier painters were achieved by this generation of sculptors, despite the
fact that a central patronage system or art organization, such as a royal academy,
never existed. Ironically, the reasons for the successes of these sculptors were the
same reasons that later modernist critics and historians used to condemn them.
Also, just as these sculptors were criticized for their desire to both reflect and to

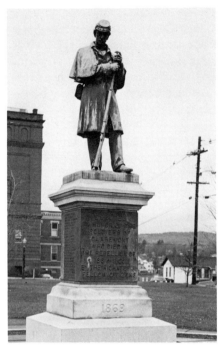

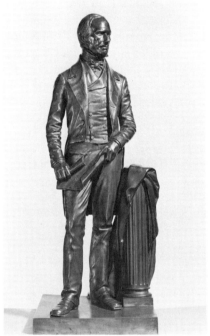

179. Martin Milmore, *Civil War Memorial*, 1869. Claremont, N. H.

180. Thomas Ball, *Henry Clay*, 1858. North Carolina Museum of Art.

lead popular taste, they were also attacked for their innocence in the face of the many formal and compositional problems that have engaged twentieth-century artists and their audiences. It is still not always easy to accept late-nineteenth-century sculpture on its own terms.

Among the several artists who developed naturalistic styles, Thomas Ball (1819–1911), John Quincy Adams Ward (1830–1910), and Martin Milmore (1844–81) are the most prominent. They often worked in bronze, and populated many plazas and parks with public monuments—especially Milmore, whose many Civil War memorials emphasized the contributions of the foot soldier rather than the military leaders and statesmen [179]. The work of these sculptors tends to be straightforward and undramatic, relying on the accretion and appreciation of facts rather than on emotions or emphatic compositional arrangements.

Ball turned to sculpture in the early 1850s, modeling portrait busts before he settled in Florence from 1854 to 1857. On his return, he designed one of his most successful pieces, a statuette of Henry Clay, which was among the first figures to be cast at the Ames Foundry in Chicopee, Massachusetts [180]. (For the next several years, this was probably the major foundry in America and was used by several prominent sculptors.) Ball returned to Florence in 1865, where he remained until the late 1890s; but never forgetting his American heritage or audience, he designed several heroic-sized groups with American themes, includ-

ing the *Emancipation Group* (Lincoln and a freed slave) for Washington, D.C., in 1874.

The Irish-born Martin Milmore apprenticed with Ball from 1858 to 1862, while the latter was completing his monumental equestrian statue of George Washington (Boston Public Garden), and then went on to become New England's leading sculptor during the 1860s. In addition to making portrait busts, Milmore devoted considerable attention to Civil War monuments [179], the first one being designed, soon after the termination of hostilities, for the Forest Hills Cemetery in Boston.

John Quincy Adams Ward, more famous than Ball or Milmore, was also artistically more adept, especially since he recognized the change in styles through the mid-1870s and incorporated into his later works the livelier surfaces and textures of the Beaux-Arts style. From Ohio, he worked for Henry Kirke Brown from 1849 to 1856, absorbing the latter's naturalistic manner, particularly during the creation and construction of Brown's equestrian *George Washington* (1853–56) for New York City's Union Square. Like Brown, he wanted to develop a sculpture suitable for Americans, believing, as he wrote in *Harper's Magazine* in June 1878, that "an American sculptor will serve himself and his age best by working at home." Although he favored a naturalistic style, he did not want to be limited by it. In a distant echo of Sir Joshua Reynolds's idealism, Ward held that "the true significance of art lies in its improving upon nature." Ward's "elevated" naturalism, then, based on nature rather than on classical or Renais-

181. John Quincy Adams Ward,
Indian Hunter, 1860. The New-York
Historical Society.

sance prototypes, included idealized images of Indians and blacks as well as famous contemporary figures [181]. (Ward was one of several sculptors, including Thomas Ball, Anne Whitney, and John Rogers, to portray blacks in major pieces.) Through the 1870s and after, Ward received several commissions for portrait busts and full-length sculptures of Civil War luminaries, of which the best is probably his Parisian-influenced *Henry Ward Beecher Monument* at Brooklyn's Borough Hall [182]. Flanking the abolitionist leader are two children and a black woman, placing a palm branch at Beecher's feet.

As the sophistication of Emanuel Leutze's work compares to the earthiness of William Sidney Mount's, so Milmore's and Ward's pieces compare with those of John Rogers (1829–1904), one of the most enterprising sculptors who ever lived. Beginning with the *Checker Players* in 1859, Rogers created a long series of genre groups based on everyday events and scenes, which were mass-produced and sold to an appreciative public. (The first casts were actually made from *The Slave Auction,* also of 1859.) Occasionally, Rogers found his point of departure in literature, but most works were derived from his own impressions and observations. The figure groups, ranging in height from eight to twenty-three inches, are entertaining, but they also contain wry comments on contemporary activities as well as psychological insights into the roles Rogers assigned to his characters [183]. The characters are forthright, shy, emotional, or awkward, and indicate the sculptor's genuine ability to suggest personality in a pose, gesture, or implied movement.

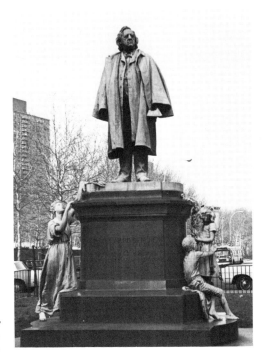

182. John Quincy Adams Ward. *Henry Ward Beecher Monument,* 1891. Brooklyn.

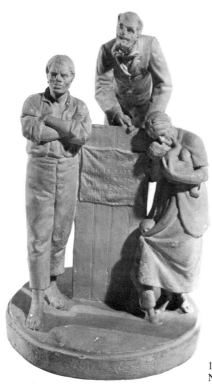

183. John Rogers, *The Slave Auction*, 1859. The
New-York Historical Society.

Unlike Rogers, who spent barely a year, 1858–59, in France and Italy,
several of his contemporaries looked forward to visiting Europe and, finding it
irresistible, decided to remain permanently. Forming the second generation of
sculptors abroad—following Greenough, Crawford, and Powers—they settled
largely in Italy. The principal figures are William Wetmore Story (1819–95),
Randolph Rogers (1825–92), and William Henry Rinehart (1825–74), along with
several important women sculptors, including Harriet Hosmer (1830–1908) and
Edmonia Lewis (1845–?).

Preferring subjects drawn from the Bible, antiquity, and literature—espe-
cially Romantic poetry—rather than exploring American themes, they turned out
a steady stream of idealized, serene, beautiful, and largely unexpressive figures
characterized by smoothly modeled surfaces and subtle transitions of planes. The
Americans tended to eliminate from their figures violent movements and emo-
tions, and to replace these with a sentimental, even saccharine, gloss. Details,
generally discretely placed, often competed with overall compositional elements
for the viewer's attention. Popular works, such as Randolph Rogers's *Nydia, the
Blind Girl of Pompeii* [185], or Harriet Hosmer's *Puck* (1856), were replicated
in large numbers by Italian artisans to satisfy the great demand for copies. But
whether a work was copied over or not, the finished marble version was usually
carved by artisans, following the plaster cast taken from the clay model.

The political and social turmoil then convulsing Europe and America hardly influenced these American sculptors' art; in a way comparable to the Hudson River School landscapes, sculpture provided an entrance into a never-never land of idealized spirit, proper behavior, and moral uplift, which acted as a soothing balm in the face of world affairs. Working well within the conventions established by Antonio Canova and Albert Bertel Thorwaldsen—the leading Neoclassical sculptors of the period—the Americans also found models in Renaissance artists, such as Michelangelo. As a result, observers questioned their significance. Nathaniel Hawthorne, for example, has two characters engaged in the following dialogue in *The Marble Faun* (1860), as they describe William Wetmore Story's *Cleopatra* **[184]**. Miriam, the painter, argues that "except for portrait busts, sculpture has no longer a right to claim any place among living arts. It has wrought itself out, and come fairly to an end. There is never a new group nowadays; never even so much as a new attitude. Greenough . . . imagined nothing new; nor Crawford either, except in the tailoring line." In response, Kenyon, the sculptor, says, "I shall steadfastly believe that future sculptors will revive this noblest of the beautiful arts, and people the world with new shapes of delicate grace and massive grandeur. Perhaps mankind will consent to wear a more manageable costume; or, at worst, we sculptors shall get the skill to make broadcloth transparent, and render majestic human character visible through coats and trousers of the present day."

Story's *Cleopatra,* the result of several years in Italy—he settled in Rome in 1851—was one of several female figures he designed in the course of a successful

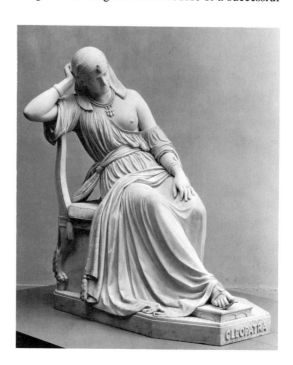

184. William Wetmore Story, *Cleopatra,* 1869. The Metropolitan Museum of Art.

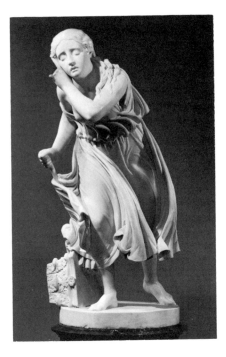

185. Randolph Rogers, *Nydia, the Blind Girl of Pompeii,* c. 1856. The Brooklyn Museum.

career. His audience, better versed than present-day viewers in religious and literary subjects, usually understood the intent or message conveyed by a statue, so the meaning would unfold as both the overall pose and the specific details were "read." In comparison with his contemporaries, Story sometimes sought morbid subjects associated with exotic persons in order to provide his work with emotional excitement. Along with his *Cleopatra,* he also modeled a *Medea* (1864) and a *Salome* (1870). All seem to be studies in correct archaeological detail as well as in differing states of emotion. Cleopatra is contemplative, Medea barely controls her rage, and Salome appears determined. Each figure was taken from a different source—history, ancient literature, and the New Testament—indicating, whatever the stylistic sources, the many possible combinations of subject and pose available to a well-educated and talented sculptor.

 Randolph Rogers, like all neoclassical sculptors of his generation, also turned to literary themes. His most famous work, *Nydia, the Blind Girl of Pompeii,* was based on a passage in Edward Bulwer-Lytton's *The Last Days of Pompeii* (1835). Although an ideal figure, this statue also reflects Rogers's desire to add an element of anecdotal naturalism to his work [185]. Based on the famous Hellenistic statue *The Old Market Woman,* it reveals Rogers's concern for suggesting movement and intense expression through deep undercutting. Rogers was friendly with Crawford during the 1850s, and his interest in baroque movement might have been prompted by the older artist's style at the time. In any event, Rogers completed in a sympathetic manner Crawford's *Washington Monument* (c. 1866) in Richmond, left unfinished at the latter's death.

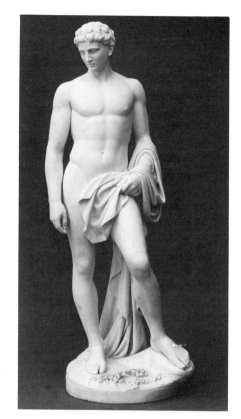

186. William Henry Rinehart, *Leander,*
c. 1858. The Newark Museum.

187. Harriet Hosmer, *Beatrice Cenci,* 1853–55.
Saint Louis Mercantile Library.

Like Crawford, Rogers was also commissioned to design a set of doors for the United States Capitol. But unlike Crawford, Rogers lived to complete his set, the "Columbus Doors," based on Ghiberti's "Gates of Paradise" for the Florence Baptistry. Rogers's doors, installed in 1862, were the first to be placed in the Capitol; Crawford's designs for the House and Senate wings were completed by William Rinehart between 1861 and 1866. (The Senate doors were installed in 1866, the House doors in 1905.)

Rinehart, considered by the art historian Wayne Craven to be the sculptor most responsible for extending the neoclassical tradition through the third quarter of the century, also responded to Crawford's work, but more to Crawford's subject matter—statues of children, for example—than to his style. In fact, Rinehart's figures tend to be motionless rather than agitated, serene rather than emotional. Although his portraits, like those of the other sculptors, tended to be naturalistic, and his genre pieces were tinged with sentimentality, his ideal works were among the most refined of the time. Rinehart's *Leander* [186], a "neoclassicized" version of Michelangelo's *David,* is considered the finest male figure of the period, just as his subsequent *Clitie* (1872) has been called the best female nude.

Harriet Hosmer was the most famous of the several women sculptors who were either expatriates in Italy or who remained there for extended periods of time. She, too, mined the literary and classical past for subjects and, like Story, found exotic and occasionally disturbing themes. Her *Beatrice Cenci,* one of the finest reclining figures of the age, displays another characteristic of the neoclassical sculptors—suggesting the contours of the body beneath the enclosing folds of drapery [187].

The exhibition of sculpture at the Centennial Exhibition in Philadelphia in 1876 marked the triumph but also the swansong of the neoclassical style, for included among the exhibits were works by Augustus Saint-Gaudens (1848–1907), Daniel Chester French (1850–1931), and Olin Warner (1844–96). The style of their works, revealing Parisian influences, quickly gained ascendancy and dominated American sculpture through the opening years of the twentieth century. The most important works in this manner may be bracketed between 1881, when Saint-Gaudens completed his early masterpiece, the *Admiral David Farragut Memorial,* and 1922, when French's *Abraham Lincoln,* a popular subject through these years, was placed in the Lincoln Memorial in Washington, D.C. The Beaux-Arts style was also seen to good advantage at the world's fairs and expositions in Chicago in 1893, Buffalo in 1901, St. Louis in 1904, and San Francisco in 1915.

Learning their craft from a host of French teachers, including François Jouffroy, Henri Michel Chapu, and Jean Alexandre Joseph Falguière, the Americans imbued their figures with a decided sense of life. Details, while present, were subordinate to overall effects. Since bronze was the preferred material, surfaces were more insistently modeled and appeared more vibrant because of the varied shadows and highlights. Although quotations and paraphrases still abounded, mostly from Renaissance artists, the new work appeared more naturalistic than that of the neoclassicists and, at the same time, was imbued with a greater sense

of personality and spirit than that of such earlier sculptors as Henry Kirke Brown and John Quincy Adams Ward.

Subject matter was broad and included portraiture, American themes—early settlers, military heroes, blacks, and Indians—ideal figures based on literary and historical sources, and personifications of concepts or places, such as Virtue or Europe. Sculptors emphasized three-dimensional qualities to a greater extent than before, and relief sculpture, which several earlier artists had attempted, was brought to a level of extraordinary sophistication, especially by Saint-Gaudens. Luckily, in a booming and expansive economy, sculptors received many public and private commissions, often in collaboration with painters, architects, and decorative artists. For example, Daniel Chester French and the architect Henry Bacon worked together on almost fifty projects. Their combined efforts, together with those of other artists, are now considered part of the American Renaissance, which gave to American art a splendor and opulence unmatched before or since.

Although Howard Roberts's *The First Pose* (1873–76, Philadelphia Museum

188. Augustus Saint-Gaudens, *Admiral David Farragut Memorial*, 1881. New York City.

of Art), a medal winner at the Philadelphia Centennial, was the first major work in the Parisian style to be seen in America, the sculpture of Saint-Gaudens set the general tone and established the standard against which other works were then and still are measured. This was apparent as early as 1875 with Saint-Gaudens's *Silence,* a robed female figure whose form and meaning are not easily traceable to specific sources, even though Saint-Gaudens studied in Paris with Jouffroy from 1868 to 1870, spent the next two years in Rome, and visited Rome again in 1874–75. Subsequently, Renaissance influences, particularly those of Donatello, appeared in his work and could be seen in the now destroyed low-relief panels he completed in collaboration with John La Farge for St. Thomas's Church, New York City, at the end of the decade.

Saint-Gaudens beautifully combined relief carving and free-standing sculpture with architecture in his *Admiral David Farragut Memorial,* completed in collaboration with the architect Stanford White [188]. Saint-Gaudens designed other significant war memorials as well—the *Robert Gould Shaw Memorial* (1884–96), a giant relief panel set up near the Boston State House, and the *General William Tecumseh Sherman Memorial* (1897–1903) in New York City, one of the finest equestrian groups in America—but his most interesting, even idiosyncratic, commemorative piece was the *Adams Memorial* in Washington, D.C. [189]. An abstract robed figure leans against the simple tomb of Henry Adams's wife, Marian, signifying the acceptance and contemplation of the inevitable. Saint-Gaudens's surfaces were, however, usually more intimately modeled, catching in their slight depressions and lifts the nervous play of light; they reflected clearly the mind and the hand movements of an expert modeler rather than carver.

Daniel Chester French was a modeler too, who spent two youthful years, from 1875 to 1877, in Florence rather than Paris. Like Saint-Gaudens, he worked in a naturalistic manner, perhaps the result of a brief period of study with John Quincy Adams Ward in 1870. Like Ward, he wanted to "work from Nature, but [to] improve on her," as he wrote to his brother in 1874. Over the next several decades, he created several monumental allegorical figures for a variety of public buildings, and, together with a glittering array of leading sculptors of the time —Saint-Gaudens, Frederick MacMonnies, Karl Bitter—participated in the decoration of the White City at the World's Columbian Exposition in Chicago in 1893. French designed the enormous figure of the Republic, perhaps the major figure there and certainly one of the most noticeable. One of his most significant later works was the four groups symbolizing Asia, Africa, America, and Europe for the United States Customs House in New York City, which sums up several aspects of post-Civil War sculpture in its exoticism, archaeological detail, personifications, and representative figures, as well as in its voluptuous forms and, in the figure of America, a determined patriotism [190].

Several other excellent sculptors developed their mature styles in the last decades of the century. Among the more interesting were Olin Levi Warner (1844–96), whose refined and selective style can be seen in his nude *Diana* (1883, Metropolitan Museum of Art, New York City), as well as in his reliefs of the

189. Augustus Saint-Gaudens, *Adams Memorial,* 1891. Rock Creek Cemetery.

190. Daniel Chester French, *America*, 1903–07. New York City.

191. Frederick MacMonnies, *Young Faun and Heron*, c. 1890. The Metropolitan Museum of Art.

1870s and 1880s; Frederick MacMonnies (1863–1937), whose playful rococo version of the Beaux-Arts style infuses his *Young Faun and Heron* with considerable spirit [**191**]; Charles Grafly (1862–1929), who combined the styles of Thomas Eakins, his teacher at the Pennsylvania Academy of the Fine Arts, with that of Rodin; and George Grey Barnard (1863–1938), whose emotionally charged figures recall both Michelangelo and Rodin.

These heterogenous sculptors indicate the rapid strides made by American sculptors within a few generations. Respected abroad, they brought to American sculpture a quality not inferior to European examples. Within half a century of the exhortations to American artists delivered by the American Art Union, it would appear that American sculptors, at least, had largely caught up with their European counterparts. However, as many sculptors were reaching their maturity in the early twentieth century, new forces in the trans-Atlantic art world were replacing them and their art, relegating them to what will probably be their place in history—the last efflorescence in the line of sculptors that began with the Italian Renaissance.

5

EARLY

MODERNISM*

THE PAINTERS who matured during the early years of the twentieth century belonged to the first generation of radical American artists. Their radicalism lay in their attitudes toward art rather than in politics, because they unequivocally felt a greater responsibility to their art and to themselves than to the recording of their country's customs and concerns. Building on attitudes implicit in Tonalism, American Impressionism, the American Renaissance, and such visionaries as Albert Pinkham Ryder, the artists of the new generation used art as a means of personal expression, as a way to visualize their feelings in the presence of a sitter or a landscape, or to solve a problem of their own invention in form and color arrangements. No longer committed to the notion of sharing experience with others, they transformed the nature of American art and left their supportive public far behind. Little interested in integrating the artistic community into the larger public community, the young artists brought to an end the last, lingering hopes, earlier articulated by John Trumbull and Samuel F.B. Morse, for a truly representative public art.

And no wonder! The new generation found the art of the academies—the kind favored by, say, the National Academy of Design and the Pennsylvania Academy of the Fine Arts—old-fashioned and stultifying. Beyond that, few self-respecting artists wanted to embrace either a modern industrial society that by its very nature contained systems of standardization and regimentation or an American society riven by political factionalism, business corruption, severe economic problems, and debates about overseas expansion. (In 1894 alone, 500 banks closed, 16,000 businesses collapsed, 1300 strikes were recorded, and unemployment reached 20 percent.) Deriving strength from an abstract sense of the people, as well as from spiritual rather than material and traditional religious values, the artists seemed to work (and to write about their art) with an intensity not previously recorded and with a sense of gratification in acquiring pictorial techniques that succeeding generations have never indicated.

This generation found its stylistic sources in European art. Of the two major

*Sculpture created during the years covered by this chapter is discussed in Chapter 6.

groups of Americans—the realists and the modernists—the former derived their art from artists such as Courbet, Whistler, Sargent, and the seventeenth-century Dutch painter Frans Hals. The latter group found inspiration in contemporary artists, including the Nabis, the Cubists, the Fauvists, and the Futurists [194 and 214]. Despite obvious differences in technique and subject matter, both groups sought ways of self-discovery and, at the same time, means of communicating with others through their art. They wanted to probe and to illuminate interior states of mind—that which is felt—along with the reality that lies behind appearances rather than to illustrate the externals of life—that which is merely describable. In trying to capture the textures of modern life and to give meaning to untested values, they rarely resorted to rigorous theoretical positions or tried to duplicate modern, impersonal technological systems. Rather, for most of them, art was the vehicle for a great personal adventure into the twentieth century. Escaping from late Victorian restraints placed upon their passions, pleasures, and freedoms, they created what might be called a joyous season, perhaps the last one that will occur in American art.

This is not to say that their lives were without struggle. Rather, they exulted in their individuality, personal growth, and unique achievements, as well as in the knowledge that their art was central to the growth of a viable contemporary art rather than being a mere alternative to "official" art. Each group was guided by a charismatic figure. Robert Henri led the realists, and Alfred Stieglitz supported the modernists. Both recognized the necessity to develop a new art, indicated clearly by Henri's statement in 1902 that "the big fight" between traditional and modern forces had been joined.

Independent exhibitions served the purposes of promoting and sustaining that fight. Several were held in the opening years of the century, often sponsored and supported by both realists and modernists. Together with the ever-increasing numbers of art galleries in New York City and in other urban centers, these exhibitions provided needed outlets for the younger artists now better able to bypass the academies, which were no longer willing or able to adjust to the new forces in the art world. Henri organized an exhibition of realist and modernist works as early as 1902 in New York City. This was followed by a more important show in 1904 at the National Arts Club, which included the realists William Glackens, George Luks, John Sloan, and Henri, as well as the symbolist Arthur B. Davies and the Post-Impressionist Maurice Prendergast. The same artists, with Everett Shinn and the Impressionist Ernest Lawson, exhibited together as The Eight in 1908; until that time, it was the most popular and notorious show of dissident artists' work in the country. It was organized in part as a result of the rejection of paintings by Glackens, Luks, and Shinn by the National Academy of Design in 1907. In 1910, Henri, with Walt Kuhn, Sloan, and Davies, organized the Exhibition of Independent Artists, a nonjuried show in which 103 artists participated, many of whom were Henri's students. Three years later, in 1913, the Armory Show took place, and was probably the most important American exhibition of the century. Sponsored by the Association of American Painters and Sculptors, it included works by realistic American painters, but, most important,

192. Jerome Myers, *Festival,* 1905.
Berry-Hill Galleries.

193. Eugene Higgins, *Huddled
Together,* n. d. Marbella Gallery.

it surveyed the recent history of modern art. Since American audiences, with the exception of a small group of people aware of avant-garde developments in New York City and other cities such as Chicago, were unaware of Post-Impressionist movements, let alone Cubism and Fauvism, the show was a stunning eye-opener, an overwhelming revelation of the latest trends as well as a clear indication of how far modern artists had departed from familiar conventions and traditions. (The exhibition later traveled to Boston and Chicago.) Walt Kuhn and Arthur B. Davies were primarily responsible for the personality of the show. Since European modern movements emerged as the dominant ones, the Forum Exhibition of Modern American Painters was held in 1916 in part to redress the balance. Under the direction of the author Willard Huntington Wright, the works of seventeen American modernists were shown. The last major exhibition of the period, that of the newly formed Society of Independent Artists, was held in 1917, with the help of European artists living in New York City during the First World War. (Its final show took place in 1944.)

Through the last decades of the nineteenth century, several artists painted the American scene in a straightforward way, but their work did not add up to a new American realism. Even with the appearance of industrial scenes by, say, John Ferguson Weir (1841–1926) (*Forging the Shaft,* 1877, Metropolitan Museum of Art, New York City) or Thomas Anshutz (1851–1912) (*The Ironworkers' Noontime,* 1880, The Fine Arts Museum of San Francisco) or Robert Koehler (1850–1917) (*The Strike,* 1886, Deutsches Historisches Museum, Berlin), a coherent point of view never emerged. Nor did a realistic movement coalesce around Jerome Myers (1867–1940), who began to paint lower-class urban subjects about 1885 [**192**]. In fact, his Italian and Jewish immigrant subjects, living in New York City's ethnic slums rather than in more picturesque locales in southern and eastern Europe, are portrayed with the same kind of sentimentalization and therefore trivialization that characterizes the paintings of several older urban genre artists, such as Thomas Hovenden (1840–1895) and John George Brown (1831–1913). And Eugene Higgins (1874–1958), who started painting the poor of New York City in 1904, had little impact, probably because his subjects resembled European peasants much too closely [**193**].

But a group of newspaper artist-illustrators, prompted by the galvanizing presence of Robert Henri (1865–1929), did begin to develop a more up-to-date realism in Philadelphia in the mid-1890s, which reached maturity in New York City after the turn of the century. Henri, considered one of America's great art teachers, exemplified the kind of overwhelming energy and blunt yet profound inquisitiveness associated with the public persona of Theodore Roosevelt. Henri arrived in Philadelphia in 1886. By 1892, he had befriended a few newspaper illustrators, who became the nucleus of the new realists. These included William Glackens, George Luks, Everett Shinn, and John Sloan. All moved to New York City—Luks and Glackens in 1896, Shinn in 1901, and Sloan in 1904—but Henri's arrival in 1900 may conveniently symbolize the beginning of modern American realism. Until the transplanted Philadelphians began to pursue personal styles

after 1910, they flourished as a coherent artistic group. Their most famous joint effort occurred in 1908, when, with Arthur B. Davies, Ernest Lawson, and Maurice Prendergast, they exhibited as The Eight.

When Henri first reached Philadelphia, he studied at the Pennsylvania Academy of the Fine Arts under Thomas Anshutz, a former pupil of Thomas Eakins. Henri adopted Impressionist techniques after traveling abroad from 1889 to 1891, but during a second trip, from 1895 to 1897, he renounced the coloristic and abstract tendencies of recent art for the tonal styles of Hals, Velázquez, and Rembrandt. He became convinced at that time that art should remain a matter of personal exploration rather than of formal manipulation. Henri's belief that life should be art's principal subject coincided with the workaday, journalistic interests of Glackens and the others. Rejecting, as Sloan said, the "eyesight" painting of Impressionism for styles better able to convey human drama, the younger men, trained to visualize scenes as black-and-white newspaper illustrations, found the tonal styles favored by Henri entirely to their liking. Together, they explored the life of the city.

However, with the exception of some of Shinn's work about 1902 and a few paintings by Luks in the 1920s, the realists did not paint scenes with the critical eye of the contemporary muckrakers, then attacking and exposing political, industrial, juridical, and social corruption, nor did they view city scenes with the gritty determinism of novelists such as Theodore Dreiser, Frank Norris, or Stephen Crane. Rather, their general attitude was closer to that of William Dean Howells, who in his *A Hazard of New Fortunes* (1890) describes New York City

194. Robert Henri, *Laughing Boy,*
1907. Whitney Museum of
American Art.

—including its rich and its slum districts—as a place of great vibrancy. Less concerned with social problems than their subject matter might indicate, the artists reveled more in their responses to life than in the kind of life they found during visits to the ghetto districts. In fact, they found poor people to be a kind of modern-day Noble Savage, happy in their poverty and innocent of the responsibilities of wealthier people.

With Henri's encouragement, they read Ralph Waldo Emerson, but the message they found in his writings concerned self-realization and self-confidence rather than mystical transcendence. Leo Tolstoy, the Russian novelist, was also influential, especially through his book *What Is Art?* (American edition, 1898). Tolstoy argued that art could provide emotional communion between people and that an important function of art was to re-create in the viewer the feelings possessed by the artist in the heat of creation. Because the viewer could re-experience the creative act, "true art," reasoned Tolstoy, "thus prevents isolation and brings about a common brotherhood."

But while Tolstoy favored religious art, Henri sought a more generalized expression. He wanted, as he said in 1910, to "express the *spirit* of the people today," believing that "the artists who produce the most satisfactory art are . . . those who are absorbed in the civilization in which they are living." Initially, Henri believed that an artist might derive such an art by universalizing the conditions of his own country. Toward the end of his life, he felt that the spirit of life was supranational. But what he really searched for was a reflection of his own exuberance and his own desire to find "something of the dignity of life, the humor, the humanity, the kindness" in what he called "my people." Perhaps for this reason, he and the other realists painted so many portraits of children, finding their youthful radiance not yet shattered or even tarnished by the hardships of life. Henri, who searched in both cosmopolitan and primitive societies for the sparkle of life etched on the faces and bodies of his subjects, was apparently oblivious to the more truthful conditions found by Jacob Riis, the social observer and photographer. Riis, by contrast, discovered those whose dignity and humanity had been pulverized by the very slum conditions Henri seemed to enjoy [**198 and 199**].

As a portraitist, Henri wanted all parts of a sitter's face to appear alive and mobile [**194**]. Eyebrows, quickly brushed in, revealed both muscular actions and the sitter's psychological state. But since art was the medium through which Henri expressed his love of life, aesthetic qualities could not be easily distinguished from human feelings. He often attacked his canvases with such gusto that his compositions could not always contain the aggressiveness of his brush strokes. Compared to Courbet or Manet, he was largely innocent of the ability to weave forms in tight patterns across a picture's surface. Where the Europeans might treat a human figure as a bit of still life in an integrated structure of color planes, Henri focused on personality, gesture, and glance. The creation of a painting was less an intellectual exercise than an outburst of feeling [**195**].

Surprisingly, the majority of Henri's city views and landscapes, which date primarily from the early years of his career, are much more reticent, even Whist-

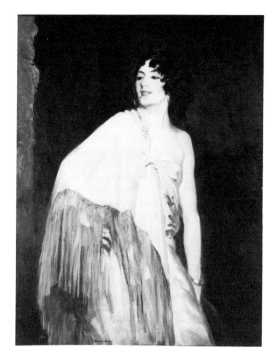

195. Robert Henri, *Dancer in a Yellow Shawl,* c. 1908. Columbus Museum of Art.

196. Robert Henri, *West 57th Street, New York,* 1902. Yale University Art Gallery.

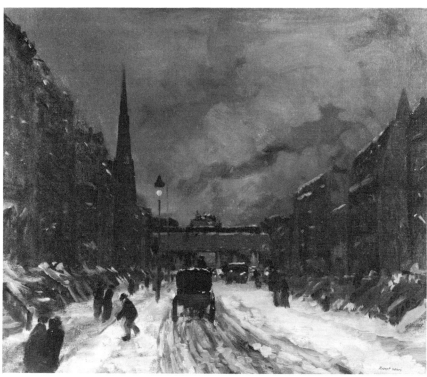

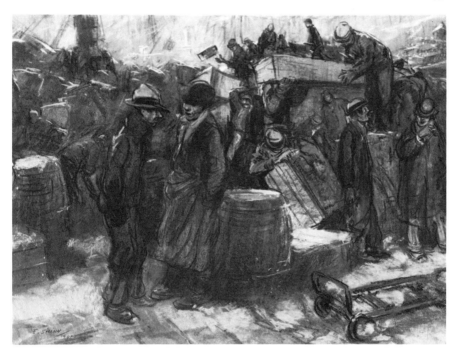

197. Everett Shinn, *The Docks, New York City,* 1901. Munson-Williams-Proctor Institute.

lerian **[196]**. Although he found the new skyscrapers to be excellent symbols of the nation's modernity and virility, he never captured the staccato pulse of the modern metropolis. For an artist so intoxicated with life, he probably could not encompass the abstract dynamism of an entire city scene, but needed a particular focus upon which to concentrate. In both his landscapes and portraits, color brightened appreciably after 1909, when he adopted Hardesty Maratta's color system. Maratta, an unsuccessful painter, developed a table of twelve basic colors, which could be used to find complementary shades as well as degrees of pigment saturation. Using this system flexibly, Henri applied it primarily to his portraits and figure studies, which, for the remaining twenty years of his life, were his preferred subject matter.

Among all the realists, Everett Shinn (1873–1953) painted slum life the most accurately—and bleakly—but only in a handful of paintings and sketches made just after 1900 **[197]**. By 1906, his preference for theater scenes reminiscent of Degas had replaced his earlier subject matter. By contrast, George Luks (1867–1933) remained closest to Henri's early vision of humanity throughout his career. Intellectually undisciplined, Luks's portraits vary wildly from the incisive to the saccharine, from the profoundly inciteful to the superficially anecdotal **[201]**. When he was good, he was probably the best portraitist of the group; when he was bad, he was awful.

Luks lived and studied in Paris and Düsseldorf between 1885 and the middle

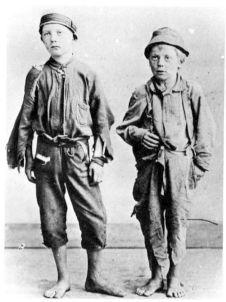

198. George Luks, *The Spielers,* 1905. Addison Gallery of American Art.

199. Jacob A. Riis, *Two Ragamuffins Didn't Live Nowhere,* c. 1890. Museum of the City of New York.

1890s. His European experience probably countered his innate desire to let his brushes fly, at least until about 1910. Before that year, his rapid-fire delivery was usually contained within broad, flattened patterns. Afterward, broad swatches of color energized his figures. Regardless of the method he used, however, Luks remained the most loyal to the realists' early attitudes. It was he who most consistently sought the sparkle of life in his sitters and who responded to it in a manner as uncomplicated as possible. In addition, he was perhaps the only one to paint specific incidents of the immigration process itself [202].

Like Henri, Luks painted portraits in studio settings, but, with Sloan, he also favored another type. Against a barely indicated background, he would arrange a figure engaged in some sort of activity [198]. Usually these works consisted of three main masses—the ground, the neutral rear wall, and the figure itself. Although subjects were individualized, they also represented types—the aged, bent woman or the gleeful child—combinations of the specific and the universal he actively and knowingly sought.

The author Frank Norris once remarked that the muse of American fiction would lead people into "a world of the Working Man, crude of speech, swift of action, strong of passion, straight to the heart of a new life." These words are especially relevant to Luks's paintings because they describe his style and approach as well as the range of his subject matter. He rarely painted a scene that could not fit into a lower-class setting. His street scenes, filled with narrative incidents, are quite different from similar contemporary European works, in which people are either reduced to automaton-like patterns of color and tone or

are dignified beyond their station in life. At the same time, Luks's sympathies for his subjects stopped well short of political or social action. Unlike the muckrakers or the novelists, he found slum life exotic and colorful [200]. The young and the old seem to lead simple, happy lives. The photography of Riis found slum life quite the opposite, both miserable and degrading [199]. His late portraits of coal miners and their families, therefore, are unusual because they reveal in the weary faces and spent bodies the enduring difficulties and privations of their lives [201]. Probably jostled by youthful memories of his early years in coal mining communities, these works are among Luks's best.

George Bellows (1882–1925) sought more than the sparkle Luks and Henri found; he wanted to experience the raw physical impact of modern life. During the opening years of the century, he turned to themes of violent recreation, the masculine vigor of labor, and the turbulence of slum life [203]. He viewed the artist as a kind of Nietzschean superman who could know and feel and experience everything. Bellows not only recorded his own exuberance but wanted his paintings to throb and to pulsate in their own right. He multiplied the number of people in a scene when other realists might include only one or two. His street scenes encompassed vaster acreage. Buildings surrounded by empty lots forced awareness of the erection and demolition of neighborhoods. A riverview scene that in the hands of, say, Glackens might serve as a backdrop for a pleasant anecdote or seaside promenade was turned into a symbolic statement of the dynamic forces that propelled modern society. Since Bellows's images were always realistic ones,

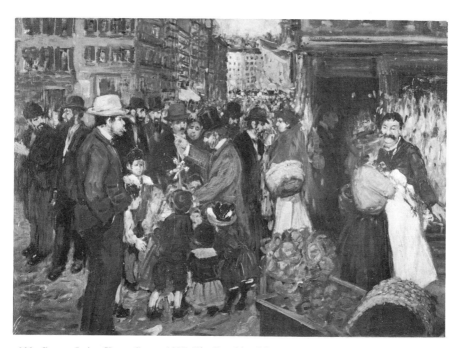

200. George Luks, *Hester Street*, 1905. The Brooklyn Museum.

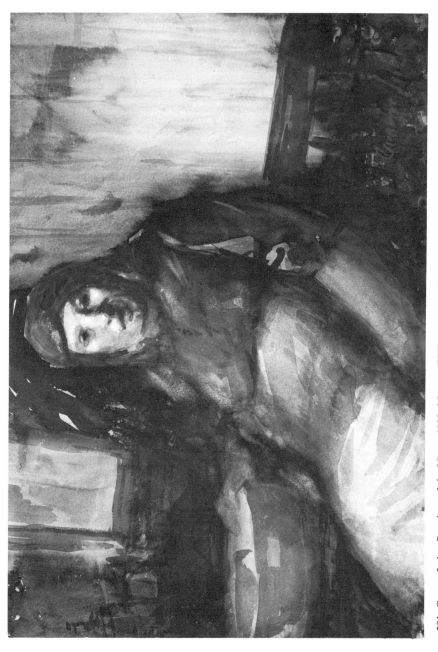

201. George Luks, *Daughter of the Mines*, 1923. Munson-Williams-Proctor Institute.

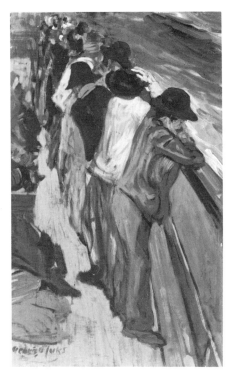

202. George Luks, *In the Steerage,* n. d. Hirschl and Adler Galleries.

203. George Bellows, *Stag at Sharkey's,* 1907. The Cleveland Museum of Art.

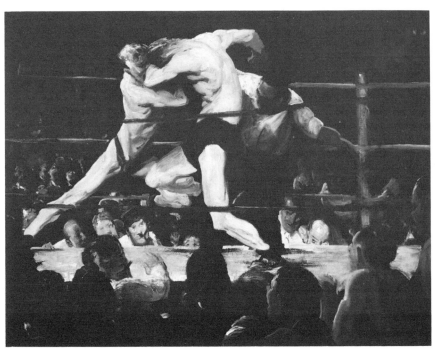

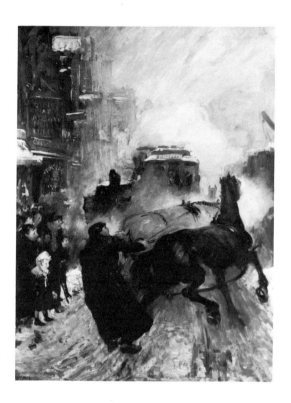

204. George Bellows, *Steaming
Streets*, 1908. The Santa Barbara
Museum of Art.

as if understanding could be gained only by directly experiencing physical sensa-
tions, his work also reflects Henri's belief that the American temperament resisted
cerebral formulations in art [204].

A pupil of Henri and a close companion of the other realists, Bellows arrived
in New York in 1904 from his native Ohio. (Although he showed works as early
as 1906, he did not participate in the famous exhibition of The Eight in 1908.)
Perhaps because he never worked as a newspaper illustrator, he was best able to
grasp the wider implications of Henri's philosophy. Trained to record neither the
telling gesture nor the critical narrative incident, he could let his imagination
range more freely as it confronted urban life. But at the same time he imposed
firm compositional restraints on his effusive responses. Of all the realists, Bellows
had the best sense of pictorial organization. Even if he neglected to integrate
objects with their backgrounds—a common American trait—he usually indicated
a broad triangular or circular infrastructure or sequence of movements that gave
order to his work.

Not surprisingly, Bellows enjoyed tremendously the modern works exhibited
at the Armory Show because of the modernist emphasis on composition, formal
arrangements, and techniques. Although he did not dramatically alter his style
afterward, he began to experiment with Jay Hambidge's doctrine of dynamic
symmetry, which consisted of a method of compositional organization based on
arithmetical formulas. Ultimately, these experiments helped blunt Bellows's im-

mediate responses to his subject matter. However charming his subsequent portraits and landscapes, they lack the compelling force of his earlier works, painted without resort to Hambidge's theories.

John Sloan (1871–1951) also responded to the new abstract art in his later years by substituting idiosyncratic stylisms for his genuine powers of observation. Knowing that he had much to learn from modern European art, he even flirted with Van Gogh-like brush marks and colors after the Armory Show, but he could not adapt modernism to his essentially realistic vision. Finding delight in color for color's sake no more reasonable than liking sound for sound's sake, he once noted, "Who ever heard of a musician who was passionately fond of B-flat?"

His finest works, then, were his earlier ones, in which he recorded city activities. From the time he made the set of etchings known as *City Life* (1905–06), he became a tireless observer of urban vignettes—those moments in the lives of urban citizens that give a city a human aspect. He painted backyard, street-corner, restaurant, theater, kitchen, and bedroom scenes in seemingly endless profusion [205]. Taken altogether, Sloan's paintings are psychologically uncomplicated; figures radiate a pleasant and mellow warmth, seemingly insensible to the urban tensions and neuroses suggested in the works of, say, Edvard Munch or Ludwig Kirchner, or the hardboiled exposés of slum life by Jacob Riis.

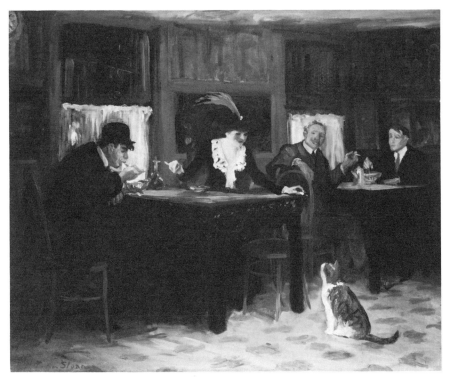

205. John Sloan, *Chinese Restaurant,* 1909. Memorial Art Gallery, University of Rochester.

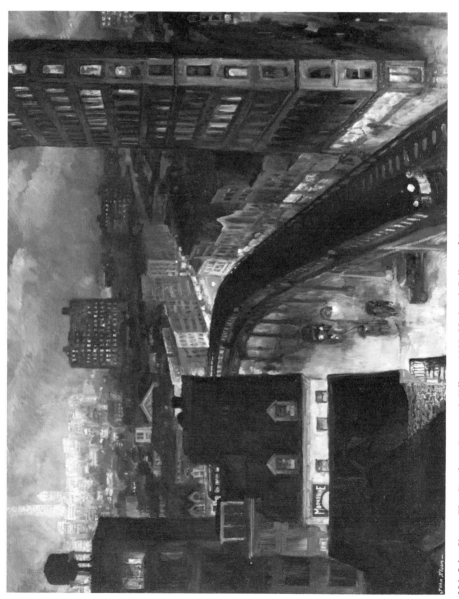

206. John Sloan, *The City from Greenwich Village*, 1922. National Gallery of Art.

But Sloan's infatuation with the activities of daily life was not as mindless as this observation might suggest. A member of the Socialist Party from 1910 and an editor of *The Masses,* the socialist magazine, from 1912 to 1916, he reserved his more biting observations for his political cartoons and illustrations. Furthermore, he often portrayed women as initiators of activities rather than as passive respondents at a time when artists such as Thomas Dewing were still painting semi-somnolent females.

Like his fellow realists, Sloan used a nearly monochromatic palette early in his career, his forms emerging through the modeling of tones rather than from separate touches of color. Less addicted to the slap-dash techniques of Henri or Luks, Sloan created figures that were more volumetric and sculptural. Always interested in the texture of life wherever he found it— in New York City, the Southwest, on the New England coast—he initially preferred concentrating on individual persons. After 1910, the city and the countryside as spectacle became his preferred subject matter [206]. His city scenes, especially, imitated a type used by artists such as Childe Hassam and Birge Harrison (1854–1929) earlier in the century. One of the best in this mode was *Between Daylight and Dusk* by Edward Redfield (1869–1965), a friend of Henri and the other realists since their Philadel-

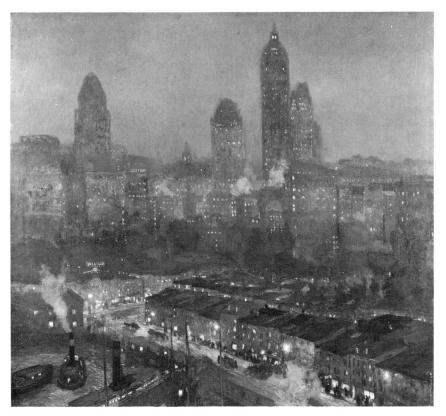

207. Edward Redfield, *Between Daylight and Darkness,* 1909. Private collection.

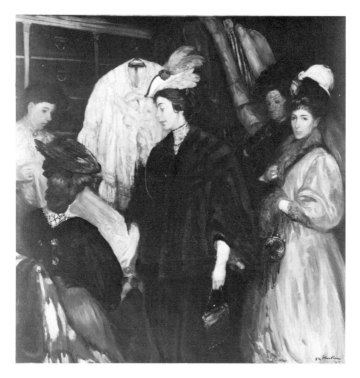

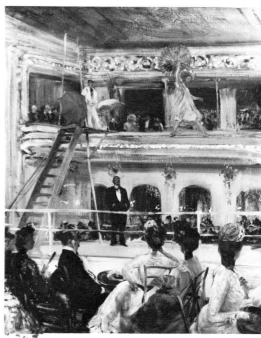

208. William Glackens, *Shoppers,*
1907. The Chrysler Museum.

209. William Glackens,
Hammerstein's Roof Garden,
c. 1903. Whitney Museum of
American Art.

phia days and the leader of the Bucks County (Pennsylvania) Impressionists early in the century [207]. In the late 1920s, Sloan became almost exclusively a studio painter, who in his studies of nudes would invariably place a lacy filigree of wiry red lines over their bodies.

William Glackens (1870–1938) also preferred urban scenes early in his career. His subject matter, however, tended to be more elegant than that favored by his friends, and included fancy clothing stores, skating rinks, lovely seaside parks, and well-tended public gardens [208]. Glackens also enjoyed the visual splendor of the theater—the performers as well as the richly clad patrons [209]. (The realists were the first and last group to paint theater scenes with any frequency. Among younger painters, only Reginald Marsh, a follower of the Henri tradition, painted such scenes into the mid-century period. Since the 1960s, artists concerned as much with the processes of art as with the completion of art objects, have performed theater pieces in which they have been participants rather than observers.) Glackens also enjoyed observing people at beaches (another favorite theme of Reginald Marsh), especially after he became an ardent devotee of Renoir's art about 1905. Clearly, Glackens was the worldling of the Henri circle, but his attitude was shared by several other artists of the period, including Edmund Graecen (1877–1949), who also enjoyed the city as a marvelous middle-class spectacle, a place for pleasure and enjoyment, good meals and fine clothes, leisure and entertainment.

The realists were, in truth, painters adrift in the twentieth century, amiable provincials determined to find joy in life and nobility in character. And when, by 1910, their commitment to such themes abated, most of them began to drift aesthetically and never found a new subject matter or style that carried the same conviction as their earlier work. Nevertheless, their art, one of human engagement, prolonged the humanistic tradition of Daumier and Courbet into the twentieth century and provided a base for its revival and continuation in the 1930s. Furthermore, in the continuing dialogue between American art and European culture, the realists represented a flowering of native art not necessarily nationalistic in intent, but certainly not international in scope, a wedge between the late-nineteenth-century American Impressionists and expatriate artists such as Whistler and Vedder on the one hand and the American followers of the School of Paris in the early twentieth on the other. Finally, the realists also maintained and broadened the counter-establishment posture of American artists expressed in the post-Civil War decades by organizations such as the Society of American Artists and the Ten American Painters, until their art also grew too conservative to serve as a model for other artists, intent on expressing nonacademic views.

By embracing modernism, these artists found such a model and used it to explore styles and techniques perhaps more appropriate to the new century. In an international age, they were international in outlook, for as Max Weber once said, the sources of modern art lay in Italian, Spanish, Oriental, Byzantine, Peruvian, Mexican, African, Hindu, Persian, and Russian art. To a much greater extent than the realists, the modernists accepted the radical notion that modern

art, as described by the art historian Joshua Taylor, grew from "an assumption of expressive freedom that [looked] upon the relationship of meaning and form as infinitely variable, subject only to the inner discipline of the artist himself." And many might have agreed with Willard Huntington Wright's assertion in his *Modern Painting* (1915) that "any attempt to democratise art results only in the lowering of the artistic standard."

Yet, despite the abstract qualities of their paintings, the modernists held attitudes in common with the realists—which might help explain why artists from both groups jointly sponsored exhibitions and also exhibited together. Both groups developed styles that, because of their personal and idiosyncratic qualities, resisted the dehumanizing effects of technology. In fact, much significant art of the period reaffirmed the individuality and humanity of artists. Even though realists and modernists expressed their individual concerns in different styles, both groups sought to capture living presences in their art. The realists' interest in life fed on their vital contacts with people; the modernists, concerned more generally with life forces, sought abstract essences **[204 and 225]**. And, finally, both groups tended to rely more on their emotions rather than on dispassionate manipulations of form in the creation of a painting.

The landscape, a traditional American subject, played an important role in the subject matter of the modernists, especially for John Marin, Arthur Dove, and Georgia O'Keeffe, the three artists whom Alfred Stieglitz considered the most American of all. But whereas the Hudson River School painters saw the landscape as an instance of God's handiwork, the Luminists suggested the Emersonian concept of the continuity between spirit and matter, and the Tonalists reveled in the poetic moods they found in the landscape, the modernists viewed the landscape as an aspect of all of living nature in which they, too, wanted to be participants. In brief, they wanted first to apprehend particular objects in nature; second, to grasp the soul and spirit of those objects; and third, to express their own subjective responses to those objects in an open and evolving dialogue. In this regard, their art paralleled and was affected by the turn-of-the-century interest in the human mind and how it perceived reality—as mere appearance or as that which lay behind appearance. In varying ways, philosophers, psychologists, historians, and novelists—such as Nietzsche, Freud, Bergson, and Proust —dealt with this profound question in their research and writings. Bergson, especially, was extremely popular in both Europe and the United States at the turn of the century. His philosophical writings, occasionally excerpted in Stieglitz's magazine, *Camera Work,* both strengthened the antimaterialist bias that swept the trans-Atlantic art world after the middle 1880s and provided a credible philosophical basis for the writings of the Symbolists. If one can speak of a mood descriptive of the first flush of American modernism, then one can speak of a Bergsonian mood.

Bergson held that intuition rather than intelligence—instinct rather than intellect—provided the more meaningful grasp of reality. Reality was an ongoing process, a flux, perceived in immediate experience. By contrast, intellectual constructions halted reality's flow by forcing one to focus on specific ideas or things.

Such constructions, although obviously useful for language development and social communication, prevented artists from feeling their way into the life of objects or from experiencing sympathetically their own organic connections to the flow of life. Intuition provided an avenue of entry, which, as one communed with the life inherent in forms and objects, allowed an endlessly continuous sense of creation within the eye and the mind of the beholder.

Bergson's ideas, whether directly or indirectly known, helped justify the artists' desires to improvise without specific plan and to release through their brushes the revelations of their souls as well as the harmony they felt with the flow of life. When, for example, Max Weber wrote in his *Essays on Art* (1915) that "even inanimate objects crave a hearing, and desire to participate in the great motion of time," that "the flower is not satisfied to be merely a flower in light and space and temperature [because] it wants to be a flower in us, in our soul," and that "things live in us and through us," he was echoing Bergson's notion that an artist tries to move "back within the object by a kind of sympathy in breaking down, by an effort of intuition, the barrier that space puts between him and his model." Critics, too, influenced by Bergsonian thought, encouraged artists to create pictorial equivalents of emotions derived from nature and to interact directly with the pictorial forms they had created in order to create yet newer forms when in the act of painting.

The viewer was asked to share and to duplicate within himself the emotions felt by the artist when the latter, in the heat of creation, had sought the essential life flow of objects. This idea, which can be traced to German Romanticism, was often discussed about the turn of the century, perhaps most significantly by Wassily Kandinsky in his *On the Spiritual in Art* (English translation, 1912). But Bergson actually provided the viewer and the painter with a method of achieving shared feelings. He believed that the rhythms of a painting should be regulated, since regularity and intensification of rhythms could establish a type of nonverbal communication. The viewer was invited to experience these rhythms in at least three ways: as spatial displacements of the human body in motion; as a means to provoke subjective emotions; and as analogues for the great, constantly moving forces of material existence. Perhaps for this reason both artists and writers on art invariably stressed, when explaining the new art, the rhythmic aspects of a work and the necessity for understanding them intuitively.

Modern painting and sculpture were often compared to music, another art form of nonverbal communication. Artists were encouraged to develop techniques of—to use a phrase of the time—"abstract expression." Art, it was held, should communicate moods and feelings and, like music, refrain from describing literal facts. As in musical composition, the meaning of a painting should unfold gradually as one adjusted to the rhythmic intervals of lines and planes. A painting, like a musical composition, should possess duration, should become part of the flow of life.

In contrast to the more recent desire among painters and critics to see three-dimensional references eliminated from paintings, the early modernists insisted on maintaining a sense of pictorial depth, finding that it contributed to

the viewer's empathetic responses. Willard Huntington Wright explained this principle when he said in his *Modern Painting* that he liked solid form "harmonized and poised in three dimensions in such a way that, should we translate our bodies into spatial forms, we should experience its dynamism." Single-color matte finishes, which would ensure the effect of flatness, were foreign to the early modernists. Instead, their paintings, alive with subtle spatial allusions, flicker with minute color and tonal changes, and throb with movement and vitality. Artists constantly praised Cézanne and returned to his work not only because he was acknowledged as the seminal figure in modern art but also because of his great ability to combine flat patterns with a sense of depth.

Perhaps because of still strong societal constraints, the modernists wanted to make clear their knowledge of the differences between intuitive and irrational behavior—the former being acceptable, the latter, not. To help justify their interest in intuitive modes of creativity, they pointed not only to the expressive forms of primitive art but to the beauty and integrity of primitive cultures. In a radical reversal of nineteenth-century beliefs, artists now held that primitive people lived in greater harmony with their emotions than Euro-Americans and that the greatness of their art reflected such harmony. As a result, artists studied the art and social patterns of nearby primitive cultures (Southwest Indian rather than African). Max Weber particularly enjoyed Hopi kachina figures, and Marsden Hartley believed that Indian intuition was capable of brilliant insight and that, as a whole, Indian life was "concerned entirely with the principle of conscious unity in all things." Indian art, Hartley felt, was characterized by the integration of body, spirit, and matter, an ideal condition he and others profoundly wanted to attain.

Because of their interest in immediate feeling, most American modernists resisted those European styles concerned primarily with manipulation of forms or mechanical reproduction of effects, preferring instead those that suggested a buoyant, emotional spontaneity. The stylistic rigors of Analytic Cubism or the psychological complexities of Central European Expressionism were generally remote from American concerns; at least, the Americans did not take these styles to new levels of complexity or originality as, say, the Russian modernists did. The Americans who went abroad—including Alfred Maurer, 1897–1914; Abraham Walkowitz, 1905–08; Max Weber, 1905–08; John Marin, 1905–11; Morton Schamberg, 1906–09; Morgan Russell, 1906–46; Charles Demuth, 1907, 1912–14; Stanton MacDonald-Wright, 1907–15; Thomas Hart Benton, 1908–11; Arthur Dove, 1908–10; Joseph Stella, 1909–12; and Marsden Hartley, 1912–16—when compared to other modern artists in the international community, seemed to be the most lighthearted, at least until roughly 1920, when a more reflective and somber mood began to affect their work. Paradoxically, their art appeared to be most joyous during the years of neglect and vilification of their art at home. Even abroad, they received so little support from the conservative American art colony that they formed the secessionist New Society of American Artists in Paris in 1908, under the leadership of Alfred Maurer, Max Weber, and Edward Steichen, the painter and photographer.

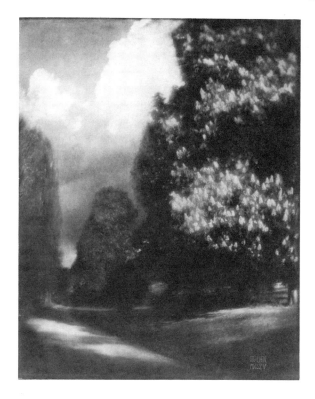

210. Edward Steichen,
Chestnut Blossoms, 1904. The
Metropolitan Museum of Art.

At home, Alfred Stieglitz (1864–1946), the photographer, served as the most articulate and aggressive spokesman for the modernists—through his magazine, *Camera Work,* published from 1903 to 1917, and the exhibition space called the Little Galleries of the Photo-Secession that he established in 1905 with Edward Steichen. Steichen, also a photographer, created some of the most abstract visual images in any medium early in the century **[210]**. (The Little Galleries, also known as "291" because of the address on New York City's Fifth Avenue, lasted until 1917. Afterward, Steiglitz ran the Intimate Gallery from 1925 to 1929 and An American Place from 1929 to 1946). After 1907, when Stieglitz began to exhibit painting and sculpture in addition to photography at 291, both the gallery and the magazine became crucial to the development and spread of modernism in America.

Stieglitz did not act alone in his support of modern art. His friend Marius de Zayas, the Mexican caricaturist and theoretician, helped popularize primitive art through his book, *African Negro Art: Its Influences on Modern Art* (1916), written with Paul Haviland, a member of the Stieglitz circle. (De Zayas was also the first to introduce machine-like forms to American art, with his caricatures of 1913–14.) Several artists, not especially attracted to Stieglitz because of his imperious personality and intuitive and emotional approach to art, clustered instead around Walter and Mary Arensberg. Important figures in the New York City art world from 1914, when they settled there, until 1921, when they left for

California, the Arensbergs were particularly responsive to Europeans who visited the country during World War I, including Marcel Duchamp, Albert Gleizes, and Francis Picabia, as well as Americans such as Man Ray, Morton L. Schamberg, and Charles Demuth. These artists tended to be more intellectual and cerebral in their approach, given to questioning and extending the premises of art. In fact, a variant of Dada art was developed in the Arensberg circle during these years, particularly by Duchamp, Picabia, and Man Ray. But just as an ample give-and-take existed between realists and modernists, so relationships among the various modernists were usually open and fluid. Another significant figure of the period, the writer Willard Huntington Wright, helped bring to the public's attention Synchromist painting and other types of abstraction, especially through his book, *Modern Painting,* and was the guiding force in the Forum Exhibition of Modern American Painters in 1916. Other individuals, such as Katherine Dreier, together with Duchamp and Man Ray, helped found supportive organizations such as the Société Anonyme in 1920, which sponsored exhibitions and acquired paintings for its collection (now at Yale University). Altogether, the support and patronage provided the modernists was probably similar to that received by earlier artists through informal clubs or more formally constituted organizations, although the commitment seems to have been more intense in the early twentieth century. Unlike earlier patrons, who supported art as an avocation, several devoted themselves to artistic causes with much greater dedication and conviction.

Despite the amount of activity and energy that characterized the art scene in New York City, the most consistently radical American works painted between roughly 1900 and 1910 were those by Maurice Prendergast (1859–1924), who lived in Boston. This is probably not an accident of fate, since Prendergast was undoubtedly aware of the ideas of at least three local men who held remarkably advanced ideas about art and who, in their writings and teachings, provided fundamental insights into modernist compositional devices. The three were Ernest Fenellosa (1853–1908), the pioneer specialist in East Asian art who served as curator of Japanese art at the Museum of Fine Arts, Boston, from 1890 to 1896; Arthur Dow, the artist and teacher, who served as Fenellosa's assistant from 1893 to 1896 and whose important book, *Composition,* was published in 1899; and Denman Ross (1853–1935), the painter and theorist who lectured at Harvard University from 1899 to 1935 on the theory of design. More pedagogical than Stieglitz, they not only spoke Stieglitz's language, stressing intuitive feelings, but grounded those feelings in well-considered notions about modern composition. For example, Fenellosa once said that Japanese art could be viewed upside down, since the Japanese "admire beauty in line and color in art, rather than . . . merely depicting nature." Dow, whose students included such major artists as Max Weber (at Brooklyn's Pratt Institute from 1898 to 1900), the photographer Alvin Langdon Coburn (at the Ipswich, Massachusetts, summer art colony in 1903), and Georgia O'Keeffe (at Teachers College, Columbia University, in 1914–15), gave them a thorough preparation in space and value relationships, emphasizing in his classes and in his book the importance of line, color, and *notan,* the Japanese term for light-dark or value relationships.

211. Maurice Prendergast, *Piazza de San Marco,* c. 1898. The Metropolitan Museum of Art.

Prendergast was also receptive to various modernist currents when he lived in Paris from 1891 to 1894 or 1895 **[211]**. Together with his friends Charles Conder, from England, and the Canadian James Morrice, Prendergast was especially impressed by Whistler and the French Nabi artists Edouard Vuillard and Pierre Bonnard. In fact, in later years Prendergast rarely ventured beyond the formal and thematic range of the Nabis, although he occasionally experimented with color, indicating awareness of Cézanne and the Fauvists, after another trip abroad, in 1907. Concerned with formal relationships, Prendergast invariably projected a mood of evanescent pleasure through simplified and stylized shapes. His figures do not exult like those of, say, Henri, but they do enjoy themselves, the sunny days, and the simple pleasures of promenades in gardens and parks. Of the important modernists, only John Marin maintained a similarly uncomplicated vision throughout his career.

212. Maurice Prendergast, *The Promenade,* before 1916. Columbus Museum of Art.

Prendergast, in his watercolors as well as oils, which he began to paint about 1903, and in his almost two hundred monotypes, developed a style that grew from a Whistlerian sense of figural organization to a realization of the figure through bands of color about 1905 and then through larger, mosaic-like, units of color about 1910 [212]. In his later works, his figures grew more monumental and static in position and posture, perhaps reflecting the influence of Puvis de Chavannes, whose works Prendergast would have known from his early stay in France and from Puvis's murals in the Boston Public Library (1896).

Unlike Prendergast, whose painting style developed logically over the years, Alfred Maurer (1868–1932) abruptly changed the character of his art between 1905 and 1907. One of many American artists living abroad at the turn of the century—he had arrived in Paris in 1897—Maurer was initially influenced by William Merritt Chase and John Singer Sargent, as well as by Hals and Velázquez. He won first prize in 1901 at the Carnegie Institute's International Art Exhibition in Pittsburgh, for a Whistlerian study of a woman kneeling on an Oriental rug. Afterward, he painted able, but not memorable, beach and café scenes. Then, between 1905 and 1907, Maurer abruptly caught up with the avant-garde and, as a recent convert to modernist art, helped found the New Society of American Artists in 1908.

Unlike other Americans who taught themselves modern art by imitating the Impressionists and Post-Impressionists, Maurer began painting Fauve landscapes

almost immediately; he was perhaps the first American to work in the latest style of the time. Probably influenced by the exhibition of Fauvist paintings at the famous Autumn Salon of 1905 or by the Cézanne retrospective in 1907, he began to produce works as explosively charged as those of any Fauvist [213]. Individual brush strokes of sustained energy and lozenges of Divisionist color enlivened his forms. The tilted perspectives of his Whistlerian works were pushed further against the picture surface so that an evenness of color intensity pervaded all shapes. Yet, despite an effect of random invention, these works were invariably held together by a superstructure of related planes and continuous circular or rectangular linear rhythms. In fact, Maurer's Fauvist works are almost textbook exercises in the way two-dimensional patterns both emphasize and contradict spatial penetration. Such obvious rational control, intertwined with Maurer's driving emotional force, reflects a basic postulate often repeated early in the century to explain modern art: that traditional principles of organization (or, of rhythmic form) were reinterpreted in modern ways. It was as if the kind of pictorial organization used by, say, Rubens, were done over abstractly.

After his return to the United States in 1914, Maurer explored increasingly nonobjective modes of composition and even allowed a Cubist control to quiet

213. Alfred Maurer, *French Landscape*, c. 1907. Blanden Memorial Art Gallery.

214. Alfred Maurer, *Twin Heads,* c. 1930.
Whitney Museum of American Art.

the paroxysms of his earlier works. A similar tempering calm, if momentary, also dampened the current expressionist impetuousness of John Marin and Marsden Hartley, probably because of the presence in New York City of Francis Picabia and Albert Gleizes, as well as the returning Synchromists Stanton MacDonald-Wright and Arthur Frost, Jr. In any event, Maurer's subsequent work, whatever its idiosyncratic aspects, lost the earlier sense of joy and innocence.

During the 1920s, when many artists accommodated their modernism to a revived realism, Maurer continued to paint both Fauvist and Cubist landscapes and Cubist interior scenes. But his figure studies were his most striking works— often of two, occasionally four, women, and sometimes of two men [214]. Painted in both semi-realistic and Cubist styles, they haunt and disturb, especially those containing two men. Probably based on Maurer's unpleasant relationship with his father, a successful commercial artist who lived to the age of one hundred years, they record physical proximity but psychological distance between people. In the Cubist versions, heads sometimes merge, but the eyes, which Maurer invariably emphasized, revealed profound psychological disturbances. Among the most important portraits of their time, they show, unexpectedly, how Cubism could be used to convey charged emotional feelings. They also reveal how well Maurer mastered the various styles in which he worked.

Such technical dexterity, which encouraged easy manipulation of borrowed

motifs, probably delayed the emergence of Maurer's individual style. A similar dexterity almost prevented Max Weber (1881–1961) as well from finding his own distinctive artistic personality. From 1905 until roughly 1920, when he began to develop a personal expressionism, he worked in virtually all the modern idioms current in Paris. But among the American painters, Weber probably sustained most easily the visual shocks of modern art because of his background and training. Raised in the rigorously intellectual but, at the same time, mystical traditions of orthodox Judaism, he could absorb abstract and spiritualist theories of modern art with little difficulty. He also had the good fortune to study with Arthur Dow, then the most advanced art teacher in the United States, at the Pratt Institute in Brooklyn from 1898 to 1901. When Weber left for Europe in 1905, he already viewed art as "the expression of an idea," as Dow had taught, rather than as an assemblage of facts.

Weber participated in Matisse's first art classes in 1908, with Patrick Henry Bruce, Arthur Frost, Jr., and H. Lyman Säyen, in addition to Walter Pach and Maurice Sterne, who visited occasionally. (The classes were organized in 1907 by Sarah Stein, Gertrude Stein's sister-in-law, who, along with her brother, Leo, introduced several young American artists to the major European modernists.) Because of Weber's friendship with Matisse, his European paintings are generally Fauvist in style and subdued in spirit.

After returning to America in 1909 and until 1911, when they parted company, Weber helped Stieglitz understand more sympathetically the latest artistic movements, about which the latter was still hesitant. Weber himself explored freely and widely the various pictorial alternatives modernism had to offer. His views of New York City, and those by Joseph Stella, dating from 1913, were probably the first Futurist-styled paintings done in the United States. A deft manipulator of form, Weber could reduce a human figure to a sequence of cubic volumes [215], he could record the tumult of the city through interpenetrating planes and mechanically rhythmic arcs, and he could turn a landscape into a Cézannesque or Fauvist exercise. He painted in various pre-Cubist and Cubist modes—African, Analytic, Synthetic—informing his most reserved efforts with an impelling emotional dynamism. In some works, it would seem as if he used the containing grids of Cubism to restrain the emotional and visual explosiveness of the scene [216]. But like other American modernists, he employed the new styles to express mood rather than to probe the limits of formal arrangements.

Weber's explorations of mood never ventured as far as complete abstraction, with the exception of his sculpture. As he said in 1958, "*we must have an origin, a point of departure, and that is man and nature.*" But just as his early paintings ranged from formalistic Cézannesque reserve to Futurist excitement, his statements about art also covered a broad spectrum of feeling. In 1911, for example, after a walk through the Berkshire Mountains of Massachusetts, he wrote, "I really communicated with the wonderful elements—the massive and gigantic rocks that reach far, far into the interior of the earth . . . the trees that reach high up into space . . . and the stillness and the loneliness mutelessly [*sic*] revealing

215. Max Weber, *Composition with Three
Figures,* 1910. The Ackland Art Museum.

216. Max Weber, *Chinese Restaurant,* 1915.
Whitney Museum of American Art.

217. Max Weber, *Adoration of the Moon*, 1944. Whitney Museum of American Art.

or telling the reality of this greatest secret." Yet, in the same year, he wrote, in an unpublished essay, of his interest in "intersecting planes," which afforded him "a great opportunity of expanse and space." In addition, the human figure at that time was "important . . . as a piece of architecture or structure of so many forms, so varied and moveable." When not losing himself in nature or reducing the human form to a sequence of manipulated parts, he could also respond to the razzle-dazzle of the modern metropolis. Describing a painting of 1915 entitled *New York at Night* (Michener Foundation, University of Texas, Austin), he said, "Electrically illumined contours of buildings, rising height upon height against the blackness of the sky now diffused, now interknotted, now pierced by occasional shafts of colored light. Altogether—a web of colored geometric shapes, characteristic only of the Grand Canyons of New York at night." Whatever his language—Bergsonian, Emersonian, Futurist, formalist—the common thread that bound his ideas together was the necessity to reveal through his work his inner feelings and his moods in a manner not unlike that of such late-nineteenth-century landscapists as George Inness. In fact, comparisons between the writings of these two generations of artists indicate a genuine continuity of attitude toward the art-making process, regardless of the particular styles used.

Influenced by the European figurative revival after World War I, Weber began to paint large studies of solemn nudes in the styles of Cézanne and Picasso during the 1920s. Later in that decade, the authentic Weber finally emerged. He had always wanted to reveal, and to revel in, the spirit of things, as he had written in his *Essays on Art* (1915). Now, in his figure studies, images finally appeared

as spiritualized beings, fluctuating between material and ghostlike presences, as if Weber, at last, could possess both the tactility of their bodies and the intangibility of their souls [217]. Especially in his paintings of Jewish themes, one senses both the physical closeness and the psychic elusiveness of the figures. They never quite emerge from the welter of open-ended planes and independent linear inventions, nor do they fully dissolve into inexplicable spaces.

Unlike Maurer and Weber, Marsden Hartley (1877–1943) discovered the new art in the United States—at Stieglitz's gallery—before going abroad to Paris in 1912. The moodiest of the modernists, he gravitated from the orbit of Albert Pinkham Ryder, whose art he discovered in New York City in 1909, to the circle of Kandinsky and the Blue Rider artists in Munich, which he first visited in 1913. Hartley's initial European works, abounding with emphatic, swooping lines, which run across vaguely sketched areas of color, are more clotted and taut than Kandinsky's work. Their floral images and geometric forms suggest an esoteric symbolism derived from sources as varied as modern mystical theories and European primitive art [218]. He called his works at this time "Cosmic Cubism"; they reflect a Bergsonian rush of life even if their meanings are indeterminate. To Hartley, they illustrated the notion that "modernity is but . . . a new fire of affection for the living essence present everywhere." He tried to communicate through his works an open-eyed wonder, as he sought out "the spirit substance in all things." And, like other modernists and realists, he sought out the inner being and meaning in all things at the same time that he wanted to know and to feel his own responses to them. In 1914 he wrote, for an exhibition at Stieglitz's gallery, "a picture is but a given space where things of the moment which happen to the painter occur," a statement that Robert Henri, Max Weber, and the later Abstract Expressionists would certainly understand.

In 1914, Hartley began a series of "portraits" of German officers, in which textures grew thicker and forms became firmer than in his earlier work [219]. Representing a type of Synthetic Cubism with added symbolic meaning, several of these paintings "describe" his friendship with Karl von Freyburg, a German officer killed near the start of World War I. After returning to America in 1915, Hartley started a group of "movement" paintings, actually Cubist permutations of ships' sails [220]. By 1918, he had grown weary, as he said, "of emotional excitement in art." No wonder! Within an eight-year period, he had reviewed roughly three decades of modern art, careening from Cézannesque and Cubist landscapes to Expressionist and symbolic statements and back to Cubist manipulations of abstract form, all charged with an emotional aura uniquely his own.

During the 1920s and 1930s, Hartley painted in the American Southwest, in France, and in Germany. The essential Hartley emerged, however, only in the 1930s, when he decided to become a painter of New England scenes. A heavy-handed, depressing expressionism informed his work after this time [221]. His intensely colored, generally unmodeled forms, usually profiled or placed frontally and accented by dark outlines, emit a primitive directness of feeling. Objects enlarged beyond normal scale slow down previously quickened rhythmic cadences to purposeful, dirgelike rhythms. In the several paintings of Maine's

218. Marsden Hartley, *Musical Theme (Oriental Symphony)*, 1912–13. Rose Art Museum.

219. Marsden Hartley, *Portrait of a German Officer*, 1914. The Metropolitan Museum of Art.

220. Marsden Hartley,
The Boat, c. 1916.
Salander-O'Reilly Galleries.

221. Marsden Hartley,
Mount Katahdin, 1942.
National Gallery of Art.

Mount Katahdin, for example, the peak does not reach up to the sky—the incredibly transparent sky of northern Maine—but presses down on the landscape below as if it were a northern fog grown solid. One wonders what spiritual essence Hartley sought in the nature paintings of his native state. One also wonders if the buoyant modernism of the 1910s hindered the ultimate emergence of his essentially tragic vision, in a way similar to the Cubist restraint Alfred Maurer placed on his obviously throttled emotions. Perhaps Hartley might not have been able to paint such views of Mount Katahdin if he had not experienced modern European art so profoundly. On the other hand, he might have forged an interesting and personal style somewhere between those of his fellow New Englanders, Ryder and Homer, whom he greatly admired. If so, his late paintings might have marked a beginning rather than a summation. With Hartley, questions needed to be asked—to what extent did modern art help or hinder him, and what would have happened if, like Ralph Earl in the 1780s, he had rejected European modernism?

Arthur Dove (1880–1946) and John Marin (1870–1953) were also landscape painters, but they tended to seek essences of moods rather than reflections of their own anxieties in nature. Seeing in nature elemental and optimistic efflorescences of the creative principle, both wanted to embrace the landscape with primal directness. Dove once said that he would like to take "wind and water and sand as a motif and work with them." Marin expressed similar sentiments when he observed that "the true artist must perforce go from time to time to the elemental big forms—Sky, Sea, Mountain, Plain—and those things pertaining thereto to sort of re-true himself up." Their recognition of raw nature's inspirational powers has, of course, a long history in American culture and is especially apparent in the writings of the Transcendentalists. For example, Henry David Thoreau, in his *The Maine Woods* (1864), wrote "not only for strength, but for beauty, the poet must, from time to time, travel the logger's path and the Indian's trail, to drink at some new and more bracing fountain of the Muses, far in the recesses of the wilderness." And, in a generation after that of Dove's and Marin's, artists such as Barnett Newman and Mark Rothko sought in the 1940s an even more basic aspect of existence in their paintings of primitive biological organisms.

Of the two—Dove and Marin—Dove was the less anecdotal painter; his themes were less specific, less dependent on particular locales. Soon after returning from Europe in 1909, where he had spent two years learning about modern art, Dove described his method of working in language that recalls Ryder's explanation of his style. "Then one day I made a drawing of a hillside. . . . I chose three forms from the planes on the sides of trees, and three colors, and black and white. From these was made a rhythmic painting which expressed the spirit of the whole thing. The colors were chosen to express the substances of those objects and the sky. There was the earth color, the green of the trees, and the cyan blue of the sky." Colors and forms, initially similar to the original objects, assumed a complexity of shape and hue—a life of their own—independent of the objects until "the means of expression [became] purely subjective." Lines, which at first "followed the edges of planes . . . [were] used in and through objects and ideas

222. Arthur Dove, *Nature Symbolized No. 2,* 1911–12. The Art Institute of Chicago.

as force lines, growth lines." Possibly this direction in Dove's work was reenforced by Max Weber, who visited Dove at his Connecticut home in 1910 or 1911 and is reported to have told Dove to "symbolize things" rather than paint what he saw. In any event, this method, followed to its logical conclusion, led to the creation of works, the *Abstractions,* about 1910 or 1911 that evoked the landscape but that were also nonrepresentational. Rejecting this kind of art, however, Dove preferred to use landscape features as generative forms instead. The so-called *Ten Commandments,* which dates from 1911–12, represents this aspect of his work and marks its future direction [222].

Throughout his career, Dove also flavored his landscapes with Symbolist elements. In the 1920s and 1930s, he would visualize the sound of fog horns on a foggy day *(Fog Horns)* [223] and the sound of music (*George Gershwin, Rhapsody in Blue Part I,* 1927, private collection) or integrate objects with the landscape, suggesting a personal form of animism or biomorphic abstraction (*Goat,* 1935, Metropolitan Museum of Art, New York City). In the 1930s, he also painted phallic and egg-shaped images, suggesting the generative forces of nature, as if intent on distilling nature's processes to their most elementary principles [224].

223. Arthur Dove, *Fog Horns,* 1929. Colorado Springs Fine Arts Center.

224. Arthur Dove, *Summer Orchard,* 1937. Munson-Williams-Proctor Institute.

225. John Marin, *Church and Other Buildings,* c. 1911. The Art Institute of Chicago.

Between 1924 and 1930, Dove completed twenty-five collages; collage was a medium that others, such as Weber, had explored years before. Weber's collages grew naturally from his paintings, but Dove's seem to have been created by a different person, one who had looked back to the Dada collages done by Francis Picabia in New York City in 1915 or later ones by Joseph Stella. Cute rather than clever (a portrait of Stieglitz included a camera lens, a photographic plate, clock springs, and steel wool), they indicate that Dove's strength lay in nature imagery

226. John Marin, *Tree and Sea,*
Maine, 1919. The Art Institute of
Chicago.

rather than in exploring the more abstract processes of modern art. Such imagery, at its best, was invariably small and intimate in scale, and allowed the viewer to observe Dove's immediate decisions of mind and hand.

The aura of improvisation hovering over Dove's work was also present in Marin's. Both artists, apparently, were able to extemporize constantly and brilliantly, but Marin seems to have recorded more directly his emotional responses and visual sensations. For Marin, nature simply existed—it was—and he wanted to duplicate his feelings before it. As he said in 1909 about a painting of the Seine River in Paris, he had added dots of color because "I had to put them there. They were not there, but to express my feeling, they had to be there."

In comparison to his contemporaries, Marin evolved the most consistent style. Abroad from 1905 to 1911, he developed his mature style only in 1912, with a set of watercolors of New York City [225]. Less concerned than previously with atmospheric variation or transient moods of nature—with responding to objective reality—Marin increasingly began to use forms from the environment as springboards for his emotional outbursts. Spaces became dislocated as recessional movements were manipulated for expressive and compositional purposes. In what might be called Bergsonian fashion, he found the entire city, its buildings and people, alive, "and the more they move me," he said, "the more I feel them to be alive." It was this ever-burgeoning feeling that Marin tried to express, the forces and movements of the city interacting with each other and, internalized, within himself. His city scenes were less intimate than those by Bellows, because people were not central to his purpose, but at the same time they were more

personal, because Marin concentrated more on expressing his feelings than on recording a narrative sequence; these works represented Marin's stylistic amalgam of Cubism, Fauvism, and Futurism, as well as the styles of Cézanne and Robert Delaunay.

About 1917, Marin briefly eliminated virtually all references to specific places from his paintings, but his sources of inspiration remained in particular objects and scenes. Sometimes he would paint these as if in an orgiastic frenzy [226]. Perhaps to control the force of his emotions and the rapidity of his brush strokes, as well as to maintain an equilibrium between flat pattern and depth, Marin introduced extended linear forms to his work. These, acting as frames within the actual frame, appeared as early as 1914, but became common only after 1920. Late in his career, lines grew wiry and, at times, totally unrelated to his brushy squiggles and shapes, as if he were testing a picture's equilibrium to the breaking point [227].

In his watercolors and oils (he began to make oils in 1928), Marin built forms through small strokes of color. In the watercolors, he often allowed one color to intrude on another; in the oils he used a brush that often contained more than one color. Although his techniques and style varied little over the years, he did impose a Cubist-like control on his exuberance during the late 1920s, by encasing large units within single, planar forms. Some paintings even looked like wildly splayed decks of cards. He abandoned these constraints in the 1940s and, manipulating oils as if they were watercolors, created some of his most tumultuous works.

227. John Marin, *In the Ramapos, No. 2,* 1949. Hirshhorn Museum and Sculpture Garden.

228. Joseph Stella,
Brooklyn Bridge, c. 1919.
Yale University Art
Gallery.

He wanted, as he then said, to allow the paint to show itself as paint. The significance of these works lies in Marin's final synthesis of abstract design and representational imagery. Although nature's forms are always evident, the viewer is also aware of the pigment itself, the process of putting pigment to the surface, and the arbitrarily arranged compositions—qualities that unexpectedly link Marin to the art of the young Abstract Expressionists of the late 1940s.

Joseph Stella (1880–1946), a more complex personality than Marin, who painted symbolic as well as Futurist works, responded just as vehemently as Marin to the city, at least between 1913 and 1920. Channeling his passion into an obsessive regard for the Brooklyn Bridge, he re-created it as a "towering imperative vision," alive, as he said, "with the blaze of electricity scattered in lightings down the oblique cables . . . , the shrine containing all the efforts of the new civilization of America" [228]. Stella's language was based as much on Walt Whitman's impulsive rhetoric as on the Futurists' praise of the Machine Age. Familiar with Futurism since 1912, when members of the movement staged a major exhibition in Paris, where Stella was then living, he painted the Brooklyn Bridge in a variant of that style: he approximated the effects of an automobile moving across the bridge through successive layers of space, while the objects of peripheral vision—the cables and girders—appear at the sides.

Despite Stella's rhetoric, the sturdy central axis of this painting provides the composition with a rigidity and intellectual control missing from Marin's work

229. Joseph Stella, *Factories,* 1915. The Art Institute of Chicago.

in general and from other paintings of the Brooklyn Bridge by both American and European artists. And since Stella's work so often exhibits a centrality of focus and such carefully defined forms, his paintings are usually even less dynamic than *The Brooklyn Bridge.* Unlike Marin, who maintained his impetuous attack throughout his career, Stella developed a more ordered approach that, in industrial and city scenes, prefigured the Precisionist vision of the 1920s [229].

Other artists of this generation created works that superficially resembled those of Marin and the rest. But one basic difference exists: their works are generally not the product of an interaction with nature, but seem to be more dependent on other works of art or on ideas about art. Such works, more involved with the intricacies of the art-making process than with personal expression, are, consequently, more abstract, more intellectual, and more calculated.

An interesting and enigmatic figure in this regard was Manièrre Dawson (1887–1969), who worked as a civil engineer for the architectural firm of Holabird

and Roche in Chicago from 1909 to 1913. Rejecting nature as a primary source of inspiration, he wrote in his journal in 1910 that "great art must come from within oneself and is thus from nature only in that one is part of nature." Influenced by Picasso at the astonishingly early date of 1909, he made nonobjective paintings at the equally astonishing date of 1910, based, as he said, on "parabolas, hyperbolas and circles" [230]. Only then did he go abroad for a few months. On his return, he made several paintings based on Picasso's works as well as many modernized versions of Renaissance and Baroque masterpieces. He turned to farming in 1914, which effectively ended his artistic career, at about the time that Americans were returning from Europe because of the outbreak of general war.

One of the most important and immediate effects of the Americans' return from Europe was the exhibition of Synchromist paintings organized by Stanton MacDonald-Wright (1890–1973) in New York City in 1914. About a year before, he and Morgan Russell (1889–1913) had developed Synchromism, a type of color painting, in Paris [231 and 232]. Its introduction to New York City, together with the return of the color painter Arthur B. Frost, Jr., provoked a series of short-lived experiments in this style by several artists, including Thomas Hart Benton, Andrew Dasburg, and James H. Daugherty, which reached a climax with the Forum Exhibition of Modern American Painters in 1916.

Morgan Russell and MacDonald-Wright, abroad from 1906 and 1907, re-

230. Manierre Dawson, *Prognostic
—Right Panel*, 1910. Collection of Gilda and Tommy LiPuma.

231. Morgan Russell, *Synchromy in Orange: To Form*, 1913–14. Albright-Knox Art Gallery.

232. Stanton Macdonald-Wright, *"Conception" Synchromy*, 1915. Whitney Museum of American Art.

spectively, were diligent observers of recent artistic trends. Both believed they could take modern art to another and perhaps final level of evolution by creating forms as a function of color. They studied the color theories of Michel Chevreul (*De la loi du contraste simultané des couleurs*, originally published in 1839) and of Ogden Rood (*Modern Chromatics*, 1879), among others, in order to develop a style that could reproduce sensations of projecting and receding forms primarily by manipulation of color, rather than through devices of linear and atmospheric perspective. Developed during a period of great interest in the pictorial properties of color, Synchromism grew naturally from the slightly earlier movement of Orphism and the work of its leading exponent, Robert Delaunay. Since the Synchromists tended to accent movement in depth rather than the flat patterns preferred by Delaunay, two other sources were influential in Russell's and Mac-Donald-Wright's stylistic development. First, they undoubtedly responded to the works of artists such as Francis Picabia, who about 1912 were employing Cubist techniques in a cubic manner rather than in Picasso's flat planar style. Second, the Synchromists based their early works on Michelangelo's statues of slaves in the Louvre, therefore treating color more sculpturally and emphasizing three- as well as two-dimensional patterns. Thus, the Synchromists believed their art completed the development of modern art because it re-created in formal, non-realistic ways art's traditional concerns for pattern and depth.

The rhythms of a Synchromist painting were supposed to reproduce the actions of a human body, or the spatial position of an object, through the interactions of warm, emergent colors and cool, recessive ones. With colors divided into major and minor chords, or triads, the ideal Synchromist painting created logical relationships of form and color, as well as abstract equivalents of commonplace realities by means of rhythmic movements of color. These abstract equivalents became "pictorial realities," through which the painting gained intelligibility. A sense of order was apparent when one understood the necessity of placing a certain colored form in a certain place, in a manner similar to that of a traditional artist, who placed objects in appropriate relationships. Just as, for instance, a large, unmodeled red flower might destroy a traditional composition of small, carefully modeled flowers, so an improperly colored and positioned plane could destroy the unity of a Synchromist painting.

Although Russell and MacDonald-Wright worked closely for a few years, each developed a distinct style. Russell tended to paint nonobjectively, with less regard for three-dimensional effects. MacDonald-Wright's paintings are generally more atmospheric and three-dimensional, because of his greater use of tonal changes, variations of color intensity and, most important, the appearance of figures through the color planes.

Although Russell and MacDonald-Wright have received the most attention among American color painters of the period, Patrick Henry Bruce (1881–1936), a follower of Delaunay from 1912 to 1915 or 1916, evolved the most subtle use of color effects, first in a series entitled *Compositions* (1916–17) and then in one called *Formes* (1917–36). The *Compositions*, loosely based on the forms of danc-

233. Patrick Henry Bruce, *Composition III*, c. 1916–17. Yale University Art Gallery.

234. Patrick Henry Bruce, *Still Life*, 1925. Philadelphia Museum of Art.

ers in a nightclub, suggest three-dimensional movement through the manipulation of opaque bars of color [233]. The *Formes,* early examples of the orderly, hard-edged style that emerged in Paris during and after World War I, are abstracted still lifes [234]. Their particular brilliance lies in Bruce's ability to suggest depth and planarity at the same time through areas of bright, unmodeled color, in which shapes abruptly meet each other at odd and antic angles. But since Bruce remained abroad until 1936, and was generally ignored by the art world (he left America in 1903), his works had no influence in the United States; indeed, they were unknown.

America became a haven for several European writers, musicians, and artists during the First World War; the most important were Francis Picabia, Albert Gleizes, and Marcel Duchamp. Picabia, who made two important visits, arrived in time to see the Armory Show in 1913 and achieved immediate fame in the still-small modernist community in New York City. Through interviews and in exhibitions of his work, he reenforced the current Bergsonian concerns of the Stieglitz circle. Returning to America in 1915, he began to espouse a machinist point of view that was both more cerebral and provocative. He created "object portraits" of friends—for example, an unworkable camera as a portrait of Stieglitz [235]—which were probably derived from Marius de Zayas's caricatures of 1914–15 [236]. In 1915, Picabia and Stieglitz founded *291,* a Dadaist magazine,

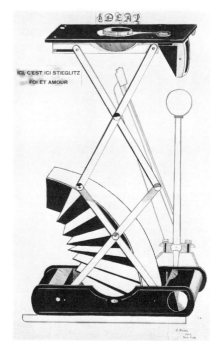
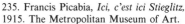

235. Francis Picabia, *Ici, c'est ici Stieglitz,* 1915. The Metropolitan Museum of Art.

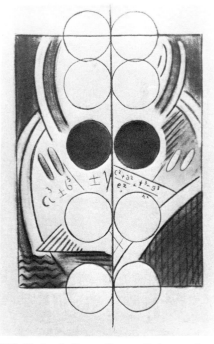

236. Marius de Zayas, *Abstract Caricature of Stieglitz,* 1913. The Metropolitan Museum of Art.

which ran for twelve issues. Its machine-like illustrations influenced several artists, including Morton L. Schamberg, Charles Demuth, Charles Sheeler, and, if momentarily, John Marin. Equally important was Picabia's attitude toward art, which served as an alternative to Stieglitz's concern for the expression of one's inner feelings. As Picabia stated at this time, "The machine has become more than a mere adjunct of life. It is really part of human life, perhaps the very soul. . . . I have enlisted the machinery of the modern world and introduced it into my studio."

Albert Gleizes, the Cubist painter, and Marcel Duchamp arrived in America in 1915. Gleizes, not as charismatic or innovative as Picabia and Duchamp, was nevertheless an important presence—a respected artist with a recognizable style of painting. His Bermuda landscapes of 1916–17 seem to have prompted Demuth to begin to paint in a Cubist manner at this time, and reminiscences of Gleizes's city views appear in Demuth's works about 1920.

Duchamp, the most iconoclastic of the three, had already invented the "readymade," in 1913, before he created his first American versions in 1915, such

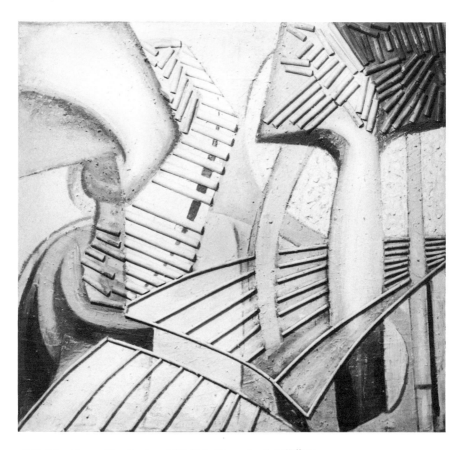

237. John Covert, *Vocalization*, 1919. Yale University Art Gallery.

238. Morton Livingston Schamberg, *Telephone,* 1916. The Columbus Gallery of Fine Arts.

as *In Advance of a Broken Arm* (a snow shovel). The central figure of the Arensberg circle, he achieved great notoriety when in 1917 he submitted a urinal, signed "R. Mutt," to the first exhibition of the New York Society of Independent Artists. In the short-lived magazine *The Blind Man,* he explained in language that must have been almost as shocking to Stieglitz as to the more traditionalist art community, "Whether Mr. Mutt with his own hands made the fountain or not has no importance. He CHOSE it. He took an ordinary article of life, placed it so that its useful significance disappeared under the new title and point of view

239. Man Ray, *Interior,*
1915. Philadelphia Museum
of Art.

—created a new thought for that object. As for plumbing, that is absurd. The only works of art America has given are her plumbing and her bridges."

Since Marin and Marsden Hartley painted their most abstract works at this time, and since the American artist Man Ray found in Duchamp an intellectual kinsman, it would appear that the arrival of the Europeans, rather than the Armory Show, had a more immediate stylistic impact on American modernism. But the challenging ideas presented by Picabia and Duchamp were not easily accepted by the Americans. Few were ready to use mechanical forms in satiric ways, to repudiate the idea of value by relying on chance or random choice, or to manipulate forms as if they were open-ended intellectual propositions with varying and complex meanings. Art, for most Americans, provided a way to arrive at personal truths rather than at statements of conscious ambiguity, to reveal one's inner self rather than to duel with abstract ideas, to seek essences rather than complexities, and to make reality meaningful rather than to show that reality was either illusive or nonexistent.

But Americans were drawn to the Europeans, nevertheless. John Covert (1882–1960) created collages based on Duchamp's work [237]. Morton L. Scham-

berg (1882–1918), after passing through a Synchromist phase, imitated Picabia's satiric machine forms by 1916, and was the first American to do so [238]. If he had not died during the influenza epidemic of 1918, he probably would have influenced the development of Precisionist painting in the 1920s by giving it both a more hard-edged machinist quality and a broader subject matter, which carried none of the environmental references of Demuth's and Sheeler's subsequent work.

It would seem that Man Ray (1890–1977) best understood the implications of Duchamp's and Picabia's works. Even before their arrival, he had made works that challenged basic assumptions concerning the nature of subject matter, the relationship of content and form, and the nature of aesthetic judgments. After meeting the Europeans, he created the most problematic art of any American painter of the time, juxtaposing random images, which, in denying easy intellectual resolution, provoked endless speculation concerning meaning [239]. (Such art did not become truly domesticated until some forty years later.) In 1918, in works called aerographs, Ray began to explore new techniques of paint application, using airbrushes. In 1920, he invented the "rayograph," in which, without the aid of a camera, he printed photographic paper that had been manipulated with lights and objects in the darkroom. Had he not left for Europe in 1921, where he remained, with the exception of a stay in America during the Second World War, he might have given the art of the 1920s a more Dadaist quality, or at least a more probing character and cosmopolitan flavor.

6

BETWEEN
THE WORLD WARS

THE YEARS covered in this chapter begin and end with major international wars. In the 1920s, inevitable and severe differences of opinion developed and crystallized within American society as the nation emerged from the First World War an increasingly urban and industrialized international power, rapidly growing self-indulgent and consumer-oriented. Social scientists as well as cultural critics and observers from all levels of society, in an orgy of self-doubt and self-analysis, debated the following questions: Could spiritual renewal be snatched from evident moral fatigue? Could a fragmented society ever become a harmonious one? Could mechanization be controlled for positive ends rather than be allowed to trample over the lives of individuals? Could traditional notions of personal initiative survive in an increasingly complex age? Did the past offer any lessons for the present, and was there a viable and useful past worth resurrecting? Should artists grow farther apart from society, or could they integrate themselves into the larger community of the nation? Should they honor the demands of art, separate from those of society, or should they build an art responsive to environmental interests? To what extent should disillusionment with European affairs after World War I influence American artists? The 1930s were marked by the Great Depression, which was triggered by the stock market crash in 1929, and by the rise of totalitarian regimes abroad.

Of course, critics and artists did not articulate these questions each time they picked up a pen, brush, or chisel, but these issues permeated the artistic atmosphere and, to varying degrees, influenced almost everybody concerned with American culture. As a result, a tense and apprehensive climate replaced the buoyant optimism and experimentalism of the pre-World War I days. Some older artists, such as Robert Henri and John Marin, were able to sustain their enthusiasm over the succeeding decades, but others grew more reticent—the realists finding comfort in more traditional forms of landscape painting and formal portraiture, and the modernists, still stylistically restless, assimilating realistic forms to their modernist images. Nevertheless, all of their works were invariably touched by the warmth of life, even if a few artists, such as Alfred Maurer and Marsden Hartley, allowed their personal anguish to gain the upper hand. Theirs

was never an art that appeared clinical, dispassionate, critical of life, or painted without profound personal commitment.

It is these very qualities, however, which characterize the art of the post-World War I decade. Yet the painters who helped set the artistic mood of the 1920s had either participated in or had developed from the prewar movements. Edward Hopper had studied with Henri between 1900 and 1906, Charles Sheeler had exhibited Fauvist works in the Armory Show, Charles Demuth was an intimate of Duchamp, Georgia O'Keeffe became one of the artists Stieglitz supported most actively, and Charles Burchfield, whose art developed outside the eastern cosmopolitan circles, had painted some of the most intensely personal visions of nature until about 1918. These artists projected, to a greater or lesser extent, an alienated vision during the 1920s, one having little in common with the prewar Bergsonian mysticism. In their work, anecdote disappears and transient effects of mood and climate vanish. In most instances, the impelling individual gesture of a brush stroke was replaced by a smooth, impersonal surface, which masked the artist's emotional presence. One searches in vain for levity. If paintings had been *the* determining factor, the "roaring twenties" would never have existed (compare 225 and 242).

Literary and intellectual figures, perhaps suffering a loss of moral innocence in the wake of World War I, also expressed a similar range of moods—from depression to devitalization. Writers such as Waldo Frank, Harold Stearns, Lewis Mumford, and Sherwood Anderson decried the nation's spiritual poverty even as they boasted about its industrial wealth. The countryside, previously considered the safe and true repository of American democracy and social ideals, was unmasked as a storehouse of hypocrisy, intolerance, and spiritual leveling. At the same time, the city, once regarded as the forerunner of the nation's new society, was exposed, even by its partisans, as a crippler of the human psyche. Reenforcing these critical attacks, rural and disaffiliated elements, challenged by the ascendancy of urban and cosmopolitan cultures, helped institute the anti-Communist crusades immediately after World War I, the restrictive racist immigration laws of the early 1920s, the spreading of the Ku Klux Klan beyond the South, and the various textbook controversies—the most famous of which, concerned with the teaching of evolution in the public schools of Tennessee, ended in the Scopes trial.

Earlier periods of American history were also criticized, including the time of Puritan settlement and the post-Civil War era. The maligned Puritans, held responsible for many subsequent emotional ills, were pilloried as much as the rapacious robber-baron entrepreneurs of the 1870s and 1880s. In three memorable phrases, the social critic Lewis Mumford summarized attitudes about America during the 1920s. In his essay "The City," in Harold Stearns's *Civilization in the United States* (1922), Mumford wrote, first, that "the highest achievements of our material civilization—and at their best our hotels, our department stores and our Woolworth towers are achievements—count as so many symptoms of its spiritual failure," and second, that "we have had the alternative of humanizing the industrial city or de-humanizing the population. So far we have de-humanized the population." Finally, in an essay in *The American Mercury* for July 1926, he

240. Louis Lozowick, *Minneapolis,*
1926–27. Hirshhorn Museum and
Sculpture Garden.

noted that, after examining the Spoon Rivers, the Gopher Prairies, and the Winesburgs (referring to Edgar Lee Masters's *Spoon River Anthology* of 1916, Sinclair Lewis's *Main Street* of 1920, and Sherwood Anderson's *Winesburg, Ohio* of 1919), he had become aware of the pathology rather than the heroism of the pioneers.

The country was subjected to a minute social, intellectual, and cultural examination, and it was found wanting. Artists, not yet insulated from national concerns, as they would be after World War II, participated in the critical attack and, at the same time, were its victims. Their art may be considered both a commentary on and a product of the cultural barrenness observers found endemic to American life, since the kinds of observations made about American culture in general might also be used to describe the art; the juices of life seemed not to flow through American paintings.

A surprisingly large number of artists used the architecture of cities as a major motif rather than as a backdrop for human activity [240, 254, 258]. They acknowledged the urbanization of the country and explored the industrial, business, and residential districts of modern America with an obsessiveness similar to that with which nineteenth-century painters examined the rural countryside and the wilderness. But while all the earlier painters reveled in the visual and spiritual pleasures of nature, the twentieth-century artists accommodated themselves to a modern, urban America with varying degrees of tolerance and sympathy.

Several artists who developed their mature styles about 1920 have since been called Immaculates, Cubo-Realists, or Precisionists [241]. Unlike painters of the preceding generation, they did not cluster around a single gallery or individual, nor did they exhibit together. But they did share certain stylistic traits, even though a single style never emerged. Forms were clearly indicated, and edges of planes were precisely delineated. Transitions between tones were smoothly meshed rather than roughly indicated. Yet, because most surfaces were painted with an even brightness, tonal modeling rarely imparted a sense of mass. The combination of tonal modeling and an even brightness inhibited the development of spatially ambiguous and constantly shifting planes typical of European Cubism. Since two- and three-dimensional effects tended to remain distinct—flat pattern and movement in depth did not easily coalesce—a sense of rigidity, even frigidity, characterizes Precisionist works. It is implausible to argue, as has been done, that Precisionists misunderstood Cubism and used it simply as a decorative mode, a means of looking modern without being modern. Rather, one might suggest more reasonably that the Precisionists, like the American Impressionists, preferred to slow down the surface movements of their European models almost to the point of stasis. (American artists have not always felt comfortable with the subtleties of Cubism's figure-ground complexities, as clearly indicated by the development of holistic, static imagery in the 1950s and 1960s.)

The Precisionists were fascinated by forms in the environment. People rarely appear, except in incidental ways. Atmospheric conditions are neutralized and landscapes are often denuded. Nothing moves. Industrial themes occur, but without the sense of the prewar exaltation. Nor are they treated with the kind of disdain Duchamp favored. Although aware of the Dadaist presence in New York, the Precisionists did not use industrial objects as part of abstruse pictorial puzzles, nor did they mock the functions of objects they did not understand. They rarely, if ever, reduced industrial forms to still-life arrangements. Rather, one senses ambivalence toward such subject matter, since the power of industrial forms and products is implicitly acknowledged, but these forms are usually placed in quiet settings.

Nevertheless, an artist such as Louis Lozowick (1892–1973), who added strong political messages to his work of the 1930s, could still grow exultant when contemplating American civilization in the 1920s. While finishing a series of works based on the architecture of major cities, he wrote in 1927, for the Machine Age Exposition, that "the dominant trend in America of today, beneath all the apparent chaos and confusion, is towards order and organization which find their outward sign and symbol in the rigid geometry of the American city. . . . By using an underlying mathematical pattern, the artist could create a new expression of optimism."

Rather than dwell upon his own responses to the city, like Marin or Bellows, Lozowick revealed instead his faith in human ability to impose order on modern civilization [240]. In this regard, one might argue that Lozowick's faith reflected that of America's business managers in the 1920s. Their forefathers, having subdued the wilderness, were now subduing and ordering America's productivity.

241. Charles Sheeler, *River Rouge Plant,* 1932. Whitney Museum of American Art.

Each object, as in a Precisionist painting, had its proper, carefully indicated location, emblematic of the triumphant American system of organization, a symbol of American capitalism victorious. For some, obviously, the price was too high.

Charles Sheeler (1883–1965) perhaps best reflected this ambivalence when he created a modern version of a nineteenth-century landscape painting—his *River Rouge Plant* [241]. In place of a body of water surrounded by gorgeous mountains, Sheeler encircled a pond with clean and neat industrial buildings. Both the earlier and the later images are ideal visions of America—Sheeler now assuming that the rational capabilities of the American mind, able to harness and control the machine, have replaced the Deity as the guide and protector of the American nation. The rustic canoe in Sheeler's twentieth-century industrial pond replaces the machine in the nineteenth-century American garden as a symbol of continued national innocence, simplicity, and harmony with nature. Cole would have been aghast, Durand and Church probably delighted.

Sheeler's paintings represent the major stylistic trends of Precisionism—abstract in the 1920s, realistic in the 1930s, and abstract, once again, in the 1940s and after. His work began to assume Precisionist qualities as early as 1915 or

1916. Instead of creating abstract studies from forms seen in nature, he began to reason "that pictures realistically conceived might have an underlying abstract structure." In other words, he would start from a realistic premise and then shear away essentials until he arrived at the intrinsic, but recognizable, abstract core. The poet William Carlos Williams, a friend of Sheeler's, cogently observed that when Sheeler abstracted form, it was "left by the artist integral with its native detail" [242]. In Sheeler's early barn studies, one sees not only the "native detail" of rural Pennsylvania buildings, but also senses their essential mass despite the use of flat, detached planes.

Sheeler's interest in early American artifacts, especially those of Shaker communities, probably influenced his choice of motifs and forms. His work as a creative photographer after 1915 was equally important, since his photographs reflected similar qualities of precise tonal contrasts, carefully adjusted patterns, and minimal environmental references. By 1920, skyscrapers were added to his repertory of pictorial and photographic images. These, and other subjects, were rendered with increasing literalness toward the end of the decade. As if to compensate for his growing realism, he used worm's-eye and bird's-eye perspectival schemes; by portraying rugs, grained woods, and implements of varied texture, as well as a variety of shadow patterns, he created works of compelling abstract force, which, at the same time, remained realistic [243]. In the hands of others, such paradoxical intentions occasionally assumed Surrealistic overtones [244]; in

242. Charles Sheeler, *Bucks County Barn,* 1918. Columbus Museum of Art.

243. Charles Sheeler, *Home Sweet Home,*
1931. Detroit Institute of Arts.

244. Preston Dickinson, *Factory,* c. 1920.
Columbus Museum of Art.

Sheeler's work, however, meaning rarely had implications beyond immediate content.

Believing that his art bore little connection to current events or popular attitudes, Sheeler never knowingly ventured into social or political comment, nor did he paint American subjects with chauvinistic intent. In this way he tried to avoid the major social issues confronting artists during the 1930s. His interest in

245. Charles Sheeler, *Continuity,* 1957.
Forth Worth Art Museum.

the formal aspects of composition, always evident, abruptly assumed dominance once again in 1946, when he began to paint flattened architectural forms as if seen through multiple photographic exposures [245]. In fact, they were initially sketched on superimposed sheets of glass and plastic.

These late paintings have a significance beyond their small size. Although an abstract movement did flourish during the 1930s (see below), Sheeler's late paintings, as well as those of other Precisionists, such as Niles Spencer (1893–1952), George Ault (1891–1948), Ralston Crawford (b. 1906), and even the Social Surrealist, O. Louis Guglielmi (1906–56), formed the first coherent body of abstract art in the United States that was largely free of specific European antecedents. Its distinctive attributes included a basic subject matter derived from architectural sources [246]. Buildings and bridges, often isolated from any environmental context, lacked mass yet appeared to be illuminated by brilliant sunshine. These are modernist outdoor paintings, which bear a relationship to earlier Precisionist paintings, comparable with that of Luminism to the Hudson River School.

Had Charles Demuth lived beyond 1935 (he was born in 1883), he might have served as a major link between the modernist movements of the 1910s and the 1940s. On the one hand, some of his industrial subjects, certainly his titles for them, skirted Dadaist satire and, on the other, he never abandoned the early modernist concern for subtly changing nuances of tone and color, whether using watercolors, tempera, or oils. Demuth first painted in a Precisionist manner when visiting Bermuda in 1917, perhaps prompted by Marsden Hartley and Albert Gleizes, who also visited the island at that time. Within a Cubist-Futurist framework, Demuth painted virtually undistorted fragments of buildings and trees arranged in superimposed and juxtaposed patterns [247]. By 1921 a studied

246. Ralston Crawford, *Grain Elevators from the Bridge,* 1942. Whitney Museum of American Art.

247. Charles Demuth, *Trees and Barns, Bermuda,* 1917. Williams College Museum of Art.

248. Charles Demuth, *Incense of a New Church,* 1921. The Columbus Gallery of Fine Arts.

realism began to pervade his work. Buildings, even if cut at their bases by the edge of the canvas, no longer floated in space but appeared to rise from solid foundations. Futurist ray lines, or probably telegraph and telephone wires, joined disparate forms, adding a sense of movement to planes otherwise threatened by spatial inertia.

Demuth's choice of titles most nearly approximated the attitudes of literary critics who found a materialistic America sadly lacking in cultural antecedents. Demuth called chimney smoke the incense of a new church, and he found in a grain silo the equivalent of an ancient Egyptian monument [248]. But his sallies were lighthearted in comparison to those of, say, H. L. Mencken and Van Wyck Brooks. Nevertheless, Demuth's observations, clever rather than profound, were among the first pictorial works to question the "glories" of American industrial culture. As the novelist Sinclair Lewis was attracted to and also rejected small-town America during the 1920s, Demuth sensitively conveyed the paltriness and banality of the hinterland's architectural monuments while at the same time bringing out the beauty of their forms.

Of all those associated with Precisionism, Georgia O'Keeffe (b. 1887) is most closely allied to the modernism of the Stieglitz circle. Her style, to be sure, was characteristic of the newer developments, but, with the exception of urban themes explored in the late 1920s, her imagery remained nature-bound and biomorphic. More important than serving as a link between periods, her work reaffirms certain characteristics central to the history of American art. She has painted the disembodied fact, like William Harnett and Andy Warhol, as well as the endless American landscape that sweeps beyond the confines of a canvas—like Thomas Cole, late-nineteenth-century painters such as William Trost Richards and Alfred Bricher, and more contemporary figures, including Jackson Pollock and Kenneth Noland. But true to the attitudes of the 1920s, O'Keeffe painted bleached animal bones as disembodied facts, and her boundless landscapes are arid rather than lush [251].

Since many of O'Keeffe's paintings are life-affirming, one senses in them a transcendent understanding of cyclic processes of birth and death rather than a perverse interest in decay alone. Stieglitz, after seeing her work for the first time in 1915, is supposed to have exclaimed, "Finally, a woman on paper!" His comment was probably not a sexist one but rather a confirmation of O'Keeffe's ability to capture on paper and canvas the most elemental forces of nature. Paintings such as *Blue No. II* [249] suggest the generative principle in nature to a greater extent than any work by Marin or Dove. Her *Light Coming on the Plains, No. II* (1916, Amon Carter Museum of Western Art, Fort Worth) is among the few paintings by any artist that begins to capture the primeval quality of light and life with which Turner imbued his watercolors.

O'Keeffe's style had turned realistic by the mid-1920s, but her concerns remained as before. Her intimate flower and shell studies, perhaps influenced by the development of "close-up" photography, transmute biological images into overt sexual ones [250]. These reflect a loosening of the country's puritanical

249. Georgia O'Keeffe, *Blue #2,*
1916. The Brooklyn Museum.

250. Georgia O'Keeffe, *Black Iris,*
n. d. Richard York Gallery.

251. Georgia O'Keeffe, *Red Hills and the Sun,* 1927. The Phillips Collection.

sexual mores and a willingness, induced by increasing awareness of Freud's theories of repression, to create works containing suggestive erotic symbols.

Not all artists seemed to be as "liberated" as O'Keeffe. The persistence of sexual repression in American society was vividly evident during these years in the paintings and prints of Edward Hopper (1882–1967). For example, the nude woman in his *Evening Wind,* aroused by the warm breeze streaming through the open window, seems barely able to control her emotions [252]. It is an intensely sympathetic and understanding study, and there is probably no other example of a female nude by an American male artist that is both so openly compassionate and sexual at the same time.

This theme of personal frustration was part of a larger group of ideas to which Hopper constantly returned throughout his career—the social and cultural isolation of the urban dweller who has become an apathetic witness to the passing of life. Although a student of Robert Henri, Hopper rejected the eager optimism of his teacher for the more sober pessimism of those who found in modern life a human wasteland. The Edenic sheen glossing over the destructive and demoralizing aspects of American civilization had been punctured at the end of the nineteenth century, but now it was peeled away entirely. Several writers almost seemed to be writing texts for Hopper's paintings at this time, or Hopper appeared

252. Edward Hopper, *Evening Wind*, 1921. Philadelphia Museum of Art.

to be illustrating their arguments. For example, Waldo Frank, in *Our America* (1919), described the typical New Yorker—or urban dweller—as "lowly, driven and drab. . . . A bankrupt people, unable with the repose of night to meet the fearful drainage of the day. The city is too high-pitched, its throb too shattering fast." One remedy was to accept despair as a sign of maturity. As Joseph Wood Krutch suggested in *The Modern Temper* (1929), "for us wisdom must consist not in searching for a means of escape which does not exist, but in making peace with it [modern civilization] as we may."

In any event, Hopper's future interests were apparent as early as 1913 and were further clarified in the series of etchings he made about 1920. His figures rarely participated in social activities, but might view them through an open window or from a porch. In both interior and exterior scenes, his figures appear enveloped by architectural elements, which establish clear physical and psychological perimeters of action, thus reducing the possibilities of chance human encounters. Such alienating elements also extended to Hopper's colors, which are usually bright and intense but impart no warmth [253 and 254].

The sense of mute entrapment revealed in Hopper's figures is derived as much from the situations in which the figures find themselves as from the artist's

253. Edward Hopper, *Sunday,* 1926. The Phillips Collection.

uncanny deployment of compositional elements. The latter trait reflects the influ-
ence of Edgar Degas, whose work Hopper greatly admired. Hopper's own sense
of form, however, is one of the most sophisticated in modern American art and
distinguishes his work from that of otherwise similar artists, such as Guy Pène
du Bois (1884–1958) [255]. Hopper's figures seem unable to move because they
are locked into their compositional formats. Despite their three-dimensional bulk
and realistic appearance, their humanity is denied, for Hopper treated them as
props in a two-dimensional pattern [254]. At times they are even less important
than the architectural forms around them. Directional movements might course
through their bodies, and their arms and legs might become parts of a sequence
of verticals and diagonals. The colors of the clothing often relate directly to other
colored areas. Held objects might be tied visually to other forms. Since Hopper's
figures rarely interact with each other, or with the viewer, their isolation is only
emphasized by such formal devices.

A taciturn individual, Hopper once said that *Cape Cod Morning* "perhaps
comes nearer to my thought about such things than many others [paintings]."
He did not indicate his thought, but this painting might hold the key to his work
[256]. In it the viewer looks through one window beyond the woman and out a

254. Edward Hopper, *The City,* 1927. University of Arizona Museum of Art.

255. Guy Pène du Bois, *Evening,* 1929. The Brooklyn Museum.

256. Edward Hopper, *Cape Cod Morning*, 1950. Sara Roby Foundation.

second window. The woman stares out a third. The painting is a *tour de force* of physical barriers and missed psychological connections. One wonders, by contrast, how Sloan might have treated this subject.

It is significant that during the 1920s, art critics considered Hopper and Charles Burchfield (1893–1967) important artists, praising them for capturing the true American spirit and the true quality of American life in their works. Surprisingly, both artists described contemporary ennui, Hopper through his figural studies, and Burchfield through his many paintings of decrepit post-Civil War buildings. But perhaps the critics were responding to the rising nationalism and growing anti-urbanism of the period. At least Burchfield's dreary streets, however tattered and rundown, portrayed the majority of ethnic America and its roots in small-town communities rather than the more exotic urban immigrant groups favored by Henri and his circle.

But this observation refers only to Burchfield's middle period, between 1919 and 1943, in which his paintings of buildings broadly mirror the mood of the 1920s. In his early and late periods, before 1919 and after 1943, he created some of the most idiosyncratic paintings made by a major American artist.

257. Charles Burchfield, *Dandelion Seed Balls and Trees,* 1917. The Metropolitan Museum of Art.

His early work, painted when he still lived in his native Ohio, was influenced by the writings of the naturist John Burroughs. Burchfield became so attuned to nature's moods that he tried to visualize insect and leaf noises through short calligraphic strokes and long airy arabesques [257]. Certain shapes—saddlebacks, spirals—came to signify specific moods; they were a personal shorthand of Burchfield's emotions at the moment forces in nature triggered them. The paintings are not formal equivalents of nature's forms, as Marin might have painted them, but emotional transcriptions of what Burchfield saw, heard, and felt.

After completing a series of hallucinated frame houses with humanoid fea-

tures in 1918, Burchfield gave up painting nature as autobiography to suggest, in the brooding presences of old, broken-down buildings, a poetry of place, a nostalgia for an earlier and better time [258]. One wants to mourn for the people who lived in those houses and worked on those crabbed main streets, also so disconsolately described by Sinclair Lewis in *Main Street*.

Less figments of his imagination than the structures of his earlier years, these mansarded, bracketed, gabled, and false-fronted buildings rarely defy gravity. Their worn sideboards assume characteristic textures of age. As if to underline his imaginative self-control, Burchfield quieted his whiplash brush strokes. At the same time, the humble dignity rather than the hoary majesty of these old structures suggests that the energies of George Caleb Bingham's post-pioneer settlements had long since been spent. Hopper's urban malaise had spread to small-town America.

In 1943, perhaps because of the exigencies of World War II, Burchfield abruptly altered his style and retreated into the private world of his dreams once again. For the next twenty years, he created an unprecedented sequence of nature paintings and, what is rare in American art, he developed a brilliant style in old age. Surfaces seem radiant and alive with strokes evoking forest noises and movements. Seasonal changes are telescoped within a single painting, reflecting Burchfield's interest in Chinese art [259]. In effect, he tried to abandon his awareness of his own personality so that he could become a vehicle to record nature's ongoing processes. These late works, in spirit if not in style, fulfill the desires of the early modernists to feel nature's creative pulses. Just as the Lumi-

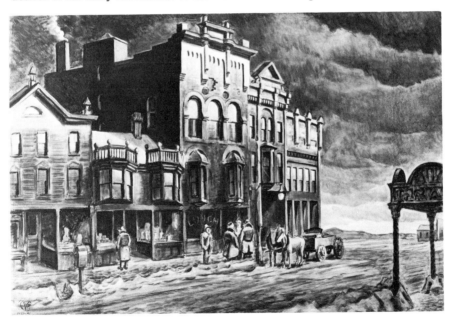

258. Charles Burchfield, *Edge of Town*, 1921–41. William Rockhill Nelson Gallery of Art.

259. Charles Burchfield, *The Four Seasons,* 1949–60. Krannert Art Museum.

nists have been called, in Emerson's phrase, "transparent eyeballs" in the face of nature, so Burchfield became a transparent soul. Together with artists as diverse as Morris Graves, Mark Tobey, and Mark Rothko (see below), Burchfield may be considered one of the century's leading mystical painters. At the same time, his interest in time breaks and time sequences, evident in works before 1918 and after 1943, bear resemblance to the time-sequencing devices that Stuart Davis and Thomas Hart Benton used about 1930 (see below).

Toward the end of the 1920s, attitudes toward American culture began to change appreciably. Growing support and interest developed in colleges and universities, in rural meeting houses, and on the editorial boards of art journals. Programs in regional studies and American civilization were instituted in school systems. Sophisticated persons who had once attacked the small-town ethos came to believe, by 1930, that it represented the backbone of America's spiritual strength. An order and direction to life not found in cities might still be found in rural areas. Social observers hoped that regional experiences could establish or maintain community values fast disappearing in modern America. Opposed to the psychological costs of contemporary industrialism and predatory capitalism, they believed that regional cultural interests might tie together an increasingly fractious and fragmented populace. To others, the growing interest in American culture reflected the persistent fear of seeing old-fashioned rural and sectional cultures replaced by an urban, cosmopolitan culture dominated by one or two eastern cities. For all concerned, from dispassionate academics to racial and religious bigots, the national experience required redefinition.

Within the art world, some, distressed by the influx of modern European art, thought they might be witnessing the death of American art. Those who were

more knowledgeable began to perceive in the paintings of Sheeler, Hopper, and Burchfield the emergence of a genuine American point of view, and they wanted desperately to encourage it (even if its images were not always flattering). Still others questioned the aesthetic basis of modernist art, believing that art must grow from interactions with local environments and experiences. Race, climate, geography, and shared experiences, it was held, generated an art of greater value than one reflecting the moods of a shifting, international, rootless intelligentsia loyal only to abstract ideas. Not surprisingly, the strongly nationalistic Mexican art movement of the 1920s grew enormously popular in the United States at the end of the decade. People hoped that it might serve as a model for the creation of an American art. When its leading figures, Diego Rivera, José Clemente Orozco, and David Alfaro Siqueiros, visited the country about 1930, they gained immediate, if short-lived, popularity, far exceeding that of Duchamp and Picabia some fifteen years before.

Increasing numbers of artists began consciously to document the American scene rather than simply to paint landscapes or urban views, as if in their documentation they might learn to understand the country's past and its present course, and perhaps be able to help chart its future. Their confusion in the face of enormous social change was the reverse of the optimism of most painters of the Hudson River School. The interest in the American landscape and the American character, which had been subsumed within the larger aesthetic concerns of Sheeler, Hopper, and Burchfield, now grew dominant. The onset of the Depression only catalyzed this trend.

By the early 1930s, an American Scene movement was recognized. In a way not unlike the central position assumed by Stieglitz and his circle early in the century, the critic Thomas Craven and his favored artists, Thomas Hart Benton (1889–1975), Grant Wood (1892–1942), and John Steuart Curry (1897–1946), assumed the central role in the American Scene movement and gave it a particularly xenophobic and anti-urban character [260]. As the miseries of the Depression increased, an amorphous, urban-oriented, and politically motivated group also emerged. [265]. Called Social Realists, they were supported by left-leaning groups such as the John Reed Clubs and various Communist factions. But, just as many painters of the rural American Scene did not agree with Craven and even objected to his usurpation of the movement, many artists found in the left-wing causes a broad humanitarianism rather than ideological dogma. On many points the Social Realists and the Regionalists (as the more apolitical rural-based painters were called) did actually agree, including a distaste for modernist art, a dislike of industrial capitalism, a desire to communicate with as many people as possible through their art, and a belief in the importance of environmental experience in the creation of art. Neither group treated art as an elite function, and artists identified with both groups traveled across America to document "the reality" of America. But differences remained, the most important being the Regionalist concern for particular American experiences and the Social Realist interest in universal class experiences. The Regionalists often looked to the past with nostalgia and nationalistic pride. The Social Realists saw in the past the seeds of contemporary problems and were fearful of nationalism in any guise.

The various government art projects, instituted to help artists when normal avenues of support had disappeared, gave official sanction to environmentalist aesthetics. On whichever of the four major programs artists were employed, subject matter was almost always drawn from some aspect of the American scene. The four programs were the Public Works of Art Project (1933–34), the Section of Painting and Sculpture in the Treasury Department (1934–43), the Treasury Relief Art Project (1935–39), and, the largest and most important, the Federal Art Project of the Works Progress Administration (1935–43).

Although the programs were established primarily to support artists through a period of economic stress, they also reflected longstanding aspirations concerning the purpose, function, and character of American art, which reached back to the eighteenth century. With government backing, a democratic and decentralized art movement had finally begun to appear all over the country. In addition, both the study and the creation of art objects had started to permeate most levels of society. More in fancy than in fact, supporters of the programs detected, finally, the beginnings of a unique American art. An American Renaissance had finally arrived, one based on American subjects rather than European theories, and on American styles rather than European importations. The backers of the American Art Union might have understood the excitement caused by American Scene painting; the proponents of the late-nineteenth-century American Renaissance probably would have disapproved.

In 1933 Hopper observed that American artists would humiliate themselves if they continued their apprenticeship to French art. "After all," he said, "we are not French and never can be and any attempt to be so is to deny our inheritance and to try to impose upon ourselves a character that can be nothing but a veneer upon the surface." During the 1920s, Thomas Hart Benton began chipping away at the veneer in order to paint the measure of the country. He wanted to establish an American style derived from American themes that would be as meaningful to as many Americans of the majority culture as possible. Like the early modernists, with whom he had once been closely associated, he, too, wanted to create works that would suggest the essence of reality, but Benton's reality was an American one, based not on emotional mysticism but on common experiences and on an environmentalist recognition of commonly held habits, occupations, and activities. Opposed to Big Business, Big Government, and Big Labor— several of his paintings are penetrating critiques of contemporary America—he wanted to return to a slower-paced, nineteenth-century mode of existence.

By the middle 1920s Benton had created a style and a range of thematic imagery based on typical and mythic American experiences. In contrast to Hopper, who showed the psychological devastation resulting from rapid social change, Benton stressed the physical energies expended in building the country [260]. He reasoned that the nation's tumultuous and diverse growth demanded a staccato-like, constantly moving pictorial organization. Consequently, he titled landscapes and juxtaposed spaces in broken, kaleidoscopic fashion. His figures, with their bulging muscles, seem also to have been given extra sets of joints. Subject matter, usually based on working-class themes, was generalized so that more people might relate a painting's content to their own experiences.

260. Thomas Hart Benton, *Cotton Pickers, Georgia,* 1928–29. The Metropolitan Museum of Art.

Benton painted three sets of murals and prepared extensive studies for a fourth before the start of the government-aid programs. As a result, he, together with the Mexican artists, popularized various themes that were developed further by later muralists. These included histories and contemporary panoramas of particular regions; surveys of particular industries, including agriculture; and prophetic works concerned either with the promise of the future or the fulfillment of present dreams [267]. Benton's major mural achievement, a representation of the true and legendary history of his native Missouri, is the masterpiece of the rural American Scene. Tempering his praise for the self-sufficient working person, he painted a scathing denunciation of predatory capitalism, false and self-serving religiosity, and political corruption [261].

Several artists altered their styles and outlook about 1930 by emphasizing the "American" aspects of their art: Grant Wood was one of them. Paradoxically, he fleshed out his "American" style only after visiting Munich in 1928, on his fourth trip abroad, when he saw fifteenth-century German art and the works of the contemporary New Objectivity painters. Catapulted to fame by the first important painting he completed after his return, *American Gothic,* he then painted a few other similarly sardonic works [262]. These are aggressively midwestern equivalents of Hopper's figures—spiritually barren, unforgiving, and

261. Thomas Hart Benton, *Pioneer Days and Early Settlers,* 1936. State Capitol, Jefferson City.

actively self-righteous. They offend because they project personalities incapable of compromise. To many, they doubtlessly laid bare the worst qualities of the American character, and, possibly, our dislike of these personalities has been transferred to a dislike for Wood. Yet, few artists have caught so deftly the pernicious qualities endemic in the American psyche. The dry facture, the taut edges, and the crisp modeling as well as the simple composition are exact pictorial equivalents of the banalities of most people's lives and the clichés by which they live. As Wood wrote in his famous essay, "Revolt Against the City," in 1935, "your true regionalist is not a mere eulogist; he may even be a severe critic."

Like any reasonable person immersed in his particular culture, Wood also found positive values in midwestern materials. He respected and made heroic the life of farmers, unfortunately with woodenly posed figures involved in candy-coated activities [263]. He hoped that his art, together with that of other midwesterners, might someday lead to a specifically midwestern style. Ultimately, it would coalesce with other regional styles to form a great national style. This attitude, nationalistic and idealistic—and sociologically impossible—was based on two assumptions: first, that regional cultures and ultimately a national culture could develop in a vacuum untouched by the potent and mobile forces of modern life; second, that local cultures were similar enough to be blended into a unified whole. Implementing such anti-pluralistic notions would result in an American dream for some, but a nightmare for other Americans.

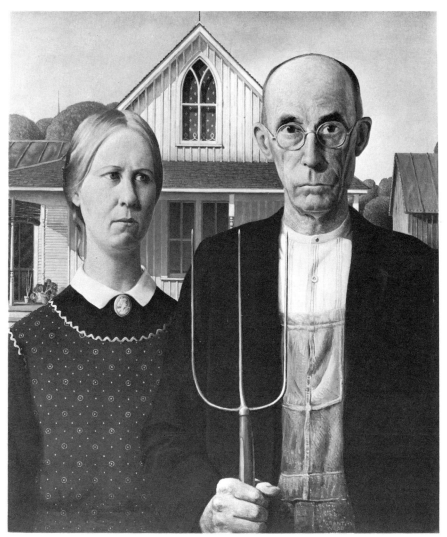

262. Grant Wood, *American Gothic,* 1930. The Art Institute of Chicago.

The implications of Wood's and Benton's Americanism enraged left-leaning artists, especially when considered in the context of contemporary Germany's murderous nationalism. The disagreements therefore were not merely aesthetic ones, which, with Henri and Stieglitz, still permitted occasional cooperation in exhibitions, but fundamental political ones. Many Social Realists, the children of Eastern European immigrants, obviously understood that to survive, let alone to flourish, a climate of international cooperation was essential. Thus, socialism and communism became attractive. These movements provided forums for necessary social and political change. And their cosmopolitan flavor effectively opposed a potentially exclusionary nationalism.

263. Grant Wood, *Breaking the Prairie*, 1936. Iowa State University Library.

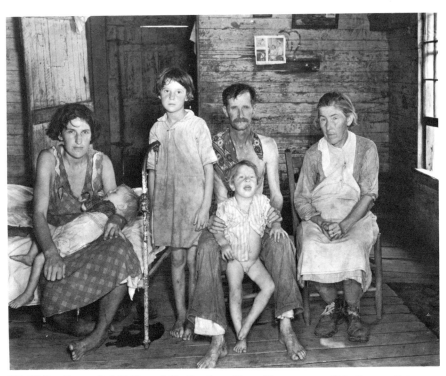

264. Walker Evans, *Bud Fielde and His Family at Home. Sharecroppers, Hale County, Alabama,* 1936. Library of Congress.

Social Realists generally painted in expressionistic styles and found their subject matter in urban equivalents of Regionalist themes—factory workers in place of farm hands. Many had drawn cartoons for the *Masses,* the *Liberator,* and the *New Masses* and, in effect, painted enlarged cartoons. Their arbitrary stylizations, use of abrupt tonal contrasts, and distortions of forms were also influenced by the works of Jules Pascin and George Grosz, who came to the United States in 1927 and 1933, respectively.

Artists concerned with social problems might also have responded to the work of many photographers who were supported by the Resettlement Administration (subsequently called the Farm Security Administration) between 1935 and 1942. Several, including Walker Evans (1903–75), photographed the rural and urban poor, some using highly charged and improvisational methods; others, like Evans [264], provided their subjects with a dignity and tragic beauty akin to the late portraits of Eakins.

Ben Shahn (1898–1969) toured rural districts for the Resettlement Administration in 1935, but earlier, in the gouache studies commemorating the trial and death of Sacco and Vanzetti, painted the first major monument of Social Realism [265]. Striking a political middle ground between overt propaganda and a vague,

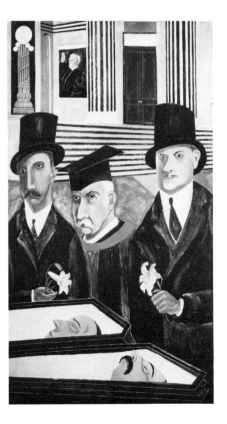

265. Ben Shahn, *The Passion of Sacco and Vanzetti,* 1931–32. The Whitney Museum of American Art.

266. Ben Shahn, *Age of Anxiety,* 1953. Hirshhorn Museum and Sculpture Garden.

nondirected humanitarianism, Shahn assumed a political point of view without explicitly stating one. But even this subtle blending of ideology and esthetics caused Shahn and others discomfort late in the 1930s because of the Stalinist usurpation of the far left. Just as modernists had reconsidered their artistic directions after World War I, so Social Realists (and Regionalists) were forced to reevaluate their attitudes during World War II. Shahn survived the reorientation better than most, interpreting politically loaded subjects in an increasingly personal way and developing an enlarged range of imaginative imagery. A developing calligraphy began to dominate his style so that his late works are held together by networks of sensitively adjusted linear webs which often act independently of areas of color [266].

267. Philip Evergood, *The Story of Richmond Hill,* 1936–37. Richmond Hill Branch Library.

268. Philip Evergood, *Juju as a Wave*, 1935–42.
Hirshhorn Museum and Sculpture Garden,
Smithsonian Institution.

The career of Philip Evergood (1901–75) is similar, in that his basically poetic personality, suppressed during the 1930s, did not fully emerge until the 1940s [268]. Through the 1930s he recorded social and political injustices, the quality of life led by the underclasses, and the dreams held by immigrants of financial and physical security in the United States [267]. His mural outlining the history of Richmond Hill, originally a working-class garden suburb of New York City, describes the immigrant vision of happiness through enlightened social engineering.

Nonpolitical urban painters, especially the pupils of Kenneth Hayes Miller (1876–1952), such as Reginald Marsh (1898–1954) and Isabel Bishop (1902–88), focused on the excitement of urban living [269, 270], reveling in the crowds

269. Reginald Marsh, *Twenty-Cent Movie*, 1936. The Whitney Museum of American Art.

270. Isabel Bishop, *Encounter*, 1940. The St. Louis Art Museum.

271. Raphael Soyer, *R.R. Station Waiting Room,* 1939–40. The Corcoran Gallery of Art.

shopping on busy streets and the bathers sunning at nearby beaches. In contrast, the Soyer brothers—Raphael (1899–1987), Moses (1899–1975), and Isaac (1907–81)—paused in their perambulations to witness particular moments of sorrow or personal introspection [271]. In contrast to Marsh's obsessive concern for movement, the Soyers found in their subjects a subtle glance or movement that revealed intimacies of character. In their different ways, these artists continued the precepts of the Henri circle into the second half of the century.

Others, such as Jack Levine (b. 1915), have painted with a generalized sense of moral outrage [272]. Jacob Lawrence (b. 1917), on the other hand, has often channeled his outrage into scenes of racial prejudice. Deceptively sophisticated, Lawrence's flattened, angular, and awkward figures reveal an urban environment of which most whites are oblivious [273]. Lawrence's work, with Max Weber's late paintings, indicates the rich but still unexplored ethnic contribution to the imagery of the American Scene.

Several other artists used the human figure to populate a much more private and idiosyncratic universe, especially during the 1930s. Although they did not necessarily explore further the kinds of literary and religious subject matter of Elihu Vedder, Robert Loftin Newman, and Albert Pinkham Ryder, they nevertheless indicate the continued presence of a rich and still barely acknowledged strain of poetic intensity and personal mysticism among American artists. Certainly the influence of Surrealism can be observed, particularly after the first

272. Jack Levine, *The Feast of Pure Reason*, 1937. The Museum of Modern Art.

273. Jacob Lawrence, *Tombstones*, 1942. The Whitney Museum of American Art.

American exhibitions at the Wadsworth Atheneum in Hartford and at the Julien Levy Gallery in New York City in 1931 and 1932, respectively. The exhibition entitled *Fantastic Art, Dada and Surrealism* at the Museum of Modern Art in New York City in 1936 also called attention to the figurative and abstract sides of Surrealist art. The juxtaposition of unrelated objects, menacing atmosphere, and haunted spaces of the Italian artist Giorgio de Chirico, as well as the meticulous finish and seemingly anxiety-ridden subject matter of German New Objectivity painting of the 1920s, were also influential.

But no European movement quite accounts for the unprecedented art of Edwin Dickinson (1891–1978), perhaps the first American artist about whom some knowledge of dream theory is essential for decoding his works. As early as 1916 he began to juxtapose and superimpose figures, whose actions were not always understandable, in odd spatial sequences. A brilliant technician who carefully controlled degrees of focal clarification, Dickinson sometimes added props to indicate that a very private and overwhelming drama was taking place in his unconscious that would never be allowed to struggle through to consciousness or rational explanation. For instance, his *Composition with Still Life* contains images of death as well as symbols of useless sexual organs [274]. His self-portraits, more provocative and disturbing than any others in American art, reveal Dickinson in serious combat with his private demons, particularly when he painted himself as a dead person. It is as if he took Hopper's figures to the next level of psychological investigation, trying to experience the contents of their minds rather than merely to observe their outward appearances. Since Hopper summered on Cape Cod, and Dickinson lived there the year round, the two might have known each other and profited from each other's company in the manner of Ryder and Newman in the 1880s.

In contrast to Dickinson's personal symbolism, other artists, such as Peter Blume (1906–92) and O. Louis Guglielmi (1906–54), created images that are decipherable and that usually describe improbable, but understandable, events. Both also painted works that commented on current affairs. Blume, who painted government-sponsored murals in Pennsylvania and New York in 1936 and 1941, gained popularity with his *South of Scranton* (1930, Museum of Modern Art, New York City), the record of a trip from Scranton, Pennsylvania, to Charleston, South Carolina. Subsequent paintings had allegorical content, including *Light of the World,* in which an image of modern technology rising above symbols of past cultures, such as the darkened church, pours its light on three uncomprehending adults [275].

Guglielmi's paintings of the 1930s, with their obvious political overtones, might be designated as Social Surrealism. His *View in Chambers Street,* a mordant comment about America during the Depression, also suggests the claustrophobic quality of life on the grim, mean streets of lower Manhattan [276]. He said in 1944, "I like to evoke the feel of a street, the unseen life hidden by blank walls, its bustle and noise, the mystery of a deserted alley"; this is a point of view different from that of Evergood, who showed workers, or Marsh, who reveled in turning people-watching into episodes of nonstop improvisational theater.

Guglielmi stopped painting haunting urban themes in the 1940s. Like Shahn,

274. Edwin Dickinson, *Composition with Still Life*, 1933–37. The Museum of Modern Art.

Evergood, and others, he found that neither current events nor strong political themes offered artists viable subject matter any longer. No doubt the psychological and emotional effects of World War II prompted these artists to question the assumptions of their art—leading some, such as Burchfield, into a private world of identification with natural forces; others, such as Shahn, into a broad humanitarianism; Evergood into either poetic fantasy or gentle satire; and Guglielmi into a more rationally conceived world of abstract images, over which the artist exercised total control. In a still not clearly understood way, their paintings

275. Peter Blume, *Light of the World,*
1932. The Whitney Museum of
American Art.

276. O. Louis Guglielmi, *View in
Chambers Street,* c. 1936. The Newark
Museum.

of the 1940s, and even those of the 1930s, helped undercut the premises of realistic figurative art because the artists wanted their work to carry meanings far beyond recorded visual experiences. The complex content of their work, unlike that of, say, Sloan, Bellows, and Marsh, often contained political, racial, economic, or intensely personal meanings, which required nonrealistic dislocations of space, arbitrary colors, and bizarre as well as disjointed figural arrangements. Such uses of art might have contributed to the rising interest in abstract art toward the end of the decade.

In any event, despite overwhelming public and critical approval of American Scene and realistic painting, abstract art did exist and flourish during the 1930s. Major European artists, such as Hans Hofmann and Josef Albers, immigrated in 1931 and 1933, respectively, and Fernand Léger and Jean Hélion visited the United States for various periods of time. The Gallery of Living Art, the Museum of Modern Art, and the Museum of Non-Objective Art (The Solomon R. Guggenheim Museum) were founded in New York City in 1927, 1929, and 1937, respectively. Major exhibitions of major movements and significant artists were held with increasing frequency. Americans, when abroad, became familiar with, and even joined, such important European modernist groups as the *Cercle et Carré* (1929–30) and the *Abstraction-Creation-Art non-figuratif* (1931–c. 1936). Perhaps most important, a strong bond began to develop among modernist artists —in part because of their isolation from more popular currents and because of their shared experiences on the government projects. Through mutual support, they began to forge a community that encouraged artistic development and gave their work a sense of continuity it had previously lacked. It was, therefore, only in the 1930s that American artists finally created the kind of self-sufficient artistic community that had existed in Europe for generations.

By the decade's end, three major groups could be identified: those who derived images from the American Scene; those who synthesized elements from Cubism, Constructivism, Neoplasticism, and Bauhaus modernism; and those who developed independent styles. Although lacking spokesmen such as Stieglitz or Craven, these artists nevertheless created an estimable body of work, which indicated the high professional level reached by American modernists within a single generation.

Whatever styles American modernists worked in or passed through, virtually all dealt with one major compositional problem—how to control the suggestion of depth. This might involve either indicating a slight oscillation between a form serving as a figure and the shapes serving as its background or presenting a more static relationship, in which forms lay inert on the surface. The former method tended to reflect Cubist influences; the latter, those of the interwar modern styles. (In the 1940s artists such as Arshile Gorky and Jackson Pollock allowed the surface to become a more fluid skin, while Barnett Newman made the viewer be aware of the entire canvas as the art object rather than concentrate on the relationship of forms within the canvas's borders.) In the 1930s one of the chief devices by which artists explored relationships between surface design and suggestions of depth was to separate line and plane from each other. In painting

after painting—and in sculpture as well—the interweaving of lines and planes can be seen easily [277, 281, and 298]. Sometimes the canvas itself served as a neutral surface upon which lines and planes were placed. On occasion the canvas became, in effect, a large plane, a repository, receiving a series of lines. Sources varied, but the more important ones included some of Picabia's paintings completed in America during World War I, Picasso's sculptures of the late 1920s, and Mondrian's mature works, which became well known only in the 1930s. This mode of visualization, it is important to note, also has antecedents in the history of American art. One need look no further than the portraits of Copley and Charles Willson Peale, or the landscapes of Durand and the Luminists, to understand how important was the interaction of line and plane to establish interrelationships of surface pattern and depth. (In the 1960s, Robert Irwin still found enough complexity in this issue to explore its ramifications in several paintings.)

Stuart Davis (1894–1964) is the most interesting of the interwar modernists, especially in the way he combined formalist values with environmental concerns, or European styles with American themes and attitudes. Although Davis emphasized abstract forms and representational images at different times in his career, he basically wanted to create, like Benton, a pictorial reality parallel to that of American life. But his sources lay in the modern milieu of the radio, the telephone, the automobile, and the airplane rather than in a dream world of an earlier, simpler America. Davis exulted in the rapid pace of American life, preferring to suggest rather than describe what he saw and felt. His images, consequently, project staccato-like and montage-like effects through uniformly bright and unmodulated colors.

A student of Robert Henri from 1910 to 1913, Davis turned to modernism after seeing the Armory Show in 1913; he was one of the few artists upon whom the exhibition had a telling effect. Davis's commitment to modernism became profound. When others began to accommodate their styles to more traditional modes after World War I, he pursued his investigations of abstract form as well as theory. This phase of his art culminated in the *Eggbeater* series of the late 1920s [277], based on the forms of an eggbeater and rubber gloves placed on a table, in which he seemed deliberately to have pulled apart and flattened a painting in the style of Francis Picabia.

Through these years, Davis developed his characteristic airless surfaces and his habit of juxtaposing, rather than superimposing, elements as if each painting were an assembled jigsaw puzzle—a technique Benton put to good use in his murals for the New School for Social Research in New York City in 1930. Through the 1930s Davis's style turned more realistic, but in the early 1940s it grew abstract once again, probably in response to Mondrian's presence in New York City [278]. In the works of the 1940s, letters became compositional elements more than signifiers of words. Solid bars of black might outline objects or become independent planes of color. Detail might multiply upon detail, pushing forms to the edge of the canvas, as if Davis were unable to contain or capture the energies of the American scene within traditionally balanced compositions.

His own ambivalence between finding the genesis of his forms within the

277. Stuart Davis, *Egg Beater Number One,* 1927. The Phillips Collection.

design of a painting or as a result of environmental factors is well summarized in two statements he wrote in 1942 and 1943. In an article in *Art News* for February 1, 1942, he wrote, "I have enjoyed the dynamic American scene for many years past, and all of my pictures . . . are referential to it. They all have their originating impulse in the impact of the contemporary American environment. . . . Paris School, Abstraction, Escapism? Nope, just Color Space Compositions celebrating the resolution in art of stresses set up by some aspects of the American scene." But in his journal in July 1943, he stated, "today I disassociate the painting experience from general experience and attain a universal objective statement that transcends the subjectively particular. The emotion is given intellectual currency beyond time and place." The latter statement describes *Ultramarine,* one of Davis's first works announcing his turn toward abstraction in the 1940s, which informed his paintings for the rest of his life.

Throughout his career, Davis absorbed many stylistic elements without submerging his own personality in them. As a result, his style shows a rare continuous growth, whether he used collage-like elements or responded to the works of Matisse, Léger, or the Surrealists. In addition, intimations of later movements can be spotted in his work. Both a Pop Art and an Op Art sensibility

surface occasionally, and the amplification of detail, particularly in the 1940s, prefigures the all-over patterns of Abstract Expressionism. During the 1930s he actively supported political militancy among artists, serving as Executive Secretary of the left-leaning American Artists Congress, which was formed in 1936 and disbanded in the early 1940s. Rarely have so many artistic and social currents intersected in the work and personality of one artist.

Other artists treated subject matter more radically, by eliminating almost all references to anecdotal sequence or the environment. Nor did they fall back on the personalized modernism of the Stieglitz group. Instead, they preferred formulating an art based on interwar modernist movements in general and on a combination of Juan Miró's biomorphic forms and Mondrian's more rigid geometries in particular. Several of these artists founded the American Abstract Artists in 1936, for reasons similar to those surrounding the formation of the Society of American Artists in the 1870s. Generally ignored by the American art world and unrepresented in the Museum of Modern Art's large exhibition, *Cubism and Abstract Art,* in 1936, a group, including Byron Browne, Rosalind Bengelsdorf, Gertrude and Balcomb Greene, Harry Holtzman, and Ibram Lassaw, formed the organization to publicize and promote abstract art in America. Burgoyne Diller was an especially important member, in part because as head of the Mural Division of the Federal Arts Project in New York City he obtained mural commissions for some abstract artists.

A typical AAA painting of the late 1930s might include the following: hard-edged forms impersonally precise and placed against a neutral ground, overlapping shapes with minimal transparencies, unmodulated colors, or, contrarily, almost imperceptible gradations of tones [279]. After the arrival of Mondrian in New York City in 1940, which was achieved primarily through the efforts of Harry Holtzman, the AAA style grew more calculated and rigid. Right angles

278. Stuart Davis, *Ultra Marine,* 1943. Pennsylvania Academy of the Fine Arts.

279. Byron Browne, *Variations from a Still Life*, 1936. The Brooklyn Museum.

280. Burgoyne Diller, *Second Theme*, 1937–38. The Metropolitan Museum of Art.

281. Ilya Bolotowsky, *White Abstraction,* 1934–35.
Robert Hull Fleming Museum.

replaced curvilinear forms. Colors grew simpler. Suggestions of depth were permitted, but were severely controlled **[282]**.

Burgoyne Diller (1906–65), who incorporated Constructivist elements into his work as early as 1930, turned to the gridlike forms of Mondrian by 1933; he was perhaps the first American to do so. Most of his subsequent paintings and relief constructions were then created in three distinct modes, which he called *Themes.* In the First Theme, rectangular forms floated freely on a neutral ground. A simple Mondrian grid characterized the Second Theme, and a complex, active grid enlivened the Third Theme **[280]**. Others, such as Ilya Bolotowsky (1907–1981), first tried to develop a hybrid style in the 1930s, combining the forms of Miró and Mondrian—Bolotowsky developed his by 1933—and in the 1940s began to order their canvases more rigorously either in emulation of Mondrian or with Mondrian-like elements **[281 and 282]**. In contrast, Byron Browne (1907–61) turned toward a more loosely formed art in the 1940s, in response to the presence of the Surrealist painters who had fled war-torn Europe for America and to the growing presence of those artists who were to become Abstract Expressionists **[283]**.

Most of the artists associated with the American Abstract Artists probably would have subscribed to the ideas of George L. K. Morris (1905–75), the painter and writer who can be considered the chief spokesman for the group. In its exhibition catalogue for 1938 he wrote, "the bare expressiveness of shape and position of shape must be pondered anew; the weight of color, the direction of

282. Ilya Bolotowsky, *Inside and Outside,* 1949. Martin Diamond Fine Arts.

line and angle can be restudied until the roots of primary tactile reaction shall
be perceived again." Such a drastic renewal of art was necessary, it was held, to
reflect the ideals of a technological modern culture and also to impose order on
that culture. For as Morris wrote in *Partisan Review* in September 1941, "an era
of convulsion evidently requires of artists that they restrict their horizons and
close in upon a consciously ordered world where every facet is completely under-
stood."

At least two important artists found comfort neither in forcing order on art
nor, by extension, wishfully imposing a symbolic order on modern culture, but
by responding to non-Western philosophical and religious ideas. These are Mark
Tobey (1890–1976) and Morris Graves (b. 1910), whose association with the
Pacific Northwest underlined their separation from the New York–Paris artistic
axis.

Although well aware of contemporary developments, Tobey was more pro-
foundly influenced by his conversion to the Baha'i World Faith in 1918, his study
of Oriental calligraphy, dating from 1923, and his travels to the Far East in 1934.
Best known for his "white writing" paintings begun in 1935, Tobey usually

worked on an intimate scale. He once said that the white lines "symbolize light as a unifying idea which flows through the compartmental units of life." To break down those compartments, he substituted diffused focal points for traditional dominant and subordinate elements [284]. The white lines, lacking velocity, form myriad stationary strokes that appear to vibrate and fill a void, but do not suggest mass. Reflecting Baha'i attitudes about the unity of life, these works invoke a sense of cosmic wholeness, combining matter with nonmatter, space with non-space, and individual stroke with the totality of the pictorial field.

Morris Graves employed white writing about 1940, but he never abandoned recognizable imagery. Rather, he used it to "trap" his subjects, often birds, as they emerged from spaceless voids [285]. For Graves, as for Tobey, such images seem to represent the human voyage through the spaces of inner consciousness as the mind forever tries to push away the webs and tangles of reality. Zen and other Eastern mystical systems have provided Graves with the insights necessary to still "the surface of the mind and [let] the inner surface bloom."

Both Tobey and Graves gained prominence about 1940, when artists once again began turning to personally meditated themes. Part of a broad-ranging revival of abstract art, their work heralds the turn toward the self-generated

283. Byron Browne, *Firebird*, 1948–50. Washburn Gallery.

284. Mark Tobey, *Edge of August*, 1953. The Museum of Modern Art.

285. Morris Graves, *Blind Bird*, 1940.
The Museum of Modern Art.

image, the statement of private meaning, that led to the emergence of Abstract Expressionism later in the decade.

The artists most closely associated with this development, including John Graham, Arshile Gorky, and Willem de Kooning, seemingly allowed the anxieties and tensions of the 1930s to affect their art profoundly. Rather than impose rational order on their forms or seek sustenance in religion, they confronted more directly the mysteries of artistic creation and the vagaries of the unconscious mind by altering the shallow surfaces of late Cubism with mysterious shifts of space, and they modified the geometric styles of the 1930s with biomorphic forms and enigmatic imagery. Their art grew prominent and important in the next decade.

SCULPTURE

Sculptors were not as radical as the painters of the Stieglitz and Henri circles during the opening decades of the twentieth century. Perhaps the cost of materials inhibited them from exploring modern realistic and abstract modes as vigorously, even though many traveled abroad to visit and to study in the major artistic centers of Europe. Support was also insufficient. The historian of sculpture Roberta Tarbell has determined that of the seventy-nine exhibitions held at Stieglitz's 291 Gallery, only four were devoted to sculpture. A few exhibitions were held in other galleries favoring the modern movement—those run by Marius de Zayas, Hamilton Easter Field, and Martin Birnbaum—but not as many as those given to painters. The sculptor George Grey Barnard, influenced by Rodin, was about as safely modern as one might become and still receive commissions. For all intents and purposes the sculptors of the American Renaissance, still productive and supported by an appreciative public, dominated the field.

Yet modern works were made by sculptors as well as by painters who occasionally turned to sculpture. Genre pieces comparable to paintings by the realists were created by Mahonri Young (1877–1957) and Abastenia St. Leger Eberle (1878–1942), and modernist pieces were attempted by painters, including Maurice Stearne (1878–1957), Andrew Dasburg (1887–1979) and, most important, Max Weber. All these artists were essentially modelers. About 1912 Robert Laurent (1890–1970) began to carve directly in wood, helping to make popular that mode of sculpture. And, during these years, a handful of European sculptors immigrated to America, adding their particular talents to what was then a small, but not necessarily shallow, pool of talent. These included Gaston Lachaise (1882–1935), who arrived in 1906, Elie Nadelman (1882–1946) in 1914, and Alexander Archipenko (1877–1964) in 1923.

A modern naturalism appeared most strongly in the works of Mahonri Young [286]. Best known for his studies of laborers and athletes, he rejected the impressionist surfaces of Rodin for broadly modeled and large-scaled planes that recalled the painting style of the French painter Jean François Millet. Young's preference for Millet was courageous, since Rodin was popular with Americans early in the century. He influenced, among others, Jo Davidson and John Storrs, as well as the painter Morgan Russell, who had studied sculpture early in his career.

Max Weber's work was much more daring. By 1911, he had modeled several

286. Mahonri Young, *Stevedore,* 1904. The Metropolitan Museum of Art.

287. Max Weber, *Spiral Rhythm*, 1915. Hirshhorn Museum and Sculpture Garden.

small sketchlike pieces that revealed his knowledge of both African sculpture and Matisse's sculpture. Weber's deliberate use of distortions, rough surfaces, and accented angles was unique among American sculptors of the period. Even more revolutionary were his nonobjective pieces, done in 1915, barely two years after the first nonrepresentational sculptures were made in Europe [287]. Small and in plaster, they recall Weber's similar pictorial explorations of mass-volume relationships, the interactions of curved and straight surfaces, and the ways planes can be balanced in space when liberated from defining particular objects. But Weber, who certainly would have become one of the most inventive sculptors of the age, abandoned sculpture for painting.

Paul Manship (1885–1966) explored another alternative to academic modes during these years—archaic-styled sculpture. An admirer of early Greek figures when he studied in Italy between 1909 and 1912, he developed a highly stylized art of taut contours, simplified forms, and smooth finishes [288]. Although obviously concerned with mass, he emphasized line to a considerable extent. As he indicated in 1912, "the entire statue can be considered as a decorative form upon which all the detail is drawn rather than modelled." By the 1930s his manipulation of details and contours grew more geometric. In place of rounded forms, planes met at abrupt angles. His work at this time typified the style known as Art Moderne or Art Deco—a modernized, streamlined version of naturalism that is well exemplified by his statue of Prometheus in New York City's Rockefeller Center.

By contrast, Gaston Lachaise, who worked for Manship from 1913 to 1920, emphasized mass and, early in his career, enriched surface textures. Not content with themes from ancient legends, he turned obsessively to the female form about

288. Paul Manship, *Europa and the Bull,* n. d. Hirschl and Adler Galleries.

289. Gaston Lachaise, *Walking Woman,*
1922. Hirshhorn Museum and Sculpture
Garden.

290. Elie Nadelman, *Woman at the Piano
(Femme au Piano),* c. 1917. The Museum of
Modern Art.

1910, modeling ever larger bosoms, thighs, and buttocks [289]. Whereas Renoir seemingly caressed the female figure in his sculpture, Lachaise pumped his full of air. As he indicated in 1935, "What I am aiming to express is the glorification of the human being, of the human body, of the human spirit with all that there is of daring, of magnificence, of significance."

Considered symbols of fertility or of sexual freedom and representations of the Earth Mother, these figures have remarkable stylistic integrity. They are pinched, inflated, rounded, or otherwise altered so that naturalistic forms become integral with abstract shapes. Especially after 1927 Lachaise was one of the first American sculptors to reduce systematically the human figure to large-scaled elemental volumes and to convex and concave shapes. As a result of the shadowed forms thus generated, his work is sculptural and pictorial at the same time, despite his preference at this time for smooth surfaces.

Elie Nadelman also concentrated on the human figure, but with greater emotional and sensual restraint. A cosmopolitan artist who created Cubistic works as early as 1908 when living in Paris, he became best known for sculptures that combined elements of neoclassical suavity with American folk art forms and themes after he arrived in the United States in 1914 [290]. Whatever the particu-

lar inspiration of his mannered and tubular pieces, they reflect his statement of 1910 that he employed "no other line than the curve."

Young, Weber, Manship, and Lachaise were, for the most part, modelers who worked up a piece in clay or plaster for subsequent casting in bronze. Robert Laurent started his career as a carver instead. He learned carving in Rome in 1908 and, after returning to the United States in 1909 or 1910, helped popularize it among younger Americans. His first important works—reliefs—were influenced by African sculptures as well as by Gauguin's. These date from 1911. Laurent carved a few nearly abstract pieces after the Armory Show, between 1915 and 1917, but he soon turned to figural representation and remained a realistic sculptor for the rest of his life. Beginning in 1920, and over the next several decades, he carved about fifty pieces in alabaster, a rarely used material [291]. His work at Rockefeller Center, along with Manship's, is among the classic examples of American Art Deco sculpture of the early 1930s.

William Zorach (1887–1966), originally a painter like Max Weber, made his first sculpture in 1917—a relief panel—but, unlike Weber, he turned to sculpture as his primary medium. By 1919 he had made his first three-dimensional piece in wood. Aware of Laurent's pioneering efforts, he developed a style of great simplicity and repose; his forms were massive in scale but intimate in feeling [292]. His figures seem to breathe within their material substances, animated by their rich and rough textures. Zorach must have been aware of the disparity

291. Robert Laurent, *The Wave*, 1925. The Brooklyn Museum.

292. William Zorach, *Affection*, 1933.
Munson-Williams-Proctor Institute.

between their lively presences and the inert substances, and perhaps he purpose-
fully emphasized the contrast between spiritual vitality and impermeable matter.
It is as if he intended to create tension between these two qualities, making the
viewer aware both of the content and of the art of his carving.

It was John Flannagan (1895–1942), however, who could extract from stone
something of the life of the material. A carver since the early 1920s, Flannagan
felt that in sculpture he found a "deep pantheistic urge of kinship with all living
things and [a] fundamental unity of life." Unlike Mark Tobey, who sought unity
in mystical beliefs, Flannagan felt such unity in the very shapes of rocks, for they
evoked in him atavistic memories of the human race. As a result, he would not
violate the blocky compactness of stone; his figures invariably approximated
elemental forms that preserved the identity of their materials [293]. Not interested
in relating hollows and voids, he carved rounded volumes that seemed inert rather
than suggesting growth or expansion. They remained tied to an imagined core or
appeared as if they were geological ridges uncovered by the sculptor's hand.
Earthbound in the most basic and best sense of the word, his art reflected a
tremendous love for the land and its contents. His art also looked forward to the
quest for archetypes that fascinated artists in the 1940s.

293. John Flannagan, *Ram,* n. d. Hirschl and Adler Galleries.

By contrast, Chaim Gross (b. 1904), who studied with Laurent in the late 1920s, allows a more antic imagination to inform his figures. Large blocky forms intersect with each other and seem to burst the confines of their own bodies and the blocks of wood as well. Gross created the most robust carved forms during the interwar years [294].

Even though the sculptor Alexander Archipenko settled in the United States

in 1923, few sculptors were influenced by his example. The attitudes he and Max Weber held were not really sustained or developed with any vigor except by John Storrs (1885–1956), through the 1920s, and even Storrs worked in a style different from that of the other two. Archipenko and Weber explored the interrelationships of solids and voids as well as the ways space might be "trapped" between forms, but Storrs rarely opened the interiors of his pieces or exposed their cores. His first abstract pieces, dating as early as 1917, appear as versions of architectural slabs. (Born and based in Chicago, he might have been influenced by the skyscrapers in that city.) Soon after, he began to mix materials—wood with various metals —and was one of the first Americans to do so [295]. In his figural work, his subjects appear as cubed, mechanistic, robot-like forms seemingly capable of only jerky, Frankensteinian movements. He did not intend parody, however, for he spoke, in 1922, about his reductive geometric slabs in a manner that anticipated Louis Lozowick's attitude later in the decade. "Let the artists create for your

294. Chaim Gross, *Strong Woman (Acrobat)*, 1935. Hirshhorn Museum and Sculpture Garden.

295. John Storrs, *Study in Pure Form (Forms in Space, No. 4)*, 1919–25. Hirshhorn Museum and Sculpture Garden.

296. Alexander Calder, *Mobile,*
c. 1935. The Solomon R.
Guggenheim Museum.

public buildings and homes forms that will express that strength and will to
power, that poise and simplicity that one begins to see in some of America's
factories, rolling mills, elevators and bridges."

Alexander Calder (1898–1976) also understood the implications of moder-
nity, but emphasized instead the concepts of motion and the displacement of form
through motion. Whereas Storrs's work appears streamlined but solid, Calder's
is curvilinear and full of real or implied movement. The feeling for movement and
growth, seen in Dove and O'Keeffe, recurred in Calder's stabiles and became a
reality in his mobiles. His sources, though, were European rather than American.

In Paris since 1926, he responded positively to advanced European art and
became one of the few Americans to join the Abstraction-Creátion group in 1931.
(Members included Jean Arp, Theo van Doesberg, and Jean Hélion.) By this time
Calder had already begun to synthesize the biomorphic forms of Miró and Arp
with the more rectilinear style of Mondrian. This resulted initially in works that
contained motorized moving objects within fixed frames—three-dimensional
Mirós, as it were. In 1932 Calder produced his first nonmotorized, wind-driven

297. Alexander Calder, *Deux Disques (Two Discs)*, 1965. Hirshhorn Museum and Sculpture Garden.

mobiles [296]. Examples of moving sculpture had existed earlier—in theory in Umberto Boccioni's Technical Manifesto of Futurist Sculpture (1912) and in fact in pieces by Giacomo Balla and Fortunato Depro in 1915, and by Naum Gabo and Marcel Duchamp in 1920, among others. But unlike these earlier pieces, Calder's had no central focus. Their importance lay not in movement itself, but in the changing relationships of parts to each other. Calder's sources perhaps transcended those within the art world, for as he said in 1951, "I think at the time [1930] and practically ever since, the underlying sense of form in my work has been the system of the Universe, or part thereof."

His first stabiles, dating from 1932, eventually grew to enormous sculptures through which people can move easily [297]. His mobiles are his more important contribution to modern sculpture. They reached beyond Futurism and Constructivism because of their displacement of space by means of random as well as planned movement. Calder was the first sculptor, European or American, to explore so intently the implications of motion, and although his mobiles move through circumscribed spaces, he was also the first to allow process and chance to alter the forms of his pieces. No other American had yet contributed so fundamentally to the progress of modern art.

Like Stuart Davis's paintings, Calder's work is blunt and direct, spare, easy to read, yet complex within the limits imposed by the artist. The works of both are buoyant and boldly colored, revealing a fine sense of craft. Theirs are probably the major American artistic statements of the interwar period.

This opinion might be seriously challenged in the near future, when the significance of the American Abstract Artists and other like-minded painters and sculptors are better understood. Ibram Lassaw (b. 1913), a charter member, and Theodore Roszak (1907–81) were certainly pioneering modernist sculptors in the 1930s (as were David Smith and Isamu Noguchi, who will be considered in the following chapter). Both Lassaw and Roszak helped create a continuing tradition of growth in place of the earlier random sequence of developments in the history of modern American sculpture.

For young sculptors such as Lassaw who lived in the New York City area, a supportive community evolved slowly. European works, either through exhibitions or magazine illustrations, became available for study through the 1920s and 1930s. Of particular importance were the exhibition of the Société Anonyme in 1926–27 and the founding of the Design Laboratory in New York City in 1938 by László Moholy-Nagy, the émigré modernist. (Roszak taught at the Design Laboratory in 1938.) The writings of both Moholy-Nagy, especially his *New Vision* (1929, translated in 1932), and of Buckminster Fuller were also important.

Lassaw had begun to make open metal constructions by 1933, and in the following years he explored the possibilities of biomorphic abstraction [298]. By drawing inspiration from Miró, Picasso, Arp, and Yves Tanguy, he created three-dimensional equivalents of the paintings of some AAA members. And, like others in that organization, he responded to Mondrian's influence after 1940 by developing a more rectilinear style. In the late 1930s he began to work with sheet

298. Ibram Lassaw, *Intersecting Rectangles,* 1940. 299. Theodore Roszak, *Airport Structure,*
Zabriskie Gallery. 1932. The Newark Museum.

metal assembled and brazed with solder. His first welded pieces date from 1938. About 1950 he developed his mature style, which coincided with the evolution of Abstract Expressionism.

Roszak adopted modernist ideas in a more literal manner than Lassaw. Attracted to Bauhaus artists and styles during a visit to Europe in 1929–30, he began to simulate the appearance of modern machinery in his pieces. They looked engineered, as if they had the potential for working [299]. Composed of combinations of plastic, metal, and wood, they resembled Morton Schamberg's last paintings, brought to life [238]. But Roszak, believing that artists should contribute to and be integrated with society, presented his works in a completely non-Dadaist context. Along with his reliefs of the late 1930s, which reveal Mondrian's influence, his works approximate the utopian and idealistic aspects of abstract art in the 1930s. But, like Lassaw, he altered his viewpoint in the 1940s, and his work came to parallel the developments in painting that led to Abstract Expressionism.

7

INTERNATIONAL PRESENCE

FEW would say that the decades considered in this chapter were tranquil times. World War II dominated the first half of the 1940s, and the Cold War between the United States and the Soviet Union dispirited the second half. With the start of the Korean War in 1950, it seemed as if full-scale international hostilities might resume again. Furthermore, several events horrified the imagination of many during those years: the irrational hatreds set loose in the 1930s, which resulted in the planned and persistent massacres of entire groups of people; the use of atomic warfare; the presence or imminence of international nuclear warfare; and the failure of various political systems to cope with, let alone control, the never-ending economic and political crises of modern civilization. Whichever explanations might be offered—contradictions within the capitalist system, confrontations between democracy and fascism or between capitalism and communism, or the sheer irrationality of contemporary life—none provided solace to the artist. Although in a material sense American artists were obviously not as affected by the world situation as their European counterparts, their art, especially through the 1940s, reflected a loss of faith in the values of Western society.

Young artists searching for a viable mode of visual discourse discovered few models to follow in the late 1930s and early 1940s. Significant leadership could not be expected from the surviving early-twentieth-century realists and modernists. Nor were Regionalists and Social Realists able to find or to justify a vital subject matter in the face of world conditions. Studying the American scene and the American past as ways to avoid confronting the international present was, by this time, an irrelevant and provincial exercise. On the left, the destruction of the Communist dream by Stalin brought ideological beliefs under extreme suspicion. The kind of abstraction associated with Mondrian and the American Abstract Artists was considered too remote and utopian to counter the exigencies of immediate existence. Narrative Surrealism, which never had wide appeal among American artists, found few adherents, although several artists, such as George Tooker and Robert Vickrey, explored disconcerting themes in sharp-focused realistic styles through the 1940s and 1950s (see below).

In retrospect, the most interesting and advanced art to emerge in America

in the 1930s and 1940s, one which paralleled developments in literature and criticism, was that which turned artists in upon their own imaginations. That is, the kind of art that seemed to offer the greatest possibilities for artistic growth was that which showed no interest in altering the social and political environment or in relating to the world of middle-class culture. Sources for such an art were found most generally in earlier modernist art movements, but, more specifically, in Surrealist automatism, in the psychological theories of Freud and Karl Jung, and in the art of so-called primitive peoples. By evolving an art based on these literary and artistic sources, an artist could remain personally and artistically radical, but shun the political and literary orthodoxies of the left or the right. In this way, he or she could concentrate more directly on artistic expression as well as on his or her own moral concerns as these related to the art-making process rather than to world events. Artistic experimentation and personal freedom, according to this point of view, seemed more basic than social action to the growth of a humane society. As a result, artists turned to instinct rather than ideas as a creative force, to working with and adjusting to notions of doubt rather than certainty, and of facing directly the existence of tragedy in human life and the concept of the tragic sense of life.

In brief, the history of this kind of art can be traced through the 1930s in the works of Arshile Gorky, Jackson Pollock, Willem de Kooning, and David Smith, in the ideas of John Graham, in the presence of European Surrealists in America in the early 1940s, and in the development of Abstract Expressionism during the middle and late 1940s. Its initial achievements can be summed up in the following ways: it established the importance of the process of making an image as much as the image itself (especially among sculptors), the significance of the image as a product of the artist's desire for self-realization and, at the same time, of basic human values. In formal terms, Abstract Expressionism led to the development of a post-Cubistic pictorial space characterized, paradoxically, by either free-floating atmospheric effects or spatial stasis in which forms did not seem to move back and forth. In addition, painters such as Jackson Pollock also popularized the notion that the surface of a painting is a painted surface as much as it is the repository for forms arranged in some kind of spatial relationship, traditional or otherwise [307]. Clearly, this history is rich, diverse, and even contradictory, but it attests to the intellectual, emotional, and artistic vigor of American artists who some thirty-five to forty years after the introduction of modernism to the United States were able to create a body of work that, although based on earlier art, was nevertheless new, different, and individual.

The term "Abstract Expressionism" is more a term of convenience than a precise stylistic appellation, since artists included under its rubric did not always paint abstractly or expressionistically. In addition, two major subgroups had emerged by 1950, one in which gestural marks remained highly visible, as in the works of Pollock and de Kooning, and another, in which precise color harmonies and formal relationships were emphasized, as in Mark Rothko's and Barnett Newman's paintings [308 and 313]. Although Clyfford Still, a significant figure in the 1940s, refused to live in New York City, most Abstract Expressionists made

their homes there, thus prompting the use of the name The New York School. But this term, like the name The School of Paris, refers more to New York City as the major center of American art activity than to a particular style or set of styles. (By contrast, the San Francisco Bay Area Figurative School, which emerged in the early 1950s, describes both a particular location and a reasonably homogeneous style of painting [331]. See below.)

All of these artists, however, disavowed the use of art as a tool for education or democratic uplift in favor of an aesthetic elitism in which art served as the true bearer of a high culture remote and different from popular culture. They would have agreed with Robert Motherwell, who in the November 1944 issue of the magazine *Dyn* stated, "the materialism of the middle-class and the inertness of the working class leave the modern artist without any vital connection to society save that of opposition," and that the artist has had to "replace other social values with the strictly aesthetic." In similar fashion, Adolph Gottlieb pointed out in the issue of *Art in America* for December 1954 that "the modern artist does not paint in relation to public needs or social needs—he paints only in relation to his own needs. And then he finds that there are isolated individuals who respond to his work." Although these attitudes were present in American art since the turn of the century, Motherwell and Gottlieb might have been less assertive if several leaders of the School of Paris had not settled in the New York City area because of the outbreak of general warfare in 1939. These included, in addition to Hans Hofmann and Josef Albers, who had arrived earlier, Marc Chagall, Fernand Léger, André Breton, André Masson, Max Ernst, Yves Tanguy, Matta, Kurt Seligmann, Amédée Ozenfant, and Mondrian. These artists, by emphasizing responsibilities to art itself rather than to middle-class culture or politically and environmentally based aesthetics, reenforced the growing separation of the artistic community from popular culture. They made it easier for American artists to leave the—to them—constricted art world of the 1930s behind.

As indicated in the previous chapter, Mondrian's impact was most noticeable in the early 1940s, but the Surrealists, especially Masson and Matta, as well as Juan Miró, who remained in Europe, had the more lasting influence later in the decade. From these artists, the Americans developed an interest in improvisatory techniques as well as in ways to make Cubist space more fluid. They learned to free lines from defining shapes or areas of color. Thus, forms might appear to lie on the picture surface or float in an indeterminate space. True, some artists, such as Mark Rothko, experimented with automatic drawing procedures as early as 1938, but most, through subsequent social and artistic interchanges, later discovered various means to express feeling without the inhibitions of specific content. Some developed a personal calligraphy, a personal set of marks, and an expressive stroke that conveyed the quality of mind and mood at the moment of pictorial creation. Others preferred to initiate a work based upon a broad theme such as the idea of creation or of tragedy. Improvisation and automatism, therefore, could be an end in itself or a means to suggest the appearance and deployment of forms around a vaguely defined theme.

The Europeans, following Freud, tended to use improvisation as a way to

explore the individual's personal history and fantasies; Americans, such as Rothko and Newman, sought other sources of unconscious behavior through the ideas and theories of Karl Jung on racial memories and archetypal images presumably buried deep in one's psyche, as well as through knowledge of primitive peoples and the artifacts they produced. The Russian-born John Graham (1881–1961) was the key figure who introduced Americans to these sources of inspiration.

After arriving in the United States in 1920 and painting American Scene type of works under John Sloan's tutelage until about 1925, Graham developed an interest in primitive art and psychological theories of artistic production. In his important *System and Dialectics of Art* (1937), he defined art as a means of access to the unconscious. Creation, he held, was the production of new and authentic values based on releasing unconscious forces. Like Jung, Graham believed that an individual's unconscious contained not only memories of his own past, but was also a storehouse of all past individual and racial memories. To delve into one's own memories and fantasies was to search "the memories of [the] immemorial past." Graham thought that because primitive peoples had readier access to the unconscious, the study of primitive art would allow Western artists to paint more easily the images deeply buried in their psyches. Knowledge of the myths, rituals, and images of primitive groups might also provide insight into the modern human condition. Such knowledge might help restore a sense of oneness to life in the face of the abyss that existed between the individual and the world. (For Thomas Cole, a walk in the forest might have a similar effect.) In a single sentence in an article published in *Magazine of Art* in April 1937, Graham stated the significance of both primitive art and Jung's theories for the modern artist. "The art of primitive races has a highly evocative quality which allows it to bring to our consciousness the clarity of the unconscious mind, stored with all the individual and collective wisdom of past generations."

Through the 1930s, the Museum of Modern Art organized several exhibitions that helped focus attention on primitive art, including *American Sources of Modern Art* (1933), *African Negro Art* (1935), *Prehistoric Rock Pictures in Europe and Africa* (1937), *Twenty Centuries of Mexican Art* (1940), and *Indian Art of the United States* (1941). In addition, Barnett Newman helped organize exhibitions of North American Indian art in the late 1940s. To the young Abstract Expressionists, these exhibitions did not suggest the formation of an American art based on indigenous sources, but indicated ways to explore emotion, fantasy, the inner drama of the self, and, perhaps most important, the ways different artists, separated by time, space, and culture, dealt with the chaos of existence and the tragic sense of life. As Newman suggested in 1947, a shape was a living thing to a primitive artist, "a vehicle for an abstract thought-complex, a carrier of the awesome feelings he felt before the terror of the unknowable," rather than part of a mere decorative ensemble.

The Americans rarely imitated primitive forms directly. Of the major artists, only a few, such as Adolph Gottlieb and Jackson Pollock, employed obvious

primitive motifs. Rather, they wanted to make images and to experience reality in a manner akin to primitive artists. Pollock, especially, invoked the aura of myth, if not of particular myths, and based it on ancient Greek legends rather than on primitive ones. These, in a Jungian sense, could suggest archetypal forms related to basic aspects of personality as well as to emotional and physical states of behavior. Newman and Rothko reached back even further to suggest preverte-brate states of existence involving simple biological systems and geological condi-tions [305 and 312]. It was as if the artists were operating outside the concept of linear history in order to suggest themes of timeless and eternal value. "We assert," as Rothko, Gottlieb, and Newman wrote in a letter to the *New York Times* in 1943, "that the subject is crucial and only that subject matter is valid which is tragic and timeless."

At the end of World War II, several European artists returned to their homes. Coincidentally, changes occurred in Abstract Expressionism about 1947. Artists such as Pollock, Rothko, Newman, and Still eliminated specific references of any sort from their work. Rothko seemed to want to penetrate and to join with the void. Newman explored further the notion of the artist making the first marks in a universe of his own invention. Still, Pollock and de Kooning developed totally personal modes of expression. In Pollock's and de Kooning's work especially, the process of painting assumed priority over the resulting images, or, rather, the images grew out of the process of making them [307, 308, 313 and 316]. It would seem that both Newman and Rothko desired less to define themselves than to surrender to indeterminate thoughts about the eternal and the universal; the others were more concerned with using painting as a means of self-realization.

Interest in the process of painting itself and in viewing a canvas as an extension of the artist's personality coincided with the growing popularity of Existentialism, the philosophy that raised questions concerning responsibility for the self and ways of achieving self-definition. Although artists might not have read Jean-Paul Sartre's injunction, contained in his *Existentialism and Human-ism* (translated in 1948), "there is no reality except in action," their desire to record their feelings as well as to create a subject matter that captured abstract concepts about the universe paralleled Sartre's concerns. Still's dictum that a painting was "an episode in a personal history; an entry in a journal" corre-sponded to Sartre's belief that man is "nothing else than the ensemble of his acts."

In 1947, Herbert Ferber, the sculptor and painter, formulated the new development this way: "space and form take shape concomitantly in creating an arena where the creative personality of the artist is in anxious conjunction with the perception of the world about him." Five years later, Harold Rosenberg, the poet and critic, reformulated this idea: "at a certain moment the canvas began to appear to one American painter after another as an arena in which to act— rather than as a space in which to reproduce, re-design, analyze or 'express' an object actual or imagined. What was to go on the canvas was not a picture but an event." Rosenberg seems to have had in mind those painters for whom creation was consummated in the physical act of applying paint to surface, such as Pollock

and de Kooning. Rothko and Newman, however, downgraded the role assigned to accident. Their art, although no less passionate, appeared more contemplative. Concern for color sensation replaced emphasis on detail.

Stylistically, all these artists tried to create a post-Cubist pictorial space that would resist easy figure-ground analysis. Pollock and Newman, compositionally the most radical artists, very nearly destroyed all sense of tactile space or of forms superimposed one on the other. For these two, perhaps more than for the others, vitalization of felt states of being demanded the more abstract realm of two-dimensional space; by comparison, concern for objects and for relationships of forms required the third dimension, or depth, however shallow it might be.

Observers have stressed the connections between Abstract Expressionism and earlier styles, not necessarily to provide it with an instant heritage, but to suggest means to understanding an art still incomprehensible to many. Clearly, Surrealism and various phases of Picasso's art lay behind Abstract Expressionism in the 1940s. Similarities with Kandinsky's early improvisatory methods are apparent, especially after the major retrospective of his work held in New York City in 1945. Although the Dadaist ethical commitment was different, connections with that movement can also be inferred. The Dadaist Richard Huelsenbeck inadvertently defined a major aspect of Abstract Expressionism when he said, "the Dadaist is the completely active type who lives through action because it holds the possibility of achieving knowledge." The "all-over," diffused qualities of Impressionist paintings were influential, too, but only in the late 1940s and 1950s. Mondrian's name may be mentioned also, even if Abstract Expressionists misunderstood his metaphysical intentions, because he affirmed the flatness of the picture surface, reduced the number of elements to a minimum, and gave equal emphasis to all shapes in his work. Finally, the desire for spiritual transcendence characteristic of Romantic art, particularly that of Caspar David Friedrich and Philipp Otto Runge, has parallels in Abstract Expressionism.

In regard to earlier American art, the expansiveness of Abstract Expressionist paintings, both actual and metaphorical, recalls the landscapes of the Hudson River School. Perhaps both represent an imperialistic view of life—the mastering of the continent in the earlier period and the domination of the globe after World War II in the later one. Furthermore, the Abstract Expressionist concern with feeling at the moment paint touches the canvas corresponded to that of Robert Henri and his circle. Perhaps connections—or continuities—with Emerson and the Luminists might also be appropriate to mention, since the desire to transcend the physical and confront the universal, especially in Newman and Rothko, evidently paralleled their intentions.

Although Abstract Expressionism was accepted in the 1950s as the movement that propelled American art to the leading position in the international avant-garde, a few reservations might be mentioned here. Just as Regionalism was attacked for its political regressiveness and all of American Scene painting for its pictorial conservatism, so Abstract Expressionism is vulnerable to charges that primitivism, emotionalism, and an ahistoric concern for archetypal images are not ways to confront modern civilization, but are an escape from it. And just as

the community orientation of American Scene painting has been viewed in a critical way, so the overwhelming reliance on the artists' individual sensibilities might be considered too insular and isolating. This is not to say that the appropriate art for modern times must be rational and public or must use technological media (computers, lasers, modern industrial materials), but that the interaction of an artist with his or her present moment can take several different forms, one not always better than the next.

Although the exact chronological development of Abstract Expressionism might never be known—who did what first and when—it is clear that Hans Hofmann (1880–1966) and Arshile Gorky (1904–48) were important early figures. Both maintained total allegiance to European modernism during the 1930s. More specifically, Hofmann championed the idea of a totally activated surface, and Gorky, in his late works, focused on the relationships and antagonisms between drawing, which creates images, and paint, which asserts the presence of the canvas surface.

Hofmann, perhaps more than any other person, kept alive both the spirit and the formal principles of early modernism through the 1930s and 1940s. A resident of Paris between 1904 and 1914, he later became an important teacher in his native Germany before settling in the United States in 1931. Never a doctrinaire follower of any style, he emphasized in his teaching and painting the independent reality of pictorial life. As he said in 1949, "at the time of making a picture, I want not to know what I'm doing; a picture should be made with feeling, not with knowing. The possibilities of the medium must be sensed."

According to Hofmann, the focus of artistic activity occurs and is resolved on a picture's surface. His intense desire to let a painting both "breathe" and to maintain the flatness of its surface led him to say that depth "was not created by the arrangement of objects one after another toward a vanishing point," but "by the creation of forces in the sense of push and pull." Not unlike John Marin's controlled battles between flatness and depth, Hofmann's concept of "push and pull" provoked similar ambivalent tensions between pattern and depth, between receding and advancing forms. Resolution did not lie in stable, spatial linkages, but in dynamic and continuing relationships. For example, a large recessive green area might restrain a nearby projective red from tumbling out of the picture space, or the red shape might prevent the green from receding too far into depth [301].

Although largely unconcerned with the search for mythic images in the 1940s, Hofmann did experiment with Surrealist improvisational methods. He was among the first to exploit drip techniques in which trickles of pigment created contours and splotches within amorphous fields of color [300]. Paintings such as *Fantasia* were experiments in revealed process without premeditated content. Yet, these works appear as essentially disciplined compositions to which accidental effects have been added rather than as mindless revelings which only later assume structural coherence.

Hofmann projected an aura of affirmation and renewal in his work. "The deeper sense of art is obviously to hold the human spirit in a state of rejuvenescence," he once said. Since he explored different abstract styles simultaneously,

300. Hans Hofmann, *Fantasia,* 1943.
University Art Museum, Berkeley.

301. Hans Hofmann, *Exuberance,*
1955. Albright-Knox Art Gallery.

he found many paths to revitalization. Unlike other Abstract Expressionists, who allowed a single stylistic mannerism to become a signature, Hofmann worked in a thick, buttery expressionist mode, a geometric manner, a colorful variation of Synthetic Cubism—all informed by a brushy, exuberant optimism rare in the postwar world.

Arshile Gorky, a major link between the Surrealists and the Americans, also enjoyed manipulating pigment, but in more subtle and refined ways. The painterly finesse of his mature work—after 1942—was less apparent during the 1920s and 1930s, when he worked in the styles of Cézanne, Picasso, Miró, and Jean Arp. In these earlier works, he alternated between Cubist and biomorphic modes, his subject matter either easy to read or hidden within vegetal forms. Through the liberating influences of Miró (a major retrospective of his work was held in New York City in 1941), Masson, and Matta, Gorky's delicate color sense finally emerged. In addition, biomorphic improvisation helped guide Gorky beyond the restrictive armature of late-Cubist spaces and to release in his art a rich and imaginative flood of amorphous images. Unlike works by the Surrealists, these were created "in direct contact with nature," as André Breton pointed out. But Breton probably did not know the extent of that contact. As Harry Rand has indicated in his study of Gorky (1981), several paintings dating back to the 1930s are really autobiographical works set in interiors or in the countryside and allude to events in Gorky's life. Some celebrate moments of domestic happiness and others, such as *Agony*, refer to periods of despair [303]. In that work, the central form approximates that of a hanged man, as if Gorky made the painting in anticipation of his own suicide by hanging soon after.

These images, often separated from their linear contours and threaded with both transparent and opaque skeins of color, exist in an indeterminate atmosphere. Gorky's space, although influenced by Matta's, did not open up to cosmic depths, nor was pigment hidden in slick finishes. Rather, Gorky developed further a feature seen in Hofmann's work of the early 1940s, in which small shapes became identified with the skin of the canvas itself. In fact, this is perhaps Gorky's major stylistic contribution to the development of Abstract Expressionism. In the *Garden of Sochi*, for instance, an early example of Gorky's mature work, the various yellow and red areas in the shoelike forms do not connote modeled areas nor even changes in plane, but rather a lightening and darkening of the same skin [302]. By the time Gorky painted *Agony*, he was able to create a single skin, in which figure and ground imperceptibly merge rather than fluctuate. Upon this skin, Gorky floated black, yellow, and white shapes, but the skin itself, composed of reds, browns, and brown-yellows, is continuous, seemingly stretched thin in some areas, coagulated in others. The intensities of the colors of the floating shapes, locked into related patterns of their own, are adjusted so that they do not force parts of the underlying skin to recede or to break loose in any way. Even though Gorky allowed random brush marks, he maintained virtually total control of mind and hand, since nothing seems to interrupt the unity of the painting.

Interestingly, Clyfford Still (1904–80) arrived at a similar stylistic evolution

302. Arshile Gorky, *Garden in Sochi,* c. 1943. The Museum of Modern Art.

303. Arshile Gorky, *Agony,* 1947. The Museum of Modern Art.

304. Clyfford Still, *Untitled*, c. 1946. The Metropolitan Museum of Art.

at about the same time. Unlike Gorky, however, he omitted linear forms, concentrating instead on jagged slabs of color [304]. In his work, the various shapes do not resolve themselves into easily read figure-ground relationships, but assert the canvas surface as an almost impenetrable skin. Still achieved this effect in the following ways: first, the various forms lack precise definition; second, forms float

freely since bases and horizon lines are not indicated; third, colors are often equally strong in the amount of pigment they contain (pigment intensity), and their values (the amount of black or white added to the particular color) are often quite close to each other; and fourth, each large area of color contains more than one hue, as well as slight alterations in value, which create a rippling effect. This allows the smaller shapes to appear as points of concentrated pigment, as sections of extreme clotting on the surface, rather than as separate planes located in different positions in depth. The overall effect, then, is of a painted surface rather than a canvas to which forms have been applied in a certain order. As if to emphasize the wall-like appearance of his work, Still was among the first Abstract Expressionists to make large paintings (in excess of five feet in height and width), which destroyed the traditional scale of easel painting, and with it the sense of recession into space.

Compared to Hofmann's life-affirming posture, Gorky's intensely felt, often erotically charged content, and Still's apparently neutral subject matter, the paintings of Jackson Pollock (1912–56) project an acute kinetic presence. By the end of the 1930s, he had already made turbulent works completely covered by continuous fields of energized brush strokes, based, in part, on the influences of his teacher, Thomas Hart Benton, and of José Clemente Orozco. (During the 1930s, the three leaders of the Mexican mural renaissance, Diego Rivera, David Alfaro Siqueiros, and Orozco, spent periods of time in the United States.) Pollock, who had heard about Jung by 1934 and received Jungian analysis in 1939, was introduced to the Surrealist circle in New York City about 1942, and began a series of works in which he explored mythic and premythic states of being [305]. His anatomical imagery, derived in part from Picasso as well as from primitive artifacts, was also filtered through the automatist inventions of Miró, Masson,

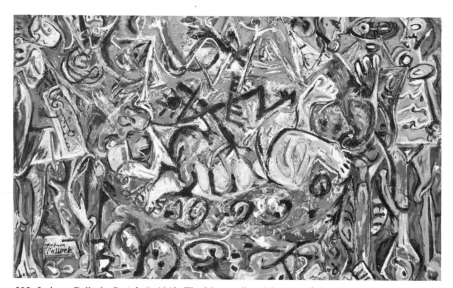

305. Jackson Pollock, *Pasiphaë*, 1943. The Metropolitan Museum of Art.

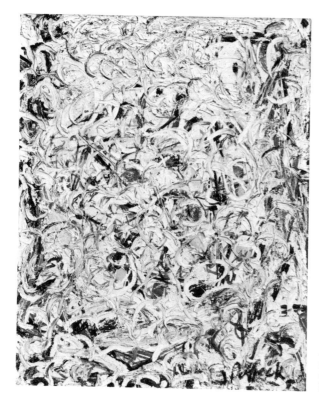

306. Jackson Pollock, *Sounds in the Grass: Shimmering Substance*, 1946. The Museum of Modern Art.

and Kandinsky. In the physical creation of these works, Pollock appears to have been a directing priest in rituals of his own invention.

The retrospective exhibition of Kandinsky's art at the Museum of Non-Objective Painting (The Solomon R. Guggenheim Museum) in 1945 helped channel Pollock's efforts toward an emphasis on gesture and paint application, since the continuous outpouring of energetic strokes and marks that had formed a basic compositional component of his art assumed formal dominance in 1946. Mythic imagery disappeared for a few years, although intimations of subject matter— eyes, faces, color that suggested seasonal changes as well as the movement of stars —remained [306]. Uniformly accented brush strokes and loops now dominated the pictorial surface. The myriad swirls, forming dense, impacted textures, produced ambivalent spatial relations similar to Still's work and the backgrounds Gorky was then painting. By 1946, then, these three artists were leading the way toward a post-Cubist space in which figure and ground had become one and in which the canvas surface had become a skin that, for the most part, remained unbroken by the superimposition of forms or by atmospheric depth. The tactile spaces accompanying the three-dimensional body rhythms that Willard Huntington Wright sought early in the century, and that had grown increasingly shallow in the works of the American Abstract Artists, had now been replaced by a space limited largely to eyesight alone. An optical space resisting penetration by depth

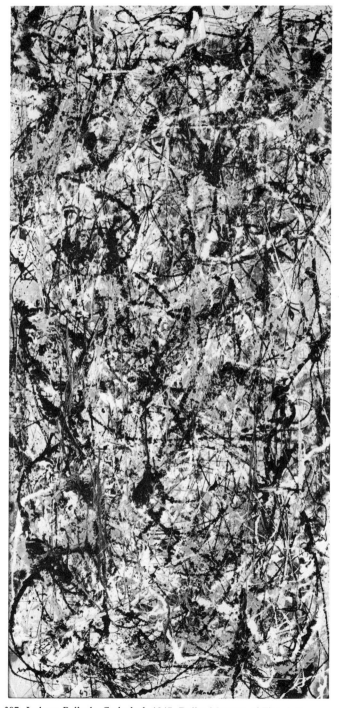

307. Jackson Pollock, *Cathedral,* 1947. Dallas Museum of Fine Arts.

cues of size, color, and value (linear and atmospheric perspectives) had been created.

In 1947, Pollock began to place canvases on the floor in order to throw, pour, and drip paint on their surfaces [307]. A logical outgrowth of his desire to use pigment without the limitations imposed by brush and palette knife, the drip technique provided greater flexibility and speed of execution. As a result, Pollock felt increasingly "in" his paintings and in closer contact with his unconscious, expressing his feelings directly rather than illustrating them. Perhaps to a greater extent than ever before, an artist identified himself psychologically and physiologically with his work. In these paintings, one senses Pollock's desire to transcend specific emotions in order to reach a level of continuous emotionality, as if his being defined itself by simply being aware of itself in action. The great linear arabesques and splatters, usually denser in 1947 than afterward, appear as one continuous explosion that extends beyond the framing edges, invoking a feeling for the continuation of the life principle beyond the painting itself. In another way, content might also be defined by the specific formal qualities involved—the way a poured line is brought into balance with the surrounding area, the manner in which a line thickens into a shape, or the way light-absorptive aluminum paints interact with oil paints.

Regardless of how one reads the content of the drip paintings, they represent a new level of formal achievement in the history of modern art. Especially in those works covered with an impenetrably dense tangle of lines and splatters, Pollock developed further the idea of opticality seen in the paintings of 1946. Contour lines do not define shapes and splotched areas lie juxtaposed, but not superimposed, on the many skeins of pigment. In effect, the painted surface reveals few or no depth cues and remains, in effect, a painted surface.

From the early 1950s until his death in 1956, Pollock returned stylistically to traditional figure-ground compositions, and thematically, to mythic subjects. The drip paintings are, consequently, his most important works and, very likely, the most important American paintings of the twentieth century. In them, pictorial depth is all but eliminated. Without beginnings, endings, or compositional centers, they substitute an "all-over" organization for traditional modes of composition. Because of the random flow of directional movements, they are also the most "cinematic" of modern paintings. (They do not have to be read in any special sequence.) Moreover, the drip paintings were an important point of departure for later movements, such as process art, minimal art, happenings, environmental art, and art-as-object art. Pollock's works, whatever their individual merits and moods—serene, agitated—have become an essential part of the continuum of Western art.

The works of Willem de Kooning (b. 1904) were more accessible, and even though his art was not as radical as Pollock's, he was acknowledged as the major gestural painter of the 1950s. His paintings of that decade and of the previous ones revealed more easily the twin dilemmas then facing artists—how to define themselves as artists and how to create a post-Cubist pictorial space. Between 1942 and 1944, de Kooning began to substitute broad, splashy, open-ended, and over-

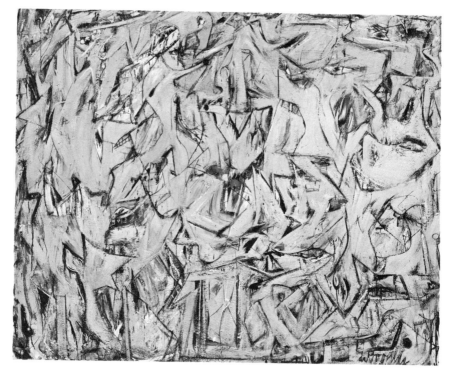

308. Willem de Kooning, *Excavation,* 1950. The Art Institute of Chicago.

lapping forms for more carefully defined planes precisely engineered into place. This culminated in a series of black-and-white studies at the end of the decade and in the paintings of women in the early 1950s. In them, one is made compellingly aware of the conflicts between depth and flatness, line and pigment, and, in the figurative works, representation and passages of pure painting [**308 and 309**].

The abstract studies, distantly influenced by Gorky's biomorphism, show de Kooning's engagement with his materials, or, in the language of the time, his presence in his paintings. Of works of this type, he said, in 1950, "I paint this way because I can keep putting more and more things in [them]—drama, anger, pain, love, a figure, a horse, my ideas about space." In other words, the flux of ideas and appearances and their development as he engaged in the act of painting. In order to destroy traditional ways of interrelating forms, he created what became known as "no environments," by arranging torn pieces of paper on a canvas, tracing their outlines, and building up sequences of forms from their contours. The resulting images, products of a continual state of pictorial movement, were composed of odd juxtapositions of cutout forms modified by drips, scrapes, and smudges. Each work grew to completion as earlier decisions were modified by the introduction of additional shapes and strokes. Held together by tense confrontations of color and line, these paintings defy calm resolution (compare 308 and 278).

One of the few major Abstract Expressionists to paint the human figure, de Kooning created images of women that defy easy interpretation. They usually appear as disembodied forms dissolving into and emerging from scumbled pigment, from lines thickened into planes, and from rapidly brushed overlays of color. At once the archetypal Mother as well as Destroyer (in the 1950s), they reflect a range of problems faced by an artist who did not want to revert to

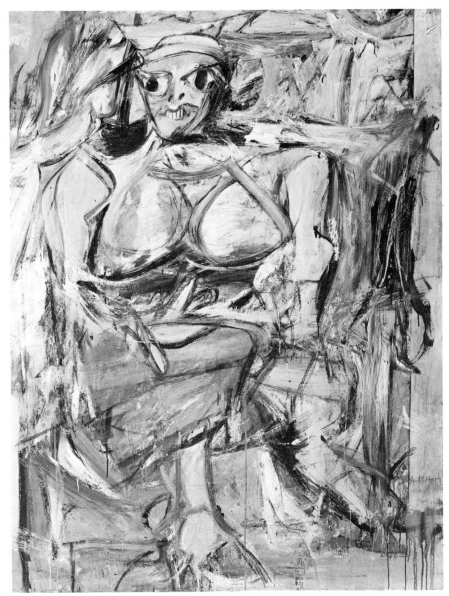

309. Willem de Kooning, *Woman I,* 1950–52. The Museum of Modern Art.

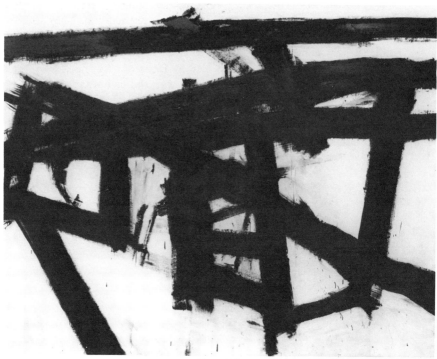

310. Franz Kline, *Mahoning,* 1956. The Whitney Museum of American Art.

traditional solutions, but who insisted on using traditional subject matter. Such intense concern for the manipulation of pigment, which grew to a rich, buttery consistency during the 1970s, subsequently caused de Kooning to paint canvases that appeared to be enlarged details of his earlier works. His easy facility with the brush influenced a younger generation of painters, who looked upon his work as seminal in their own development. By 1955, he was probably the most influential painter in the United States, but this situation ended during the early 1960s.

Franz Kline (1910–62) was probably the most important artist influenced by de Kooning (although recent research suggests that the influences were mutual). Friendly with de Kooning since 1943, Kline, a figurative painter, began experimenting with abstract forms in 1946. Within the next few years, he developed a muscular style in which enormous loose-edged black bars were juxtaposed with large, white planes [310]. If one reads the white areas as field, then the black bars appear to hurtle across the picture's surface, but if the black areas are read as background, then the white shapes seem to be an updated variation on biomorphic abstraction of the 1930s. This purposeful confusion is enhanced by Kline's centripetal compositional schemes. Without centers of focus, which normally help distinguish "objects" from backgrounds, depth cues are minimized. Consequently, the framing edges become indispensable elements in determining units of design as forms push out toward the painting's perimeters. Kline's refusal

to collapse forms around a central hub links him to earlier artists, as varied as Stuart Davis and John Kensett [84 and 278].

During the 1950s, several younger artists also developed gestural styles, which ranged from a violent de Kooning-like manipulation of thickened pigments to a more lyrical abstract impressionist concern for subtler nuances of texture and color. Among the latter, Joan Mitchell (1926–92) often evoked images of nature in both centralized and dispersed compositions [311]. Like earlier artists such as John Marin, she tried to re-create the feelings which the scene had originally prompted, but now guided by the Abstract Expressionist concern for self-expression.

Kline's paintings obviously lack precise content, but they might refer to actual landscapes with which the artist was familiar. They describe, more realistically than one might imagine, the winter countryside of Kline's native eastern Pennsylvania. When the ground there is snow-covered, the even whiteness of the snow tends to destroy a sense of depth. The trees that run along the profiles of the low hills appear, therefore, as continuous, ragged black bands remarkably similar to the effects achieved in the paintings.

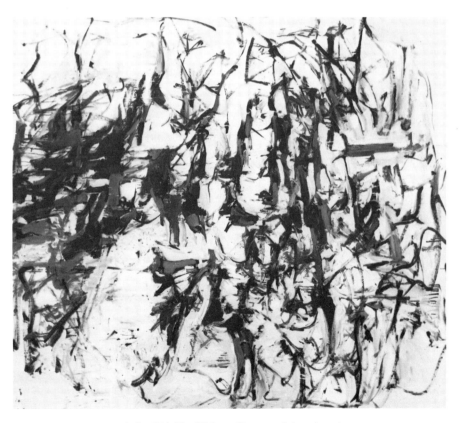

311. Joan Mitchell, *Hemlock,* 1956. The Whitney Museum of American Art.

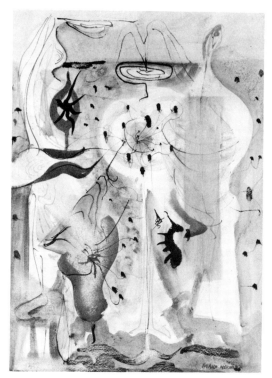

312. Mark Rothko, *Baptismal Scene,*
1945. The Whitney Museum of
American Art.

313. Mark Rothko, *Red Maroons,*
1962. The Cleveland Museum of Art.

Such realistic connections are absent from the works of the nongesturists Mark Rothko (1903–70) and Barnett Newman (1905–70). In the 1940s, before their art turned nonobjective, they invoked biological and geological elements without actually describing them. Influenced by Surrealism but wanting to develop beyond it, Rothko, Newman, and their friend Adolph Gottlieb wanted to venture into the pictorial and psychological unknown as well as to assert in their subject matter the tragic and the timeless. How well they succeeded is open to question, but their willingness to conflate their individual concerns with those representing aspects of human history attests to their ambition and to their intense desire to reach beyond the usual and the measurable. Although earthbound, they grasped for cosmic meanings and universal insights.

By the middle 1940s, Rothko began to place calligraphic forms in front of bands of color [312]. Toward the end of the decade, he eliminated all biomorphic references in order to suggest a subject matter that was timeless, if not tragic. As he said in 1947, he now wanted to create paintings that "have no direct association with any particular visible experience, but in them one recognizes the principles and passions of organisms."

To encompass this kind of content, he began to reduce the number of forms he used until no more than three or four rectangular sections remained [313]. Rothko also increased the size of his works dramatically. He sought in them an enveloping intimacy that might induce in the viewer a generalized spiritual response. As he said to Seldon Rodman in the latter's *Conversations with Artists* (1961), "The people who weep before my pictures are having the same religious experience I had when I painted them. And if you . . . are moved only by their color relationships, then you miss the point."

Color relationships there are, nevertheless. Both the large and narrow bands of Rothko's mature work seem to pulsate because, like Clyfford Still's surfaces, they are composed of many tonal and coloristic variations (within very narrow ranges of tone and color) and their blurred edges are not anchored to firm pictorial bases. When one is standing directly in front of one of these paintings, especially a large one, it is possible to see infinite distances in a rectangular band and, at the same time, to be aware of paint lying on the surface. With no firm referents, depth and flatness appear alternately, the spiritual void and the simultaneous assertion of the picture's physical surface.

Rothko's exquisite color sensibility was in part brought out by his older friend, Milton Avery (1885–1965), one of the most individualistic American painters of the century. His close-valued luminous colors, really translucent stains of pigment, defined figural and landscape forms that recalled those of both Albert Pinkham Ryder and Marsden Hartley [314]. Acknowledged as a conduit of Matisse's colorism and flattened forms during the 1930s and 1940s, Avery stressed relationships of shapes on a picture's surface rather than volumes in space.

Barnett Newman, also a friend, was less influenced by Avery's hedonistic color and simplified forms, indicating that his art would develop with greater intellectual rigor and austerity. In fact, it did. By 1950 he had created works that,

314. Milton Avery, *Landscape by the Sea*, 1944. New York University Art Collection.

315. Barnett Newman, *Genetic Moment*, 1947. Collection of Annalee Newman.

with Pollock's drip paintings, were among the most formally advanced for their time.

Their content was also important, despite the lack of depicted objects. Through the middle 1940s, Newman, like other artists, wanted to avoid the European ideal of the well-finished canvas, since he was less concerned with visual sensation than with penetrating the mysteries of life. Nor was he interested in turning out amiable decorative exercises in one or another of the currently fashionable modern styles. Sympathetic to what he thought were the motivations of primitive artists who dealt with the forces of the unknown, he evolved a subject matter concerned with birth and genesis. Interested in the cluster of ideas generated by these words rather than with illustrating a particular kind of birth or origin, Newman avoided traditional spatial placements because these would have tied his forms to particular physical environments [315]. Instead, shapes floated freely. But like Rothko, he wanted to suggest meanings with even fewer forms, so as to convey his subject matter as close to pure idea as possible. This led in 1948 to the use of vertical stripes in large fields of monochromatic, but pulsating and layered, color [316]. The content of these works reflects, in general terms, Newman's desire to convey the idea of creation—of the first separation of forms —and the idea of mankind—the verticals not yet engaged in specific activity. Stylistically, parts of a painting do not interrelate as much as they simply coexist. Without centers of focus and with relatively few forms, a work can be viewed as a unified whole rather than as a series of integrated parts.

Newman achieved stasis of the picture surface—where forms neither advance nor recede—because he neutralized depth cues. The narrow bands require the right degree of intensity to balance the larger color areas. In other words, brightness is made to balance largeness so that the thin bands neither pitch into nor fall out of the pictorial space. Rather than treat the surface as a window behind which the painting appears, he repeats the forms of the framing edges to emphasize surface flatness. Newman once said that he wanted to fill space rather than empty it. In great measure he succeeded in bringing every form up to the

316. Barnett Newman, *Vir Heroicus Sublimis,* 1950–51. The Museum of Modern Art.

317. Joseph Cornell, *Soap Bubble Set*, 1936. Wadsworth Atheneum.

surface while at the same time using each form to convey his content; this was a remarkable integration, considering the minimal means with which he worked.

Ad Reinhardt (1913–67) would probably have rejected even Newman's most hermetic paintings because of their content and because of the personal choices in locating the stripes. Reinhardt, for roughly the last twenty-five years of his life, sought a timeless, motionless, textureless, colorless, and relationless art that could not be interpreted as anything but what it was—paint on a surface. (Mondrian, by contrast, gushed with human feeling!) By 1953, Reinhardt had reduced his colors to degrees of blackness, and he arranged these in nine equal rectangles on a standard-sized canvas. Yet, despite the reductiveness of Reinhardt's paintings, slight tonal changes, which indicate spatial movement, could still be discerned; these allied the works with Analytic Cubism rather than with the paintings of Newman. But whatever their differences, Newman and Reinhardt became models for artists in the 1960s, the Color Field painters. Much less concerned with the theoretical premises of art, the younger artists filled canvases with large, flat areas of color in combinations that ranged from the traditionally relational to a new, holistic kind.

The careers of several sculptors evolved simultaneously with the rise of Abstract Expressionism. David Smith, Seymour Lipton, Herbert Ferber, and Ibram Lassaw, like the painters, preferred an art of personal invention to the more cold-blooded geometries of the Abstract American Artists. Finding inspiration in vitalist rather than technologically oriented sources, they responded much more profoundly to the works of Picasso, Julio Gonzales, and the Surrealists, even though artists such as László Moholy-Nagy and Naum Gabo had come to the United States in 1937 and 1946, respectively. For the Americans, forms tended

to grow from individual decisions of mind and hand rather than from industrial imperatives, and materials were often used for their expressive potential rather than for technological sleekness. Like the painters, some found a signature style and rarely departed from it, but others, especially David Smith, proved to be among the most inventive artists in the entire history of American art.

During the 1940s and 1950s, other sculptors developed styles equal in interest and qualitative achievement but which do not bear a family resemblance to the works of Smith, Lipton, and the others. Joseph Cornell (1903–72) and Isamu Noguchi (1904–88) are certainly among the most interesting.

Cornell was perhaps spiritually closer to the Surrealists than any other American artist through the middle years of the century. Influenced by Max Ernst's montage album, *La Femme 100 Têtes* (1929), he began to make collages a few years later. By 1933, he was exhibiting small boxes filled with a variety of ordinary household objects as well as magazine illustrations, charts, and other visual materials, which he continued to make for the rest of his career [317]. The odd and disjunctive combinations evoked vague and elusive feelings of nostalgia, dreams, fantasies, and obsessions. As Cornell said of his *Soap Bubble* sets in 1948, "shadow boxes become poetic theatres or settings wherein are metamorphosed the elements of a childhood pastime." His compulsive, but not always orderly, catalogues of objects and images would appear to be a Surrealist version of Walt Whitman's similar desire to list things in his poetry; the juxtaposition of the names of two artists is one that Cornell might have appreciated for its unexpectedness.

Noguchi's work is thoroughly international as well, but in addition to European sources, aspects of East Asian art and philosophy are also prominent. After a promising start as an academic sculptor, Noguchi turned to modernism after working with Constantin Brancusi in Paris from 1927 to 1929. Influenced by the reductive clarity and simplified shapes of his teacher's works, Noguchi nevertheless infused a greater emotional and mysterious expressiveness into his smoothly finished pieces. Responding to Surrealism in the 1940s, he added to his *Gunas* series, composed of delicately balanced marble slabs, mythic and totem-like appearances, similar to the biomorphic forms then popular among painters [318]. But these works also reflected the tenets of the Eastern philosophical system known as Sankhyn, through the tension suggested in their supports, the purity of their shapes, and the intimations (for Noguchi) of the quality of goodness they possess. Like the works of the painters, then, these sculptures have a content even if particular objects are not described.

Throughout his career, and especially in the approximately twenty sets he designed for the dancer and choreographer Martha Graham—one of America's major artists of this century—Noguchi has wanted his materials to express themselves through their textures and physical properties as well as to imply meanings suggested by the configuration of their forms. These characteristics exist even in his several environmental schemes for parks and playgrounds, which he began to design in the 1930s.

Among the sculptors associated with Abstract Expressionism, David Smith

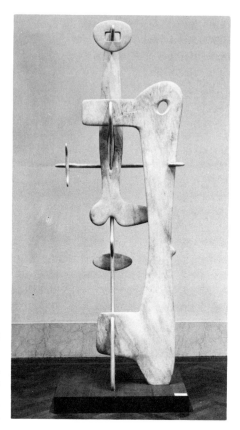

318. Isamu Noguchi, *Kouros*, 1944–45. The
Metropolitan Museum of Art.

319. David Smith, *Pillar of Sunday*, 1945.
Indiana University Art Museum.

320. David Smith, *Tank Totem IV*, 1953.
Albright-Knox Art Gallery.

(1906–65) and Seymour Lipton (1903–86) were probably the most adventurous. In the early 1930s Smith was the first to use found objects (machine parts) and to weld together metals as essential formative elements of his work. His sources included welded pieces that Picasso and Gonzales had made in the 1920s, the Surrealist works of Alberto Giacometti, especially his *Palace at 4 A.M.* (1932), permanently exhibited in New York City after 1936, and the "linear writing" in Stuart Davis's works. Whatever his stylistic and thematic concerns—Surrealist until about 1945, nonillustrative afterward—Smith was primarily a sculptor of two-dimensional images. That is, his work was usually meant to be seen from one side or from a frontal position.

In his manipulations of sources and materials, Smith often emphasized the "space frame," or borders, as much as the interior shapes. This provoked a constant and tense visual dialogue between the core and the enclosing shapes [319]. In later works, especially the *Cubi* series, the emphasis on outer edges and whatever antic forms might be projected from them became the dominant stylistic motifs. Smith also designed many pieces based on a totemic, or standing, human form. But unlike similarly composed works by other sculptors, these tend to reach outward from their centers of gravity rather than collapse in upon themselves.

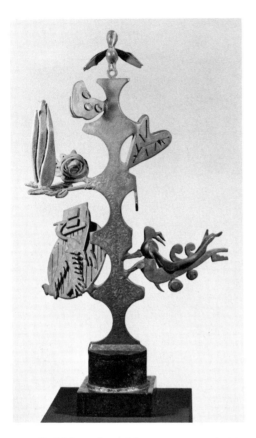
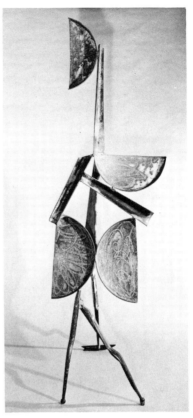

Smith's major achievements, carried forward in various series, occurred after 1950. These include the *Agricola* group, begun in 1951 and composed of old, generally slender mechanical units; the *Tank Totem* group, begun in the early 1950s and made from tank drums and steal beams [320]; the *Sentinel* series, assembled from steel I-beams; and the *Zig* and *Cubi* series of the 1960s [321]. Smith never became a "formula" sculptor; the individual pieces of a particular series are inventions on a given visual theme. Nor did he insist on using bases to connect or separate his works from the horizontal surfaces under them. Instead, the bases are incorporated into, clearly distinguished from, or entirely eliminated from the overall design of a piece. Even though Smith used assistants, modern materials, and modern means of assemblage, he did not impart a technological look to his work, which, like the paintings of the contemporary gesturists, remain indelibly stamped with the particular strength of his personality.

Seymour Lipton's works always carried thematic meanings. A direct carver and "poetic" social realist until the middle 1940s, he began to explore the formal potentials of metals when he turned to brazed lead about 1946 and, afterward, to brazed steel and Monel metal. Describing his change of style, he said that "art became for me a process of rejection. What remains is you." While eliminating

321. David Smith, *Cubi XXVII*, 1965. The Solomon R. Guggenheim Museum.

322. Seymour Lipton, *Thunderbird,*
1951–52. The Whitney Museum of
American Art.

323. Seymour Lipton, *Sorcerer,* 1958.
The Whitney Museum of American Art.

324. Ibram Lassaw, *Theme and Variations #1*, 1957. Albright-Knox Art Gallery.

325. Theodore Roszak, *Spectre of Kitty Hawk*, 1946–47. The Museum of Modern Art.

specific meaning for generalized connotation, Lipton evolved a style in which interior surfaces were contrasted with exterior ones, positing oppositions between the darkened, hidden inner surfaces and the more available, buoyant outer ones [322].

In addition to suggesting processes of growth, these works also recalled archetypal patterns of behavior. Destructive images were stressed during the 1950s, perhaps in reaction to World War II, but subsequent themes—the prophet, the sentinel, and the hero—are more affirmative [323]. Lipton's forms, less explosive than Smith's, usually turn in upon themselves. Budlike generative cores seem compressed by surrounding forms. By contrast, the pliant surfaces, which appear to have been worked by hand, provide a quality of pulsating life that, trapped for a moment in an inert form, is on the verge of expanding once again. Even in the vertical pieces, similar expansion-compression effects provide a dramatic focus for Lipton's interest in approximating lifelike processes.

Although Lipton's work both reflected and helped define sculptural styles and attitudes of the 1940s and 1950s, it relates, like Georgia O'Keeffe's paintings, to ongoing concerns in the history of American art. Lipton's obvious interest in motifs that mirror the flux of life allies him with those artists who were concerned with nature as a living presence, the kind in which Mark Rothko sought "the principles and passions of organisms," rather than as a religious metaphor or as

an echo of their personal feelings. Among the artists who apprehended nature in this manner we might include O'Keeffe and Rothko, along with Frederick Church, John Marin, Arthur Dove, and, among Lipton's younger contemporaries, Helen Frankenthaler. The qualities these artists share is obviously hard to define, let alone to link from generation to generation, but they do seem to exist in American art, at least since the middle of the nineteenth century.

Other sculptors—Theodore Roszak (1907–81), Herbert Ferber (1906–91), and Ibram Lassaw (b. 1913)—seemed less interested in these concerns, but shared other interests with Lipton during the 1940s and 1950s. All employed welding techniques and were responsive to Surrealist modes of creativity. All adopted the improvisatory, spiky-formed, surface-pitted style developed during the war and postwar years. Lassaw, who, with Roszak, had been associated with the Abstract American Artists, updated the Constructivist dematerialization of forms with the more obviously handmade look of Abstract Expressionism [324]. Roszak's style changed entirely [325]. Lipton and Roszak, as well as David Smith, employed birdlike forms that suggested escape and transcendence as well as abduction and destruction. (De Kooning's paintings of women also contain paradoxical suggestions of nurture and destruction.) In the late 1940s Lipton and Ferber explored the visual and psychological complexities of "caged" constructions, in which strong horizontal forms contained active, vertical elements [326]. Despite the many similarities, however, each sculptor developed a distinct style as well as a formal mode of organization, ranging from Lipton's concern with a generative core to Lassaw's total suppression of a specific center of interest.

326. Herbert Ferber, *Roofed Sculpture,* 1959. Jane Voorhees Zimmerli Art Museum.

327. Richard Lippold, *Variation Within a Sphere, No. 10: the Sun,* 1953. The Metropolitan Museum of Art.

328. George Tooker, *The Waiting Room,* 1959. National Museum of American Art.

Of course, not all sculptors followed the thematic and stylistic concerns of Smith, Lipton, and the others. Richard Lippold (b. 1915) continued the kind of geometric style associated with the AAA but, beyond that, challenged one's assumptions concerning the physical nature of sculpture. His works are nothing more than wires hanging in space—baseless, virtually volumeless, and dematerialized, but still occupying a measurable area **[327]**. As light reflects from their seemingly numberless wire strands, the principal effect is that of glittery surface rather than physical density. Like the paintings of Newman and Reinhardt, Lippold's sculptures link the more intellectually conceived hard-edged modes of the 1930s with the more modern versions popular in the 1960s and 1970s.

Although Abstract Expressionism was the most vital art movement of the period, many artists, probably a majority, preferred to paint in figurative styles. Some based their work on aspects of Abstract Expressionism, others remained untouched by it. Some emphasized the modern human condition, others turned to problems of paint application and compositional relationships. Perhaps never before were so many artists expressing themselves in such a variety of ways. Pluralism, a term used to describe the art world of the 1970s and 1980s, might be applied just as easily to the earlier decades.

Several artists, including George Tooker (b. 1920), Robert Vickrey (b. 1926), and Stephen Greene (b. 1918), continued to explore the kind of subject matter

and spatial arrangements of earlier artists, such as O. Louis Guglielmi and Peter Blume, but in more psychological rather than social and political contexts [328]. Like the Precisionists, they never formed a school, although they shared some stylistic traits and explored a similar range of themes. Their anxiety-ridden and occasionally hallucinated figures reflect less the Existentialist anguish of Abstract Expressionism in regard to responsibility for one's own actions than a nondirected anxiety reflecting the inability of an individual to master and control his environment. Tooker's figures, particularly, seem to have lost their individuality and will, and, in the bureaucratic systems of modern society, to have lost their humanity. Where, by comparison, the Abstract Expressionists needed to assert their vital signs in the face of contemporary existence, artists like Tooker suggest that madness and isolation might be the only logical way to cope with it. As Stephen Greene commented, his own art was "concerned with man's final isolation, man suffering not so much for others but for himself and his own sense of incompleteness." The realization of man's utter fallibility, the true subject of these artists, was recorded most poignantly in their paintings in the years just after World War II, when such thoughts logically would be uppermost in their minds.

Other artists, such as Leonard Baskin (b. 1922) and Leon Golub (b. 1922), acknowledged human vulnerability, but also recognized that without human presence and aspiration there was nothing. In his prints and sculptures, Baskin explored, and still explores, both the nobility and the failures of man and his condition. As he said in 1959, "our human frame, our gutted mansion, our enveloping sack of beef and ash is yet a glory." In that same year Golub, in referring to his own ravaged figures, said "the ambiguities of these huge forms indicate the stress of their vulnerability versus their capacities for endurance."

Golub's work is particularly interesting, since it developed outside the orbit of New York City. Probably the most important artist to emerge from the "Chicago Monster School" of the 1950s, Golub has explored the condition of man in an ongoing sequence of burnt, flailed, flawed, and brutalized figures, however heroic their scale and posture [329]. Whether using classical forms in the 1950s and 1960s or images derived from the Vietnamese War and the activities of mercenaries in the 1970s and 1980s, he reveals man's capacity to wreak havoc on himself, whatever his intentions. Refusing to paint specific events or to place his figures in specific locations, Golub is not a belated Social Realist, but a realist whose subject matter is human savagery. At heart a moralist, he must realize the fatuousness of offering a sunny, ideal vision of humanity in the tradition of Sir Joshua Reynolds and John Trumbull. Instead, he shares his sense of outrage in his bleak vision of humanity. Golub is also an excellent example of the engaged artist, the artist *engagé*. Because of his willingness to change his styles and themes, his earlier work relates as easily to the anxiety-ridden figurative works of the 1950s as his later paintings to the political art, street art, and feminist art of the 1970s and 1980s [365].

Golub's various painting styles have always been closer to modernist pictorial concerns than the more conservative styles of Tooker and Vickrey. In fact, the surfaces of his earlier works are as corruscated as those of any Abstract

329. Leon Golub, *Burnt Man,* 1953. Private collection.

Expressionist. A similar interest in the manipulation of pigment characterizes the group of figurative artists who also emerged in the 1950s and became known as the San Francisco–Bay Area School. The chief artists were David Park (1911–60), Richard Diebenkorn (1922–93), Nathan Oliveira (b. 1928), and Elmer Bishoff (1916–91). Influenced by Clyfford Still, Mark Rothko, and Ad Reinhardt, who

330. David Park, *Four Men*, 1958. The Whitney Museum of American Art.

taught in San Francisco between 1946 and 1950, they soon decided, as Diebenkorn stated about his own work, not to "explode the picture and supercharge it in some way." Park, the nominal leader, rejected Abstract Expressionism in 1950, Bishoff in 1953, and Diebenkorn in 1955 (although he has continued to paint abstract works in his ongoing *Ocean Park* series [332]). However different their particular styles, each alluded to the physical and psychological isolation of the individual in contemporary society. (No doubt, the exhibition of Edvard Munch's paintings in San Francisco in 1951 provided numerous clues for posing figures and unveiling interior states of being.) Parks's noncommunicative figures [330], rigid and archaically frontal, seem immobilized by thickly textured Fauvist-like pigment. Diebenkorn's subjects [331], slightly less isolated than Parks's, are marked by a pathos and inner sadness that also link them to those of Edward Hopper [253]. Diebenkorn never stressed environment to the same extent, but did impose on these paintings a compositional rigor as taut as any by Hopper. One doubts, however, that if Hopper had painted abstractly, he would have developed a color sense equal to Diebenkorn's, which in the 1970s was the most subtle of any living American painter.

Because of the overwhelming presence of first- and second-generation Abstract Expressionists in New York City, the situation was different there for realist painters. If a coherent school did not emerge in the 1950s, at least several talented and sophisticated figurative artists did achieve prominence, including Fairfield Porter (1907–75), Alex Katz (b. 1927), and Larry Rivers (b. 1923). Among the traits they shared were a nonproblematic content, amiable and suburban-like in disposition; a light, bright palette, often pastel in tone; the habit

331. Richard Diebenkorn, *Woman in a Window*, 1957. Albright-Knox Art Gallery.

of emphasizing equally shapes, colors, and details across a picture's surface; and an awareness of the picture's surface, where forms could be read both in depth and as flattened shapes. The last two characteristics, of course, reflect the influence of Abstract Expressionism as well as, more distantly, that of Impressionism and the work of Pierre Bonnard and J. Edouard Vuillard.

Porter was the most traditional, but also the most subtle [333]. Although his compositions are carefully studied, they project informal and impromptu qualities. His observation of Katz's work describes his own just as accurately. Porter liked Katz's paintings because they reminded him of "a first experience in nature, the first experience of seeing. . . . It must be that 'first timeness.' The world starts in [these pictures]."

Katz began to paint portraits, mostly of family and friends, in 1957, and within a year his mature style emerged. It was probably the first in which the scale of Abstract Expressionist painting was adapted to figurative painting [334]. Unlike the California painters, Katz employed little internal modeling and hardly

332. Richard Diebenkorn, *Ocean Park No. 27,* 1970. The Brooklyn Museum.

333. Fairfield Porter, *Flowers by the Sea,* 1965. The Museum of Modern Art.

334. Alex Katz, *Ives Field II*, 1964. Weatherspoon Art Gallery.

explored the personalities of his sitters. Poses are conventional and, after 1962, parts of faces and bodies were cropped for compositional purposes. Bright, even color and abrupt disjunctive changes in the sizes of his subjects contributed to the development of a flattened decorative manner. Katz's physically healthy and psychologically uncomplicated figures project an image of a complacent, confident America. They are contemporary versions of many middle-nineteenth-century picnic scenes, of Homer's vacation pictures of the 1860s and 1870s, and of John Sloan's urban scenes of the early twentieth century. They seem to indicate, in the late twentieth century, that happiness is possible by looking good and relishing one's leisure time.

Like Katz, Larry Rivers helped pioneer the figurative reaction to Abstract Expressionism in New York City, but his relationship to that movement is more problematical, since his work seems to grow as much from inner necessity as from a desire to plot an artistic strategy in reference to it. That is, his dialogue is as much with reality as it is with the immediate politics of the current art scene, and the kinds of images he created were as much an exploration of new forms as they were a conscious reaction to previous ones. As he said of his *Washington Crossing the Delaware,* "in relation to the immediate situation in New York . . . [it] was another toilet seat—not for the general public as it was in the Dada show, but for the painters" [335]. (Rivers was obviously referring to Duchamp's *Fountain,* a urinal submitted to the Exhibition of Independent Artists in 1917.) In other words, Rivers wanted to shock artists into acting and reacting in new ways, to reach beyond the new orthodoxies as well as to show the art world that he was doing exactly that. In other works, he introduced, with intended bad taste, commonplace objects to his paintings—flag forms, letters, and motifs derived

335. Larry Rivers, *Washington Crossing the Delaware,* 1953. The Museum of Modern Art.

336. Larry Rivers, *The Athlete's Dream,* 1956. Marlborough Gallery.

from advertising and artistic sources—as if to scandalize those who believed that an artist should record his deepest feelings on canvas. And perhaps in intentional parody of Abstract Expressionism, he also used such gestural elements as the calculated sloppiness of paint dripping and brush dragging as if to personalize the impersonal elements in his work.

But Rivers's works are more than exercises in gamesmanship. In paintings such as *The Athlete's Dream,* he employed repetitive images so that however easily one reads the subject matter, spatial relations and time sequences grow amazingly complex [336]. Other works are entirely autobiographical, and these raise another serious issue. Paintings that reflect a personal view of the world are different from those that are autobiographical. In the former, the artist works from a particular set of assumptions and offers insights as well as observations based on those assumptions. But how is the viewer supposed to relate to the content of autobiographical works if he does not share with the artist those memories and experiences upon which the content is based? Autobiography that is not self-explanatory becomes a private language to which the viewer has no access. And if meaning is somehow explained, then what? Is it worth the effort if the meaning is so idiosyncratic as to permit no generalizations? What has the viewer in fact learned other than private gossip? Or are the formal qualities of the work in question so special that the viewer should view the content merely as a pretext for an exercise in composition and skilled paint application?

The same questions may be raised when considering the work of Robert Rauschenberg (b. 1925). By the middle 1950s he had emerged as one of the major figures of the younger generation. Like others who rejected the supercharged atmosphere of Abstract Expressionism, he denied the confessional aspects of the painting process, the idea that the artist and his work were one, or that subject matter might involve cosmic significance. Instead, he hoped "that the artist could be just another kind of material in the picture, working in collaboration with all the other materials." However, like those airline pilots who speak to their passengers in a relaxed, nonchalant way while attending to the serious business of keeping several hundred people and several tons of equipment from falling out of the sky, so Rauschenberg's art and words are not quite what he says they are. Only in recent years have observers begun to "decode" his carefully arranged content disposed in seemingly unrelated images.

Collaboration did not necessarily mean throwing together found materials and painted forms in pleasing and usually well-organized compositions, but in allowing visual and verbal suggestions contained within one image to suggest the nature and placement of an adjacent image. For example, Rauschenberg's *Bantam* (1954, Mr. and Mrs. Donald Karshan, Zurich) and *Canyon* [337] are elaborate re-creations of and commentaries on Marcel Duchamp's *The Bride Stripped Bare by Her Bachelors, Even* (1915–23, Philadelphia Museum of Art) and Rembrandt's *The Rape of Ganymede* (1635, Gemäldegalerie, Dresden), respectively. A bad Rauschenberg, invented by the author, might include photographs of Judy Garland, a playing field, and President James Garfield, the "gar" and the "field" suggesting "Garfield." Other works might contain images and sequences of images that are entirely autobiographical in nature.

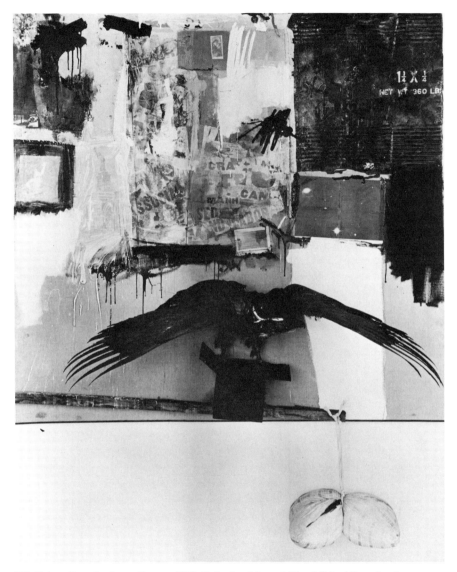

337. Robert Rauschenberg, *Canyon,* 1959. Collection Mr. and Mrs. Michael Sonnabend.

To permit such flexibility in the creation of a work and to interact with his materials, Rauschenberg has to possess considerable self-awareness, a quick mind, and a good memory to respond to the hints and clues suggested by his "collaborators." Perhaps an idea will lead to the choice of particular images or an image might suggest a particular thought sequence. In any event, collaboration is the key to his exploration and manipulation of the visual and verbal possibilities of images and colors that catch his attention, as well as the way he moves from idea to idea. Although all artists are obviously limited by their intelligence, imagination, and skill, artists who work in Rauschenberg's manner are especially

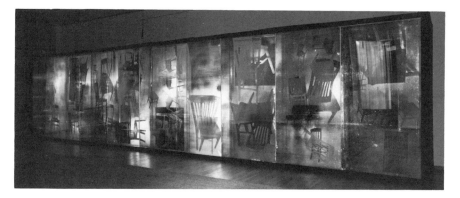

338. Robert Rauschenberg, *Soundings*, 1968. Museum Ludwig.

held prisoner by their own abilities to transform their materials to something other than a mere itemization of the day's activities.

Rauschenberg's affinities lie clearly with Duchamp and other Dadaists, with whose work he became familiar in the middle 1950s. John Cage, the avant-garde composer, whom Rauschenberg met in the late 1940s, was especially important in encouraging him to rely on chance encounters with various materials. Cage well summarized the ideas they came to share when he wrote in his book, *Silences* (1957), "one may give up the desire to control sound, clear his mind of music, and set about discovering means to let sounds be themselves rather than vehicles for man-made theories or expressions of human sentiments." Cage wanted to call "attention to the activities of sound" in the same way that Rauschenberg wanted to liberate the art-making process from established procedures.

Liberation can lead to self-indulgence, but Rauschenberg carefully controls the compositional, tonal, and color balances in his work. Details are logically emphasized or amplified when required. From his monochromatic paintings of the early 1950s, to his combines of the middle of the decade (two- and three-dimensional collations of paints, scraps, photographs, and objects), to his silkscreens begun in 1962 and the later electronic pieces, he imposes order on the visual and physical properties of his materials. Objects in a particular work often retain a sense of their own history, but also yield to Rauschenberg's overall schemes. However, all relationships—formal, thematic, environmental—remain fluid. For Rauschenberg, a canvas is neither complete nor static. His early *White Painting* (1951, collection of the artist) reflects shadows; his electronic *Soundings* lights up when spectators make noise in front of it, revealing silkscreened images [338]. As he said about one of his pieces, which included a radio, "I had to make a surface which invited constant change of focus and an examination of detail. Listening happens in time—looking also has to happen in time."

Jasper Johns (b. 1930) also disallowed final responsibility for his work early in his career, despite the clarity and simplicity of his images and his use of commonplace objects. "Publicly a work becomes not just intention [what the artist intended], but the way it is used," he said in 1964. (In contrast, Mark

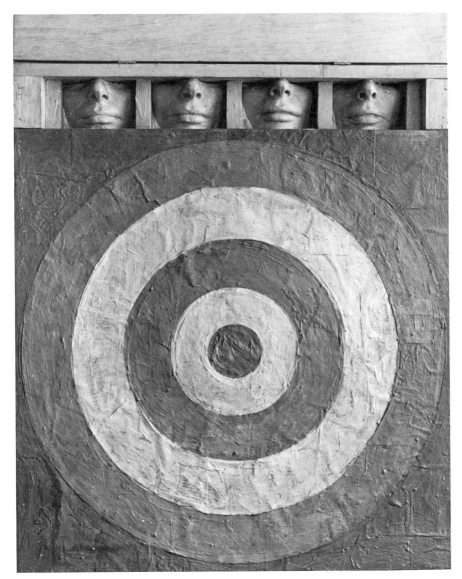

339. Jasper Johns, *Target with Four Faces*, 1955. The Museum of Modern Art.

Rothko believed that insensitive people could spiritually destroy a painting.) This sort of presumed flippancy, however, belied a profound seriousness concerning choice of motifs. Johns's straightfaced statement, "what it is—subject matter— is simply determined by what you're willing to say it is. What it means is simply a question of what you're willing to let it do," is, like Rauschenberg's remarks, a challenge to exercise one's intellect and imagination rather than an invitation to bargain-basement free association.

340. Jasper Johns, *Device,* 1961–62.
Dallas Museum of Fine Arts.

Johns's earliest important works—his *Flags, Targets,* and *Numbers* of the middle 1950s—confront us directly in this regard [339]. The contents are easily identifiable, but are they parts of paintings or duplications of the objects themselves? If we accept them as paintings, then how do we relate their subjects to the painted surfaces, since with some of the *Flags* and *Targets,* the subjects fill the entire field? Because these images are so commonly seen as unitary fields, do we relate their forms and colors to each other or do we read them, as with Barnett Newman's paintings, as holistic images? How do we equate the use of banal images with their presentation in subtle and resonant colors? Furthermore, since targets, flags, and numbers have no depth, how do we reconcile the paradoxical notion of a volumeless object? (Can an object possess surface, but no bulk? Is a number an object?) One further question: how do we resolve the paradox of finding in such obvious and dull themes such highly structured compositional features? The best answer to all of these questions was given by Johns himself, when he suggested that he chose such ordinary images so that one's mind could work on other levels. What appears at first glance to be a loss of imagination on Johns's part becomes instead a very careful process of selection.

These puzzles grew even more complex after 1961, when, using a rich brushy technique despite the growing popularity of hard-edged styles, he began to add objects and printed descriptions of his pictorial activities to his paintings [340]. Like the Dadaists before him, Johns is not as interested in making a "finished" picture as in exploring a set of possibilities. In a painting such as *Device*, for instance, Johns seems to be exploring the contrasts between the busy surface he created and the simple circle easily formed by rotating the piece of wood, as well as the differences between circles and squares.

Despite the very personal and ambiguous nature of his works, they are historically continuous with the achievements of Pollock and Newman, and central to the development of subsequent art movements. The holistic imagery of the works of the middle 1950s develops further the identification of the image with the entire field, first seen in Pollock's drip paintings, but now in recognizable objects. Like Pollock and Newman, Johns, too, denies thematic and formal hierarchies by giving all elements equal importance, and, like them, he tried not to violate the integrity of the two-dimensional picture plane. Johns's control of depth cues subsequently affected Minimal artists of the 1960s, even though they did not work with recognizable imagery. His use of ordinary and typical images helped Pop artists discover a wide-ranging subject matter in the artifacts of popular culture. And linguistically oriented Conceptualists were probably influenced by his use of printed descriptions. In short, Johns, with Rauschenberg, is probably the most important artist of the generation that followed Abstract Expressionism.

Before turning to art of the 1960s, we should devote several paragraphs to the international movement known as Assemblage, of which Rauschenberg became an acknowledged leader in the late 1950s. Assemblage was a neo-Dadaist development; an assemblage is essentially a three-dimensional object assembled by collage techniques. Materials might be new or old, found or specially crafted, permanent or destructible, clean or suggestive of urban detritus. Subject matter might range from the thematically neutral to the macabre, but rarely to the Surreal. Sources might be found in earlier art movements, but for Americans, the forms, if not the sense of personal revelation, of Willem de Kooning and Franz Kline were most important. The works of three sculptors, Louise Nevelson (1898–1988), Mark di Suvero (b. 1933), and Edward Kienholz (1927–94), suggest the variety of styles and themes of Assemblage.

Although a sculptor since the early 1930s, Nevelson began to add Assemblagist elements to her work in the middle 1950s. Her materials, initially notched, perforated, hollowed, and turned wooden forms, were collected in boxed relief panels or attached to free-standing totemic figures [341]. These were painted a uniform black, white, or gold. (Since the 1960s, Nevelson has used aluminum, plexiglass, and Cor-Ten [342].)

More austere than Rauschenberg's combines, her reliefs proliferate formal complexities as well as ambiguous meanings, as one tries to penetrate the aura of mystery contained in each individual unit. Nevelson searches out, as she has said, not simply the nature of the object but the "in-between places. The dawns

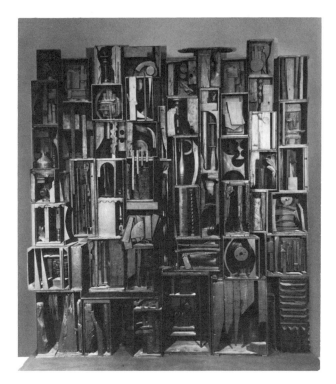

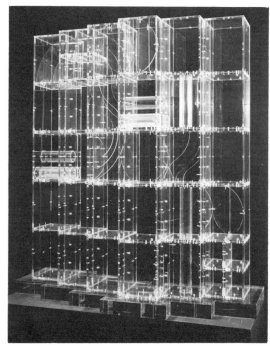

341. Louise Nevelson, *Sky Cathedral*, 1958. The Museum of Modern Art.

342. Louise Nevelson, *Transparent Sculpture I*, 1967–68. Albright-Knox Art Gallery.

and the dusks." A pioneer environmentalist as well, she arranged her first major shows in the middle 1950s around specific themes, and indicated precisely the lighting and location for each piece. In effect, the space of the exhibition area became part of the exhibition. When these interiors are compared with the more visually barren ones arranged by Minimalist sculptors some ten years later, it is apparent how close Nevelson's sensibility is to artists such as Rothko and Still, even though her later work acknowledges the more geometrically rigid and technologically oriented art of the 1960s and 1970s [compare 341 and 381].

By contrast, the sprawling forms of Mark di Suvero, which bear a familial relation to the paintings of Kline, deny autobiographical or mysterious references [343]. They reach out into space and are balanced precariously in defiance of gravity. The histories of the specific materials—battered tree stumps, planks, chains, rubber tires—are neither suppressed nor transformed. Instead, they link together visually in a manner similar to that of a Rauschenberg combine.

Many of di Suvero's pieces lack a central base. Removed from their pedestals, they are part of the viewer's space and create, on an impressive three-dimensional scale, the three-dimensional body rhythms that Willard Huntington Wright thought were a major goal of modern art. Although di Suvero's works are usually motionless, they communicate tremendous kinetic energy because, like human limbs, their parts extend outward from an implied center and therefore seem capable of instant readjustment. By comparison, David Smith often worked around a presumed center, emphasizing perimeters at the expense of

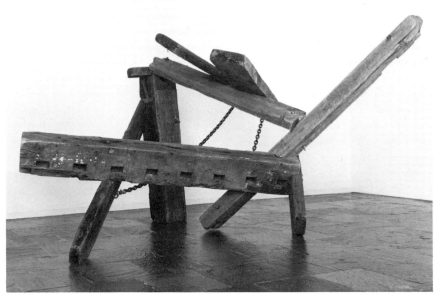

343. Mark di Suvero, *Hankchampion*, 1960. The Whitney Museum of American Art.

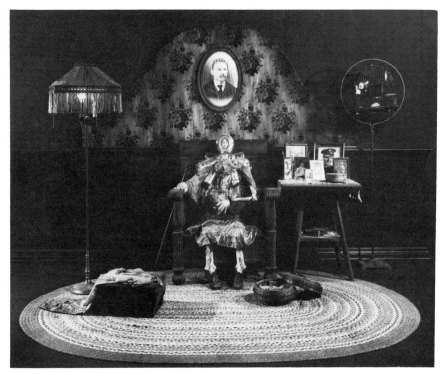

344. Edward Kienholz, *The Wait,* 1964–65. The Whitney Museum of American Art.

dynamic centers. Even when di Suvero began to use metal exclusively in the late 1960s, a similar contained movement was felt in his works.

In the tableaux of Edward Kienholz, narrative is more important than composition. Humanoid figures began to appear in his assemblages about 1960, five years after he first made wood reliefs and just before he incorporated figures into entire environments. His content is usually obvious, but it is loaded with allegorical, political, and social implications [344]. Kienholz pinpoints the horrors of old age, illegal abortions, antiquated sexual customs, and other subjects, ranging from necrophilia to the excretions of an affluent society. In *The Wait* the old woman, with her picture face and bovine leg bones, sits waiting for death. Childhood memories hang in jars around her neck. Nostalgic rather than violent —the latter mood being more common in Kienholz's work—the woman seems as much a victim of her past as Grant Wood's figures. In fact, Kienholz and others who focus so unblinkingly on American life have continued the search for American truths without ideological and nationalistic overtones in ways that recall the art of the 1930s.

Happenings, a combination of Assemblage and theater, also evolved during the 1950s. The immediate history of this movement—its antecedents lie in Futurism, Dada, and Antoine Artaud's Theater of Cruelty—began in 1952, when John Cage arranged an improvisational theater piece within a space bordered by Rau-

schenberg's all-white paintings. However, artists did not respond to the improvisational nature of the piece nor to the full implications of Cage's methods until the late 1950s, when the various influences of Cage's type of Dadaist play and of Abstract Expressionism were sorted out. Allen Kaprow (b. 1923) deserves much of the credit for this. He had studied with Cage in the middle 1950s and, in the issue of *Art News* for October 1958, he acknowledged Jackson Pollock's equally seminal influence, stating that Pollock's diaristic gestures, enormous canvases, splashing pictorial attack, and involvement in an improvised ritual of artistic creation "left us at the point where we must become preoccupied with and even dazzled by the space and objects of our everyday life, either our bodies, clothes, rooms, or, if possible, the vastness of Forty-Second Street." In short, Kaprow suggested that the activities, sights (and sites), and sounds considered in a given time period, however loosely or tightly structured around given themes, would become art events.

Developed primarily by artists—including Kaprow, James Dine, Claes Oldenburg, Robert Whitman, and Red Grooms—Happenings were first performed in 1958. Initially staged in artists' lofts, they were soon moved to gymnasiums and then outdoors. Happenings permitted improvisational activities, temporal discontinuities, and illogical uses of materials. One typical Happening, for example, concerned ideas about chickens. In different parts of a large room—as in compartmentalized sections of a Rauschenberg combine—performers sold chickens, women posed as "chicks," and others plucked feathers from dead chickens. Soon, mock ritualized killings of chickens occurred, and each participant responded in his or her own way. Subsequently, a staged fight began, police arrived, and those participants who were "chicken" fled the room. Little information passed back and forth between the various episodes. Sustained thematic development was nonexistent. But each participant could move into or out of different roles, could ritualize certain activities, and could become part of a series of nonsequential events. In effect, each person became his or her own art object in the self-conscious performance of activities based on the stated theme. Although Happenings grew less popular in the late 1960s, their legacy continued to inform all those art activities in which time, movement, found materials, and improvisation are important components.

8

CONTEMPORARY DIVERSITY

DURING the last forty years American art has assumed a commanding position in the Western art world. If new movements did not start in the United States, they seemed to flourish there as exuberantly as in any other country. Fueled by an expansive economy that showed signs of reaching its limits in the middle 1980s, art galleries, art schools, and art publications, as well as private and public foundations, provided artists with unprecedented means of support, instruction, and access to a public hungry for quality and novelty. It seemed, as a result, that more art was produced in the last generation than in all previous ones, dating back to the 1780s. Even if the last several years will or will not prove to be a golden age for American art, it certainly became one for art in America.

In recent years viewers have been confronted with a variety of movements and styles, baffling in their diversity. The range of significant work extends from the nonobjective to the meticulously realistic, from systems-oriented to purposefully casual, from process-oriented to object-concerned, from blandly apolitical to determinedly political, from gallery-structured to work representing the street culture, from technologically inspired to craft-derived, and from small indoor-scaled forms to those concerned with the exterior environment. Furthermore, the old hierarchical differences between art forms have been pulverized, since photography and ceramics, glass making, and other so-called craft media are now considered equal to painting and sculpture.

Opposing views have been stated freely and argued openly in the pages of magazines and in artists' forums. For example, the figurative painter Jack Beal said in 1979, "I think that what we have to try to do . . . is to make beautiful paintings about life as we live it, by verifying and celebrating the good parts of life as we live it," but Richard Serra, the Anti-Form sculptor, mentioned in 1982, "it's not the business of art to deal with human needs." The different ideas about the functions of an art critic can be summed up by contrasting the sculptor Dan Flavin's assertion in 1970 that he knew of "no occupation in American life so meaningless and unproductive as that of art critic," with the critics Michael Fried's and Donald Kuspit's desires to assign value and historical significance to specific works or movements. But all of this only serves to underline the pluralism and exciting instability in recent American art.

It is appropriate at this point to consider the term "post-modernism," which has been commonly used since the 1970s. Although it is not necessary to create a list of movements or artists containing post-modern characteristics, it is worthwhile to indicate briefly some ways to define the term. Broadly speaking, modernism was and still is concerned with exploring issues of trying to understand something about the world, of discovering one's place in the world, and of exploring issues of interpretation and communication. Post-modernism, by contrast, is more concerned with the ultimate unknowableness of the self, of things, of values, and of what had been considered basic understandings. Modernism allows to a greater extent the possibility of human endeavor, authenticity, and agency. Post-modernism asserts the reverse, that we are products of forces — political, cultural, linguistic — which prevent us from any kind of ultimate understanding and that our intentions are less our own, less personal, than the results of those forces working upon and through us.

In regard to works of art — post-modernists might even question if there are such things — no rules apply. A work might be a traditional object, a process, or an idea that confronts any or all of our traditionally held beliefs and that might elude any specific or ultimate meaning. Following this line of thinking, what is called the work of art is now allowed to escape from our preconceptions about art and from our cultural values, which are now suspect, anyway. As the critic Peter Schjeldahl has stated, "Our new artists want to know what art can represent and signify and subvert and discover — what art in any and all forms and

345. Claes Oldenburg, *Giant Hamburger*, 1962. Art Gallery of Ontario.

346. Claes Oldenburg, *Colossal Fag
End in Park Setting*, 1967. Leo
Castelli Gallery.

mediums can *mean.*" Or as Pina Bausch, the director of the German Tanztheater Wuppertal has said of her dance theater presentations, "[I] can only make something very open" that reflects in some way "where you are in life at that period."

With this statement in mind, it is interesting to contemplate one of the paradoxes of post-modernism: if each of us is little more than a palimpsest, a blank tablet, inscribed with influences beyond our knowledge and control, then why are we ultimately forced to rely on our own imagination, experience, and intelligence, either as the artist or the viewer to make appropriate judgements? As Donald Kuspit has stated, with all boundaries blurred, it is the idiosyncratic artist who stands out, the artist who "seems to conform to no prevailing views and ideals while absorbing them all." Quality, then, however we judge it, resides less in a standard of style, whether it be Cubism or Abstract Expressionism, than in the object or event itself, the effects of its forms, brush marks, time sequences, as well as the level of creative imagination of the artist and the viewer.

The differences between modernism and post-modernism boil down to differences of intention rather than of chronology. For one can argue that Dada of the 1910s is really post-modern because the odd and arbitrary use and juxtaposition of materials often defies explanation, and that Abstract Expressionism of the 1940s is really a modern movement because of the artists' concern with self-definition and self-understanding. One can further argue that the first important American post-modernists are, therefore, Jasper Johns, Robert Rauschenberg,

347. Andy Warhol, *Campbell's Soup*, 1965. Leo Castelli Gallery.

and Alan Kaprow whose works are derived from Dada premises. But it is important to keep in mind that not all subsequent artists are post-modern nor do they have to be exclusively modern or post-modern, but can contain elements of both within their work.

In the earliest Happenings, considered in the previous chapter, the refuse and clutter of rundown urban business districts were reproduced in the claustrophobic loft spaces of the participating artists. At least one important sculptor emerged from this milieu, Claes Oldenburg (b. 1929), whose first important environments, *The Street* (1960) and *The Store* (1961), re-created the character of those interiors. With a nod of recognition to the images of the French painter Jean Dubuffet, and the destructive impulses reflected in Louis-Ferdinand Céline's novels and in Antonin Artaud's theories of performance explored in his Theater of Cruelty, Oldenburg filled *The Street* with dirty and burned paper and wood. *The Store,* filled with painted plaster objects parodying the tastes of a materialist society, lacked the underlying sense of violence of its predecessor. Compared to earlier views of city life, however, both works refused to exalt the spirit of the people, as in Henri's work, the dynamism of the metropolis, as in Marin's, nor did they describe urban alienation, as in Hopper's, but instead they allowed the continuum of certain city activities—accumulation of garbage, deterioration of objects, sales of goods—to intrude upon and become the art events. It is as though these works

348. Roy Lichtenstein, *O.K. Hot-Shot*, 1963. Collection Mr. Remo Morone.

were either mobile assemblages or static Happenings. In either instance, time became a factor in experiencing the works, and, especially in *The Store*, change assumed a major role in the artistic process; these were two qualities that were to assume major importance in the 1970s.

In 1962, Oldenburg narrowed his focus, and enlarged his forms, by making enormous sculptures of food products—hamburgers, slices of cake, ice cream cones. Initially made of canvas-covered foam rubber, they were subsequently formed from vinyl-covered kapok [345]. Burlesquing consumer-oriented tastes, Oldenburg allowed these works to "go soft," to collapse in upon themselves, after

1963, as if to underline their shiny uselessness. Although Oldenburg said that he wanted merely to push space around, these pieces were innovative and influenced later Anti-Form artists such as Eva Hesse because their surfaces yielded to gravity and their shapes changed when moved. Oldenburg, as Jasper Johns before him, also made several versions of the same piece in different colors, sizes, and materials. This proliferation of the same image through several permutations also influenced later artists, in that repetition and the idea of repetition became part of a work's content whatever its apparent subject. Finally, Oldenburg's drawings of large-scale monuments for outdoor sites, begun in 1964, called attention to the possibilities of using the exterior environment in an art work [346]. Clearly, he was one of the seminal figures in the 1960s.

Oldenburg's attention to single objects in 1962 coincided with the emergence of Pop Art, a movement initially developed by artists familiar with Happenings. However, the key figures, Roy Lichtenstein (b. 1923), Andy Warhol (1928–87), Tom Wesselmann (b. 1931), and James Rosenquist (b. 1933), disavowed the imaginative use of materials and techniques associated with Happenings, assemblages, or the type of work Rauschenberg represented. The incorporation of junk elements and the easy convertibility of objects into art played little part in their work. Instead, they *created* new art objects—paintings and sculptures. Less interested in process, they took their subject matter, but not their materials, from popular culture. Mass-media sources, which lie at the root of their art, were reproduced, not reused. In this regard, the visual sensibility of Pop Art was quite different from its germinating environment.

349. Jim Dine, *The Flesh Bathroom with Yellow Light,* 1962. The St. Louis Art Museum.

The critic Lawrence Alloway pointed out in his catalogue for an exhibition of Pop Art at the Whitney Museum of American Art in 1974 that the subject matter of Pop Art is "the twentieth-century communications network of which we are all a part," making a clear acknowledgment that our shared culture, our common storehouse of knowledge, is no longer derived from religious, mythological, or literary sources. Superman has replaced Prometheus, Elvis Presley the Founding Fathers, and the Campbell's soup can a Grecian urn [347]. Since personal feelings have been replaced by moods manipulated by the media, we think, talk, and love in clichés, and buy what is brightly packaged or made attractive in other ways. In effect, Emerson's Oversoul, to which all of us should have access, now runs an advertising agency that manipulates rather than enlarges our feelings.

The most famous early Pop images, Lichtenstein's comic-strip figures, express feelings, filtered through the images of the mass media, second-hand [348]. These might be considered portraits of the "other-directed" personality made famous in the most popular sociological text of the period, David Riesman's *The Lonely Crowd* (1950). This individual, sensitive to his relationships with others, is basically a conformist and takes his behavioral cues from the mass media. His emotional range is checked by the limiting clichés of popular sentiment, feeling, and personal relationships. Unlike the slightly earlier figures of Richard Diebenkorn or Leon Golub, the anxieties of Pop figures have been reduced to stereotyped

350. Tom Wesselmann, *Great American Nude #99*, 1968. Washington University.

351. James Rosenquist, *Silver Skies,* 1962. The Chrysler Museum.

platitudes. (Presumably Lichtenstein and the others intended irony. Pop Art's immediate popularity suggests a different conclusion in regard to its supportive audience, however.)

In other important ways Pop Art differed from movements of the late 1950s. First, the typical Pop image has clearly defined, hard-edged forms. Painterly slickness and happy accidental effects are severely controlled. Manipulation of pigment for its own sake or to reveal emotional states is suppressed. Second, since typical Pop subjects are derived from preexisting images—comics, cartoons, advertisements, posters—rather than from direct contact with actual situations, a greater emotional distance exists between the artist and his work. If artists such as Rauschenberg and Johns parried and parodied the autobiographical excesses of Abstract Expressionism, the Pop artists ignored them altogether (with exceptions for Lichtenstein's versions of Abstract Expressionist brush strokes).

Pop Art also differs from earlier styles in that its images do not possess the quality of movement. Pop paintings do not contain a sense of duration, of having been composed over a period of time. Unlike Abstract Expressionist and earlier vitalist works, which are filled with immediately personal insight, a Pop work seems to have no prior history. Its author is not present in the work, nor are the marks of its making always present. From this point of view Pop Art might be considered a modern classicism in which stable images, usually frontal and appearing in a flattened space, take precedence over those depicting the flow of time or personal feeling. Despite its association with communications networks, Pop Art paradoxically suggests a desire for timelessness, for stasis in a world of immutable change, to which the sensibility of the 1950s seemed open and responsive.

Pop Art did, however, pay homage to the American interest in literal fact; products of the communications networks *are* depicted rather than abstract representations of electronic communications systems. But Stuart Davis, considered a forerunner of Pop Art, probably would have objected to its literalness, and Richard Lindner, another possible forerunner, might have recoiled from its blandness. Thomas Hart Benton, divested of his Americanist theories, is a much closer antecedent.

352. Roy Lichtenstein,
Stepping Out, 1978. The
Metropolitan Museum of Art.

Although a strict definition of Pop Art does not really exist, most would agree that the early assemblages of Jim Dine (b. 1935) contain Pop elements but are not examples of Pop Art [349]. Dine, like Marcel Duchamp before him, presented objects isolated from normal contexts and explored paradoxical relationships between real objects and simulated effects, such as painting the shadow of a genuine axe attached to a canvas. In contrast, the early collages and subsequent paintings of Tom Wesselman are Pop works with Assemblagist overtones. Objects and collage elements retain their identities when juxtaposed with painted passages. Ambiguity of meaning is subordinated to straightforward presentation of content. After 1961, Wesselmann preferred using bright, unmodulated colors aligned within taut contours, seen with particular clarity in *The Great American Nude,* a recurrent theme in his art [350]. Painted or sculpted in plastic, she mindlessly smiles or is openly erotic. As if to set off the artificiality of her existence, Wesselmann has made passing reference to Matisse's color and to Mondrian's structural organization. The impersonal Danish modern decor, coupled with carefully organized formal balances, does not leave her much emotional space in which to maneuver, since she is really a male fantasy figure, agreeable, submissive, but no longer chained, like Hiram Powers's *The Greek Slave* [115].

James Rosenquist (b. 1933) is probably the most thematically and compositionally adventurous Pop artist. He juxtaposes disparate images in varied and illogical spatial sequences, as if he were constantly changing the channels of a

television set [351]. He presents subjects but not coherent contexts, in a purposeful scheme to suggest as many different meanings as possible. "I paint anonymous things," he said in 1962, "in the hope that their particular meanings will disappear." To emphasize this way of handling content, Rosenquist often enlarged the scale of the images in relation to the size of the painting so that they might be read as abstract forms.

Clearly, the years he worked as a billboard artist from 1954 to 1960 affected his subsequent style. Images that had filled his range of vision when viewed from short distances become spatially dislocated when transferred to easel-sized canvases. The odd and abrupt combinations of images call to mind passages in the works of French novelists such as Alain Robbe-Grillet, in which parallel realistic, but not necessarily relational, situations are described.

The works of Roy Lichtenstein are much less ambiguous. They describe the trivialization of culture through images derived from the popular media. In a style reminiscent, but not identical with, the comic strip, he has portrayed prepackaged and preprocessed emotions and objects. Women are concerned with love and marriage, men with violence. Since 1962, when he began to make Pop versions of famous modern paintings in bright, strident colors, he has also pointed out the "secularization" of high culture and the reduction of its artifacts to commodity status [352]. His statement, "I'm interested in portraying a sort of anti-sensibility that pervades society," is really more profound than ironic.

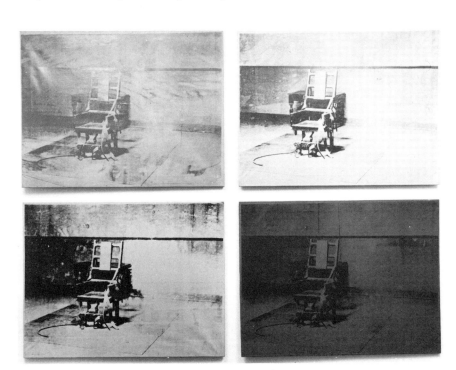

353. Andy Warhol, *Electric Chair,* 1967. Leo Castelli Gallery.

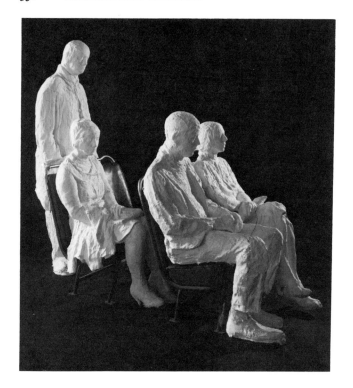

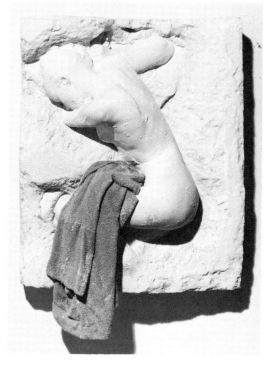

354. George Segal, *Bus Riders,* 1964.
Hirshhorn Museum and Sculpture
Garden.

355. George Segal, *The Blue Robe,*
1974. Sidney Janis Gallery.

He also developed an appropriate method of painting his works to convey a notion of anti-sensibility—the Ben Day dot system, which, in hiding the record of his own hand, gives his surfaces a hard, steely, and antiseptic quality. But Lichtenstein is himself an artist of great sensibility, and he composes in the tradition of Cézanne and the Cubists. His forms are invariably flattened against the picture plane. Red, white, yellow, blue, and occasionally green are the predominant colors; variety is added by the use of Ben Day dots, which provide half-tones such as pink and baby blue. Lichtenstein carefully links shapes by means of color similarities—solid color with solid color, darks with darks, and half-tones with half-tones. He also integrates figure-ground relationships by relating shapes to each other, whether they are part of an object, a figure, or a background form. Directional movements linking units create closure patterns that might encompass several figures and forms in a large configuration. In effect, Lichtenstein still works in a stylistically conservative manner, transforming his sources but not obliterating them.

Andy Warhol only minimally transformed the models of his first cartoon paintings of 1961. It was not until he began to use photographic silkscreen processes in 1962 that he really altered his models through the manipulation of pigment. He also multiplied the number of individual images so that one might lose sight of the subject and its possible meanings in the riotous assault of color and repetitive forms. One hundred soup cans do not have the iconic significance that a single one has, and repeated views of a car accident dull the viewer's response to the horrors of the scene [353]. In these works Warhol seems to imply that repetition obliterates content and promotes passivity in place of engagement. When he said in 1962, "I think everybody should be a machine," he was probably talking more about masking true feelings than employing modern methods (silkscreening in an age of space exploration is hardly advanced). This is borne out in his ongoing series of multiple silkscreened portraits, to which varying colors are arbitrarily applied for emotional effect.

Warhol also used the cinema with equally misleading, although interesting, intent. In the early 1960s he focused a camera on a single object for a seemingly interminable length of time (eight hours on a person asleep). In this type of cinematography, which destroyed the camera's ability to capture duration and spatial changes, the medium was used as if it were that of still photography.

Although no other major figurative mode emerged during the 1960s to compete with Pop Art, a number of artists did explore ways to portray the human figure in painting and sculpture. George Segal (b. 1924) and Philip Pearlstein (b. 1924), among others, created some of the most memorable images.

Segal is often associated with Pop artists, but his subjects and points of view are not derived from the popular media. In contrast to the emotional and cultural clichés that Lichtenstein so deftly skewered, Segal preferred, as he said in 1967, "to intensify my sense of encounter with the tangible world outside of me." To achieve this goal, he has preferred to work with people he knows and to create scenes that are either extensions of his own experience or which can be experienced empathetically by others [354].

Since 1960 Segal has created both relief-like and three-dimensional environ-

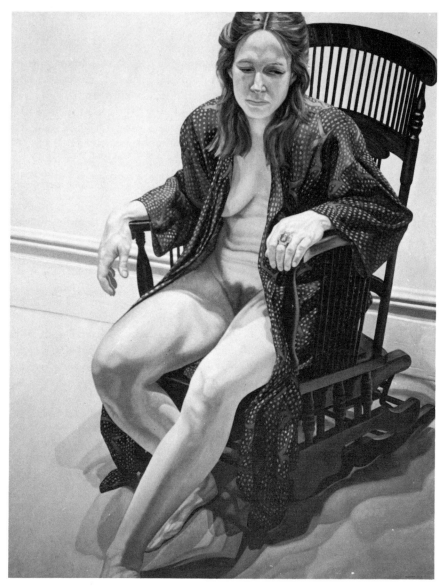

356. Philip Pearlstein, *Female Model in Robe Seated on Platform Rocker,* 1973. San Antonio Museum of Art.

ments containing plaster figures. Molded directly from his sitters, their reverse images are literally locked inside the plaster, unknowable and unviewable. The exteriors, however, are responsive to Segal's touch and can be altered to affect allusive formal and psychological nuances, especially when colors are arbitrarily applied. In these works Segal has created two sets of formal and psychological

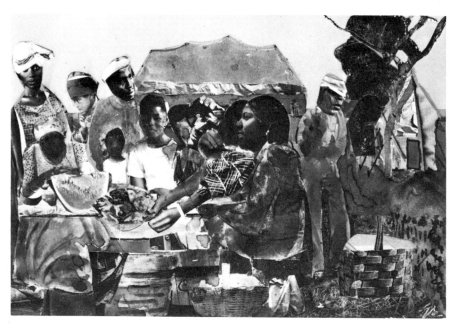

357. Romare Bearden, *Dinner Before Revival Meeting*, 1978. Cordier and Ekstrom.

relationships—between the figures themselves and between the figures and their environments. Tensions are generated by the carefully constructed compositional arrangements of realistic, but slightly askew, figures. Within the environments real objects are made part of tightly knit organizational formats, yet they still possess a sense of their own prior history. Segal seems purposely to leave unresolved these dualisms between reality and artifice in the figures and also in their environments. Rauschenberg once said that he liked to operate in the gap between art and life, but Segal probably makes the viewer more aware of that gap.

The figures in Segal's tableaux, like those of Diebenkorn, bear comparison to Hopper's alienated apartment dwellers. In 1970, however, Segal began to make half-length reliefs in which formal patterns were increasingly emphasized [355]. By coincidence, this development brought his work into closer correspondence with the paintings of Philip Pearlstein. Both began their careers with Abstract Expressionism, the "academic" style of their artistic youth, and both turned to the figure around 1960, but Pearlstein has studiously deemphasized those emotional qualities stressed by Segal. In his own carefully chosen phrase, Pearlstein considers himself a "post-abstract realist"; in fact, his work might almost be considered a realistic analogue of Franz Kline's paintings [356 and 310]. Bodies and limbs bisect Pearlstein's paintings to create large abstract units. These, like similar elements in Kline's paintings, establish centripetal rhythms, which involve both interior forms and the framing edges in taut organizational relationships. To emphasize his preference for abstract units, Pearlstein often cuts through heads

358. Richard Estes,
Woolworth's, 1974. San Antonio
Museum of Art.

359. Chuck Close, *Frank,* 1969.
The Minneapolis Institute of
Arts.

360. Audrey Flack, *Wheel of Fortune,* 1977–78. HHK Foundation for Contemporary Art.

and limbs, and contorts his models into poses that stress formal rather than psychological connections. But their sallow colors, languorous instead of voluptuous poses, and intimate but not sexually provocative male-female relationships suggest that Pearlstein's figures do live in a world of private moments, psychologically deadened to the world and probably to themselves. They seem depressed beyond knowing or caring, the descendants of Copley's figures of the early 1770s, Eakins's of the late nineteenth century, and Hopper's of the 1920s and 1930s, and far removed from Alex Katz's contemporary hedonists.

In contrast to Pearlstein's figures, which seem to lack a sustaining modern culture, those by Romare Bearden (1914–88) inhabit a universe filled with symbols and myths. Since the early 1960s he has populated a fictional world based on his experiences as a black [357]. Using collage and photo-montage elements, he has created a fantastical archetypal black world of "conjure women," baptisms, and garden scenes, which, depending on the particular set of images, resonate good or evil intentions.

Few, if any, figurative painters of the last twenty years have had such an active and imaginative rapport with their particular community, whether it is racial, religious, or regional, or have been able to re-create it in such fanciful and nondocumentary ways. It was just such a documentary approach, however, that helped galvanize a figurative revival in the late 1960s and 1970s [358 and 359]. The most popular and compelling images were painted in a smoothly textured, sharp-focused, often excruciatingly detailed manner. Colors tended to be applied with equal brightness across a picture's surface. Some artists painted from the

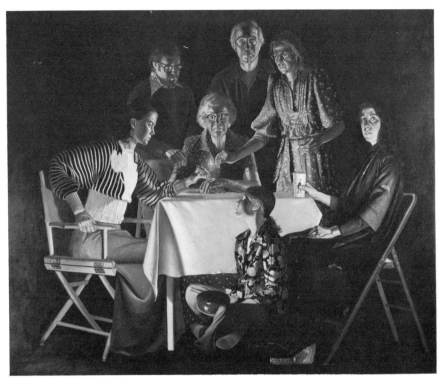

361. Alred Leslie, *A Birthday for Ethel Moore*, 1976. Frumkin Gallery.

model (a person, a building), and others used photographic sources, often simulating the appearance of a photograph itself. The name Photo-Realism describes the latter group, but the term Super Realism better defines the works of all of these artists. The Photo-Realists include artists such as Malcolm Morley (b. 1931), Richard Estes (b. 1936), Robert Cottingham (b. 1935), Audrey Flack (b. 1931), and Chuck Close (b. 1940); among other sharp-focused realists there are Alfred Leslie (b. 1927) and Jack Beal (b. 1931).

Photo-Realists might be considered second-generation Pop artists, since they use already existing images as source material. The transformations that occur depend upon the ways in which the photographic models are cropped and assembled, as well as the ways in which detail and color are suppressed or intensified. As in Luminist paintings and in works by Stuart Davis and Jackson Pollock, there are an evenness of effect and an equal, all-over amplification of detail. But unlike these earlier works, Photo-Realist paintings carry no particular messages. Richard Estes has said in various statements during the 1970s that his goal was "only to set down on canvas or paper what was before me," and Cottingham feels that "the end result" should be "a detached, unsentimental observation of a piece of our world." Chuck Close has also indicated that he is "not concerned with painting people or with making humanist paintings."

The desire to avoid meaning is, of course, meaningful in its own right and

362. Jack Beal, *Industry,* 1977. United States General Service Administration.

363. Duane Hanson, *Janitor,* 1973. Milwaukee Art Museum.

364. Mitchell Caton and Clavin Jones, *Builders of the Cultural Present,* 1981. Chicago Mural Group.

implies that the images, usually based on banal contemporary activities and scenes, are to be witnessed, but not experienced in any meaningful way. Whatever the subject, one's visual response is the key response, as if the subject were part of a still-life painting. Imagine—without implying a value judgment—how Max Weber or Jackson Pollock might respond to Estes's statement, "the great thing about the photograph is that you can stop things—this is one instant."

Malcolm Morley is the pioneer Photo-Realist. In the middle 1960s he based a group of paintings on photographic advertisements of cruise ships, but it was Estes, who began to use photographs in the late 1960s, who developed into the major figure of the movement, because of the complexity of his style [358]. Preferring urban scenes, he evidently delights in painting reflections of and on surfaces so that it is sometimes difficult to determine what lies on and what appears to lie behind the picture plane.

In contrast to Estes, who uses several photographs to compose a painting, Chuck Close transfers the content of one photograph to canvas or paper [359]. In fact, his subject, beginning in 1967 when he first began to paint heads, is the way the photograph can be transferred. Using a grid, he will transfer the distortions of noses or ears to make the viewer aware of the photographic source. By 1972 he had allowed the grid system itself to remain visible and to become part of the finished product. Close might also take a single image and in a series of related works paint it in different colors as well as in different degrees of realistic resolution, or, as he said in 1980, plug "the same image through a variety of

365. Leon Golub, *Mercenaries, II,* 1979. Susan Caldwell Gallery.

systems and [see] how it effects their looks . . . how subtle shifts can make drastic differences in how something is perceived." In this respect his permutations of the same image and his concern for process ally his work with that of Jasper Johns, Claes Oldenburg, and the conceptualist Sol LeWitt (see below).

In contrast to the deadpan approach of most Photo-Realists, Audrey Flack manipulates her forms for emotional effects, loading her cluttered tabletops and display-case surfaces with religious symbols and images of vanity and death [360].

The line separating Photo-Realists from Super Realists is an artificial one, and is based primarily on the use of photographs as models. Among the larger group of Super Realists, many equipped with superb technical resources, at least two stand out because of the didactic intent of their art. These are Alfred Leslie and Jack Beal. Leslie, a former Abstract Expressionist, turned to figurative painting in the early 1960s and, later in that decade, added narrative intent to his large frontal portraits. His *A Birthday for Ethel Moore,* for instance, a remote descendant of Charles Willson Peale's *Family Group,* celebrates community values and respect for the aged, if in more modern, slightly hallucinated ways [361 and 42]. Beal, who has always painted the figure, turned to a precisely detailed style in 1971 and began to employ narrative sequences in 1976. A moralist, he explores subjects more general than those of Leslie, and has painted themes concerned with planting and harvesting as well as with vices and virtues. In 1976–77, Beal painted *The History of Labor in America* in four panels for the United States General Services Administration [362]. In a manner akin to that of Cole in *Course*

366. Judy Chicago, *The Dinner Party,* 1979.

367. Miriam Schapiro, *Presentation,* 1982. Barbara Gladstone Gallery.

of Empire and Benton in his murals in the Missouri State Capitol, Beal showed how early optimism changed to pessimism and confusion in modern America. Duane Hanson (b. 1925) and John de Andrea (b. 1941) have developed a comparable realism in sculpture. Using fiberglass and vinyl painted with flesh colors, they have created shockingly humanoid figures [363]. Since these stand or lie on the ground shared by the viewer, one almost feels like a voyeur, especially when the figures are undressed. Of the two sculptors, Hanson has explored a wider variety of themes, including, since 1966, street and supermarket scenes, race riots, and recreational pursuits.

Such technical feats are beyond the interests of the People's Mural Movement, a nationwide development of artists who belong to or identify with minority groups traditionally disenfranchised by American society. Although the first murals appeared in Chicago in the late 1960s, paintings have subsequently been created on walls in black and Hispanic communities from Boston to Los Angeles, often with the direct help of local residents [364]. Beginning with the *Wall of Respect* by William Walker in Chicago in 1967, artists have portrayed the aspirations and deprivations as well as the heroes and villains of their communities.

It is one of the more significant ironies of the history of American art that an art movement that finally reflects the wishes and aspirations of a significant number of Americans, an art that is truly egalitarian and democratic, has been created by those who have been denied the full benefits of the country's democratic and egalitarian processes. The kind of people painted by, say, Robert Henri and his circle are for the first time creating an art in their own image and on their own turf.

A similar expressionist bias appeared in the more traditional world of the art galleries in the late 1970s and early 1980s, in the works of such artists as Jonathan Borofsky (b. 1942), Julian Schnabel (b. 1951), and David Salle (b. 1952 see below), but the representative figure who combines in his work the attention to pictorial qualities and paint handling of the gallery artists with the sense of moral outrage of the People's Mural Movement is Leon Golub. This can be seen especially in his series of paintings of the early 1980s about mercenaries and political torture [365]. As in his Hellenistically styled *Gigantomachies* of the 1960s and his *Assassins* series of the 1970s, which commented upon the American military involvement in Southeast Asia, the more recent works describe scenes of savagery and confrontation. Golub's mordant observations on man's lust for violence and his inability to control it, whatever his dreams, contrasts strongly with, say, John Trumbull's idealized battle scenes painted two hundred years ago [34]. That Golub paints large works on this theme in a modern grand style is one thing; that he implicates the United States as a victimizer is quite another.

In fact, discontent with conditions both in the art world and in the country as a whole has prompted several different kinds of responses since the 1960s. Artists have fought the economic control of art galleries as well as the exclusion of various groups from representation in art galleries and from equal participation in American life. The feminist art movement certainly has been one of the best

368. Mary Beth Edelson, *Goddess Head*, 1975.

organized, most visible, and most important of those groups critical of establish-ment controls at all levels of society. Realizing that women were not being taken seriously as artists, women formed several groups just before and after 1970 to alter this discriminatory situation and to eliminate the isolation many women artists experienced in a white, male-dominated art world. Building on the activist politics of the civil rights and student movements of the 1960s, these groups organized exhibition spaces for women, picketed museums, created supportive networks, and, in general, made the public aware of women not only as women artists but as artists. Women Artists in Revolution (WAR), founded by Muriel Castanis, Juliette Gordon, and Nancy Spero in 1969, was one of the first groups. In 1971 Miriam Schapiro and Judy Chicago started a feminist art program, the first of its type, at the California Institute of the Arts in Valencia. The following year, Schapiro and Chicago helped form Womanhouse in Los Angeles, at the

369. Nancy Spero, *Torture of Women* (detail), 1976. Collection of the artist.

same time that the cooperative Artists in Residence (AIR) Gallery was founded in New York City. Similar organizations soon followed across the country. In exhibitions that included both static images and performances, artists explored and critics wrote about those forms, styles, and materials that might be associated with women. Some women attacked men through their art, others used female subject matter to address both the human condition and the condition of women in particular.

Judy Chicago (b. 1939) is the best-known feminist artist. A Minimal painter in the 1960s, she began to use female sexual symbols about 1968 as a way to find and to document her social and biological self. These explorations led in 1974 to the cooperative effort that four years later produced *The Dinner Party* [366]. A room-size environment, its major element is a triangular table with place settings for 39 women. Chicago intended the piece to be a celebration of the arts associated with women—embroidery, knitting, and cooking.

The decorative artifacts as well as the political nature of *The Dinner Party* reflect two important components of feminist art. The decorative aspect helped spark the development of Pattern Painting in the middle 1970s. In this type of art, floral patterns, human forms, or nonobjective shapes recalling Henri Matisse's cutouts might be arranged in ways resembling strips of wall paper. Miriam Schapiro (b. 1923), a second-generation Abstract Expressionist until the middle 1960s, when she began to use egg-shaped motifs, has invested this type of art with an emphatic feminist content. About 1975 her "femmages," as she calls them, grew to mural-length size and were composed of cloth, paint, needlework, and embroidery [367].

Several feminist artists have explored the nature of womanhood beyond the world of artifacts. The inquiries might take the form of didactic or imaginative static presentations in mixed-media formats or in performances. The latter might range in content from the horror of rape to the ritualistic incantations of mythic forces and persons. Mary Beth Edelson has invoked, since the 1970s, images of the Goddess, often using her own body, to suggest "not who I am but who we are," as she has indicated [368].

Nancy Spero (b. 1926), by contrast, uses feminist content both to describe the ways women have been abused in the past and as symbols of human oppression. In this respect, she can be associated with those figurative and abstract artists not necessarily associated with feminism whose works contain political and social messages. Her long, scroll-like pieces celebrate and condemn the conditions of women through combinations of print, collage, and paint [369]. These include the *Codex Artaud* (1969–72), for which she assumed the persona of the experimental dramatist Antonin Artaud, *Torture of Women* (1976), and *Notes on Time on Women* (1978). Preferring ambiguity to reportorial observation, she has used graffiti-like mythic and invented forms to explore themes of torture, childbirth, menstruation, and divorce, among others. In *Torture of Women,* a scroll 175 feet long, a Babylonian myth involving Marduk, who cut the goddess Tiamat in half to form a covering for the heavens, provides the key to subsequent mythic images and truthful accounts of torture and violation.

370. Helen Frankenthaler, *Round Trip,* 1957. Albright-Knox Art Gallery.

Obviously Spero makes visual images to express strong personal feeling rather than visual delectation. That is, art is not an end in itself but an instrument to convey specific content. Among artists associated with more abstract and nonobjective modes, there are some who have used forms in a manner equivalent to Spero's, as well as others who prefer to engage in more purely aesthetic adventures. The range of intent among these artists—male and female—is at least as wide, if not wider, than among the figurativists. The history of this type of recent art may be picked up a few years before 1960 in the development of Color Field painting.

After artistic leadership had passed to the United States in the late 1940s, abstract artists could hardly avoid the looming presence of Abstract Expression- ism. If they were not to be absorbed by it, they needed to progress beyond it. For the most part, artists rejected its autobiographical and gestural aspects, preferring to consider problems of form, as well as those pertaining to the definition of art

and the ways in which information is communicated. Painters also began to search for ways to create shapes that did not necessarily establish planes of depth. They wanted to make ambiguous or to neutralize depth cues such as superimposition or overlap, atmospheric perspective, centralization of image, and figure-ground interactions, so that no single cue would dominate the other and therefore suggest three-dimensional recession. The canvas was not treated as a surface upon which to record a scene, but as an object in its own right, a surface covered with pigment. The manipulation of paint became an important subject itself; even the size and shape of the canvas became a determinant of content. As the range of compositional alternatives narrowed, a heightened sense of color awareness emerged to maintain those intricate balances needed to hold the spatial field in a condition of stasis or near stasis. For some artists, color even left the canvas surface completely, to become part of the space of a room or environment. Although paintings often contained very few forms, they were the products of intense visual meditation. The viewer was invited to immerse himself in color sensation rather than to discriminate between different organizational units of a work, to contemplate not a subject nor even a relationship of forms, but the particular colors chosen to create the intended effects. Many of these effects, it should be noted, would not have been possible without the development of acrylic paints, as well as other modern sources of light and color, such as fluorescent tubes and colored gels.

The immediate models for this hermetic art included the works of Pollock, Still, Rothko, Newman, Reinhardt, and Johns. From these sources two principal modes emerged—a soft-edged and a hard-edged type. Perception through fields of color was emphasized in the former, pictorial structure in the latter. In both instances color tended to be regarded as a perceptual object rather than a conveyor of emotion.

Helen Frankenthaler (b. 1928) provided Color Field painting with new possibilities of development in the early 1950s. After seeing Pollock's "black and white" paintings, she realized that Pollock had stumbled upon a potentially new kind of figuration. Black paint, which had been soaked directly into unprimed canvas, had literally become part of the canvas surface. Rarely had image and canvas achieved such close physical and visual identification. By soaking much thinner pigments into the canvas as early as 1952 in her *Mountains and Sea* (National Gallery of Art, Washington, D.C.), her first mature painting, Frankenthaler achieved an even closer identification of image and surface. This is also true in her *Round Trip* [370]. The weave of the cloth was still visible through the images, which appeared to be a part of the surface rather than layered on it. The canvas, no longer simply a support for the painting, had become a painted object. But the particular emotional charge this work possesses lies in Frankenthaler's ability to suggest atmospheric effects as well as in her technical achievement. The forms might be read as veils of color floating on the same indeterminate plane in depth, or they might evoke landscape memories. In any case, Frankenthaler did not eliminate all references to real space and real objects. As she stated in

371. Morris Louis, *Capricorn,* 1960–61. Private collection.

372. Morris Louis, *Alpha Khi,* 1961. Andre Emmerich Gallery.

373. Jules Olitski, *Beyond Bounds,* 1966. Jewett Arts Center.

374. Dan Flavin, *Untitled (to a Man George McGovern),* 1972. Leo Castelli Gallery.

375. Robert Irwin, *Untitled,* 1971. Walker Art Center.

1971, "pictures *are* flat and part of the nuance and often the beauty or the drama that makes a work, or gives it life . . . is that it presents such an ambiguous situation of an undeniably flat surface, but on it and within it an intense play and drama of space, movements, light, illusion, different perspectives, elements in space." Like Arthur Dove before her, she refused to follow her discovery to its logical conclusion—the creation of a perfectly flat and spaceless pictorial field—but preferred to invest her images with organic allusions and flood her surfaces with rich washes of color.

Morris Louis (1912–62), an undistinguished Abstract Expressionist, saw Frankenthaler's work in 1953 and, understanding the implications of her technique, began to experiment with soak-stain methods of painting at once. His mature works, however, date from 1958. Louis's so-called "veil" paintings, his first important response to Frankenthaler's works, were poured rather than brushed or dripped on unprimed canvas [371]. These were followed by the "florals" in 1959 and the "unfurleds" in 1960 [372]. Color looks as if it always had been part of the cloth, since the marks of its application are minimal. Ideally, the successive waves stained into the canvas produce a skin identical with that of the surface itself. Such close correlation is based on at least three visual effects (especially in the "veils"): color is continuous and unbroken; the weave of the canvas can still be seen; and edges of stains do not always create linear enframements, which, with their suggestions of drawn lines, might interrupt the unceasing visual flow of color. Color appears, therefore, as a continuous membrane, largely devoid of psychological, emotional, or philosophical associations.

Perhaps less visually stunning but more important than the "veils" are the "unfurleds." In these, rivulets of color cascade diagonally across the edges while

the central sections remain blank. Consequently, the edges are forced to bind the compositions into coherent units. The use of edges in this manner bears little resemblance to the works of Stuart Davis, Franz Kline, or even Helen Frankenthaler, in which forms push outward toward the painting's perimeters. In the "unfurleds" the rectangle of the canvas *is* the binding element; the patterns cannot continue beyond the borders without destroying the composition. The edges, then, do not merely define the shape of the canvas, but are important terminal elements of the entire design.

In the works of Jules Olitski (b. 1922), the relationships between edge and surface are crucial ones. His work assumes significance only after 1964, when he began to use spray guns (squeegies in the 1970s) and began to flood surfaces with mists of color [373]. These were set off only by drawn forms at the edges, which served to keep the chromatic areas from seemingly floating off the picture's surface. In a comment that perhaps describes Olitski's paintings better than his own, Kenneth Noland stated in 1968, "the thing is color, the thing in painting is to find a way to get color down, to float it without bogging the painting down in Surrealism, Cubism or systems of structure. . . . In the best color painting,

376. Ellsworth Kelly,
Yellow-Blue, 1963. Des Moines
Art Center.

377. Kenneth Noland, *Bend Sinister,* 1964. Hirshhorn Museum and Sculpture Garden.

structure is nowhere evident, or nowhere self-declaring. . . . It's all color and surface. That's all."

Dan Flavin (b. 1933), who can also be associated with more technologically inclined artists (see below), moved color right off the canvas and into space in 1963, when he began to use fluorescent lights as his working material [374]. Depending on their size, massing, color, and the environment in which they are situated, Flavin's object-images, or proposals, as he has called his pieces, make one aware of the tubes themselves, the color-light contained within each tube, and the radiant glow pervading the surrounding atmosphere. The progression of effect is from tube surface to ambient space, from object to colored air.

Flavin has assigned varied meanings to his work. At times he has likened the tubes to mythic totems or to items purchased in a hardware store, and certain color combinations might suggest or provoke heightened emotional states. Robert Irwin (b. 1928), on the other hand, is more concerned with perception as the essential subject of his art. In response to a question he might have posed to himself, "Is it possible to make a painting without a frame?" he created a series of disc paintings in 1966–67. A work of this type might include a white disc placed two feet from the wall flooded with light. The disc, the light, and the reflected overlapping halos would constitute the work, thus linking inseparably the object and its environment. In subsequent works he has arranged environments that are free of objects, but contain lighted areas, wires, and scrims in order to allow the viewer to concentrate on the entire space [375]. For Irwin art lies in ways of perceiving (in carefully constructed environments, to be sure) rather than in painting objects. As the appropriate technology continues to be developed, artists such as Irwin will continue to explore formats and programs of presentation that can now only be guessed at.

In the works of a group of related artists, including Ellsworth Kelly (b. 1923), Kenneth Noland (b. 1924), and Frank Stella (b. 1936), the viewer is equally aware of the painting as an object to which color has been applied and as a surface, or environment, on or in which to explore effects of color. Among the three Kelly is more concerned with color relationships, and the other two with coordination of compositional units and shapes. In the works of all three, at least during the 1960s, compositions tended to be holistic or nonrelational; that is, all forms contain equal strength rather than existing in dominant and subordinate relationships. Nor are there centers of focus or hierarchies of shapes and colors. In comparison to Morris Louis and Jules Olitski, these artists are better considered Hard Edge rather than Color Field painters.

Kelly is probably America's first Hard Edge painter. He lived in France from 1948 to 1954. During those years several artists on both sides of the Atlantic Ocean explored different kinds of color relationships. For example, Matisse created brightly colored collages, and Josef Albers began in 1949 his famous series *Homage to the Square,* to explore the effects one color had on another. But Kelly painted works different from theirs beginning in the early 1950s. He used modular systems, either within a single canvas or in groups of juxtaposed canvases [376]. Emphasizing nonrelational units, he minimized depth cues considerably. As early as 1952 he painted single-color canvases in which line and edge were the same, the area of color coinciding with the complete form of the work, the literal shape of the image coinciding with the literal shape of the canvas.

Since the early 1950s, then, and until the present day, Kelly has explored

378. Frank Stella, *Pagosa Springs,* 1960. Hirshhorn Museum and Sculpture Garden.

379. Frank Stella, *Steller's Albatross,* 1977. Collection Mr. and Mrs. Harry Anderson.

the relationships between color, form, and object, and their degrees of inseparabil-
ity. Unlike Noland's and Stella's, however, his forms tend to be more antic,
personal, and even derivative from objects in nature. Noland, in the late 1950s
and 1960s, preferred to work with circles, ovals, chevrons, and diamond shapes,
as well as with horizontal stripes painted in colors of equal brightness and
intensity [377]. In these the entire compositional field is activated and must be
considered as a whole, since no single form or part dominates the others. (An
illustration of a detail is meaningless.) To maintain the flatness of surface and the
integration of image and canvas shape, Noland had to pay special attention to
his choice of colors. None could project or recede into space, and none, such as
a blue band at the top of a canvas, could suggest atmospheric effects. That some
paintings succeeded and others failed attests to the narrow margins for error
within which he worked.

During the 1970s Noland returned to more traditional notions of pictorial
space, allowing forms to advance, recede, and appear layered, rather than testing
the limits within which one's eyesight could incorporate forms in holistic images
and coordinate different colors on the same plane in depth. In effect, he began
to reexplore Cubist space, but in forms much larger in scale than those used by
Braque and Picasso earlier in the century.

During the 1960s Frank Stella defined the narrow range of the new formal-
ism more systematically than any other artist. In works dating from 1958, Stella

indicated the two pictorial problems he wanted to resolve: one was concerned with relationships of forms, the second with the elimination of depth cues. He soon realized that symmetry destroyed formal relationships and that regulated patterning eliminated depth cues. He then began to repeat the lines of the framing edges throughout a painting. The edges, in effect, determined the internal shapes [378]. Succinctly characterizing these works, the art historian Robert Rosenblum noted in his study of Frank Stella (1971), "a predetermined regularity of design and surface treatment, a recognition of the framing edge as an integral source of the internal patterns, and an awareness of the picture as an almost palpable object rather than as a surface of illusions." Stella himself stated in 1964 in a radio interview, "my painting is based on the fact that only what can be seen there *is* there. It really is an object. . . . All I want anyone to get out of my paintings, and all I ever get out of them, is the fact that you can see the whole idea without confusion. . . . What you see is what you see." The principal source for this attitude and imagery lies in the work of Jasper Johns, despite its figurative imagery, because of the identification of the motif with the entire canvas field.

Throughout the 1960s Stella worked in series. Individual paintings varied

380. Donald Judd, *Untitled,* 1969. Norton Simon Museum.

slightly, but there was neither a first nor a last in any given sequence, no buildup to the final resolution of a pictorial problem. After 1966 his style grew less hermetic, however. Edges no longer determined internal forms, but engaged them in dialogue. The relationships between image and edge were still visible, but no longer indivisible. Moreover, Stella allowed his gifts as a colorist to compete with his keen sense of structure. During the 1970s he emerged as one of the few Hard Edge painters to develop a genuinely post-1960s style. Yet his paintings and constructions still seem derived from nonrelational premises, even though they contain many forms and colors in a baroque exuberance [379].

By the early 1970s, however, Hard Edge painting seemed to have lost its direction. Painters had eliminated depth cues and thematic content. They had neutralized their own presence in their work. Immobility had replaced duration. A painting had become an object rather than a personal statement. Some artists, such as Robert Ryman (b. 1930), searching for new pictorial riddles to solve, exhibited thin, unstretched sheets of canvas painted white, as if to suppress the notion of the canvas as an object in order to emphasize the paint and the painted surface. But this would appear to be a variation rather than a new development. This type of abstract art seemed to have fulfilled the theories of Clement Greenberg, the art critic, who in a series of articles during the 1960s suggested that modern painting, an art of self-criticism and self-purification, sought what was uniquely its own—a flat surface, the shape of its support, and the elimination of three-dimensional elements. Having found these elements, it had nowhere further to go.

During the 1960s sculptors shared many assumptions with painters. They sought more precise definition of three-dimensional form (as painters had of two-dimensional form), and analyzed the nature of form relationships and the ways objects altered surrounding spaces. The uses of shape, color, light, and the environment were subjected to careful scrutiny. As a result, many traditional notions of sculpture were destroyed. After the great intellectual and visual adventure during the 1960s, the history of sculpture, like that of painting, left many asking, "Where do we go from here?"

In the early years of the 1960s sculptors began to discard the attitudes and forms of both Abstract Expressionism and Assemblage. The new sensibility sought a less personal, less accidental appearance. Surfaces grew smooth and less cluttered. Colors became opaque and edges gained a machine-like finish. Although the sculptural base did not entirely vanish, the visualization of a compositional center virtually disappeared, denying sculpture its ages-old anthropomorphic orientation. A sculpture no longer "grew," nor did its parts interconnect like those of a human form. At the same time, the new sculpture forcefully impinged on human space, since it was no longer isolated on a pedestal. The viewer was encouraged, therefore, to relate to a work's physical presence despite its noncommittal personality. Finally, an intricate tangle of perceptual and conceptual problems was explored, especially in those instances when, during the perception of a simple, geometric form, one could conceptualize its entire shape without seeing its other side. Such sculpture tickled both the eye and the

381. Robert Morris, *Untitled*, 1965–67. Collection Philip Johnson.

382. Robert Morris, exhibition installation, 1968, Leo Castelli Gallery.

mind, its surfaces appealing to the former and its intellectual puzzles gratifying the latter.

This type of sculpture is seen most easily and clearly in the work of Donald Judd (1928–94) and Robert Morris (b. 1931). Judd, initially a painter, began to make reliefs in 1962 and, within a year, had created free-standing objects. Opposed to traditional compositional and relational effects, which he considered relics of European art, he preferred to design symmetrical forms [380]. If a work was to be considered successful, then its units would appear to be parts of a single entity and, in the aggregate, spatially continuous rather than traditionally balanced. The whole would be more than the sum of its parts. Major and minor elements, if there were any, would be subsumed within the whole. Furthermore, lacking thematic allusions or iconic references, the shapes and materials could not be altered by specific contexts, since the shapes and materials *were* the context. They were the total product rather than the raw data from which content might be extracted. As he stated in the *Arts Yearbook* for 1965, "it isn't necessary for a work to have a lot of things to look at, to compare, to analyze one by one, to contemplate. The thing as a whole, its quality, is what is interesting."

Both Judd and Robert Morris have written penetrating art criticism, which is characteristic of artists of their generation, but it is Morris's articles, as well as his art, that have probably been the most influential in forecasting and describing developments in sculpture through the 1960s and 1970s. Morris's art also reflects an increased artistic inbreeding, in which strategies are engendered in response to developments within the art world. Increasingly, understanding the meaning or intent of a work or movement has required knowledge of the immediate past and of the present context surrounding it.

In ways comparable to those of Frank Stella, Robert Morris explored the properties of sculpture through the middle 1960s, attempting to redefine more precisely its essential qualities—its physical presence, its scale, proportions, elementary shapes, and mass, rather than its surface colors or textures. The last two qualities, being optical, belong to painting, in his view. To fathom the basic components of sculpture more easily, Morris reduced the variety of sensations associated with it by creating what he called "unitary forms" [381]. But he also reasoned that since a sculpture occupies space, it is important to be aware of the relationships between a piece and its environment, as well as the relationships within a piece. Morris held that perception of the object should remain reasonably constant because of its simple shape, but that our experience of it should vary because of our changing perceptions of the environment caused by movement around the object.

In 1967 Morris altered his approach, now concentrating on questions concerned with process rather than with perception of the object. Interested in manipulating materials and the effects of gravity, he reasoned, writing in *Artforum* in April 1968, that "considerations of ordering are necessarily casual and imprecise and unemphasized." Exploring ways in which objects are shaped by design or by accident, Morris began to use felt, a soft pliable material [382]. He also questioned notions of permanence, since any time a felt object was moved,

its configuration was changed. Who, in fact, was responsible for the shape of the object—the artist or the mover?

Within a year, Morris began to explore the nature of the visual field. As if to underline the ephemeral nature of visual fields, he admitted virtually anything to them, from gases to solid boulders. At this time he preferred working with accumulations, even dirt, rather than with discrete objects. Change, which in his minimal pieces of the middle 1960s was effected by movement of the viewer, was now considered part of the work itself. In these later pieces both the visual field and the life of the object or event was determined arbitrarily, based on the length of the exhibition, or, if the piece were exhibited outdoors, until the forms were changed by the elements.

Soon after, Morris explored yet other aspects of art—the making and behaving activities. These extended beyond the nature of specific materials to involvement with body activity, gravitational laws, time, and perception, in which an end product, the traditional work of art, might be incidental. Such an art, no longer concerned with taste or aesthetics, often reveals the means of its making in a fashion heretofore not usually associated with art. One particular work, entitled *Pace and Progress* (1969), included the riding of a few horses along a path, the groove that resulted from the riding, and photographic documentation of the event. In pieces of this type there is a necessary, but very particular, interaction between the artist and the world that, as Morris wrote in the April 1970 issue of *Artforum,* "admits that the terms of this interaction are temporal as well as spatial, that existence is process, that art itself is a form of behavior."

383. Sol LeWitt, *13/5,* 1981.
John Weber Gallery.

Morris was not the only artist to probe beyond art's traditional concerns. Toward the end of the 1960s many artists had begun to reject the value of composition, of a specific end product, or of a specific end point of artistic activity. Any form of presentation, including words, objects, or performance, was considered valid. Materials might range from one's own body to the contents of one's mind, from solid objects to air. Results might be incorporated into immaculately rendered, hastily put together, systematically thought out, or completely improvised images. Generally, emphasis was placed on the making or doing activity; on the motivating ideas, or the thinking activity; on materials and their properties; and on the interactions among object, process, event, and environment. In brief, the concept as well as the process of execution and the effects of the process on objects, people, or environments replaced concern for the quality of specific objects. For the moment, at least, interest in a finely wrought object lost credibility. The most influential figures in this development were Rauschenberg, Johns, and, through them, ultimately Duchamp.

For the viewer, response to activity often superseded response to order, and participation sometimes replaced observation. In such an experimental atmosphere, a willingness to let art events develop over periods of time became obligatory. As stylistic consistency grew irrelevant, questions were raised about the nature of information, about message structure and dissemination, about predictability and variability, and about complexity and ease of communication. Hopefully, the viewer could find in a particular object, process, or event a functional or behavioral logic, if not a relational one. Despite a significant increase in the number of articles and statements explaining this type of art—indeed, the printed word often became the art object—explanations often boiled down to a single proposition: the event or object was considered art because the maker said it was. Logically this gave the viewer the equally arbitrary privilege to say no, it is not. Such aesthetic anarchy, both exhilarating and frightening, was clearly based on the assumption that the artist, rather than society, would provide art with its goals, aims, and purposes.

Several terms have been used to describe this type of art, including the all-embracing one, Post-Minimal Art. Varying aspects have been called Conceptual Art, Anti-Form Art, Earth Art, and Performance Art. Each has its major figures and all share to a reasonable extent the characteristics suggested above.

Sol LeWitt (b. 1928) has been a major force in the development of Conceptual Art. For him, the idea alone can be a work of art. If it is executed, the work should be viewed as the realization of the idea rather than as an object to be valued for itself. LeWitt's working methods, opposite to those of such expressionists as Robert Henri and Mark Rothko, are based on precise systematic plans, in which few or no changes are permitted between conceptualization and realization. This procedure eliminates the arbitrary, the capricious, and the subjective. Perhaps more than any other artist, LeWitt has continued into the last years of the century the rigorous self-discipline favored by Ad Reinhardt, and, like Reinhardt, he has tried to excise his personality from his work.

To accomplish these ends, since 1965 LeWitt has worked with modules and

384. Sol LeWitt, *Forms Derived from a Cube*, 1982. John Weber Gallery.

385. Joseph Kosuth, *One and Eight—A Description*, 1965. Leo Castelli Gallery.

386. Eva Hesse, *Right After,* 1969. Milwaukee Art Museum.

serial systems. His open-frame pieces are based on predetermined ratios that can be described almost without need of visual example [383]. Beginning in 1967, he has given directions for wall drawings that can be completed by others, within predetermined guidelines [384]. In these wall pieces LeWitt has developed what might be called a strategy of anonymity that has reached beyond the psychological neutrality of the open-frame works; not incidentally, they raise at least two important questions: must the artist accept responsibility for working out all details of a piece, and must the artist be responsible for the execution of a piece? These conceptual puzzles ally LeWitt with such "hardcore" Conceptualists as Douglas Huebler (b. 1924) and Joseph Kosuth (b. 1930). Their works have consisted of printed lists of ideas, sets of directions, photographs, photostats, and three-dimensional objects. Kosuth has said that he only makes models, since the actual works of art have remained ideas. But he is willing to call his models art objects because they are concerned with art. This kind of mental play points to the differences that exist between the art object as an idea and the art object as a model. Edward Hopper also noted that his paintings departed in many ways from his original conceptions (the art idea), but he immediately bypassed that problem in his concern for the finished product. Kosuth, by contrast, prefers to explore the linguistic, philosophical, and phenomenological aspects of the art-making process instead [385].

Although Conceptualist elements inform much post-Minimalist work, the sculptures of Richard Serra (b. 1939) and Eva Hesse (1936–70) might better be associated with Anti-Form Art, part of the free-form expressionist revival of the late 1960s. These two artists, together with Robert Morris, have used the inherent capabilities of materials—weight, texture, surface appearance—to take imaginative and improvisational risks in ways analogous to the psychological risks previously attempted by the Abstract Expressionists. The content of their works is often the process of making the work. For the viewer, re-creating the actions used to create the work or experiencing it in time, whether it might or might not reach a formal conclusion, can add additional levels of meaning. The resulting objects might appear as distinguishable units or as jumbled accumulations.

In contrast to Romantic artists, who give meaning to the world and provide it with value systems, Anti-Form artists are concerned primarily with conception, execution, and completion of the work. Imagination, rather than put at the service of something else, is employed primarily to show itself. Consequently, Anti-Form works are limited (or liberated) largely by the imagination, intelligence, and craft of the artist, since a work relates to little else but itself. This sort of art, then, is based on imagination for imagination's sake more than on anything else.

Understanding the "meaning" of an Anti-Form piece resides in understanding the sustained logic of the process of its creation. That is, even if there is no narrative meaning, meaning adheres to a piece through observation of the logic

387. Richard Serra, *Sign Board Prop,* 1969. BlumHelman Gallery.

of its procedures, the steps of its making, and the relationships of these factors to its completed form. Often, the results might be interesting and affecting in their own right. The viewer might observe a piece or a performance, therefore, that reveals an order, but has no comprehensible "story line." This seems to describe Eva Hesse's works of the late 1960s, in which she used such opposing concepts as regularity/irregularity, squeezing/expanding, and meticulous-attention-to-detail/total-lack-of-meaning (or purposefulness-purposelessness) [386]. For this type of "subject matter," Hesse used fiberglass, rubber-covered cheesecloth, and cord, among other materials, sometimes in obsessively repetitive patterns or making activities. Works might be spread out across floors, walls, and ceilings, calling attention to entire interior spaces or to the objects themselves.

Richard Serra splashed molten lead on floors in 1968 and the next year propped large lead plates against each other [387]. In these and other pieces, which included neon tubing and torn objects, he used systems that depended on his own physical movements, on gravity and cooling, and on accumulation. In 1970 he began to design outdoor pieces that were site-adjusted rather than inviolate in their own right. Location and the surrounding space became part of the overall effect of these works and were intended to be part of the viewer's experience of the individual forms.

Some artists, such as Vito Acconci (b. 1940), have used their bodies as the basic material of their art, the art event being experienced by an audience or documented on film or video. Acconci has acted on his own body (biting himself) or has moved through space (following people for specific periods of time and under certain conditions). In the late 1970s he added political allusions to his art, when he began to make multimedia projects.

The art production of Bruce Nauman (b. 1941), who, with Robert Morris, is one of the most restless and inventive contemporary artists, would seem to constitute an inventory of objects and effects of post-Minimal art. An explorer of the qualities and characteristics of all media, of the effects of words and word games, and of the effects of space on the viewer (by erecting forms that channel the viewer through an exhibition space), Nauman might be said sometimes to subtract information from rather than to add information to a particular piece. That is, the piece might seem so confusing that the viewer comes away with more questions than answers however serious one's concern might be [388]. Accordingly, it is less important to determine the esthetic value of a piece than to respond directly and openly to the piece, and thereby learn more about oneself without necessarily understanding oneself any better.

Nauman, like several conceptual artists as well as earlier figures such as Stuart Davis, uses words as shapes in themselves and as signifiers to suggest meanings that might be either scrambled or easily understood. Since the 1970s, some artists have gone public, in effect presenting words alone or combined with images and presented in public spaces such as Times Square in New York City or in galleries and museums. The messages, usually cryptic, often voice social and political concerns. Rather than paint their points of view like the Social Realists during the 1930s, these artists present them in formats reminiscent of commercial

388. Bruce Nauman, *Human Nature/Life Death/Knows Doesn't Know*, 1983. Los Angeles County Museum.

advertising, thus joining art with both the print culture and with mass culture. As Jenny Holzer (b. 1950) has indicated, she wants her messages to function in the public sphere **[389]**. On the other hand, when Holzer, who turned to "pure writing" in 1977 and to didactic messages in the mid-1980s, presents her pieces in a gallery or museum setting, spaces are activated in a manner that calls to mind Robert Irwin's and Dan Flavin's interiors **[374 and 375]**. In moving through interiors containing Holzer's statements, the viewer is faced with the interesting paradox of experiencing spaces estheticized by the illuminated words, but also politicized by their messages.

Not all sculptors have explored such open-ended states of meaning or non-meaning since the 1970s; some have instead created works in more traditional formats. These might contain explicit subject matter as in the work of Mel Edwards (b. 1937) who since the early 1960s has created a series of works called *Lynch Fragments* [390] These reliefs allude to the subject of lynching indirectly through the use of chains, weapon-like forms, and found objects. These pieces, although abstract, are filled with trenchant commentary about genocide and destruction, but also suggest growth and construction. Their meanings are clearly personal, but easily communicated through both formal arrangements and choice

389. Jenny Holzer, *Laments,* 1989. Installation at Dia Art Foundation, New York.

of imagery, and provide pointed commentary about the possibility of physical harm as well as the anger minority persons might feel in the larger culture. Works, or series of works, such as these are in the mainstream of contemporary American art, but at the same time speak to the predicament of those marginalized by the larger culture.

By contrast, Martin Puryear (b. 1941), perhaps in reaction to the expressionist interests of sculptors just before and after 1970, began to explore Minimalist forms, but by using natural materials and less rigid formats, invested them with organic qualities of design [391]. His work appears handmade, and some pieces seem as if they had been used for some other purpose. To an audience aware of the use of impersonal modern materials and the seeming random quality of much contemporary art, Puryear's spare and neat forms reveal a rare elegance almost classic in their sense of reserve.

Since the 1960s, several artists, who wanted to function outside of the gallery setting and gallery system, began to use the land itself as their raw material. Some, artists, called Earth Artists, use the land itself as their raw material, but some, such as Carl Andre (b. 1935), work primarily as sculptors who use objects to organize the environment. In the middle 1960s, Andre developed a radical

390. Mel Edwards, *Samba Tijuca*, 1987. Courtesy CDS Gallery, New York.

391. Martin Puryear, *Lever I*, 1988–89. The Art Institute of Chicago.

approach to the medium by insisting that specific objects were nothing more than components of the surrounding environment. He no longer designed objects for their own intrinsic qualities, but used them to organize surrounding spaces [392]. "Rather than cut into the material," he explained in 1966, "I now use the material as the cut in space." Since Andre assigns no meaning or value to his works, their content is identical with their existence. Several pieces, created for specific sites, have no meaning if moved or put in storage, but other pieces, such as his "rugs," made of flattened metal blocks, usually can be set up anywhere.

The works of Earth Artists cannot be moved, of course. Some artists use the land itself to make earthworks, and others construct works, often architectural in size and scale, for specific outdoor sites. The former alter earth or water in some way, by making simple marks on surfaces, by burying something, or by altering profiles by piling and heaping. Earthworks range from simple activities presented in an art context, such as digging ditches, to major alterations of the natural landscape. The works are best known through photographic documentation or through written articles, which are often considered part of the piece. If one should visit a site, however, one might encounter, in addition, durational, spatial, visual, and kinaesthetic experiences.

Among Earth Artists, some, such as Michael Heizer (b. 1944), might be considered formalists. His *Double Negative* (Virgin River Mesa, Nevada, 1967–70), for example, consists of "nonobjective" cuts into a hillside, which relate to the environment of the area. As often as not, however, there is little sympathetic interaction with the particular terrain, but rather a brute imposition of alien elements in disregard of local conditions or sociological factors. In place of the Hudson River School's religious devotion to nature, the Barbizon-influenced poetic contemplation of nature by the Tonalists, and the early modernist desire to internalize the living qualities of nature, a number of earthworks reflect the basic American contempt for the landscape in its natural state.

Robert Smithson (1938–73) is the most interesting Earth artist, not necessarily for the visual qualities of his works, but for the ways he did consider the interactions between art and nature. Beginning in 1966, he visited various sites, which he documented in photographs. Within a year he exhibited what he called sites/non-sites, which included maps as well as rocks from the particular site, and in 1970 he started to make outdoor pieces, the most famous being *Spiral Jetty* (1970) on Great Salt Lake [394].

The sites/non-sites are probably more interesting to think about than to look at. Smithson was concerned with the connections between a site as a fragment of the earth in a state of change and the exhibited non-site as a fragment of the original fragment. Finding "the strata of the earth [to be] a jumbled museum," he wanted to explore the various ways they might be understood. To that end, he considered the interactions between the material exhibited and the site itself as exercises in coordinating different systems—those of nature and of gallery exhibitions—through maps, photographs, and samples [393]. As a result, he resisted emphasizing art objects as things in themselves and chose to view them as part of ongoing processes—in this case, nature itself.

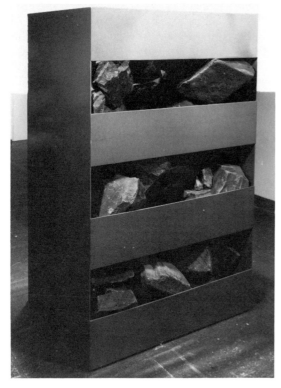

392. Carl Andre, *Angellipse,* 1979.

393. Robert Smithson, *Non-Site (Palisades, Edgewater, N. J.),* 1968. The Whitney Museum of American Art.

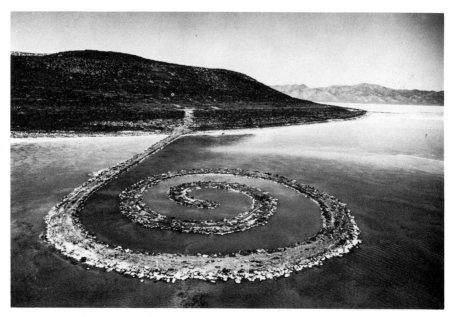

394. Robert Smithson, *Spiral Jetty*, 1970.

Smithson's view of nature was not evolutionary or optimistic, but one in which balances occurred between growth and decay, creation and destruction. In the end, an equilibrium would result. His position was opposite to that of Emerson and the middle-nineteenth-century landscapists, for whom nature was a vehicle to transcend one's immediate reality by experiencing directly or indirectly the Deity. In contrast to Emerson's ever-expanding horizons, described in his essay "Circles" (1841), Smithson wrote that just as the horizon "can extend onward and onward . . . you suddenly find the horizon closing in all around you. . . . In other words, there is no escape from limits." In comparison to the early-twentieth-century sculptor John Flannagan, who found emergent objects in rock shapes [293], Smithson saw the return of these shapes to undifferentiated forms, "a return to the origins of material, sort of a dematerialization of refined matter."

A similar dialectic of thought informs the *Spiral Jetty* [394]. Created in a salt lake that suggested to Smithson primordial beginnings (which Rothko might have appreciated), it was actually built in a polluted area of abandoned oil rigs. Since Smithson knew that the work would disappear beneath the water in a short period of time, its entire conception telescoped his idea of equilibrium into a period of a few years.

Among those artists who make site-specific pieces rather than earthworks, Alice Aycock (b. 1946) first designed structures and underground mazes in the middle 1970s that suggested, as one moved through them, notions of dwelling, passage, and ritual. Toward the end of the decade, the structures grew larger and

more complicated, and included forms and corridors analogous to highways and communications networks [395]. But since her analogies are usually based on only passing references to their models, these structures suggest random and nonspecific experiences that lead to childlike playacting.

Although parts of Aycock's pieces have motor-driven parts, they would not be called examples of Technological Art. Nevertheless, they do reflect the pervading influence of technological systems among artists. Availability of materials and knowledge of mechanical and electrical procedures has, in recent decades, affected their conceptions, working methods, subject matter, and images. But, at the same time, common ignorance has lessened the potential value of technology. In time, its profound alterations of our ways of seeing and thinking might cause us to view the late twentieth century as a major turning point in the history of art. In the future Pollock's drip paintings might be viewed as a John Henry-like attempt to compete with random electronic signals, or Andy Warhol's silkscreens might be viewed as a very primitive kind of technological feat. These artists might be compared to an as yet unknown technologically inspired figure in the same way that Cimabue is compared to Giotto.

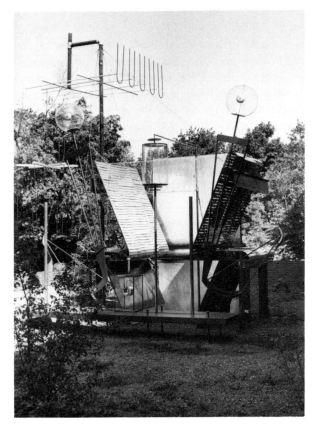

395. Alice Aycock, *The Miraculating Machine in the Garden (Tower of the Winds)*, 1982. Rutgers, The State University.

396. Larry Bell, *Untitled,* 1969. The
Pace Gallery.

Perhaps because of the dominance of Abstract Expressionism in the United
States, major developments occurred in Europe through such groups as the
German Group Zero, founded in 1958, and the French Le Groupe de Recherche
d'Art Visuel, founded in 1960. In the middle 1960s, however, increasing numbers
of American artists began to use mechanical and electronic devices, but Techno-
logical Art has remained a truly international art. Because of the need for ample
patronage and engineering expertise, and because of the ease of global travel and
communication, national developments have become largely irrelevant. The only
noticeable American characteristic is perhaps the preference for improvisation
rather than the mastering of difficult techniques—at least through the 1960s and
early 1970s. With the recent rise of computer art programs in universities, this
situation will inevitably change, however.

The fantastic possibilities open to artists through use of technological sys-
tems was brought to worldwide attention during the middle and late 1960s by a
number of exhibitions, comparable to those held earlier in the century to help
popularize modern art. These included *9 Evenings: Theater and Engineering*
(New York City, 1966) and The Pepsi-Cola Pavilion at Expo '70 (Osaka, 1970),
both organized by Experiments in Art and Technology, Inc., an organization of
engineers and artists; *Cybernetic Serendipity* (London, 1968), which emphasized
computer technology; and *Art and Technology* (Los Angeles, 1970–71), which
brought artists together with scientists and engineers.

The bewildering variety of works produced since the 1960s may be separated
into two loose categories—one in which nonmoving, static objects are produced,
the other in which movement, mobility, and duration are stressed. The works of
Dan Flavin (see above) and Larry Bell (b. 1939) barely indicate the range of

materials available to artists in the first group. Flavin uses fluorescent lights, and Bell uses specially prepared transparent glass. Bell, in the middle 1960s, made transparent, subtly colored glass boxes and, since the 1970s, has brought the entire space of the exhibition room into play by placing large sheets of transparent glass on the floor [396]. Of the second group, George Rickey (b. 1907) deployed sculptural forms in moving relationships after 1945. These—usually thin, oscillating blades in the 1960s and 1970s—are wind-driven [397]. By contrast, James Seawright (b. 1936), who has experimented with electronic sculpture since 1963, has been concerned with the ways motors, lamps, and electrical circuits can become part of functioning visual and aural systems. In his pieces, sound and movement might be generated by light patterns or by heat given off by people [398].

By the middle 1970s it became commonplace to think about computer-generated images and film, video art, and such advanced technological media as laser-beam sculpture. The first continuous use of computers to generate artistic images began in the middle 1960s, particularly in the field of computer-generated graphics. These have included figural distortions and permutations or serial

397. George Rickey, *Marsh Plant,* 1962. Hirshhorn Museum and Sculpture Garden.

398. James Seawright, *Night Blooming (Serious),* 1982. Collection Mr. David Bermant.

images showing the progression of a form through a series of programmed changes. Since computer art requires formidable training if the artist is to create his own programs without the aid of technicians, video art has become more popular. It is simply easier to manipulate various video systems—sets, monitors, portable recorders. According to observers of the medium, video art has developed in three main directions: first, in the creation of imagery on a screen by manipulation of components within a particular set; second, in the creation of imagery on a screen in response to external stimuli (humans, light, heat); and, third, in the creation of closed-circuit environments in which viewers activate or respond to situations involving monitors and cameras. In the first category the television screen is presented as a discrete object for viewing; in the latter two, participation and interaction are essential. In all three the processes of telecasting —instant-delayed, realistic-distorted—are the content. Sensory perceptions replace formal considerations, and ways of experiencing become more important than what is seen. As a result, fixed relationships between viewer and object are called into question. In video art, the juxtaposition of disparate images characteristic of Rauschenberg's and Rosenquist's works, and the use of nonsequential occurrences in Happenings, are transposed to electronic systems.

In recent years the proliferation of video activity indicates that video art will become as common as painting. The availability of portable videotape recorders and video discs will, if it has not already, cause a revolution in the way art is perceived and used by both artists and the general public. Certainly the impact of video art will be as great as that of the camera and the cinema. As Nam June Paik (b. 1932), the most important pioneer in video art has suggested perhaps too hyperbolically, the cathode ray tube will replace the canvas just as collage has replaced oil paint.

Nam June Paik was, in 1963, the first person to exhibit "prepared" television sets. In 1965, he first used a portable videotape recorder and in 1970 helped develop a video synthesizer, which can convert an infinite number of patterns into black-and-white or color image [399]. The range of his work has included altering wave patterns on a TV screen, mounting exhibitions with many screens on which images might appear randomly, their selection based as much on color as on content. The different qualities of movement, of stasis, of subliminal images, of non-causal connections, and of collaged sounds that one hears and sees moving through the space of an exhibition allies Park's work with Process Art in that individual TV monitors as well as the collective effect of all monitors contribute to a constantly changing series of effects both within the works themselves and in the viewer's perceptions of them.

Video art is not just about gadget wizardry, but can also be used to project qualities of mystery and spirituality. The video installations of Bill Viola (b. 1951) perhaps best reflect this kind of image production in which differing psychological states of being are projected through landscape forms and the dissolving of precise definitions of time and place [400]. Viola even feels that he is sculpting time by combining different levels or periods of time within individual frames. That is, he combines elements of traditional linear time with recorded time and edited

399. Nam June Paik, *Fin de Siecle, II,* 1989. Collection of the Whitney Museum of American Art, New York.

400. Bill Viola, *The City of Man,* 1989.

time. In effect, the viewer's sense of the present moment is simultaneously everywhere and nowhere.

The availability of video systems as well as microcomputers has recently led to the development of an art that, in effect, uses the computer as a playback device. Artists such as Philip Orenstein (b. 1938) can visualize computer programs through video presentation [401]. This combination of devices allows greater flexibility than computer-film or computer-paper works, since the artist can gain access to the image at any point in the program. That is, nonlinear, random access to a program (events, images, sounds) is possible. Still in a primitive state, this type of expression has an exciting and still unknown future.

The use of laser—Light Amplification by Stimulated Emission of Radiation —beams in an artistic context marks yet another area of collaboration between artists and scientists. Lasers, first developed in 1960, are light beams that do not disperse in travel and do not have any physical substance. Consequently, when the equipment is turned off, the beam no longer exists. In an art context this fact challenges the very concept of sculpture as some kind of solid form, and it also raises the question whether an art object is an art object when it does not exist.

Rockne Krebs (b. 1938) first experimented with lasers in 1967, initially in interiors and then over entire sections of cities, by throwing beams of light as

401. Philip Orenstein, *F.I.T. Piece,* 1983.

patterns and as space-dividing elements [402]. "Actual space is the medium of sculpture," he said in 1968, suggesting that his work is the technologically advanced equivalent of that of Carl Andre, who, by comparison, has employed traditional materials to organize and divide space.

In the 1970s the popularity of different forms of process art coupled with the exhaustion of formalistic advances in painting prompted many to predict the death of painting. What was there new to say? Nevertheless, artists continued to paint and, beginning in the 1970s, they have re-examined the nature of figurative and abstract painting. Many, but not all, have avoided overt political statements, and those who have explored an expressionist terrain, which developed in the late 1960s, have generally become more popular than those who have not. Exhibitions with titles such as *New Image Painting,* held at the Whitney Museum of American Art in 1978, and *Conceptual Abstraction,* held at the Sidney Janis Gallery in New York City in 1991, have attempted to point out varying contemporary trends.

One of the most interesting and controversial painters to emerge in the 1980s was David Salle (b. 1952). His use of sexist, even misogynist, images are undoubtedly value-laden, but, paradoxically, his art can also be considered drained of values [403]. His juxtapositions and superimpositions of disparate images, more adventurous than those of Thomas Hart Benton or Robert Rauschenberg, suggest

402. Rockne Krebs, *Study for Laser Project, Philadelphia Festival,* 1973. Philadelphia Museum of Art.

403. David Salle, *Sextant in Dogtown,* 1987. Collection of the Whitney Museum of American Art, New York.

that no specific meaning can adhere to any combination of images. These might be copied from earlier art or from his own drawings and brought together in a flux of borrowed images and as disconnected, jumbled fragments which deny the viewer access to a completed idea or a clearly resolved complex of forms. Since Salle says that he is attracted to reproductions rather than to original works, he asserts, in effect, that images create their own unreadable reality, that they deny authentic experience, and that a logical narrative structure is an impossibility. It is as if his mind is a blank TV screen on which images appear randomly and about which his intellect refuses to impose order. Human agency, or the ability to provide that order, is subverted and the artist is victimized by the modern world's daily assault of visual and verbal images.

This type of analysis locates Salle as a post-modernist. More specifically, his obvious use of recognizable source material allies him with appropriation art in which artists, heavily influenced by Pop Art, find their material in all visual sources, sometimes even duplicating the source itself (making a painting in imitation of Jackson Pollock, but signing one's own name to it). The overall subject of such works relies less on the life experiences than on the art experiences of the artist, that is, art that the artists has seen from around the world, created either in the past or the present.

404. Pat Steir, *The Brueghel Series (A Vanitas of Style),* 1982–84. Robert Miller Gallery, New York.

405. Cindy Sherman, #*123*, 1983. Courtesy of the Artist and Metro Pictures.

For the appropriations artist, space, time, originality, perhaps even the artist's own personality are collapsed into an ahistorical present. As Pat Steir (b. 1940) said of her *The Brueghel Series (A Vanitas of Style)*, she wanted to enter into the mind of another artist to see how that artist might have painted [404]. In this two-part, eighty-panel work, she painted each panel of a floral still life based on a work by Brueghel in the style of a different artist, appropriating not an entire image of a single artist, but the styles of different artists as they might have painted a section of that work.

A variant of appropriation art inhabits the photographs of Cindy Sherman (b. 1954) who in the late 1970s began to present herself in photographs as personages derived from advertising, from literary sources, and from earlier historical periods [405]. Using herself as the appropriated object, she views herself as mediated through these sources. In effect, she comes to know herself by how she looks rather than how she feels. The use of the camera itself as a form of

406. Susan Rothenberg, *Axes,* 1978. The Museum of Modern Art, New York.

representation is secondary to the effect she seeks, which is not a duplication of a now suspect reality, but of the fictions each individual can generate.

Sherman's intentions are quite different from those of Susan Rothenberg (b. 1945), but at the same time not all that remote, either. An acknowledged major figure among the New Image painters, Rothenberg usually paints animals and parts of animals [406]. Interestingly, her images of horses or goats, which, because of historical antecedents, could trigger symbolic associations, in fact do not evoke imagined narratives of any sort. This is all the more odd because the surfaces of her paintings are thickly brushed and varyingly marked, which could imply strong emotions, but none seem to be present. In the end, the viewer does not know precisely how to respond. Or perhaps it is more proper to view her works not in a personal way, but in relation to earlier art by stating that she combines expressionist figuration with a minimalist reduction of content, that the primary meaning of her work lies in its relation to what has preceded it.

The same cannot be said of Jean-Michel Basquiat (1960–88) even though his expressionist canvases were influenced by non-Western art, Abstract Expressionism, and Robert Rauschenberg [407]. Instead, his work projects concerns for race, power, and wealth. Unlike, say, the combination and compilation of forms and graffiti that inhabit Rauschenberg's work or the kind of expressionist devices seen in figures such as Jackson Pollock, Basquiat evoked images of ghetto violence and of the disintegration of that society. He clearly understood the direction of

407. Jean-Michel Basquiat, *LNAPRK,* 1982. Whitney Museum of American Art

mainstream art, but insisted on bringing his own experiences to it. As such, Basquiat continues the line of artists who belong to minority groups and who want to exploit images and experiences associated with their particular group. Beyond that, he represents a growing tendency among several artists who view themselves as hyphenated Americans, knowledgeable of mainstream art, but insistent on recognizing their own ethnic, religious, or racial backgrounds.

Non-representational artists have also explored various facets of recent art. Elizabeth Murray (b. 1940), for example, has helped rejuvenate the abstract forms of Minimal Art by using since the late 1970s irregularly shaped canvases painted with strong colors [408]. By suggesting flux, change, and chance, she has added a layer of feeling to the impersonal concerns of flatness, of the relationship of the frame to the image, and of figure-ground concerns within the frame. She has even included recognizable images such as coffee cups, forms taken from everyday life to enliven her canvases.

Not so Jacqueline Humphries (b. 1960) whose canvases are rigorously non-

408. Elizabeth Murray, *Can You Hear Me?*, 1984. Dallas Museum of Art.

objective **[409]**. Since the late 1980s, she has used a grid, but in a gestural, seemingly uncontrolled way, thus combining elements of Abstract Expressionism and Minimal Art. Or one might say that she has given a sense of structure to Abstract Expressionism while humanizing Minimal Art. At the same time the thickened marks which gravity allows to drip to random lengths represent an alternative individual approach to artmaking in contrast to those works derived from technological and media sources. To emphasize this point one can relate her work to the biomorphic forms of Georgia O'Keeffe and Arthur Dove because it suggests the natural evolution of life's processes. But Humphries is a product of the post-minimal era, for, adding her gloss to a comment Frank Stella made in the 1960s, she has said, "Where you put something is what it means."

Because of the internationalization of art in recent years, it is not always easy to see where American art is and where it is going. But as American artists make their way through the last years of the twentieth century, some broad observations can be made. The modern movement, as it has been known since about 1860, is over. New developments will have to come from new sets of ideas and perhaps from countries outside the trans-Atlantic art world. The revolution in artistic thinking created by technology is just now reaching an initial fulfillment. Until the general public develops a scientific knowledge equivalent to its humanistic knowledge, it will probably misunderstand new art or support it in the wrong ways. Until artists understand that, as in the field of architecture certain tech-

409. Jacqueline Humphries, *Meg's Ladder*, 1992. Private Collection. Courtesy John Good Gallery, New York.

niques must be mastered, the full, even adequate, use of technological resources will be delayed.

Compared to earlier figures, contemporary artists, whatever their points of view, tend to view their art as evolving independently of the viewer's empathy. The viewer might be a participant, but contact with the viewer's emotions is not necessarily important. The art object, as a result, is increasingly seen as a system unto itself. This is not necessarily a bad thing, and might very well be a key identifying mark of very late-twentieth-century American art. Be that as it may, the present art scene no less interseting because of that.

SELECTED BIBLIOGRAPHY

PAINTING

General Surveys

Baigell, Matthew. *A History of American Painting.* New York: Frederick A. Praeger, 1971.
Barker, Virgil. *American Painting.* New York: Macmillan, 1950.
Baur, John I.H. *Revolution and Tradition in Modern American Art.* Cambridge, Mass.: Harvard University Press, 1951.
Benjamin, Samuel Greene. *Art in America: A Critical and Historical Sketch.* New York: Harper, 1880.
Brown, Milton, *et al. American Art.* New York: Abrams, 1988.
Craven Wayne. *American Art: History and Culture.* Madison, Wis.: Brown and Benchmark, 1994.
Dunlap, William. *A History of the Rise and Progress of the Arts of Design in the United States.* New York: Benjamin Blom, 1965 (1834).
Flexner, James Thomas. *First Flowers of Our Wilderness.* Boston: Houghton Mifflin, 1947.
———. *Light of Distant Skies.* New York: Harcourt, Brace, 1954.
———. *That Wilder Image.* Boston: Little, Brown, 1962.
Hartmann, Sadakichi. *A History of American Art.* New York: Page, 1901.
Isham, Samuel. *The History of American Painting.* New York: Macmillan, 1905.
Jarves, James Jackson. *The Art-Idea.* Cambridge, Mass.: Harvard University Press, 1960 (1864).
Larkin, Oliver. *Art and Life in America,* rev. and enl. ed. New York: Holt, Rinehart and Winston, 1960.
Lester, C. Edwards. *The Artists of America.* New York: Baker and Scribner, 1846.
Lynes, Russell. *The Art Makers of Nineteenth-Century America.* New York: Atheneum, 1970.
Mendelowitz, Daniel M. *A History of American Art,* rev. and enl. ed. New York: Holt, Rinehart and Winston, 1970.
Novak, Barbara. *American Painting of the Nineteenth Century.* New York: Harper & Row, 1980 (1969).
Prown, Jules David. *American Painting: From Its Beginnings to the Armory Show.* Geneva: Skira, 1969.
Richardson, Edgar. *Painting in America.* New York: Crowell, 1956.
Rose, Barbara. *American Art Since 1900,* rev. and enl. ed. New York: Frederick A. Praeger, 1975.
———. *American Painting: The Twentieth Century.* Geneva: Skira, 1969.
Sheldon, G.W. *American Painters.* New York: Appleton, 1879.
Taylor, Joshua. *America as Art.* New York: Harper & Row, 1976.
Tuckerman, Henry T. *Book of the Artists.* New York: James F. Carr, 1966 (1867).
Wilmerding, John. *American Art.* New York: Penguin Books, 1976.
Wilmerding, John, *et al. The Genius of American Painting.* New York: William Morrow, 1973.

Dictionaries

Baigell, Matthew. *Dictionary of American Art,* second ed. New York: Harper & Row, 1982.
Britannica Encyclopaedia of American Art, The. Chicago: Encyclopaedia Britannica, 1973.
Cederholm, Theresa D. *Afro-American Artists.* Boston: Boston Public Library, 1973.
Collins, Jim. *Woman Artists in America: Eighteenth Century to the Present,* 1973.
———. *Woman Artists: America II,* 1975.

Cummings, Paul. *A Dictionary of Contemporary American Artists,* rev. ed. New York: St. Martin's, 1971.
Fielding, Mantle. *Dictionary of American Painters, Sculptors, and Engravers,* with addendum by James F. Carr. New York: Carr, 1965.
Groce, George, and Wallace, David. *The New-York Historical Society's Dictionary of Artists in America, 1564–1860.* New Haven: Yale University Press, 1957.
Rubinstein, Charlotte S. *American Women Artists from Early Indian Times to the Present.* New York: Hall, 1982.
Samuels, Peggy and Harold. *The Illustrated Biographical Encyclopedia of Artists of the American West.* New York: Doubleday, 1976.
Soria, Regina. *Dictionary of Nineteenth-Century American Artists in Italy, 1760–1914.* Rutherford: Fairleigh Dickinson University Press, 1982.

Anthologies

The Artist in America. Compiled by the editors of *Art in America.* New York: Norton, 1967.
Battcock, Gregory, ed. *Idea Art.* New York: Dutton, 1973.
———. *Minimal Art.* New York: Dutton, 1968.
———. *The New Art.* New York: Dutton, 1966.
———. *Super Realism.* New York: Dutton, 1975.
Dickson, Harold, ed. *Observations on American Art: Selections from the Writings of John Neal (1793–1876). Pennsylvania State College Studies, No. 12, 1943.*
Johnson, Ellen H., ed. *American Artists on Art from 1940 to 1980.* New York: Harper & Row, 1982.
McCoubrey, John W., ed. *American Art, 1700–1960: Sources and Documents.* Englewood Cliffs, N.J.: Prentice-Hall, 1965.
O'Connor, Francis V., ed. *Art for the Millions: Essays from the 1930s.* Greenwich, Conn.: New York Graphic Society, 1973.
———. *The New Deal Art Projects: An Anthology of Memoirs.* Washington, D.C.: Smithsonian Institution Press, 1972.
Rodman, Seldon. *Conversations with Artists.* New York: Devin-Adair, 1957.
Rose, Barbara, ed. *Readings in American Art, 1900–1975,* rev. ed. New York: Frederick A. Praeger, 1975.
Shapiro, David, ed. *Social Realism: Art as a Weapon.* New York: Frederick Ungar, 1973.

Related Topics

Callow, James. *Kindred Spirits: Knickerbocker Writers and American Artists, 1807–1855.* Chapel Hill: University of North Carolina Press, 1967.
Dijkstra, Bram. *Cubism, Stieglitz and the Early Poetry of William Carlos Williams.* Princeton: Princeton University Press, 1969.
Harris, Neil. *The Artist in American Society: The Formative Years, 1790–1860.* New York: Braziller, 1966.
Miller, Lillian B. *Patrons and Patriotism: The Encouragement of the Fine Arts in the United States, 1790–1860.* Chicago: University of Chicago Press, 1966.
Mitchell, Lee C. *Witnesses to a Vanishing America: The Nineteenth-Century Response.* Princeton: Princeton University Press, 1981.
Morgan, H. Wayne. *New Muses: Art in American Culture, 1865–1920.* Norman: University of Oklahoma Press, 1978.
Silverman, Kenneth. *A Cultural History of the American Revolution.* New York: Crowell, 1976.
Stein, Roger. *John Ruskin and Aesthetic Thought in America, 1840–1900.* Cambridge, Mass.: Harvard University Press, 1967.
Tashjian, Dickran. *Skyscraper Primitive: Dada and the American Avant-Garde, 1910–1925.* Middletown, Conn.: Wesleyan University Press, 1975.
———. *William Carlos Williams and the American Scene, 1920–1940.* Berkeley: University of California Press, 1978.

Particular Themes, Movements, Styles, and Periods

Agee, William. *The 1930s: Painting and Sculpture in America.* New York: Whitney Museum of American Art, 1968.

————. *Synchromism and Color Principles in American Painting.* New York: Knoedler, 1965.

Alloway, Lawrence. *American Pop Art.* New York: Whitney Museum of American Art, 1974.

————. *Topics in American Art Since 1945.* New York: Norton, 1975.

American Renaissance, The. New York: The Brooklyn Museum, 1979.

Arcadian Landscape, The: Nineteenth-Century American Painters in Italy. Lawrence: University of Kansas Museum of Art, 1972.

Ashton, Dore. *American Art Since 1945.* New York: Oxford University Press, 1982.

————. *The New York School: A Cultural Reckoning.* New York: Viking, 1973.

————. *The Unknown Shore: A View of Contemporary Art.* Boston: Little, Brown, 1962.

Avant-Garde Painting and Sculpture in America, 1910–1925. Wilmington: Delaware Art Museum, 1975.

Baigell, Matthew. *The American Scene: American Painting of the 1930s.* New York: Frederick A. Praeger, 1974.

Barr, Alfred H., Jr., and Miller, Dorothy. *American Realists and Magic Realists.* New York: The Museum of Modern Art, 1943.

Belknap, Waldron Phoenix, Jr. *American Colonial Painting.* Cambridge, Mass.: Harvard University Press, 1959.

Bermen, Greta, and Wechsler, Jeffrey. *Realism and Realities: The Other Side of American Painting, 1940–1960.* New Brunswick, N.J.: Rutgers University Art Gallery, 1982.

Bermingham, Peter. *American Art in the Barbizon Mood.* Washington, D.C.: Smithsonian Institution Press, 1975.

Bizardel, Yvon. *American Painters in Paris.* New York: Macmillan, 1960.

Boime, Albert. *The Magisterial Gaze: Manifest Destiny and American Landscape Painting, c. 1830–1865.* Washington, D.C.: Smithsonian Institution, 1991.

Born, Wolfgang. *American Landscape Painting: An Interpretation.* New Haven: Yale University Press, 1948.

Boyle, Richard J. *American Impressionism.* New York: Watson-Guptill, 1974.

Brown, Milton. *American Painting from the Armory Show to the Depression.* Princeton: Princeton University Press, 1955.

————. *The Story of the Armory Show.* New York: The Joseph Hirshhorn Foundation, 1963.

Chase, Judith Wragg. *Afro-American Art and Craft.* New York: Van Nostrand Reinhold, 1971.

Cockroft, Eva, *et al. Toward a People's Art: The Contemporary Mural Movement.* New York: Dutton, 1977.

Coplans, John. *Serial Imagery.* Pasadena: Pasadena Art Museum, 1968.

Corn, Wanda. *The Color of Mood: American Tonalism, 1880–1910.* San Francisco: M. H. de Young Memorial Museum, 1972.

Craven, Wayne. *Colonial American Portraiture: The Economic, Religious, Social, Cultural, Philosophical, Scientific and Aesthetic Foundations.* Cambridge: Cambridge University Press, 1986.

Curry, Larry. *The American West: Painters from Catlin to Russell.* New York: Viking, 1972.

Davidson, Abraham. *Early American Modernist Painting, 1910–1935.* New York: Harper & Row, 1981.

————. *The Eccentrics and Other American Visionaries.* New York: Dutton, 1978.

Dickason, David H. *The Daring Young Men: The Story of the American Pre-Raphaelites.* Bloomington: Indiana University Press, 1953.

Dickson, Harold G. *Arts of the Young Republic: The Age of William Dunlap.* Chapel Hill: University of North Carolina Press, 1968.

Doss, Erika Lee. *Benton, Pollock, and the Politics of Modernism: From Regionalism to Abstract Expressionism.* Chicago: University of Chicago Press, 1991.

Dover, Cedric. *American Negro Art.* Greenwich, Conn.: New York Graphic Society, 1960.

Drepperd, Carl. *American Pioneer Arts and Artists.* Springfield, Mass.: Pond-Ekberg, 1942.

Driskill, David C. *Two Centuries of Black American Art.* New York: Knopf, 1976.

Egbert, Donald Drew. *Socialism and American Art.* Princeton: Princeton University Press, 1967.

Eldredge, Charles C. *American Imagination and Symbolist Painting.* New York: New York University, Grey Art Gallery, 1979.

Evans, Dorinda. *Benjamin West and His American Students.* Washington, D. C.: Smithsonian Institution Press, 1980.

Ewers, John C. *Artists of the Old West.* New York: Doubleday, 1973.

Ferber, Linda S., and Gerdts, William H. *The New Path: Ruskin and the American Pre-Raphaelites.* Brooklyn, N.Y.: Schocken Books, 1985.

Fine, Elsa Honig. *The Afro-American Artist.* New York: Holt, Rinehart and Winston, 1973.

Fink, Lois. *Academy: The Academic Tradition in American Art.* Washington, D.C.: Smithsonian Institution Press, 1975.

Frankenstein, Alfred. *After the Hunt: William Harnett and Other American Still Life Painters, 1870–1900,* rev. ed. Berkeley: University of California Press, 1969.

Fried, Michael. *Three American Painters: Kenneth Noland, Jules Olitski, Frank Stella.* Cambridge, Mass.: Fogg Art Museum, 1965.

Friedman, Martin. *The Precisionist View in American Art.* Minneapolis: Walker Art Center, 1960.

Geldzahler, Henry, ed. *New York Painting and Sculpture, 1940–1970.* New York: The Metropolitan Museum of Art, 1969.

Gerdts, William H. *American Impressionism.* Seattle: University of Washington, Henry Art Gallery, 1980.

————. *The Great American Nude: A History in Art.* New York: Frederick A. Praeger, 1974.

————. *Painters of the Humble Truth: Masterpieces of American Still Life, 1801–1939.* Columbia: University of Missouri Press, 1982.

Gerdts, William H., and Sweet, Diana Dimodica. *Tonalism, An American Experience.* New York: Grand Central Art Galleries, 1982.

Gibson, Ann Eden. *Issues in Abstract Expressionism: The Artist-Run Periodicals.* Ann Arbor, Mich.: University Microfilms International Research Press, 1990.

Goodyear, Frank H. *Contemporary American Realism Since 1960.* Boston: New York Graphic Society, 1981.

Gordon, John. *Geometric Abstraction in America.* New York: Whitney Museum of American Art, 1962.

Greenberg, Clement. *Art and Culture.* Boston: Beacon, 1961.

Hassrick, Peter. *The Way West.* New York: Abrams, 1977.

Hiesinger, Ulrich W. *Impressionism in America: The Ten American Painters.* New York: Te Neues Press, 1991.

Heller, Nancy, and Williams, Julia. *The Regionalists.* New York: Watson-Guptill, 1976.

Hess, Thomas B. *Abstract Painting—Background and American Phase.* New York: Viking, 1950.

Hills, Patricia. *The American Frontier: Images and Myths.* New York: Whitney Museum of American Art, 1975.

————. *The Painter's America: Rural and Urban Life, 1810–1910.* New York: Whitney Museum of American Art, 1974.

————. *Turn-of-the-Century America.* New York: Whitney Museum of American Art, 1977.

Hobbs, Robert C., and Levin, Gail. *Abstract Expressionism: The Formative Years.* Ithaca: Cornell University, Herbert F. Johnson Museum of Art, 1981.

Homer, William Innes. *Alfred Stieglitz and the American Avant-Garde.* Boston: New York Graphic Society, 1977.

Hoopes, Donelson F., and von Kalnein, Wend. *The Düsseldorf Academy and the Americans.* Atlanta: High Museum of American Art, 1972.

Howat, John. *American Paradise: The World of the Hudson River School.* New York: Abrams, 1987.

Howat, John. *The Hudson River and Its Painters.* New York: Viking, 1972.

Huntington, David. *Art and the Excited Spirit: America in the Romantic Period.* Ann Arbor: The University of Michigan Press, 1972.

Johns, Elizabeth. *American Genre Painting: The Politics of Everyday Life.* New Haven: Yale University Press, 1992.

Kaprow, Allan. *Assemblage, Environments, and Happenings.* New York: Abrams, 1966.

Kirby, Michael, ed. *Happenings.* New York: Dutton, 1966.

Kuenzli, Rudolf E. *New York Dada.* New York: Willis Locker & Owens, 1986.

Leja, Michael. *Reframing Abstract Expressionism: Subjectivity and Painting in the 1940s.* New Haven: Yale University Press, 1993.

Levin, Gail. *Synchromism.* New York: Whitney Museum of American Art, 1978.

Lewis, Samella. *Art: African American.* New York: Harcourt, Brace, Jovanovich, 1978.

Lippard, Lucy. *Changing: Essays in Art Criticism.* New York: Dutton, 1971.

————. *From the Center: Feminist Essays on Women's Art.* New York: Dutton, 1976.

————. *Pop Art.* New York: Frederick A. Praeger, 1966.

Marling, Karel Ann. *Wall-to-Wall America: A Cultural History of Post-Office Murals in the Great*

Depression. Minneapolis: University of Minnesota Press, 1982.
McKinzie, Richard D. *The New Deal for Artists.* Princeton: University of Princeton Press, 1973.
Melosh, Barbara. *Engendering Culture: Manhood and Womanhood in New Deal Public Art and Theater.* Washington, D.C.: Smithsonian Institution Press, 1991.
Meyer, Ursula. *Conceptual Art.* New York: Dutton, 1972.
Milroy, Elizabeth. *Painters of a New Century: The Eight and American Art.* Milwaukee: Milwaukee Art Museum, 1991.
Nauman, Francis M. *New York Dada 1915–1923.* New York: Abrams, 1994.
Novak, Barbara. *Nature and Culture: American Landscape Painting, 1825–1875.* New York: Oxford University Press, 1980.
O'Connor, Francis V. *Federal Support for the Visual Arts: The New Deal and Now.* Greenwich, Conn.: New York Graphic Society, 1969.
Parry, Ellwood. *The Image of the Indian and the Black Man in American Art, 1590–1900.* New York: Braziller, 1974.
Pearlman, Bennard. *The Immortal Eight.* New York: Exposition, 1962.
Pierce, Patricia Jobe. *The Ten.* Hingham, Mass.: Pierce Gallery, 1976.
Pincus-Witten, Robert. *Post Minimalism.* New York: Out of London Press, 1977.
Plagens, Peter. *Sunshine Muse: Contemporary Art on the West Coast.* New York: Frederick A. Praeger, 1974.
Polcari, Stephen. *Abstract Expressionism and the Modern Experience.* New York: Cambridge University Press, 1991.
Porter, James. *Modern Negro Art.* New York: Arno, 1969.
Quick, Michael. *American Expatriate Painters of the Late Nineteenth Century.* Dayton: Dayton Art Institute, 1976.
———. *Munich and American Realism in the Nineteenth Century.* Sacramento: Crocker Art Gallery, 1978.
Quimby, Ian, ed. *American Painting to 1776: A Reappraisal.* Charlottesville: University Press of Virginia, 1971.
Quirarte, Jacinto. *Mexican American Artists.* Austin: University of Texas Press, 1973.
Real, Really Real, Superreal: Directions in Contemporary Realism. San Antonio: San Antonio Museum Association, 1981.
Rose, Barbara. *American Abstract Artists: The Early Years.* New York: Sid Deutsch Gallery, 1980.
Rosenberg, Harold. *The Anxious Object.* New York: Horizon, 1966.
———. *Artworks and Packages.* New York: Horizon, 1969.
———. *The De-Definition of Art.* New York: Horizon, 1972.
———. *The Tradition of the New.* New York: Horizon, 1959.
Russell, John, and Gablik, Suzi. *Pop Art Redefined.* New York: Frederick A. Praeger, 1969.
Sandler, Irving. *The New York School.* New York: Harper & Row, 1978.
———. *The Triumph of American Painting: A History of American Painting.* New York: Frederick A. Praeger, 1970.
Saunders, Richard H., and Ellen G. Miles. *American Colonial Portraits, 1700–1776.* Washington, D.C.: Smithsonian Institution Press for the National Portrait Gallery, 1987.
Schwarz, Arturo. *New York Dada.* Munich: Prestel Verlag, 1973.
Stein, Roger. *Seascape and the American Imagination.* New York: Potter, 1975.
Taft, Robert. *Artists and Illustrators of the Old West.* New York: Scribner's, 1953.
Tsujimoto, Karen. *Images of America: Precisionist Painting and Modern Photography.* Seattle: University of Washington Press, 1982.
Video Art. Philadelphia: University of Pennsylvania, Institute of Contemporary Art, 1975.
Wechsler, Jeffrey. *Surrealism and American Art.* New Brunswick, N.J.: Rutgers University Art Gallery.
Weinberg, H. Barbara. *The Lure of Paris: Nineteenth-Century American Painters and Their French Teachers.* New York: Abbeville, 1991.
Weinberg, H. Barbara, *et al. American Impressionism and Realism: The Painting of Modern Life, 1885–1915.* New York: Abrams, 1994.
Whiting, Cecile. *Antifascism in American Art.* New Haven: Yale University Press, 1989.
Williams, Herman Warner, Jr. *Mirror of the American Past: A Survey of American Genre Painting, 1750–1900.* Greenwich, Conn.: New York Graphic Society, 1973.
Wilmerding, John, *et al. American Light: The Luminist Movement, 1850–1875.* Washington, D.C.: National Gallery of Art, 1980.

————. *A History of American Marine Painting.* Salem: Peabody Museum, 1968.
Wilson, Richard Guy, and Pilgrim, Dianne. *The Machine Age in America, 1920–1941.* Brooklyn, N.Y.: The Brooklyn Museum, 1983.
Wright, Louis B., *et al. The Arts in America: The Colonial Period.* New York: Scribner's, 1966.
Wright, Willard Huntington. *Modern Painting: Its Tendency and Meaning.* New York: Lane, 1915.

Painters

ALBERS. Weber, Nicholas Fox, *et al. Josef Albers: A Retrospective.* New York: Guggenheim Museum, 1988.
ALLSTON. Bjelajac, David. *Millennial Desire and the Apocalyptic Vision of Washington Allston.* Washington, D.C.: Smithsonian Institution Press, 1988.
AVERY. Hobbs, Robert Carleton. *Milton Avery.* New York: Rizzoli, 1990.
BASQUIAT. Marshall, Richard. *Jean-Michel Basquiat.* New York: Abrams, 1992.
BEARDEN. Brown, Kevin. *Romare Bearden.* New York: Chelsea House, 1995.
BELLOWS. Quick, Michael, *et al. The Paintings of George Bellows.* New York: Abrams, 1992.
BENTON. Adams, Henry. *Thomas Hart Benton: An American Original.* New York: Knopf, 1989.
BIERSTADT. Anderson, Nancy, and Ferber, Linda. *Albert Bierstadt: Art and Enterprise.* New York: Hudson Hills Press, 1990.
BINGHAM. Shapiro, Michael Edward. *George Caleb Bingham.* New York: Abrams, 1993.
BIRCH. Gerdts, William H. *Thomas Birch.* Philadelphia: Philadelphia Maritime Museum, 1966.
BISHOP. Yglesias, Helen. *Isabel Bishop.* New York: Rizzoli, 1989.
BLAKELOCK. Geske, Norman A. *Ralph Albert Blakelock, 1847 – 1919.* Lincoln: Nebraska Art Association, 1974.
BLUME. Trapp, Frank. *Peter Blume.* New York: Rizzoli, 1987.
BLYTHE. Chambers, Bruce W. *The World of David Gilmour Blythe.* Washington, D.C.: National Museum of American Art, 1980.
BOLOTOWSKY. *Ilya Bolotowsky.* New York: Solomon R. Guggenheim Foundation, 1974.
BRIDGES. Hood, Graham. *Charles Bridges and William Dering: Two Virginia Painters, 1735 – 1750.* Williamsburg, Va.: University Press of Virginia, 1978.
BRUCE. Agee, William C. *Patrick Henry Bruce, American Modernist: A Catalogue Raisonné.* New York: Museum of Modern Art, 1979.
BURCHFIELD. Baur, John I.H. *The Inlander: Life and Works of Charles Burchfield.* Newark: University of Delaware Press, 1982.
CASSATT. Matthews, Nancy Mowll. *Mary Cassatt.* New York: Rizzoli, 1992.
CATLIN. Treuttner, William. *The Natural Man Observed: A Study of Catlin's Indian Gallery.* Washington, D.C.: Smithsonian Institution Press, 1979.
CHASE. Bryant, Keith L. *William Merritt Chase: A Genteel Bohemian.* Columbia: University of Missouri Press, 1991.
CHICAGO. Chicago, Judy. *Holocaust Project: From Darkness into Light.* Photography by Donald Woodman. New York: Penguin, 1993.
CHURCH. Kelly, Franklin. *Frederic Edwin Church.* Washington, D.C.: National Gallery of Art: Smithsonian Institution Press, 1989.
CLOSE. Lyons, Lisa, and Storr, Robert. *Chuck Close.* New York: Rizzoli, 1987.
COLE. Treuttner, William H., and Wallach, Allan, eds. *Thomas Cole: Landscape into History.* Washington, D.C.: National Museum of American Art, Smithsonian Institution, 1994.
COPLEY. Prown, Jules David. *John Singleton Copley.* Cambridge, Mass.: Harvard University Press, 1966.
COVERT. Klein, Michael. *John Covert, 1882 – 1960.* Washington, D.C.: Smithsonian Institution Press, 1976.
CRAWFORD. Haskell, Barbara. *Ralston Crawford.* New York: Whitney Museum of American Art, 1985.
CROPSEY. Foshay, Ella, *et al. Jasper F. Cropsey: Artist and Architect.* New York: New York Historical Society, 1987.
DAVIS. Sims, Lowery Stokes. *Stuart Davis: American Painter.* New York: Metropolitan Museum of Art, 1991.
DAWSON. Gedo, Mary. *Manierre Dawson.* Chicago: Museum of Contemporary Art, 1977.
DE KOONING. Cateforis, David. *Willem de Kooning.* New York: Rizzoli, 1994.

DEMUTH. Haskell, Barbara. *Charles Demuth.* New York: Abrams, 1987.

DICKINSON, EDWIN. Geske, Norman A. *Edwin Dickinson: A Vision of Coast and Sea.* New York: Babcock Galleries, 1990.

DICKINSON, PRESTON. Cloudman, Ruth. *Preston Dickinson.* Lincoln: Sheldon Memorial Art Gallery, 1979.

DIEBENKORN. Nordland, Gerald. *Richard Diebenkorn.* New York: Rizzoli, 1987.

DILLER. Haskell, Barbara. *Burgoyne Diller.* New York: Whitney Museum of American Art, 1990.

DINE. Livingstone, Marco. *Jim Dine Flowers and Plants.* New York: Abrams, 1994.

DOUGHTY. Goodyear, Frank H., Jr. *Thomas Doughty, 1793 – 1856: An American Pioneer in Landscape Painting.* Philadelphia: Pennsylvania Academy of the Fine Arts, 1973.

DOVE. Morgan, Ann Lee. *Arthur Dove: Life and Work, with a Catalogue Raisonné.* Newark: University of Delaware Press, 1984.

DOW. Herbert F. Johnson Museum of Art. *Arthur Wesley Dow and His Influence.* Ithaca, N.Y.: The Gallery, 1990.

DUNCANSON. Ketner, Joseph D. *The Emergence of the African-American Artist: Robert S. Duncanson, 1821 – 1872.* Columbia: University of Missouri Press, 1993.

DURAND. Lawall, David Barnard. *Asher Brown Durand: His Art and Art Theory in Relation to His Times.* Ann Arbor, Mich.: University Microfilms International, 1966 (1988 printing).

DUVENECK. Quick, Michael. *An American Painter Abroad: Frank Duveneck's European Years.* Cincinnati: Cincinnati Art Museum, 1987.

EAKINS. Wilmerding, John, ed. *Thomas Eakins (1844 – 1916) and the Heart of American Life.* London: National Portrait Gallery, 1993.

EARL. Kornhauser, Elizabeth Mankin. *Ralph Earl: The Face of the Young Republic.* New Haven: Yale University Press, 1991.

EDMONDS. Clark, Henry Nichols Blake. *Francis W. Edmonds: American Master in the Dutch Tradition.* Washington, D.C.: Smithsonian Institution Press, 1988.

ESTES. Arthur, John. *Richard Estes: Paintings and Prints.* San Francisco: Pomegranate Artbooks, 1993.

EVERGOOD. Taylor, Kendall. *Phillip Evergood: Never Separate from the Heart.* London: Associated University Presses, 1986.

FARNY. *The Realistic Expressions of Henry Farny: A Retrospective.* Santa Fe: The Snite Museum of Art/Peters Corp., 1981.

FEKE. Foote, Henry W. *Robert Feke, Colonial Portrait Painter.* Cambridge, Mass.: Harvard University Press, 1930.

FRANKENTHALER. Elderfield, John. *Frankenthaler.* New York: Abrams, 1989.

FULLER. Millet, Josiah, ed. *George Fuller: His Life and Work.* New York: Houghton, Mifflin and Co., 1886.

GIFFORD. Weiss, Ila. *Poetic Landscape: The Art and Experience of Sanford R. Gifford.* Newark: University of Delaware Press, 1987.

GLACKENS. Wattenmaker, Richard J. *William Glackens: The Formative Years.* New York: Kraushaar Galleries, 1991.

GOLUB. Marzorati, Gerald. *A Painter of Darkness: Leon Golub and Our Times.* New York: Viking, 1990.

GORKY. Jordan, Jim M., and Goldwater, Robert. *The Paintings of Arshile Gorky: A Critical Catalogue.* New York: New York University Press, 1982.

GRAVES. McDonald, Robert. *Morris Graves: Works of Fifty Years.* Santa Clara, Calif.: De Saisset Museum, 1990.

GUGLIELMI. Baker, John. *O. Louis Guglielmi: A Retrospective Exhibition.* New Brunswick, N.J.: Rutgers University Art Gallery, 1980.

HARNETT. Bolger, Doreen, *et al. William M. Harnett.* New York: Abrams, 1992.

HARTLEY. Robertson, Bruce. *Marsden Hartley.* New York: Abrams, 1994.

HASSAM. Hiesinger, Ulrich W. *Childe Hassam: American Impressionist.* New York: Prestel, 1994.

HEADE. Stebbins, Theodore E. *The Life and Works of Martin Johnson Heade.* New Haven: Yale University Press, 1975.

HENRI. Perlman, Bennard B. *Robert Henri: His Life and Art.* New York: Dover Publications, 1991.

HESSELIUS. Fleischer, Roland Edward. *Gustavus Hesselius: Face Painter to the Middle Colonies.* Trenton: New Jersey State Museum, 1988.

HOFMANN. Goodman, Cynthia. *Hans Hofmann.* New York: Whitney Museum of American Art, 1990.

HOMER. Cikovsky, Nicolai. *Winslow Homer.* New York: Rizzoli, 1992.

HOPPER. Strand, Mark. *Hopper.* Hopewell, N.J.: Ecco Press, 1994.

HUNT. Webster, Sally. *William Morris Hunt, 1824 – 1879.* New York: Cambridge University Press, 1991.

INNESS. Cikovsky, Nicolai. *George Inness.* New York: Abrams, 1993.

JARVIS. Dickson, Harold Edward. *John Wesley Jarvis: American Painter, 1780 – 1840.* New York: New-York Historical Society, 1949.

JOHNS. Orton, Fred. *Figuring Jasper Johns.* London: Reaktion Books, 1994.

JOHNSON. Hills, Patricia. *Eastman Johnson.* New York: Whitney Museum of American Art, 1972.

KATZ. Hunter, Sam. *Alex Katz.* New York: Rizzoli, 1992.

KELLY. Goosen, E. C. *Ellsworth Kelly.* New York: Museum of Modern Art, 1973.

KENSETT. Driscoll, John Paul, and Howat, John K. *John Frederick Kensett: An American Master.* New York: Norton, 1985.

KING. Cosentino, Andrew J. *The Paintings of Charles Bird King (1785 – 1862).* Washington, D.C.: Smithsonian Institution Press, 1977.

KLINE. Gaugh, Harry F. *Franz Kline.* New York: Abbeville, 1994.

KRIMMEL. Naeve, Milo. *John Lewis Krimmel: An Artist in Federal America.* Newark: University of Delaware, 1987.

KUHN. Pleasants, Jacob Hall. *Justus Engelhardt Kuhn: An Early Eighteenth Century Maryland Portrait Painter.* Worcester: American Antiquarian Society, 1937.

LA FARGE. Adams, Henry, *et al. John La Farge: Essays.* New York: Abbeville, 1987.

LANE. Wilmerding, John. *Paintings by Fitz Hugh Lane.* New York: Abrams, 1988.

LAWRENCE. Powell, Richard J. *Jacob Lawrence.* New York: Rizzoli, 1992.

LEUTZE. Groseclose, Barbara. *Emanuel Leutze, 1816 – 1868.* Washington, D.C.: National Collection of Fine Arts, 1975.

LEVINE. Frankel, Stephen Robert, ed. *Jack Levine.* New York: Rizzoli, 1989.

LICHTENSTEIN. Waldman, Diane. *Roy Lichtenstein.* New York: Rizzoli, 1993.

LOUIS. Elderfield, John. *Morris Louis.* New York: New York Graphic Society Books/Little, Brown, 1986.

LUKS. Cuba, Stanlet L., et al. *George Luks: An American Artist.* Wilkes-Barre, Pa.: Sordoni Art Gallery/Wilkes College, 1987.

MACDONALD-WRIGHT. *Stanton MacDonald-Wright: A Retrospective Exhibition, 1911 – 1970.* Los Angeles: UCLA Art Galleries, 1970.

MARIN. Fine, Ruth. *John Marin.* New York: Abbeville, 1990.

MARSH. Cohen, Marilyn. *Reginald Marsh's New York: Paintings, Drawings, Prints, and Photographs.* New York: Whitney Museum of American Art/Dover Publications, 1983.

MAURER. *Alfred H. Maurer, 1868 – 1932: The Cubist Works.* New York: Salander-O'Reilly Galleries, 1988.

MILLER, ALFRED J. Tyler, Ron, ed. *Alfred Jacob Miller: Artist on the Oregon Trail.* Fort Worth: Amon Carter Museum, 1982.

MILLER, KENNETH H. Rothschild, Lincoln. *To Keep Art Alive: The Effort of Kenneth Hayes Miller, American Painter (1876 – 1952).* Philadelphia: Art Alliance Press, 1974.

MITCHELL. Waldberg, Michel. *Joan Mitchell.* Paris: Editions de la Difference, 1992.

MORAN. Kinsey, Joni. *Thomas Moran and the Surveying of the American West.* Washington, D.C.: Smithsonian Institution Press, 1992.

MORSE. Staiti, Paul J. *Samuel F.B. Morse.* New York: Cambridge University Press, 1989.

MOUNT. Frankenstein, Alfred. *William Sidney Mount.* New York: Abrams, 1975.

MURRAY. Smith, Roberta. *Elizabeth Murray, paintings and drawings.* New York: Abrams, 1987.

NEWMAN, BARNETT. Rosenberg, Harold. *Barnett Newman.* New York: Abrams, 1994.

NEWMAN, ROBERT LOFTIN. Landgren, Marchal E. *Robert Loftin Newman, 1827 – 1912.* Washington, D.C.: Smithsonian Institution Press, 1974.

NOLAND. Wilkin, Karen. *Kenneth Noland.* New York: Rizzoli, 1990.

O'KEEFFE. Lynes, Barbara Buhler. *Georgia O'Keeffe.* New York: Rizzoli, 1993.

OLITSKI. Moffett, Kenworth. *Jules Olitski.* New York: Abrams, 1981.

PEALE. Miller, Lilian B. *New Perspectives on Charles Willson Peale: A 250th Anniversary Celebration.* Pittsburgh: University of Pittsburgh Press, 1991.

PEALE FAMILY. Lubowsky, Susan T. *Four American Families: A Tradition of Artistic Pursuit.* New York: Whitney Museum of Art, 1983.

PEARLSTEIN. Bowman, Russell. *Philip Pearlstein: The Complete Paintings.* New York: Alpine Fine Arts Collection, 1983.
PETO. Wilmerding, John. *Important Information Inside: The Art of John F. Peto and the Idea of Still-life Painting in Nineteenth-Century America.* Washington, D.C.: National Gallery of Art, 1983.
POLLOCK. Landau, Ellen. *Jackson Pollock.* New York: Abrams, 1989.
PORTER. Agee, William C. *Fairfield Porter: An American Painter.* Southampton, N.Y.: Parrish Art Museum, 1993.
PRENDERGAST. Clark, Carol, *et al. Maurice Brazil Prendergast, Charles Prendergast: A Catalogue Raisonné.* New York: Te Neues Press, 1990.
QUIDOR. Sokol, David. *John Quidor: Painter of American Legend.* Wichita: Wichita Art Museum, 1973.
RANNEY. Pennington, Estill Curtis. *Passage and Progress: in the Works of William Tylee Ranney.* Augusta, Ga.: Morris Museum of Art, 1993.
RAUSCHENBERG. Kotz, Mary Lynn. *Rauschenberg: Art and Life.* New York: Abrams, 1990.
RAY. Baldwin, Neil. *Man Ray: American Artist.* New York: Da Capo, 1988.
REMINGTON. Van Steenwyk, Elizabeth. *Frederic Remington: Artists of the American West.* New York: Franklin Watts, 1994.
RICHARDS. Ferber, Linda S. *William Trost Richards: American Landscape and Marine Painter, 1833 – 1905.* Brooklyn, N.Y.: Brooklyn Museum, 1973.
RIVERS. Rivers, Larry, and Weinstein, Arnold. *What did I do?: The Unauthorized Biography.* New York: Aaron Asher/HarperCollins, 1992.
ROBINSON. Clark, Eliot Candee. *Theodore Robinson: His Life and Art.* Chicago: R.H. Love Galleries, 1979.
ROSENQUIST. Brundage, Susan, ed. *James Rosenquist, Leo Castelli: The Big Paintings, Thirty Years.* New York: Rizzoli, 1994.
ROTHENBERG. Simon, Joan. *Susan Rothenberg.* New York: Abrams, 1991.
ROTHKO. Breslin, James E. B. *Mark Rothko: A Biography.* Chicago: University of Chicago Press, 1993.
RYDER. Homer, William Innes. *Albert Pinkham Ryder: Painter of Dreams.* New York: Abrams, 1989.
SALLE. Whitney, David, ed. *David Salle, 1979 – 1994.* New York: Rizzoli, 1994.
SARGENT. Fairbrother, Trevor J. *John Singer Sargent.* New York: Abrams, 1994.
SCHAMBERG. Agee, William. *Morton Livingston Schamberg.* New York: Salander-O'Reilly Galleries, 1982.
SCHAPIRO. Bradley, Paula Wynell. *Miriam Schapiro: The Feminist Transformation of an Avant-Garde Artist.* Chapel Hill, N.C.: P.W. Bradley, 1983.
SHAHN. Pohl, Frances K. *Ben Shahn.* San Francisco: Pomegranate Art Books, 1993.
SHEELER. Lucic, Karen. *Charles Sheeler and the Cult of the Machine.* London: Reaktion, 1991.
SHERMAN. Kraus, Rosalind. *Cindy Sherman, 1975 – 1993.* New York: Rizzoli, 1993.
SLOAN. Loughery, John. *John Sloan: Painter and Rebel.* New York: Henry Holt, 1995.
SMIBERT. Saunders, Richard H. *John Smibert: Colonial America's First Portrait Painter.* New Haven: Yale University Press, 1995.
SOYER. *Raphael Soyer: Life Drawings and Portraits.* New York: Dover Publications, 1986.
STANLEY. Dippie, Brian W. *Catlin and His Contemporaries: The Politics of Patronage.* Lincoln: University of Nebraska Press, 1990.
STEIR. Ratcliff, Carter. *Pat Steir.* New York: Abrams, 1986.
STELLA, FRANK. Rubin, Lawrence. *Frank Stella: A Catalogue Raisonné.* New York: Stewart, Tabori, and Chang, 1986.
STELLA, JOSEPH. Jaffe, Irma B. *Joseph Stella's Symbolism.* San Francisco: Pomegranate Artbooks, 1994.
STILL. Kellein, Thomas, ed. *Clyfford Still, 1904 – 1980: The Buffalo and San Francisco Collections.* New York: Te Neues Press, 1992.
STUART. McLanathan, Richard B. K. *Gilbert Stuart.* New York: Abrams, 1986.
SULLY. Fabian, Monroe H. *Mr. Sully, Portrait Painter.* Washington, D.C.: National Portrait Gallery, 1983.
TARBELL. Pierce, Patricia Jobe. *Edmund C. Tarbell and the Boston School of Painting, 1889 – 1980.* Poughkeepsie, N.Y.: Apollo Book, 1980.
THAYER. Anderson, Ross. *Abbott Handerson Thayer.* Syracuse, N.Y.: Everson Museum, 1982.

THEUS. Middleton, Margaret Simons. *Jeremiah Theus: Colonial Artist of Charles Town.* Columbia: University of South Carolina Press, 1991.
TOBEY. *Mark Tobey, Paintings (1920 – 1960).* New York: Yoshii Gallery, 1994.
TOOKER. Garver, Thomas H. *George Tooker.* San Francisco: Pomegranate Artbooks, 1992.
TRUMBULL. Cooper, Helen A. *John Trumbull: The Hand and Spirit of a Painter.* New Haven: Yale University Press, 1982.
TWACHTMAN. Chotner, Deborah. *John Twachtman: Connecticut Landscapes.* New York: Abrams, 1989.
VANDERLYN. Mondello, Salvatore. *The Private Papers of John Vanderlyn (1775 – 1852), American Portrait Painter.* Lewiston, N.Y.: Edwin Mellen Press, 1990.
VEDDER. Soria, Regina. *Perceptions and Evocations: The Art of Elihu Vedder.* Washington, D.C.: National Museum of American Art, 1979.
WARHOL. McShine, Kynaston, ed. *Andy Warhol: A Retrospective.* New York: Museum of Modern Art, 1989.
WEBER. North, Percy. *Max Weber: The Cubist Decade, 1910 – 1920.* Atlanta: High Museum of Art, 1991.
WESSELMAN. *Tom Wesselmann, Paintings 1962 – 1986.* London: The Mayor Gallery, 1988.
WEST. Erffa, Helmut von, and Staley, Allen. *The Paintings of Benjamin West.* New Haven: Yale University Press, 1986.
WHISTLER. Spencer, Robin, ed. *Whistler: A Retrospective.* New York: Hugh Lauter Levin Associates, 1989.
WHITTREDGE. Janson, Anthony. *Worthington Whittredge.* New York: Cambridge University Press, 1989.
WOOD. Dennis, James. *Grant Wood: A Study in American Art and Culture.* New York: Viking, 1975.
WOODVILLE. Grubar, Francis. *Richard Caton Woodville.* Washington, D.C.: Corcoran Gallery of Art, 1967.
WYANT. *Alexander Helvig Wyant.* Salt Lake City: University of Utah, 1968.

SCULPTURE

Surveys and Specific Topics

Beardsley, John. *Earthworks and Beyond: Contemporary Art in the Landscape.* New York: Abbeville, 1984.
Brooklyn Museum. *The Machine Age in America 1918 – 1941.* New York: Abrams, 1986.
Delaware Art Museum, University of Delaware. *Avant-Garde Painting and Sculpture in America, 1910 – 1925.* Wilmington: Delaware Art Museum, 1975.
Lane, John R., and Larsen, Susan C., eds. *Abstract Painting and Sculpture in America, 1927 – 1944.* New York: Abrams, 1983.
Whitney Museum of American Art. *200 Years of American Sculpture.* Boston: David R. Godine, 1976.

Sculptors:

ACCONCI. Kirschner, Judith Russi. *Vito Acconci.* Chicago: Museum of Contemporary Art, 1980.
ANDRE. Lauter, Rolf. *Carl Andre: Extraneous Roots.* Frankfurt am Main: Museum fur Moderne Kunst, 1991.
BALL. Ball, Thomas. *My Three Score Years and Ten: An Autobiography.* Boston: Roberts, 1891.
BARNARD. *George Grey Barnard: Centennial Exhibition, 1863 – 1963.* University Park: The Pennsylvania State University Press, 1964.
BASKIN. Jaffe, Irma. *The Sculpture of Leonard Baskin.* New York: Viking, 1980.
BELL. Butterfield, Jan. *The Art of Light and Space.* New York: Abbeville, 1993.
CALDER. Marter, Joan M. *Alexander Calder.* New York: Cambridge University Press, 1991.
CORNELL. Ashton, Dore. *Joseph Cornell Album.* New York: Da Capo, 1989.
CRAWFORD. Gale, Robert L. *Thomas Crawford: American Sculptor.* Pittsburgh: University of Pittsburgh Press, 1964.

DI SUVERO. *Mark di Suvero: Retrospective 1959 – 1991.* Nice: Musée d'Art Moderne et d'Art Contemporain, 1991.

FERBER. Goosen, E.C. *Herbert Ferber.* New York: Abbeville, 1981.

FLANNAGAN. *John Storrs and John Flannagan: Sculpture and Works on Paper.* Williamstown, Mass.: Sterling and Francine Clark Art Institute, 1980.

FLAVIN. Smith, Brydon. *Dan Flavin, Fluorescent Light, etc.* Ottawa: National Gallery of Canada, 1969.

FRENCH. Richman, Michael. *Daniel Chester French: An American Sculptor.* New York: Metropolitan Museum of Art, 1976.

GREENOUGH. Wright, Nathalia. *Horatio Greenough: The First American Sculptor.* Philadelphia: University of Pennsylvania Press, 1963.

GROSS. Tarbell, Roberta K. *Chaim Gross: Retrospective Exhibition: Sculpture, Paintings, Drawings, Prints.* New York: The Jewish Museum, 1977.

HANSON. Livingstone, Marco. *Duane Hanson.* Montreal: Montreal Museum of Fine Arts, 1994.

HESSE. Barrette, Bill. *Eva Hesse: Sculpture: Catalogue Raisonné.* New York: Timken Publishers, 1989.

HOLZER. Waldman, Diane. *Jenny Holzer.* New York: Abrams, 1989.

IRWIN. Ferguson, Russell, ed. *Robert Irwin.* New York: Rizzoli, 1993.

JUDD. Haskell, Barbara. *Donald Judd.* New York: Whitney Museum of American Art, 1988.

KIENHOLZ. Pincus, Robert L. *On a Scale That Competes with the World: The Art of Edward and Nancy Reddin Kienholz.* Berkeley: University of California Press, 1990.

LACHAISE. Hunter, Sam. *Lachaise.* New York: Cross River Press, 1993.

LASSAW. *Ibram Lassaw: Space Explorations, a Retrospective Survey, 1929 – 1988.* East Hampton, N.Y.: Guild Hall Museum of East Hampton, 1988.

LEWITT. Lewitt, Sol. *Lines and Forms.* Paris: Y. Lambert, 1990.

LIPTON. Elsen, Albert. *Seymour Lipton.* New York: Abrams, 1972.

MORRIS. Kraus, Rosalind. *The Mind-Body Problem.* New York: Guggenheim Museum, 1994.

NADELMAN. Baur, John. *The Sculpture and Drawings of Elie Nadelman, 1882 – 1946.* New York: The Whitney Museum of American Art, 1975.

NAUMAN. Simon, Joan, ed. *Bruce Nauman: Exhibition Catalogue and Catalogue Raisonné.* Minneapolis: Walker Art Gallery, 1994.

NEVELSON. Friedman, Ceil. *Louise Nevelson: Works in Wood.* Cambridge, Mass.: Massachusetts Institute of Technology, 1986.

NOGUCHI. Altshuler, Bruce. *Isamu Noguchi.* New York: Abbeville, 1994.

OLDENBURG. van Bruggen, Coosje. *Claes Oldenburg: Multiples in Retrospect, 1964 – 1990.* New York: Rizzoli, 1991.

PAIK, NAM JUNE. Stooss, Toni, and Kellein, Thomas, eds. *Nam June Paik: Video Time, Video Space.* New York: Abrams, 1993.

POWERS. Wunder, Richard P. *Hiram Power: Vermont Sculptor, 1805 – 1873.* Newark: University of Delaware, 1991.

RICKEY. Kolberg, Gerhard. *George Rickey: Kinetische Skulpturen.* Dortmund and New York: Galerie Utermann, 1990.

RIMMER. Stebbins, Theodore E., Jr. *William Rimmer: A Yankee Michelangelo.* Hanover, N.H.: University Press of New England, 1985.

RINEHART. Ross, Marvin Chauncey, and Rutledge, Anna Wells. *A Catalogue of the Work of William Henry Rinehart, Maryland Sculptor, 1825 – 1874.* Baltimore: Trustees of the Peabody Institute and the Walters Art Gallery, 1948.

ROGERS, JOHN. Wallace, David. *John Rogers: The People's Sculptor.* Middletown, Conn.: Wesleyan University Press, 1967.

ROGERS, RANDOLPH. Rogers, Millard F. *Randolph Rogers: American Sculptor in Rome.* Amherst: University of Massachusetts Press, 1971.

ROSZAK. *Theodore Roszak, Sculpture and Drawings, 1942 – 1963.* New York: Hirschl & Adler Galleries, 1994.

RUSH. Bantel, Linda, ed. *William Rush: American Sculptor.* Philadelphia: Pennsylvania Academy of the Fine Arts, 1982.

SAINT-GAUDENS. Greenthal, Kathryn. *Augustus Saint-Gaudens, Master Sculptor.* Boston: G.K. Hall, 1985.

SEGAL. Hunter, Sam. *George Segal.* New York: Rizzoli, 1989.

SMITH. Wilkin, Karen. *David Smith.* New York: Abbeville, 1984.

SMITHSON. Shapiro, Gary. *Earthwards: Robert Smithson and Art After Babel.* Berkeley: University of California Press, 1995.

VIOLA. Viola, Bill. *Bill Viola: Selected Works.* Los Angeles: Voyager Press, 1986.

WARD. Sharp, Lewis I. *John Quincy Adams Ward: Dean of American Sculpture.* Newark: University of Delaware Press, 1985.

YOUNG. Mather, Frank Jewett, Jr. *Mahonri Young.* Andover, Mass.: Addison Gallery of Art, 1940.

ZORACH. Baur, John I.H. *William Zorach.* New York: Frederick A. Praeger, 1959.

INDEX

Page numbers in *italics* refer to illustrations.

421